iPhoto

the missing manual®

The book that should have been in the box®

David Pogue and Lesa Snider

O'REILLY®

Beijing | Cambridge | Farnham | Köln | Sebastopol | Tokyo

iPhoto: The Missing Manual

by David Pogue and Lesa Snider

Published by O'Reilly Media, Inc.,
1005 Gravenstein Highway North, Sebastopol, CA 95472.

O'Reilly books may be purchased for educational, business, or sales promotional use. Online editions are also available for most titles (*http://my.safaribooksonline.com*). For more information, contact our corporate/institutional sales department: (800) 998-9938 or *corporate@oreilly.com*.

May 2014: First Edition.

Revision History for the First Edition:

 2014-05-05 First release

See *http://oreilly.com/catalog/errata.csp?isbn=9781491947319* for release details.

ISBN-13: 978-1-491-94731-9

[TI]

Contents

Part One: iPhoto Basics

Part Five: Appendixes

> **NOTE** Head to this book's Missing CD page (*www.missingmanuals.com/cds*) to download Appendix C, "iPhoto, Menu by Menu."

The Missing Credits

ABOUT THE AUTHORS

David Pogue (original author, editor) is the founder of Yahoo Tech, former tech columnist for the *New York Times,* a double-Emmy-winning correspondent for *CBS News Sunday Morning,* and the creator of the Missing Manual series. He's the author or coauthor of 72 books, including 30 in this series, six in the *For Dummies* line (including *Macs, Magic, Opera,* and *Classical Music*), and a novel for middle-schoolers called *Abby Carnelia's One and Only Magical Power.* In his other life, David is a former Broadway show conductor, a piano player, and a magician. He lives in Connecticut with his wife and three awesome children.

Links to his columns and weekly videos await at *www.davidpogue.com.* He welcomes feedback about his books by email at *david@pogueman.com.*

Lesa Snider, internationally acclaimed author and speaker, is on a mission to teach the world to create better graphics. She's the author of several books, including the popular *Photoshop: The Missing Manual* and The Skinny Book series of ebooks (*www.theskinnybooks. com*). Lesa is a founding instructor for creativeLIVE.com (*www.lesa. in/clvideos*), where she teaches image editing, graphic design, and stock photography, and a regular columnist for *Photoshop User, Adobe Photoshop Elements Techniques,* and *Macworld* magazines. She's also a stock photographer, a longtime member of the Photoshop World Dream Team of instructors, and captain of her very own Prometheus-class starship. Lesa and her husband, Jay Nelson, live in Boulder, Colorado, with their two cats, Samantha and Sherlock.

Visit Lesa's tutorial-riddled website at *www.PhotoLesa.com,* connect with her on Twitter (*@PhotoLesa*), or pose questions on her Facebook fan page (*www.facebook. com/Photolesa*).

ABOUT THE CREATIVE TEAM

Dawn Mann (editor) is associate editor for the Missing Manual series. When not working, she plays soccer, beads, and causes trouble. Email: *dawn@oreilly.com.*

Melanie Yarbrough (production editor) lives, works, and plays in Cambridge, Mass., where she bakes up whatever she can imagine. Email: *myarbrough@oreilly.com.*

Charles Holt (technical reviewer) is an aerodynamic man of random talents. He's co-founder of *TheTikipedia.com,* designed a steampunk ukulele, and has been hand-cuffed and interrogated by the police for performing roadside experiments with high

voltage power lines and fluorescent light bulbs. He currently works with his wife, Melissa, as an Apple Consultant in beautiful Colorado (*www.PEBMAC.com*), but his heart can be found in Napili Bay—usually most visible at low tide.

Julie Van Keuren (proofreader) quit her newspaper job in 2006 to move to Montana and live the freelancing dream. She and her husband (who is living the novel-writing dream) have two hungry teenage sons. Email: *little_media@yahoo.com*.

Ron Strauss (indexer) specializes in the indexing of information technology publications of all kinds. Ron is also an accomplished classical violist and lives in Northern California with his wife and fellow indexer, Annie, and his miniature pinscher, Kanga. Email: *rstrauss@mchsi.com*.

ACKNOWLEDGMENTS

The Missing Manual series is a joint venture between Pogue Press (the dream team introduced on these pages) and O'Reilly Media (a dream publishing partner).

I also owe a debt of gratitude to my old Yale roommate Joe Schorr, who coauthored the first two editions of this book and wound up, years later, working at Apple, where he eventually became the product manager for Aperture and—how's this for irony?—iPhoto. Some of his prose and his humor live on in this edition.

Various editions of this book have also enjoyed the prose stylings of professional photographer/writer Derrick Story and fellow *New York Times* tech columnist Jude Biersdorfer. Above all, it was my pleasure to welcome Lesa Snider, who cheerfully undertook the challenge of updating this book to reflect the changes in iPhoto without making it sound like two different authors were at work. She did a sensational job.

Above all, thanks to my beautiful bride Nicki and my gifted offspring Kelly, Tia, and Jeffrey, whose patience and sacrifices make these books—and everything else—possible.

— *David Pogue*

What a huge treat it was to rewrite this book and prepare all-new artwork! I'm really proud of the way the book turned out, and I think you'll enjoy it, too. (FYI, all the photography in this edition came from my trusty Canon 40D and Canon 5D Mark III, the latter generously provided by *www.LensProToGo.com*.) Thanks to everyone who posed so beautifully for a large chunk of the shots used in this book: our neighbors Bob and Elsbeth Diehl; our Maui 'ohana (family) Jamie Lumlun-Kaeo, Marv and Shirley Rahn; and the musicians George Kahumoku Jr., Sterling Seaton, Ken Emerson, and of course the beautiful hula artist Wainani Kealoha. You can find their wonderfully authentic, Grammy-winning Hawaiian slack-key guitar music at *www.kahumoku.com*.

Of course, a million thanks go to David Pogue for mentoring me and teaching me how to make every figure a work of art, as well as how to write in an entertaining yet informative manner. His guidance has been the foundation for my career in more ways than I can count.

Thanks also to my editor, Dawn Mann, for her amazing attention to detail, and also to J. Charles "Hawk Eyes" Holt, who tech-edited this edition.

Last but not least, I owe a galactic debt of gratitude to my husband, Jay Nelson, for being incredibly supportive during this project and for keeping me, and our two loving cats, fed and watered.

— Lesa Snider

THE MISSING MANUAL SERIES

Missing Manuals are witty, superbly written guides to computer products that don't come with printed manuals (which is just about all of them). Each book features a handcrafted index and cross-references to specific pages (not just chapters). For a full list of all Missing Manuals in print, go to *www.missingmanuals.com/library.html.*

Introduction

In case you haven't heard, the digital camera market has exploded. At this point, a staggering 98 percent of cameras sold are digital. It's taken a few decades—the underlying technology used in most digital cameras was invented in 1969—but film photography has been reduced to a niche activity.

And why not? The appeal of digital photography is huge. When you shoot digitally, you don't pay a cent for film or photo processing. You get instant results, viewing your photos just moments after shooting them, making even Polaroids seem painfully slow by comparison. As a digital photographer, you can even be your own darkroom technician—without the darkroom. You can retouch and enhance photos, make enlargements, and print out greeting cards using your home computer. Sharing your pictures with others is far easier, too, since you can email them to friends, post them on the Web, or burn them to CD or DVD. As one fan puts it, "There are no 'negatives' in digital photography."

But there is *one* problem. When most people try to do all this cool stuff, they find themselves drowning in a sea of technical details: JPEG compression, EXIF tags, file format compatibility, image resolutions, FTP clients, and so on. It isn't pretty.

The cold reality is that while digital photography is full of promise, it's also been full of headaches. During the early years of digital cameras, just making the camera-to-computer connection was a nightmare. You had to mess with serial or USB cables; install device drivers; and use proprietary software to transfer, open, and convert camera images into a standard file format. If you handled all these tasks perfectly—and sacrificed a young goat during the spring equinox—you ended up with good digital pictures.

A Quick History of iPhoto

Apple recognized this mess and decided to do something about it. When Steve Jobs gave his keynote address at Macworld Expo in January 2002, he referred to the "chain of pain" that ordinary people experienced when attempting to download, store, edit, and share their digital photos.

He also focused on another growing problem among digital photographers: Once you start shooting free, filmless photos, they pile up *fast.* Before you know it, you have 100,000 pictures of your kid playing soccer. Just organizing and keeping track of all those photos is enough to drive you insane.

Apple's answer to all these problems was iPhoto, a simple and uncluttered program designed to organize, edit, and distribute digital photos without the nightmarish hassles. Successive versions added features and better speed.

To be sure, iPhoto isn't the most powerful image-management software in the world. Like Apple's other iProducts (iMovie, iTunes, and so on), its design subscribes to its own little 80/20 rule: 80 percent of us really don't need more than about 20 percent of the features you'd find in a full-blown, digital asset management program/pro-level image editor like, say, Apple's own Aperture ($80) or Adobe Photoshop Lightroom ($150).

Today, *millions* of Mac fans use iPhoto. And the big news is that you don't even need a Mac to use iPhoto: In 2012, Apple introduced iPhoto for iOS, which can run on an iPad, iPhone, or iPod Touch. Heck, the new iOS version of iPhoto even lets you do things the desktop version doesn't, like paint changes onto your photos, upload slideshows to the Web, and create snazzy, customizable online scrapbook-style pages called *web journals* (see page 383). You'll learn all about iPhoto for iOS in Part Four of this book.

> **NOTE** In the past, Apple added a year abbreviation to iPhoto's name to help you keep track of each version (like "iPhoto '11"). But Apple has decided to drop the number, and simply calls the latest version of the program "iPhoto." If you want to get technical, this book covers iPhoto for Mac version 9.5, and iPhoto for iOS version 2.0.

What's New in iPhoto for Mac

On the surface, the current version of iPhoto for Mac looks more polished and grown-up than its predecessors. For example, the friendly, full-color icons of versions past have been replaced by more streamlined and sophisticated art. The program is also faster than ever now that it's 64-bit capable (the box on page 22 explains why), and uses Apple Maps (instead of Google's) to handle location tags. It also harbors new features that make it *shockingly* simple to share your photos with the world:

- **iCloud integration.** iPhoto sports numerous hooks into iCloud, Apple's free online storage and syncing service. By flicking a few key switches on your Mac

and your iOS gadgets, the last 1,000 photos and videos you take on your iPhone can appear on your Mac and your iPad. Likewise, the last 1,000 photos and videos you imported onto your Mac appear on your iOS gadgets, too. You can also create shared *photo streams,* which let you invite up to 100 other iCloud members to subscribe, comment on, and even contribute to online albums of photos and videos. And if the person you want to share your photos with doesn't use iCloud, you can create a beautiful web gallery (page 222) to share with him instead.

- **Social media sharing.** iPhoto '09 brought online social media sharing to the masses, and the latest version of iPhoto fine-tunes the process even further. Nowadays, you can easily upload photos and *videos* to an existing Facebook album or Flickr set, as well as create new albums and sets on the fly. You can also manage privacy settings for the individual items you post onto your Facebook Timeline (previously, you could manage the privacy settings only of albums), and view comments and "likes" in the Info panel. iPhoto also lets you share pictures via instant message using the Mac's Messages app, as well as post them on Twitter—all from inside iPhoto. The program even keeps track of *where* you've shared your images; just select an image and peek at the Info panel to see where it's been.

- **Streamlined printing process.** Printing in iPhoto used to be fraught with a dizzying array of options like digital matting, borders, and so on. Now, printing your photos is a wonderfully simple, foolproof process that involves a single screen of only the most practical of printing options, such as photo and paper size. You even get a preview of exactly what your print(s) will look like, which keeps you from wasting expensive photo paper and ink.

- **Easier slideshow exporting.** Apple revamped the way you export slideshows into a movie. Instead of multiple options, you can now choose from three sizes—480p, 720p, 1080p—and you can send the resulting QuickTime movie to iTunes for syncing onto your iOS devices.

There are other, more subtle changes, too. For example, iPhoto now behaves like a true database program and no longer makes copies of the files you edit; it merely keeps a record of your changes to each photo. That's a big, big deal that can save you a huge amount of disk space.

Keywords and location tags can now be tucked into the files you export, there are a slew of new card designs, and the process for turning your Mac into the coolest screensaver ever has been simplified, too. Unfortunately, Apple removed the ability to share iPhoto libraries over a network, though this book walks you through some great workarounds.

Overall, the entire program feels more streamlined, and complex tasks like sharing photos, exporting slideshows, and printing (to name a few) just don't seem very complex anymore. In short, there are quite a few changes, so you'll definitely need a book to keep track; lucky for you, you're holding that book right now.

■ Introducing iPhoto for iOS

These days, iPhoto isn't just for your Mac—there's a very similar app for your iPad, iPhone, or iPod Touch, too. The controls are similar, yet different enough to warrant three chapters, new in this edition, devoted solely to iPhoto on your iOS gadgets.

- **Peruse your pictures.** It's incredibly easy to get your pictures into iPhoto for iOS, whether you shot them with your iOS device, synced them onto your device using iTunes, shared them via iCloud, snatched them from an email or instant message, or downloaded them directly onto your iPad from your camera or memory card. iPhoto for iOS organizes your mementos in three handy views: Photos, Albums, and Projects.

- **Compare, flag, and tag photos.** iPhoto's slick comparison feature lets you see multiple shots side by side so you can determine which one is the best. And if you double-tap a thumbnail, iPhoto rounds up all the *similar* photos in that particular album. You can also add keywords to your pictures, as well as mark some as favorites (handy when you come across a photo that you want to do something special with later, like post it online).

- **Edit your photos.** iPhoto for iOS has all the same editing prowess as iPhoto for Mac—and then some. For example, you can use the Brushes tool to paint changes onto a photo in just the spots that need changing (teeth lightening, anyone?). You can also intensify just the blues or greens in your pictures, and/ or apply one of *nine* categories of creative effects like funky edges, color treatments, and trendy filters (including a nifty tilt-shift blur).

- **Share your photos and slideshows.** To help get your photographic life online, iPhoto for iOS provides a painless path for posting pictures on Facebook, Flickr, and Twitter, and for sending them via email or instant message. Even more exciting, you can create and post a *slideshow* online using your iCloud account so that far-flung friends and family can see it. You can also beam or AirDrop photos, videos, and slideshows onto other iOS devices.

- **Create digital scrapbooks with web journals.** Another exclusive iPhoto for iOS feature are *web journals,* which let you include up to 200 pictures in an array of highly customizable, grid-style layouts. By using gestures, you can resize, rearrange, and reposition pictures, as well as add festive visual extras such as maps, Post-it notes, weather reports, and more. You can also add dividing lines and spacers to create exactly the design you want. Once you're finished, post your journal online using iCloud, beam or AirDrop it onto another iOS device, or export it as HTML files using iTunes.

- **Order photo books and prints.** iPhoto for iOS also lets you design and order hardcover photo books and prints in a variety of sizes. The print-ordering process is *incredibly* well designed and gives you some neat, non-standard size options. And if you've got a wireless printer on your network, you can print straight from your iOS device.

■ About This Book

Don't let the rumors fool you: iPhoto may be simple, but it's far from simplistic. It offers a wide range of tools, shortcuts, and database-like features; a complete arsenal of photo-presentation tools; and sophisticated multimedia and Internet hooks. Unfortunately, many of the best techniques aren't covered in the only "manual" you get with iPhoto—its sparse electronic help screens.

This book was born to serve as the definitive iPhoto manual. It explores each of the program's features in depth, offers shortcuts and workarounds, provides helpful tips, and unearths features that the online help never mentions.

And to make it all go down easier, this book has been printed in full color. Kind of makes sense for a book about photography, doesn't it?

About the Outline

This book is divided into five parts, each containing several chapters:

- Part 1, **iPhoto Basics,** covers the fundamentals of getting your pictures into iPhoto for Mac. This includes getting photos off your cameras and smartphones, filing them, associating them with people and places, and searching them.

- Part 2, **Editing and Sharing,** is all about how to get your photos looking their best and how to show them off. It covers the many ways iPhoto for Mac can present your photos to other people: on iCloud as a shared photo stream; on Facebook, Flickr, or Twitter; as an instant message; as a slideshow; as prints you order online or make yourself; as a professionally printed card or book; by email; or as a slideshow exported as a QuickTime movie that you post online, share via iCloud, send to your iPhone, distribute on DVD, or sync with your Apple TV. It also covers workarounds for sharing your iPhoto collection across a network with other Macs and with other account holders on the *same* Mac.

- Part 3, **Advanced iPhoto,** covers a potpourri of additional iPhoto features, including turning photos into screensavers or desktop pictures on your Mac; scripting tasks using Automator; exporting the photos in various formats; managing (and even switching) iPhoto libraries; and backing up your photos using external hard drives, Time Machine, or by burning them to a CD or DVD.

- Part 4, **iPhoto for iOS,** covers everything you need to know about using iPhoto on your iPad, iPhone, or iPod Touch, including syncing, browsing, organizing, and managing albums (iPhoto creates several albums automatically). You'll also master the controls for basic and advanced editing, have tons of fun with Instagram-style filters, as well as create slideshows, web journals (gorgeous, customizable web galleries), book projects, and prints.

- Part 5, **Appendixes,** brings up the rear, but gives you a chance to move forward. Appendix A offers troubleshooting guidance, and Appendix B lists some very helpful websites that will help fuel your growing addiction to digital photography and image editing. The remaining two appendixes are available from this book's

Missing CD page at *www.missingmanuals.com/cds*: Appendix C goes through iPhoto for Mac's menus one by one to make sure that every last feature has been covered, and Appendix D shows you how to use the now-retired iDVD to make incredible slideshow DVDs.

About→These→Arrows

Throughout this book, and throughout the Missing Manual series, you'll find sentences like this one: "Open the System folder→Libraries→Fonts folder." That's shorthand for a much longer instruction that directs you to open three nested folders in sequence. That instruction might read: "On your hard drive, you'll find a folder called System. Open it. Inside the System folder window is a folder called Libraries. Open that. Inside *that* folder is yet another one called Fonts. Double-click to open it, too."

Similarly, this kind of arrow shorthand helps to simplify the business of choosing commands in menus. The instruction "Choose Photos→Duplicate" means, "In iPhoto for Mac, open the Photos menu at the top of your monitor, and then choose the Duplicate command."

About the Online Resources

As the owner of a Missing Manual, you've got more than just a book to read. At the Missing Manuals website, you'll find tips, articles, and other useful info. You can also communicate with the Missing Manual team and tell us what you love (or hate) about this book. Head over to *www.missingmanuals.com*, or go directly to one of the following sections.

■ MISSING CD

This book doesn't have a physical CD pasted inside the back cover, but you're not missing out on anything. Go to *www.missingmanuals.com/cds* to find a list of all the shareware and websites mentioned in this book, as well as Appendixes C and D.

■ REGISTRATION

If you register this book at oreilly.com, you'll be eligible for special offers—like discounts on future editions. Registering takes only a few clicks. Type *www.oreilly.com/register* into your browser to hop directly to the registration page.

■ FEEDBACK

Got questions? Need more info? Fancy yourself a book reviewer? On our Feedback page, you can get expert answers to questions that come to you while reading, share your thoughts on this Missing Manual, and find groups for folks who share your interest in iPhoto. To have your say, go to *www.missingmanuals.com/feedback*.

■ ERRATA

In an effort to keep this book as up to date and accurate as possible, each time we print more copies, we'll make any confirmed corrections you've suggested. We also note such changes on the book's website, so you can mark important corrections

in your own copy of the book, if you like. Go to *http://tinyurl.com/iphotommerrata* to report an error and to view existing corrections.

◼ The Very Basics

You'll find very little jargon or nerd terminology in this book. You will, however, encounter a few terms and concepts that you'll see frequently in your Mac life. Here are the essentials:

- **Clicking.** To *click* means to point the arrow cursor at something onscreen and then—without moving the cursor at all—press and release the clicker button on the mouse or trackpad. To *double-click,* of course, means to click twice in rapid succession, again without moving the cursor. And to *drag* means to move the cursor while keeping the button continuously pressed.

 When you're told to ⌘-click something, you click while pressing the ⌘ key (it's next to the space bar). *Shift-clicking, Option-clicking,* and *Control-clicking* work the same way—just click while pressing the corresponding key on your keyboard. (On non-U.S. Mac keyboards, the Option key may be labeled "Alt" instead.)

- **Keyboard shortcuts.** Every time you take your hand off the keyboard to move the mouse, you lose time and potentially disrupt your creative flow. That's why many experienced Mac fans use keystroke combinations instead of menu commands wherever possible. ⌘-P opens the Print dialog box, for example, and ⌘-M minimizes the current window to the Dock.

 When you see a shortcut like ⌘-Q (which quits the current program), it's telling you to hold down the ⌘ key, and, while it's down, type the letter Q, and then release both keys. And if you forget a keyboard shortcut, don't panic. Just look at the menu item and you'll see its keyboard shortcut listed to its right. (To see a list of *all* the keyboard shortcuts in iPhoto for Mac, choose Help→Keyboard Shortcuts.)

- **Touchscreen basics.** On an iOS device (an iPad, iPhone, or iPod Touch), you do everything on the touchscreen instead of with physical buttons. You'll do a lot of *tapping* on the screen, and navigate by *swiping* your finger across the screen (say, to move from viewing one album, Event, or photo to the next). You *drag* by sliding your finger across the glass in any direction.

 A *flick* is a faster, less-controlled drag. You flick vertically to scroll through lists of photos, say. You'll discover—usually with some expletive like "Whoa!" or "Jeez!"—that scrolling a list in this way is a blast. The faster you flick, the faster the list spins up or down. And lists have real-world momentum: They slow down after a second or two, so you can see where you wound up.

 Last but not least, you can zoom in on a photo or map by *spreading*—that's when you place two fingers (usually thumb and forefinger) on the glass and then spread them apart. The image magically grows as though it's printed on

a sheet of rubber. Once you've zoomed in like this, you can zoom out again by putting two fingers on the glass and *pinching* them together.

If you've mastered this much information, you have all the technical background you need to enjoy *iPhoto: The Missing Manual.*

> **NOTE** Apple has officially changed what it calls the little menu that pops up when you Control-click (or right-click) something on your Mac. It's still a *contextual* menu, in that the menu choices depend on the context of what you click—but it's now called a *shortcut* menu. That term not only matches the name of the corresponding Windows feature, but it's slightly more descriptive about its function. "Shortcut menu" is the term you'll find in this book.

Notes on Right-Clicking

In OS X, *shortcut menus* are more important than ever.

They're so important, in fact, that it's worth this ink and this paper to explain the different ways you can trigger a "right-click" (or a *secondary click,* as Apple calls it, because not all of these methods actually involve a second mouse button, and it doesn't *have* to be the right one).

- **Control-click.** For years, you could open the shortcut menu of something on the Mac screen by Control-clicking it—and you still can. That is, while pressing the Control key (bottom row), click the mouse on your target.

- **Right-click.** Experienced computer fans have always preferred the one-handed method: right-clicking. That is, clicking something by pressing the *right* mouse button on a two-button mouse.

Every desktop Mac since late 2005 has come with a two-button mouse—but you might not realize it. Take a look: Is it a white, shiny plastic capsule with a tiny, gray scrolling track pea on the far end? Then you have a Mighty Mouse. Is it a cordless, flattened capsule instead? Then it's a Magic Mouse. Each has a *secret* right mouse button. It doesn't work until you ask for it.

To do that, choose →System Preferences. Click Mouse. There, in all its splendor, is a diagram of the Mighty or Magic Mouse.

Your job is to choose Secondary Button from the pop-up menu that identifies the right side of the mouse. (The reason it's not called a "right button" is because left-handers might prefer to reverse the right and left functions.)

From now on, even though there aren't two visible mouse buttons, your Mighty Mouse does, in fact, register a left-click or a right-click depending on which side of the mouse you push down. It works a lot more easily than it sounds like it would.

(Another idea: You can also attach any old $6 USB two-button mouse to the Mac, and it'll work flawlessly. Recycle the one from your old PC, if you like.)

- **Use the trackpad.** If you have a trackpad (a laptop, for example), you can trigger a right-click in all kinds of ways.

Out of the box, you do it by *clicking the trackpad with two fingers.* The shortcut menu pops right up.

Or you can point to whatever you want to click. Rest two fingers on the trackpad—and then click with your thumb.

But even those aren't the end of your options. In System Preferences→Trackpad, you can also turn on even more right-click methods (and watch little videos on how to do them). For example, you can "right-click" by clicking either the lower-right or lower-left corner of the trackpad—one finger only.

In this book, rather than repeating those paragraphs of "101 ways to right-click" instructions over and over, we'll just say "Control-click." You now know that that can also mean "right-click" (if you have a desktop Mac) or "two-finger click" (if you have a trackpad).

▨ Safari® Books Online

Safari Books Online is an on-demand digital library that lets you easily search over 7,500 technology and creative reference books and videos to find the answers you need quickly.

With a subscription, you can read any page and watch any video from our library online. Read books on your cell phone and mobile devices. Access new titles before they are available for print, and get exclusive access to manuscripts in development and post feedback for the authors. Copy and paste code samples, organize your favorites, download chapters, bookmark key sections, create notes, print out pages, and benefit from tons of other time-saving features.

O'Reilly Media has uploaded this book to the Safari Books Online service. To have full digital access to this book and others on similar topics from O'Reilly and other publishers, sign up for free at *http://my.safaribooksonline.com*.

iPhoto Basics

Camera Meets Mac

Your camera, phone, and tablet are brimming with photos. You've snapped the perfect graduation portrait, captured that jaw-dropping sunset over the Pacific, or compiled an unforgettable photo essay of your 2-year-old attempting to eat a bowl of spaghetti. Now it's time to use your Mac to gather, organize, and tweak all these photos so you can share them with the rest of the world.

That's the core of this book—compiling, organizing, and adjusting your pictures using iPhoto, and then transforming this collection into a professional-looking slideshow, set of prints, movie, web gallery, and more. You'll also learn how to share them online via services like Facebook, Flickr, and Apple's own iCloud.

But before you start organizing and publishing pictures with iPhoto, they have to find their way from your camera to your Mac. This chapter explains how to get pictures from camera to computer and introduces you to iPhoto.

iPhoto: The Application

iPhoto approaches photo-management as a four-step process:

- **Import.** Working with iPhoto begins with feeding your digital pictures (and videos) into the program, either from a camera or from somewhere on your Mac. In general, importing is a one-click process. This is the part of iPhoto covered in this chapter.

- **Organize.** This step is about sorting and categorizing your chaotic jumble of pictures so you can easily find individual snapshots and arrange them into logical groups. You can assign searchable keywords to pictures to make them easier to

find. You can change the order of images, and group them into albums. You can organize pictures based on *who's* in them, and have iPhoto help match names to faces. You can even pin your photos to a virtual map that shows your travels around the globe. Chapters 2 and 3 cover all of iPhoto's organization tools, and Chapter 4 explains the program's Faces and Places features.

- **Edit.** This is where you fine-tune your photos to make them look as good as possible. iPhoto provides everything you need to rotate, retouch, resize, crop, color-balance, straighten, and brighten your pictures. (More significant image adjustments—like editing out an ex-spouse—require a different program, like Photoshop Elements.) Editing photos is the focus of Chapter 5.

- **Share.** iPhoto's best features have to do with sharing photos, either onscreen or on paper. In fact, the program offers *17* different ways of publishing your pictures. In addition to printing them with your own printer (in a variety of interesting layouts and styles), you can display images as an onscreen slideshow or movie; order professional-quality prints, greeting cards, books, or calendars; and so on. You can also email your photos, or share them online as a web gallery, or on Facebook, Flickr, or Twitter. And for your low-tech friends, you can even snail-mail them an actual CD or DVD with your pictures on it. Chapters 6–12 explain how to undertake all these self-publishing tasks and more.

And iPhoto isn't just for Macs anymore—you can use it on your iPhone or iPad, too. New in this edition of this book: a whole section (Chapters 13–15) on organizing, editing, and sharing pictures on iOS devices.

NOTE Although much of this book focuses on using *digital* gadgets, remember this: You don't have to shoot digital photos to use iPhoto. You can just as easily use it to organize and publish pictures you've shot with a traditional film camera and then digitized using a scanner (or had your local camera store put onto a CD). Importing scanned photos is covered later in this chapter.

iPhoto Requirements

To run iPhoto 9.5, Apple recommends a Mac that has an Intel chip (Core 2 Duo, Core i3, Core i5, Core i7, or Xeon, to be exact), OS X 10.9 (that's Mavericks) or later, and at least 4 gigabytes of memory (RAM).

The truth is, iPhoto may be among the most memory-dependent programs on your Mac. It *loves* memory. Memory is even more important to iPhoto than your Mac's processor speed. It makes the difference between tolerable speed and sluggishness. So the more memory and horsepower your Mac have, the happier you'll be.

Finally, you'll need a lot of hard drive space—not just several gigabytes for iPhoto and the other iLife programs, but also lots of room for all the photos you'll be transferring to your Mac. (Apple recommends at least 5 free gigabytes.)

Getting iPhoto

A free version of iPhoto has been included on every Mac sold since January 2002; you'll find it in your Applications folder. (To open this folder, press Shift-⌘-A or, in the Finder, choose Go→Applications.) You can tell which version of the program you have by single-clicking its icon—the little camera superimposed on the palm-tree picture—and then choosing File→Get Info. In the resulting window, you'll see the version number.

> **NOTE** If you bought your Mac *after* October 2013, you're all set—you've already got Mavericks and iPhoto 9.5.

When you upgrade to OS X 10.9 (Mavericks) on a Mac that already has iPhoto installed, you automatically get the current version of iPhoto for free (as of this writing, that's 9.5.1). So if the Get Info window described above shows that you have iPhoto version 9.5 or higher, you're all set to follow along with this book. Read the next section if you've used an earlier version of the program, or hop to page 6 if this is your first foray into the world of iPhoto.

If you have an *earlier* version of iPhoto (pre-9.5), you can buy the latest one for $15 from Apple's Mac App Store. The Mac App icon (the blue button with a white A on it) is probably in your Dock, and *definitely* in your Applications folder. In order to protect your precious photos, be sure to read the next section *before* installing the latest version.

■ UPGRADING FROM EARLIER VERSIONS

If you've used an earlier version of iPhoto, then you'd be wise to make a backup of your *iPhoto library*—your database of photos—before running iPhoto 9.5. That's because iPhoto's first bit of business is converting your library to a new, more efficient format that isn't compatible with earlier versions of the program (see Figure 1-1).

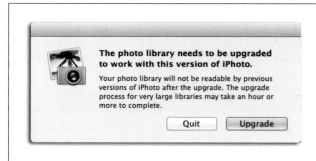

FIGURE 1-1

If you're upgrading from an earlier version of iPhoto, this warning is the first thing you see when you launch the latest version of the program. Once you click Upgrade, there's no going back—your photo library will no longer be usable in previous versions of iPhoto.

Ordinarily, the upgrade process is seamless: iPhoto smoothly converts and displays your existing photos, comments, titles, and albums. But lightning does strike, fuses do blow, and the technology gods have a cruel sense of humor—so making a backup copy before iPhoto converts your old library is very, very smart.

To perform this safety measure, open your Home→Pictures folder, and then copy the iPhoto Library icon to another location on your hard drive by Option-dragging it. (This file may be huge, since it contains copies of *all* the photos you've imported into iPhoto. This is a solid argument for copying it onto an *external* hard drive, which have become ridiculously inexpensive, either manually or by letting Time Machine do it.) Now, if anything should go wrong with the conversion process, you'll still have a clean, uncorrupted copy of your iPhoto library.

Running iPhoto for the First Time

Click the iPhoto icon in your Dock to open the program. After you dismiss the "Welcome to iPhoto" dialog box, iPhoto checks to see if you have an older version of the program and, if so, offers to convert your photo library (Figure 1-1). To give iPhoto the go-ahead, click Upgrade, and it starts the conversion. (This process is faster than ever before, so you won't have to wait long.)

Finally, you arrive at the program's main window, the basic elements of which are shown in Figure 1-2.

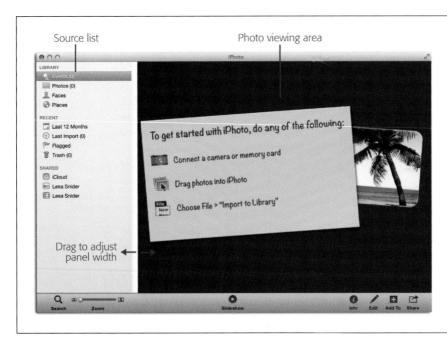

FIGURE 1-2

Here's what iPhoto looks like when you first open it. The large photo-viewing area is where thumbnails of your imported photos will appear. The sleek, charcoal-gray icons at the bottom of the window represent all the cool stuff you can do with your pho-tos. (If you've never used iPhoto before, you see this big yellow sticky note prompting you to connect a camera or a memory card to get started.)

TIP You can also open iPhoto with Spotlight. Press ⌘-space bar to summon the Spotlight search field at the top of your screen and type *iPhoto;* iPhoto probably appears as the first entry in the search list. Press Return to make it open.

◼ Getting Your Pictures into iPhoto

With iPhoto running, it's time to import your pictures—a process that's remarkably easy, especially if your photos are coming directly from your camera.

If you've been taking digital photos for some time, you probably have a lot of photo files already crammed into folders on your hard drive or stored on CDs or DVDs. If you own an iPhone and you're the *least* bit snap-happy, it's chock-full of photos, too. If you shoot with a traditional film camera and use a scanner to digitize them, then you've probably also got piles of JPEG or TIFF images stashed away, waiting to be cataloged.

This section explains how to transfer files into iPhoto from each of these sources.

Connecting with a USB Cable

Every digital camera can connect to a Mac's USB port. If your Mac has more than one USB jack, any of them will do, though it's best to plug the device into your *Mac* and not, say, the USB jack on your keyboard.

Once you've plugged a camera, iPhone, iPod Touch, or iPad into your Mac, the whole transfer process practically happens by itself:

1. **Connect the camera (or iPhone, or iPod Touch, or iPad) to one of your Mac's USB jacks, and then turn the camera on.**

 To make this camera-to-Mac USB connection, you need what is usually called an *A-to-B* USB cable; your camera probably came with one. The "A" end—the part you plug into your camera—has a small, flat-bottomed plug whose shape varies by manufacturer. The Mac end of the cable has a larger, rectangular plug. Make sure both ends of the cable are plugged in firmly.

 If iPhoto isn't already open when you make this connection, the program opens and springs into action as soon as you switch on the camera.

NOTE If this is the first time you've opened iPhoto, it asks if you want it to open automatically when you plug in a camera or memory card. If you value your time, say yes. Why is it even asking? Because, believe it or not, your Mac came with *another* program called Image Capture that can import photos. The usurper lives in your Applications folder, though you can use iPhoto's Preferences to specify which program is automatically summoned when you connect a camera: Choose iPhoto→Preferences, click the General tab, and then choose an option from the "Connecting camera opens" menu.

 Then a wonderful thing happens: After a pause, you get to see *thumbnails* (miniature images) of all the photos on your camera's memory card, as shown in Figure 1-3.

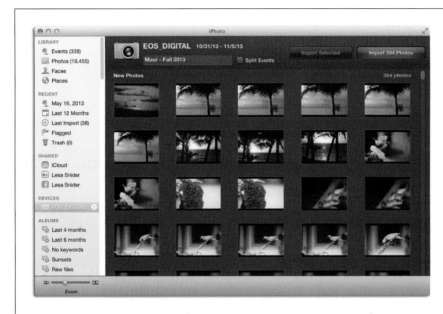

FIGURE 1-3

iPhoto is ready to import, Captain! If you have to wait for this screen to appear, it's because you've got a lot of really large pictures or videos on your camera and it takes iPhoto a moment to prepare the thumbnails. (The number of images may be somewhat larger than you expect if you didn't erase your last batch of photos from your memory card.)

TIP If iPhoto doesn't "see" your camera after you connect it, try turning the camera off, then on again. Same thing goes for a stubborn memory card or memory card reader—unplug it, then plug it in again.

How is this wonderful? Let us count the ways. First, it means that you can see right away what's on the card. You don't have to sit through the time-consuming importing process just to discover, when it's all over, that you grabbed the wrong card or the wrong camera.

Second, you can choose to import only *some* of the pictures. (To choose the photos you want to import, use any of the photo-selection techniques described on page 46.)

The option to import only some of the photos opens up a whole new workflow possibility: You can *leave all the photos on your memory card,* all the time. You can take new photos each day, and import only those onto your Mac each night. If your memory card is big enough, this routine means that you always have a backup of your photos. Plus you can easily share the photos with other (perhaps non-Mac) folks.

Something else happens when you connect the camera, too: Its name and icon appear in the *Source list* on the left side of the iPhoto window, as well as at the top of the window. That's handy because it means you can switch back and forth between import mode (click the camera's icon in the Source list) and

regular working-in-iPhoto mode (click any *other* icon in the Source list), even while the import is under way.

2. **Type an Event name for the pictures you're about to import.**

 In iPhoto, an *Event* is something you photographed within a certain time period (for example, on a certain day or during a certain week). When it's importing images, iPhoto analyzes the time stamps on the incoming photos and puts the images into named groups according to when you took them.

 You can read much more about Events on page 34. For now, your job here is to type a name for the event whose photos you're about to import. It could be *Disney Trip, Casey's Birthday,* or *Baby Meets Lasagna*—anything that will help you organize and find your pictures later.

TIP See the Split Events checkbox at the top of the iPhoto window? If it's on, iPhoto automatically groups the imported pictures into Events, as described above; you won't, however, have the chance to *name* the Events (except for the first one) until the importing is complete. If this option is turned off, then all the photos will end up in one giant Event (which you can split into multiple Events later.)

3. **Click the appropriate button: Import Selected or "Import [number] Photos."**

 If you selected just *some* of the photos in step 1, then the Import Selected button springs to life. Clicking it brings only the selected photos onto your Mac, and ignores the rest of the photos on your camera.

 If you click "Import [number] Photos," well, you'll get all the photos on the card, even if you selected only some.

 Either way, iPhoto swings into action, copying photos from your camera to your hard drive. You get to see them as they parade by (Figure 1-4, bottom).

 When the process is complete and the photos are safe on your hard drive, iPhoto has another question for you: Do you want to delete the transferred pictures from the memory card?

 If you click Remove Photos, iPhoto deletes the transferred photos from the memory card (either all the photos or just the selected ones, depending on the button you clicked at the beginning of step 3). Resist the urge to clear your memory card this way; it's better to do that using your *camera* instead.

 If you click Keep Photos, then iPhoto leaves the memory card untouched. You might opt for this approach if you've adopted the "use the card as a backup" lifestyle described on page 8. In general, it's best to use the camera's own menus to erase the memory card or, better still, to *format* it. By choosing the latter, your camera wipes the card *and* creates a fresh directory into which future photos are stored.

 Either way, your freshly imported photos appear in the main iPhoto window, awaiting your organizational talents.

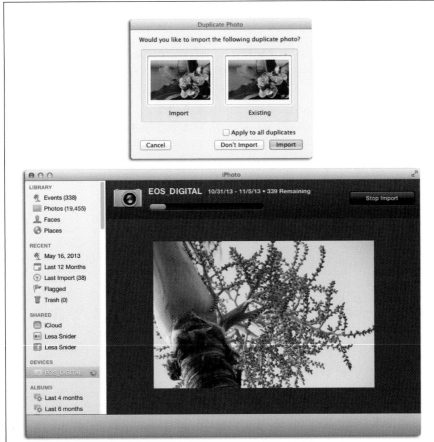

FIGURE 1-4

Top: You may sometimes see the Duplicate Photo message if, say, you drag and drop a previously imported photo onto the iPhoto window. iPhoto notices the arrival of duplicates (even if you've edited or rotated the first copy) and offers you the option of downloading them again—so you'll have duplicates on your Mac—or ignoring them and importing only the new photos from your camera.

Bottom: As the pictures get slurped into your Mac, iPhoto displays them, nice and big, in a sort of slideshow. You can see right away which ones were your hits, which were your misses, and which you'll want to delete the instant the import is complete.

4. **"Eject" the camera by clicking the ⏏ next to its name in the Source list.**

 Or, if you don't see the ⏏ button, just drag the camera's icon onto the Trash icon in the Source list (you can also Control-click the camera's icon and choose Unmount from the shortcut menu). You're not actually throwing the camera away, of course, or even the photos on it—you're just saying, "Eject this." Even if the camera is still attached to your Mac, its icon disappears from the Source list. (Unplugging the camera without ejecting it first can damage the info on the card.)

5. **Turn off the camera, and then unplug the USB cable.**

 You're ready to start having fun with your new pictures.

USB Card Readers

Almost every modern Mac model has a built-in memory-card slot. It accommodates the SD memory cards used in most cameras. That's another convenient way to transfer photos into iPhoto—maybe more convenient, in fact, since you don't have to carry around a cable.

If yours doesn't (or if your camera uses a different card type), you can buy a USB *memory card reader.* Most of these card readers, which look like tiny disk drives with a slew of slots, cost under $20, and most can read more than one kind of memory card.

If you have a card reader, then instead of connecting a cable to the Mac, simply remove the camera's card and insert it into the reader or slot. iPhoto recognizes the reader as though it's a camera and offers to import the photos—all of them or some of them—as described on the previous pages.

This method offers several advantages over the camera-connection method. First, it's faster and doesn't drain your camera's battery. Second, it's less hassle to pull a memory card out of your camera and slip it into a card reader than it is to constantly plug and unplug camera cables.

TIP iPhoto doesn't recognize most camcorders, even though most models can take still pictures. Some camcorders also have a "memory card" connection option that makes the camcorder act like, well, a *memory card* when it's attached to your Mac. If that doesn't work, many camcorders store their stills on a memory card just as digital cameras do, so a memory card reader is exactly what you need to get those pictures into iPhoto.

Using a card reader or card slot is nearly identical to connecting a camera. Here's how:

1. **Pop the memory card out of your camera, and then insert it into the slot or the reader.**

 Just like when you connect a camera, iPhoto displays thumbnails of all the photos on the card and offers you a chance to type an Event name. If you want to select only some of the photos, select them using the techniques described on page 46.

2. **Click Import All or Import Selected.**

 iPhoto bounds into action, copying the photos off the card. When the program asks how you want it to deal with the originals on the memory card, click Keep Photos and format the card in-camera (see page 9 for details).

3. **In iPhoto's Source list, click the ⏏ next to the card's name, and then remove the card from the slot or reader.**

 Put the card back in the camera, and format it so it's ready for action. (There's nothing worse than grabbing your camera to capture a prize-winning shot and finding that you forgot to put the memory card back in, or that it's completely full!)

Using iCloud's Photo Stream

iCloud is Apple's free online storage and syncing service. If you have an iCloud account and turn on your Photo Stream, up to 1,000 of your most recent photos—snapped on iOS devices such as an iPhone, iPad, or iPod Touch within the last 30 days—are automatically imported into the iPhoto library on your Mac. Conversely, any photos you've imported into iPhoto on your Mac are viewable on your iOS devices. Sounds too good to be true, doesn't it?

The setup process has three steps: Sign up for an iCloud account and turn on the sharing features on your Mac, turn on the sharing features on your iOS device(s), and then turn on the sharing features in iPhoto.

Creating an iCloud account is easy. Simply open →System Preferences→iCloud. Enter your Apple ID, if you have one, or create a new one by clicking the link beneath the first field and then following the instructions. Once you create an account, you see the window shown in Figure 1-5 (top).

> **NOTE** Need more iCloud storage? No problem. You can upgrade your account to a 20-, 30-, or 50-gigabyte plan for $20, $40, or $100 a month (respectively).

A free iCloud account includes an email address, 5 gigabytes of storage for backing up your iOS devices (free apps, documents, settings, and so on), plus room for up to 1,000 pictures. (These pictures, as well as any *paid* apps, music, movies, and TV shows, don't count against your 5 gigs of complimentary storage.)

By turning on the Photo Stream feature on your Mac and iOS devices, your most recent photos are uploaded to iCloud as soon as the device senses an Internet connection (your home network, a coffee shop's WiFi, and so on; it doesn't work over a cellular connection), though the Camera app on your iOS device has to be closed. If you take more than 1,000 pictures in 30 days, they begin dropping off the stream as newer ones replace the oldest ones.

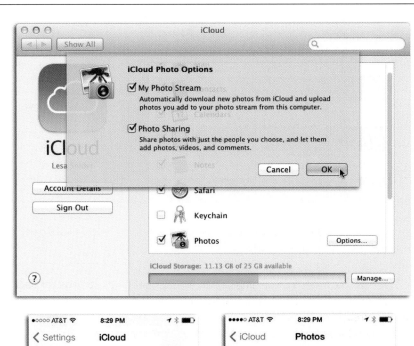

FIGURE 1-5

Top: Once you sign up for iCloud, you can choose what info to store remotely—your email, contacts, calendars and so on. Turn on the Photos setting and then click the Options button next to it to reveal the pane you see here. Turn on My Photo Stream to start syncing your photos between your Mac and iOS devices. Photo Sharing (page 198) lets you share photos with other people, who in turn can contribute photos, videos, and comments that you can see in iPhoto on your Mac.

Bottom: On your iOS device (which must be running iOS 5 or later), open the Settings app and scroll down to the iCloud icon. Tap it and then scroll to Photos. Tap Photos and, on the resulting screen, turn on My Photo Stream.

To see your Photo Stream in iPhoto, and to import photos taken on your iOS devices *before* they drop off the stream, choose iPhoto→Preferences→iCloud (see Figure 1-6).

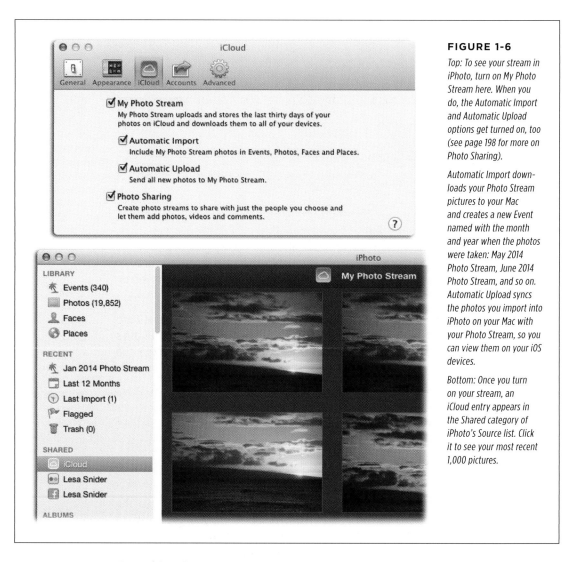

FIGURE 1-6

Top: To see your stream in iPhoto, turn on My Photo Stream here. When you do, the Automatic Import and Automatic Upload options get turned on, too (see page 198 for more on Photo Sharing).

Automatic Import downloads your Photo Stream pictures to your Mac and creates a new Event named with the month and year when the photos were taken: May 2014 Photo Stream, June 2014 Photo Stream, and so on. Automatic Upload syncs the photos you import into iPhoto on your Mac with your Photo Stream, so you can view them on your iOS devices.

Bottom: Once you turn on your stream, an iCloud entry appears in the Shared category of iPhoto's Source list. Click it to see your most recent 1,000 pictures.

From this point on, you can view your most recent 1,000 photos by clicking iCloud in iPhoto's Source list (Figure 1-6, bottom). To access streams for *previous* months, or more photos from the current month once you exceed 1,000, click Events and then scroll until you see the Event named with the month you're after.

Importing Photos from Really Old Cameras

If your camera doesn't have a USB connection *and* you don't have a memory card reader, you're not out of luck. First, copy the photos from your camera/memory card onto your hard drive (or other disk) using whatever software or hardware came with your camera. Then bring them into iPhoto as you would any other graphics files, as described next.

> **TIP** If your camera or memory card appears on the Mac desktop like any other removable disk, you can also drag its photo icons, folder icons, or even the "disk" icon itself directly into iPhoto. Your folder names will become Event names once they're in iPhoto.

Importing Existing Graphics Files

iPhoto is also delighted to help you organize digital photos—or any other kind of graphics files—that are already on your computer.

For years, Mac owners complained about the way iPhoto handled photos that were already on the hard drive: When you imported them into iPhoto, the program *duplicated* them. So you wound up with one set inside iPhoto's library (see page 25) *and* the original folder full of photos, which meant that disk space got eaten up rather quickly. This system also meant that iPhoto couldn't track photos that resided on more than one hard drive.

But today's iPhoto can track, organize, edit, and process photos on your hard drive(s) *right in the folders that contain them.* If you make a few tweaks to iPhoto's Advanced preferences (see Figure 1-7, top), the program doesn't have to copy the photos into the iPhoto library.

This is a blessing if you already have folders filled with photos. You can drag them directly into iPhoto's Source list (or the main viewing area), and iPhoto *acts* like it's importing them, but doesn't really. Yet you can work with them exactly like the ones iPhoto socked away in its own library.

If you choose to go this route, here are a few things to keep in mind:

- Very ugly things happen in iPhoto if you *delete* a photo behind its back (in the Finder) and then empty your Mac's trash. When you try to open or edit the deleted photo in iPhoto, an error message appears, offering you the chance to locate the photo. And if you can't find it, then iPhoto displays the photo as an empty, gray rectangle filled with an exclamation point.

- On the other hand, iPhoto is pretty smart if you *rename* a photo in the Finder, or even drag it to a different folder. Apple doesn't really want this feature publicized, hopes you won't try it, and won't say how iPhoto manages to track pictures that you move around even when the program isn't running. But it works. Moved or renamed photos still appear in iPhoto, and you can open, edit, and export them. However, you may have to do a lot of manual reorganizing.

- If you delete a photo within iPhoto, you're not actually deleting it from your Mac. It's still sitting there in the Finder, in the folder where it's always been. You've just told iPhoto not to track that photo anymore.

- Because of this feature, you can use iPhoto to catalog and edit photos that reside on multiple hard drives. Just make sure those other disks are "mounted" (visible on your screen) before you attempt to work with them in iPhoto.

- On the other hand, iPhoto's offline smarts don't make it a good choice for managing photos on CDs, DVDs, or other disks that aren't actually connected to, or inserted in, your Mac.

■ INTERNAL OR EXTERNAL?

It's nice that iPhoto can track external photos without having to make its own copies. But the old way had some advantages, too. When iPhoto copies photos into its own library, they're safer. For example, you can back up your iPhoto library, content in the knowledge that you've backed up *all* your photos (instead of leaving some behind because they're not *actually* in the library).

TIP Time Machine, Apple's automated backup program, backs up your main hard drive, too—yet another reason why it's safer to store your photos internally than externally.

Fortunately, how iPhoto behaves when you import graphics files is entirely up to you. It can *either* copy them into its own library *or* track photos in whatever Finder folders they're already in. You make this choice for future imports in iPhoto's Preferences (Figure 1-7, top); choose iPhoto→Preferences, and then click Advanced.

No matter what choice you make in the Preferences dialog box, you can import photos from your hard drive in two ways:

- **Drag the files directly into the main iPhoto window,** which automatically starts the import process. You can also drop an entire *folder* of images into iPhoto, as shown at the bottom of Figure 1-7, to import all its contents. You can even drag a *bunch* of folders at once.

- **Choose File→Import to Library** (or press Shift-⌘-I) in iPhoto, and then select a file or folder in the Import Photos dialog box shown in Figure 1-8.

These techniques also let you select and import files from other hard drives, CDs, DVDs, iPod Touches, and flash drives.

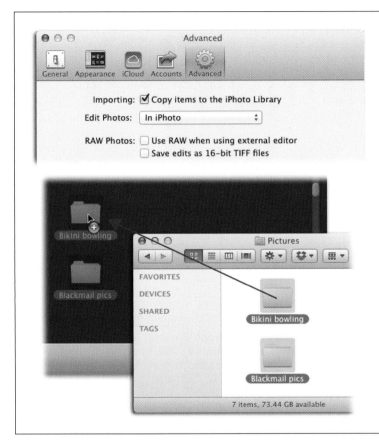

FIGURE 1-7

Top: The Importing setting shown here lets you specify whether you want iPhoto to duplicate imported photos from your hard drive so that it has its own library copy. (If you turn off this checkbox, iPhoto simply tracks the photos in their current Finder folders.)

Bottom: When you drop a folder into iPhoto, the program automatically scans all the folders inside it, looking for pictures to catalog. Depending on your Preferences settings, it may create a new Event (Chapter 2) for each folder it finds. iPhoto ignores irrelevant files and stores only the pictures that are in formats it can read.

TIP Take the time to name your folders intelligently before dragging them into iPhoto, because the program retains their names. If you drag a folder directly into the main photo area, then you get a new *Event* named for the folder; if you drag the folder into the Source list on the left side of the screen, then you get a new *album* named for the folder. And if there are folders inside folders, then they too become new Events or albums. Details on all this reside in Chapter 2.

FIGURE 1-8

When the Import Photos dialog box appears, navigate to and select any graphics files you want to bring into iPhoto. You can ⌘-click individual files to select more than one, as shown here. You can also click one file, and then Shift-click another one to select both files and *everything in the list in between.*

Side Doors into iPhoto

Don't look now, but Apple has been quietly creating other ways to get photos into iPhoto, directly from other programs on your Mac.

For example, if you use the Mail program and someone sends you a photo, you can pop it directly into iPhoto from within the email message. Just point your cursor to the dividing line between the subject and the body of the message; a row of icons appears. Click the little paperclip icon, and then choose "Export to iPhoto."

You can also send pictures to iPhoto from Preview. If you've opened one or more images, click the [↪] and choose "Add to iPhoto."

Both of those handy buttons deposit a copy of the image directly into your iPhoto library, even if iPhoto isn't open at the time. (Pro tip: There's a folder named Auto Import lurking deep inside iPhoto that automatically imports any photos you drag into it. Skip to page 297 for details.)

The File Format Factor

iPhoto can't import digital pictures unless it understands their file formats, but that rarely poses a problem. Every digital camera on earth can save its photos as JPEG files—and iPhoto handles this format beautifully. (JPEG is the world's most popular file format for photos because, even though it's compressed to occupy a lot less disk space, the visual quality is still very high.)

But iPhoto imports and recognizes some very useful additional formats.

■ RAW FILES

Most digital cameras work like this: When you press the shutter button, the camera studies the data picked up by its sensors. The circuitry makes decisions pertaining to sharpening level, contrast and saturation settings, color "temperature," and so on—and then saves the resulting processed image as a compressed JPEG file on your memory card.

For millions of people, the resulting picture quality is just fine, even terrific. But all that in-camera processing drives professional photographers nuts. They'd much rather preserve *every last iota* of original information, no matter how huge the resulting file on the memory card—and then process the file *by hand* once it's been safely transferred to their Macs.

That's the idea behind *raw,* which is an option on most pricier digital cameras. ("Raw" stands for nothing in particular, so there's no good explanation for why it's so often written in all caps.)

A raw image isn't processed at all; it's a complete record of all the data passed along by the camera's sensors. As a result, each raw photo takes up much more space on your memory card. For example, on a 6-megapixel camera, a JPEG photo is around 2 MB, but the same picture is over 8 MB when saved in raw format. Some cameras take longer to store raw photos on the card, too (though that depends more on the write-speed of the *card* than it does on the camera itself).

But for image-manipulation nerds, the beauty of raw files is that once you open them up on your Mac, you can perform astounding acts of editing on them. You can actually change the lighting of the scene—retroactively! And you don't lose a single speck of image quality along the way.

In years past, people had to use a program like Adobe Camera Raw (which comes with Photoshop and Photoshop Elements), Lightroom, or Apple's own Aperture to do this kind of editing. But amazingly enough, humble, cheap little iPhoto can edit raw files, too. For the full scoop, see Chapter 5.

■ MOVIES

In addition to still photos, today's cameras (including your iPhone and iPad) can also capture *movies.*

Movies eat up a memory card fast, but you can't beat the convenience, and the quality is amazing—usually high definition, in fact. (Recent camera models can even zoom and change focus while filming, just like a camcorder.)

Fortunately, iPhoto can import, organize, and play your movies. The program recognizes .mov files, .avi files, and many other video formats. In fact, it can import any format that QuickTime Player (the program on your Mac that actually plays these movies) recognizes, which is a very long list indeed.

You don't have to do anything special to import movies; they get pulled into iPhoto automatically along with your photos. You can even *play* them without leaving iPhoto, as Figure 1-9 shows.

FIGURE 1-9

Top: The first frame of each video clip shows up as though it's a photo in your library. The little camera icon and the total running time let you know that it's a movie and not a still image.

Bottom: Double-click a movie in iPhoto to open it at full size and play it. iPhoto is no iMovie, though. You can view and trim the length of the movie, but that's it (page 280 explains how); you can't rotate movies or edit specific scenes, for example. See Chapter 10 for details on rotating, splitting, and combining them using QuickTime Player, as well as tips on sharing movies.

■ OTHER GRAPHICS FORMATS

iPhoto also lets you load pictures that have been saved in a number of other file formats—including a few unusual ones. Here's what it can handle:

- **TIFF.** As mentioned earlier, most digital cameras capture photos in a graphics file format called JPEG. Some cameras, though, offer you the chance to leave your photos *uncompressed* on the camera, in what's called TIFF format. These files are huge—in fact, you'll be lucky if you can fit one TIFF file on the memory card that came with the camera. Fortunately, they retain 100 percent of the picture's original quality.

 However, the instant you *edit* a TIFF-format photo (Chapter 5), iPhoto converts it into JPEG. That's fine if you plan to order prints or a photo book (Chapter 9) from iPhoto, since JPEG files are required for those purposes. But if you took that once-in-a-lifetime, priceless shot as a TIFF file, then don't do *any* editing in iPhoto—don't even rotate it—if you want to maintain its perfect, pristine quality.

- **GIF** is the most common format used for non-photographic images on web pages. The borders, backgrounds, and logos you typically encounter on websites are usually GIF files—as well as 98 percent of those blinking, flashing banner ads that drive you insane.

- **PNG** and **FlashPix** are also used in web design, though not nearly as often as JPEG and GIF. They often display more complex graphic elements.

- **BMP** is a popular graphics file format in Windows.

- **PICT** was the original graphics file format of the Macintosh before Mac OS X. When you took a screenshot from Mac OS 9, pasted a picture from the Clipboard, or copied an image from the Scrapbook, you got a PICT file. (These days, in OS X Mavericks, you get a PNG file instead.)

- **Photoshop** refers to Adobe Photoshop, the world's most popular image-editing and photo-retouching program (Photoshop Elements, too). iPhoto can even recognize and import *layered* Photoshop files—those in which different image adjustments or graphic elements are stored in sandwiched-together layers. (If you want to learn more, pick up a copy of *Photoshop: The Missing Manual*.)

- **MacPaint** is the ancient file format of Apple's very first graphics program from the mid-1980s. No, you probably won't be working with any MacPaint files in iPhoto, but isn't it nice to know that if one of these old, black-and-white, 8 × 10-inch pictures generated on a vintage Mac SE happens to slip through a wormhole in the fabric of time and land on your desk, you'll be ready?

- **SGI** and **Targa** are specialized graphics formats used on high-end Silicon Graphics workstations and Truevision video-editing systems.

- **PDF** files are Portable Document Format files that open in Preview and in Adobe Acrobat. They might be user's manuals, brochures, or Read Me files that you downloaded or received on a disc. Oddly enough, iPhoto is a fantastic PDF reader. You can open a PDF document at full-screen size, page through it, and even crop or edit it as though it were a photo. In fact, OS X makes it extra easy to create PDFs and stash them in iPhoto all in one step, as described in the tip on page 182.

If you try to import a file that iPhoto doesn't understand—an EPS file, an Adobe Il-lustrator drawing, or a PowerPoint file, for example—you see a polite yet curt error message saying you just tried to feed it a file it can't digest.

The Post-Import Inspection

Once you've imported a batch of pictures into iPhoto, what's the first thing you want to do? If you're like most people, this is the first opportunity you've had to see, at full-screen size, the masterpieces you and your camera created. Until now, the only view you've had of your photos was on the camera's little screen.

There's a great way to go about inspecting your pictures after you've imported them: the old "double-click to magnify" trick (single-clicking a thumbnail and then tapping the space bar works, too).

Once you've imported some pictures, click Last Import in the Source list. In the main iPhoto window, you're now treated to a soon-to-be-familiar display: a grid of thumbnails. In this case, they represent the pictures you just imported.

Double-click the first one; it swells to fill the main part of the iPhoto window. If you're feeling frisky, click the ⬚ button at the top right of the iPhoto window to have your photo commandeer every last pixel on your monitor, as shown in Figure 1-10.

Demystifying 64-bit

Hey, I hear that iPhoto 9.5 is now 64 bit. What does that mean?

The cool phrase in computing circles for the past few years has been "64 bit." While that term may sound geeky, it's actually not that intimidating: 64-bit programs simply know how to count higher than 32-bit programs.

So what does that mean in practice? 32-bit programs can open and work with files that are up to 4 gigabytes in size—which is already huge. 64-bit programs, on the other hand, can open files that are *way* bigger than that, as long as your computer's operating system can handle 64-bit apps (every version of OS X since 10.5 [Leopard] can).

64-bit programs can also make use of more memory (RAM) than their 32-bit counterparts, which makes them run faster. This extra brainpower is mission critical when working with photos captured in raw format (page 19) by high-end digital cameras like Canon's 5D Mark III, when saving an edited raw file as a 16-bit TIFF (page 150) for printing, and when importing documents you've edited with Adobe Photoshop or Photoshop Elements (page 146).

Aren't you glad you asked?

FIGURE 1-10

iPhoto's Full Screen view is available everywhere, whether you're browsing Events, Faces, Places, or albums; editing photos; or creating a project. While you're in this view, you can walk through photos you've enlarged using the arrow keys on your keyboard or by clicking thumbnails in the filmstrip at the bottom. Use the Back button at the top left to go back a screen (or two) to pick something else to view.

To summon the iPhoto menu system, point your cursor at the top of your screen. To exit Full Screen view, click the ◲ button again or tap the Esc key.

After the shock of seeing the giant-sized version of your photo has worn off, press the ▶ key on your keyboard to bring the second one into view. Press it again to continue walking through your imported photos.

This is the perfect opportunity to throw away lousy shots, fix the rotation, and linger on certain photos for more study. You can even apply ratings with your keyboard; later, you can use these ratings to sort your pictures or create *smart albums.* (See Chapters 2, 3, and 4 for details on assigning ratings and creating smart albums.)

Here's the full list of things you can do as you walk through the magnified pictures, whether you opt for Full Screen view or not:

- Double-click the photo, or tap the space bar, to demagnify it. You return to the window full of thumbnails. (Double-click another one to magnify *it* and return to the inspection process, or single-click a thumbnail and then tap the space bar.)

- Press the ▶ and ◀ keys on your keyboard to browse back and forth through your photos, or use the filmstrip at the bottom of the iPhoto window.

- Press the Delete key to send a photo to iPhoto's Trash.

- Give each photo a star rating, from one (terrible) to five (terrific). To do that, press ⌘-1 through ⌘-5 (or press ⌘-0 to remove the rating). Chapter 3, which explains how to find and flag photos, tells you how to add star ratings in a variety of other ways (page 86).

> **TIP** You don't actually *see* the stars appear unless you choose View→Ratings (or press Shift-⌘-R) or open the Info panel by clicking the Info icon at the bottom of the iPhoto window.

Control-clicking a photo displays a shortcut menu that gives you access to even more goodies:

- Click Rotate to flip a photo counterclockwise, 90 degrees at a time. (Option-click this button to rotate the photo clockwise instead.)

- Click Hide to *hide* a photo, which isn't the same as deleting it. The photo is out of your way, but still in your library, and you can always *unhide* it to bring it back. You can accomplish the same thing (without Control-clicking first) by pressing ⌘-L. Either way, the now-hidden photo disappears from the filmstrip at the bottom of your iPhoto window, but it stays onscreen (sigh). More on hiding photos lies on page 47.

- Click Trash to throw your photo into iPhoto's very own trash can (page 68).

- Assign a star rating to the photo by clicking the hollow stars (page 86).

- Edit the image in iPhoto by choosing "Edit in iPhoto," or open it in another program (say, Photoshop Elements) by choosing "Edit in External Editor" (see page 146).

- If you Control-clicked a photo while viewing an Event, you can make this photo the *key photo* (the icon thumbnail) for the Event by choosing Make Key Photo. You'll learn all about key photos on page 35.

> **NOTE** If you Control-click a photo while viewing an album (page 52), you get two *more* options: Show Event (opens the Event containing this particular shot) and Remove From Album.

The buttons on the toolbar at the bottom of the iPhoto window offer ways to view info about your pictures; edit photos; add photos to an album, slideshow, or project; and share photos in myriad ways. You'll master *all* these options in the coming chapters.

■ Where iPhoto Keeps Your Files

Having entrusted your vast collection of digital photos to iPhoto, you may find yourself wondering, "Where is it putting all those files, anyway?"

Most people slog through life, eyes to the road, without ever knowing the answer. After all, you can preview, open, edit, rotate, copy, export, and print all your photos right in iPhoto, without actually opening a folder or double-clicking a single JPEG file.

Even so, it's worthwhile knowing where iPhoto keeps your pictures on your hard drive. Armed with this information, you can keep those valuable files backed up and avoid accidentally throwing them away 6 months from now when you're doing a little digital spring cleaning.

A Trip to the Library

As you now know, when you import pictures into iPhoto, the program generally makes *copies* of them, leaving your original files untouched. (Of course, if you tell iPhoto to erase your camera's memory card after importing, then the originals aren't untouched—they're obliterated. But you get the point.)

The question is: Where do they all go?

iPhoto stores its copies of your pictures in a special folder called the iPhoto Library, which you can find in your Home→Pictures folder. If the short name you use to log into OS X is *Mozart,* then the full path to your iPhoto Library folder from the main hard drive window would be Macintosh HD→Users→Mozart→Pictures→iPhoto Library.

Now, if you're following along closely, you might be objecting to the description of the iPhoto Library. "Hey," you might be saying, "that's not a folder! In old versions of iPhoto, it *was* a folder. But I can't open this one to see what's inside. So it's *not* a folder."

OK, you're right—it's not an ordinary folder. It's a package.

In OS X, *packages* or *bundles* are folders that *behave* like single files. For example, every properly written OS X *program* looks like a single, double-clickable application icon. Yet to the Mac, it's actually a folder that contains both the application icon and all of its hidden support files. (Even *documents* can be packages, including iMovie project files and some TextEdit documents.)

As it turns out, iPhoto's library is a package, too. It may look like a single icon called iPhoto Library, sitting in your Home→Pictures folder. But it's actually a folder, and it's teeming with the individual JPEG files that represent your photos.

If you'd like to prove this to yourself, try this experiment: In the Finder, choose Go→Home. Double-click the Pictures folder. See the iPhoto Library icon? Control-click it. From the shortcut menu, choose Show Package Contents, as shown in Figure 1-11, top. (You're asking OS X to show you what's inside the iPhoto Library.) Voilà! The iPhoto Library package window opens.

TIP You should back up your iPhoto Library regularly by copying it to an external hard drive (it's likely too big to burn to a single CD or DVD). After all, it contains all the photos you import into iPhoto, which, essentially, is your entire photography collection. Chapter 12 offers more on this important file-management topic.

■ WHAT ALL THOSE FOLDERS MEAN

Within the iPhoto Library, you'll find a set of mysteriously named files and folders. At first glance, this setup may look bizarre, but there's a method to iPhoto's madness. Open the folder named Masters; you'll discover that iPhoto meticulously arranges your photos within numbered folders according to the *creation dates* of the originals, as shown in Figure 1-11, bottom.

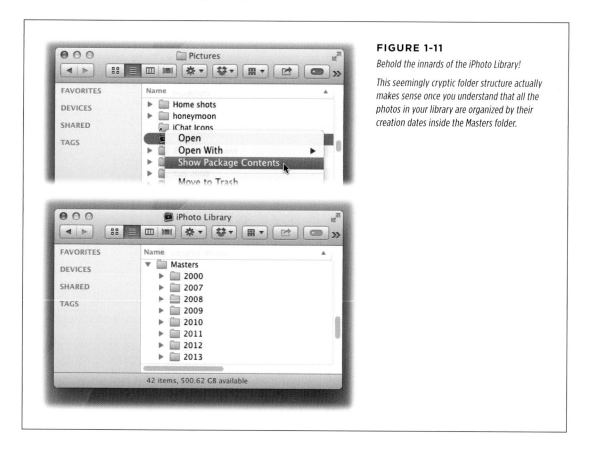

FIGURE 1-11

Behold the innards of the iPhoto Library!

This seemingly cryptic folder structure actually makes sense once you understand that all the photos in your library are organized by their creation dates inside the Masters folder.

■ OTHER FOLDERS IN THE IPHOTO LIBRARY

You'll find several items nested in the iPhoto Library window, most of which you can ignore:

- **AlbumData.xml.** Here's where iPhoto stores access permissions for the various albums you've created within iPhoto. (Albums, which are like folders for organizing photos, are described in Chapter 2.) For example, it's where iPhoto keeps information on which albums are available for sharing among accounts on a single machine. Details on sharing are in Chapter 8.

- **Library.data, Library.iPhoto, Library6.iPhoto.** You'll see these files only if you used earlier versions of the program. They store info about your iPhoto Library,

such as which keywords you've used, along with the image dimensions, file size, rating, and modification date for each photo.

- **Masters.** This folder is the real deal: It's the folder that stores your entire photo collection. Inside, you'll find nested folders organized in the year/month/day structure illustrated in Figure 1-11.

 This folder is also the key to one of iPhoto's most remarkable features: the "Revert to Original" command. Whenever it applies any potentially destructive operations to a photo—like cropping, removing red eye, brightening the image, or converting it to black and white—iPhoto *duplicates* the file and stuffs the edited copy in the Previews folder. The pristine, unedited version remains safe in the Masters folder. If you later decide to scrap your changes using the "Revert to Original" command (page 147)—even months or years later—then iPhoto ditches the duplicate. What you see in iPhoto is the original version you imported.

- **Previews.** This is where the program keeps the latest versions of your pictures, as edited. (Remember, behind the scenes, iPhoto actually duplicates a photo when you edit it.)

- **Thumbnails.** This folder contains index card–sized previews of your pictures— jumbo thumbnails, in effect—organized in the year/month/day structure shown in Figure 1-11.

■ LOOK BUT DON'T TOUCH

While it's enlightening to wander through the iPhoto Library window to see how iPhoto keeps itself organized, *don't rename or move any of the folders or files in it.*

You should do *all* your photo organizing within the iPhoto program, not behind its back in the library files. Making changes in the Finder will confuse iPhoto to the point that it will either be unable to display some of your photos or it'll just crash.

And that, by the way, is precisely why the iPhoto Library is now a *package* (which takes some effort and knowledge to open) instead of a regular folder. Apple Tech Support evidently got one too many calls from clueless Mac owners who'd opened the iPhoto Library and wound up deleting or damaging their entire photo collections.

FREQUENTLY ASKED QUESTION

Moving the iPhoto Library

Do I have to keep my iPhoto Library in my Pictures folder? What if I want it stored somewhere else?

No problemo! iPhoto has come a long way since the days when it *had* to keep its library in your Pictures folder.

Just quit iPhoto. Then move the whole iPhoto Library (currently in your Home→Pictures folder) to another location—even onto another hard drive.

Now open iPhoto again. It proclaims that it can't find your iPhoto Library. Click the Choose Library button to show the program where you put it. Done deal!

You can also press and hold the Option key when you launch iPhoto; see page 309 for details.

The Digital Shoebox

When you get right down to it, working in iPhoto takes place at three different zoom levels. You begin fully zoomed out, looking at *piles* of photos—your *Events* (called Spring Break, Robin's Graduation, and so on). Then you drill down into one of the piles; in the main Photos view, every picture appears as an individual thumbnail. Finally, you can zoom in even more, filling the iPhoto window (or your entire monitor) with just one photo.

If you've imported photos into iPhoto as described in the previous chapter, your journey out of chaos has begun. You're not really organized yet, but at least all your photos are in one place. From here, you can sort your photos, give them titles, group them into smaller subcollections (called *albums*), and tag them with keywords so you can find them quickly. This chapter helps you tackle each of these organizing tasks as painlessly as possible.

The Source List

Even before you start naming your photos, assigning them keywords, or organizing them into albums, iPhoto imposes an order of its own upon your digital shoebox.

The key to understanding it is the *Source list* at the left side of the iPhoto window. This list grows as you import more pictures and organize them—but right off the bat, you'll find categories such as Library, Recent, and Albums, each containing icons you can click for fast access to particular photos (Last Import, Last 12 Months, and so on). This section explains each category in detail.

NOTE If you're enjoying Full Screen view (page 22) while perusing your albums, you can use the Events, Faces, Places, Albums, and Projects buttons at the bottom of your monitor to see what's in your Source list. That said, it might be easier to remain in standard view while you're poring over this chapter.

Library

The first four icons in the Source list are under a heading called Library. This is a reassuring heading, because no matter how confused you may get in working with subsets of photos later in your iPhoto life, clicking one of the first two icons in this category (Events or Photos) returns you to your entire picture collection and makes *all* of your photos appear in the viewing area, grouped by date. Clicking the Faces or Places icons (Chapter 4) shows *all* of your photos grouped by *who's* in them or *where* they were taken.

- **Events.** When you click Events in the Source list, each thumbnail represents one pile (or shoebox, or envelope) of pictures. (Figure 2-1, top, shows the effect.) Each pile is one *Event,* a batch of pictures that were all taken at about the same time—all on someone's birthday or wedding weekend, for example.

 You can open one of these "shoeboxes" by double-clicking it, or you can flick through the thumbnails within an Event by passing your cursor slowly across its thumbnail, left to right. Details on Events begin on page 34.

- **Photos.** Click Photos, on the other hand, to see *all* the photos' thumbnails displayed—not just summary Event thumbnails, but one thumbnail per photo on a massive, scrolling display (Figure 2-1, bottom). Happily, you can still see which photos were taken at which Event thanks to the headings that separate the batches.

- **Faces.** If you've taken the time to introduce iPhoto to your friends and family as described on page 90, you can click Faces to see everyone grouped into neat little batches on a virtual corkboard.

- **Places.** iPhoto can also group your photos into specific spots on a map. Click Places in the Source list to see your pictures organized on a map of the world. Unless your camera or smartphone is GPS-enabled (iPhones are), this doesn't happen automatically, but you can tag your photos manually to get them on the map. Page 103 has the scoop.

Recent

Since an iPhoto library can grow to roughly a million, it's a smart assumption that you'll often want to see photos you've worked with *recently.* That's why the items under this heading change over time to reflect what you've been doing lately (they're built-in albums, really). For example:

- **[Most recently viewed Event].** The first album listed here identifies the Event you most recently opened. You can think of this item as a handy shortcut for when the Event you want to work with this morning is the same one you were editing last night. If the Event has a name, you see it here; if not, you see a date instead.

FIGURE 2-1

Top: You can think of Events as a bird's-eye view of your photo collection, with each Event a stack of photos that were taken around the same time. Events are iPhoto's primary organizing structure, though you can combine or split them as you see fit (described later in this chapter).

Bottom: Clicking Photos lets you view your entire collection; every single photo has its own thumbnail in a huge scrolling list. They're still grouped by Event, though, as indicated by the collapsible headings. These headings "float" to the top of the window as you scroll through your photos, so you always know which Event the photos belong to.

- **Last 12 Months.** This album puts the most recent photos at your fingertips. The idea, of course, is that the freshest photos are often the most interesting to you. Actually, it doesn't even have to say "Last 12 Months." You can specify how *many* months' worth of photos appear in this heap—anywhere from one month to a year and a half—by choosing iPhoto→Preferences→General (see Figure 2-2).

- **Last Import.** Another group of photos you'll probably want to access quickly are the photos you just liberated from your camera. That's the purpose of this album. With one click, iPhoto displays only your most recently downloaded photos, hiding all the others. This album can save you a lot of time, especially as your library grows.

TIP You can hide a long list of items in the Recent, Shared, Albums, Projects, and Slideshows sections by *collapsing* them in the Source list (the Shared, Albums, Projects, and Slideshows sections are all collapsed in Figure 2-1). When you point your cursor at a section name, the word "Hide" appears to its right; click it to collapse the section. To expand the section, point your cursor at its name and click the word "Show."

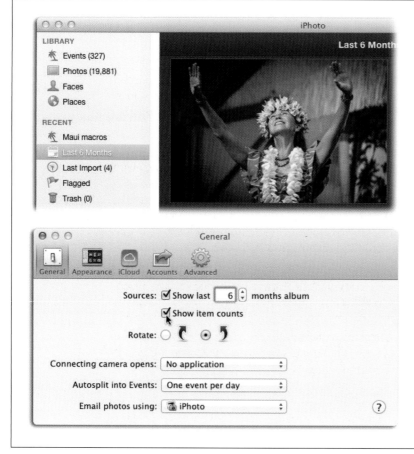

FIGURE 2-2

You can specify how far back the "Last _ Months" album goes in the General panel of iPhoto Prefer- ences window (bottom). And don't forget that iPhoto isn't limited to grouping pictures by year. It can also show you the photos you took on a certain day, in a certain week, or during a certain month. See page 78 for details.

While you're in General Prefer- ences, don't miss the "Show item counts" setting. It places a number in parentheses after each album name in the Source panel (except for smart albums and the "Last _ Months" album) to let you know how many pictures are inside. By turning on this checkbox, you can find out whether you're certifiably snap happy.

NOTE When you're designing a layout of photos to print at home, a temporary Printing album shows up under the Recent heading, too; it disappears once you cancel or print the project. Chapter 7 has more on printing photos on your own printer.

- **Flagged.** As noted on page 73, *flagging* a photo marks it for your attention later. You can flag all the good ones, or all the ones that need editing, or all the ones you want to round up to use in a calendar project. Click this icon to see all the photos you've flagged, no matter which albums or Events they're in.

- **Trash.** Click this icon to see all the photos, albums, folders, books, and other projects you've targeted for deletion. They're not *really* gone until you empty iPhoto's Trash, though. See page 68 for details.

> **TIP** Remember this key fact: Photos listed under the Library and Recent headings are the *real* photos. Delete a picture from one of these collections, and it's gone forever (once you empty iPhoto's Trash, that is). However, that's *not* true of albums, which store only *aliases*—pointers—to the real photos.

Shared

Under this heading, you'll see the names of all the places you've shared or published your photos to, such as Flickr and Facebook. This is also where you'll find your iCloud photo stream (page 12), which lets you see pictures you've taken on your iPhone, iPad, or iPod Touch.

This section is also home to one of iPhoto's coolest features: *shared photo streams.* If you've got an iCloud account (page 12), you can share a photo, video, or album with *other* iCloud members. When you do, the recipient gets an email invitation. Once she accepts it, a new stream appears in the Shared section of *her* iPhoto Source list, and she can view, "like," or comment on the item (she can even *add* photos to the stream, if you set it up that way). Think grandparents and grandkids, and you'll see the possibilities. See Chapter 8 for the full scoop on photo sharing.

> **NOTE** Alas, gone are the days when you could share iPhoto libraries across your home or office network. These days, Apple wants you to use iCloud for all your photo-sharing needs, whether *you* want to or not.

Later in this book, you'll find out how to archive photos onto CDs or DVDs—and then load them back into iPhoto whenever you darned well feel like it. CD icons and DVD icons show up under the Shared heading, too.

Devices

As soon as you plug a camera or a memory card reader into a USB port or your Mac's built-in memory card slot, its name appears here. If you plug your iPhone, iPad, or iPod Touch into your Mac, it shows up here, too.

Albums

Later in this chapter, you'll find out how to create your own sets of pictures, called *albums,* including how to stick a bunch of related albums into an enclosing entity called a *folder.* You can even have iPhoto create albums *for* you, based on criteria like "highest rated" or "is a movie" (these self-populating albums are called *smart albums*).

Your folders, albums, and smart albums appear in this section.

TIP Saved slideshows and custom-publishing projects can be filed in folders, too, right alongside albums. You might not expect that, since slideshows and projects begin life under separate headings in the Source list, as explained next.

Projects

Under this heading, you'll find the icons for any of Apple's custom-publishing good-ies that you've assembled, such as photo books, calendars, or greeting cards (of the folded or flat variety). Chapter 9 has details on creating these drool-worthy print pieces.

Slideshows

Saved slideshows (Chapter 6) get their own icons in the Source list, too.

All About Events

The primary photo-organizing concept in iPhoto is the Event: a group of photos that were all taken at about the same time. It certainly makes a lot more sense than the *film roll,* the organizing construct of early versions of the program. (A film roll consisted of all the photos you imported in one go, no matter how many months apart you took them.) Because of Events' chronological nature, photos can live in only one Event at a time.

iPhoto performs this chronological autosplitting whenever you bring new pictures in from your camera or memory card, *if* the Split Events setting was left on (see Figure 1-3 on page 8). If not, then all the pictures you import in a single batch get clumped into a single Event, regardless of when they were taken. If you're importing photos from your hard drive, they get funneled into a single Event, too. That said, you can always have iPhoto automatically split your Events *after* you import them. It's an easy process and is covered later in this chapter on page 38.

Events are the perfect place to *assess* your photos, culling your collection down to just the keepers. Once you do that, you can organize the keepers into individual albums (page 52), which you can use as the basis of projects—slideshows, calendars, books, and so on. (The box on page 88 has one possible photo-assessment strategy.)

FREQUENTLY ASKED QUESTION

Your Own Personal Sorting Order

I want to put my photos in my own order. I tried using View→Sort Photos→Manually, but the command is dimmed out! Did Apple accidentally forget to turn this on?

No, the command works—but only when you're viewing the contents of an *album.* You can't manually sort the thumbnails in All Events or Photos view because, from the factory, they're

arranged by *date* (though you can choose to view them by keyword, title, or rating, in ascending or descending order, using the aforementioned View→Sort menu).

If you create an album (as explained later in this chapter) and fill it with photos, then you can drag them into any order you want.

The Events List

When you click Events at the top of the Source list, you see an array of big, rounded thumbnails, as shown in Figure 2-1, top. Each thumbnail represents an Event. (This view is called, aptly, *All Events view*.) To save space, iPhoto shows only *one* picture from each Event; you can think of it as the top photo on the stack. Using that sample photo, along with the Event's name and date, you should be able to figure out which stack of photos the Event contains.

> **TIP** You can make the Event thumbnails bigger or smaller; just drag the Zoom slider in the toolbar.

All Events view is a zoomed-out, bird's-eye view of your entire photo collection. Thanks to the stacking concept, a single screen full of thumbnails can represent thousands of individual photos.

Here's a list of things you can do when you're peering at the Events thumbnails:

- **Scan through a pile.** Here's a tricky move that's relatively new to the Mac skillset: Move your cursor sideways across an Event thumbnail *without clicking.* As you go, the photo on the top of the stack changes, as all the pictures within flicker by. This is a quick way to get a look at the other pictures in the virtual heap.

 (If there are lots of photos in the Event, then every fraction of a millimeter of mouse movement triggers the appearance of the next photo, which makes it hard to have much control. Making the thumbnails bigger may help. And remember that this technique is just supposed to give you an *idea* of what's in the Event—it isn't supposed to be a real slideshow.)

- **Sort the Events.** Ordinarily, iPhoto presents the Event thumbnails in chronological order; in effect, it chooses View→Sort Events→By Date for you. But you can sort them alphabetically by choosing View→Sort Events→By Title. In either case, you can also reverse the sorting by choosing View→Sort Events→Descending (or Ascending).

> **TIP** Once you open an Event by double-clicking its thumbnail, you can sort its photos by keywords, too. To do so, choose View→Sort Photos→By Keyword.

- **Rearrange the Event thumbnails.** You can drag one Event's thumbnail between two others to rearrange them. When you do that, iPhoto chooses View→Sort Events→Manually for you, because your thumbnails are no longer sorted alphabetically or chronologically. (As the box on page 34 explains, you can't manually arrange the photo thumbnails *inside* an Event.)

- **Change the key photo.** The *key photo* is the one on top of the stack; the one that represents the Event itself. iPhoto seemingly picks one at random. Typically, and for pure organizational joy alone, you'll want to rummage through the Event and pick a better one to represent the whole batch. For a birthday party, for example, you might choose the candle-blowing-out shot.

To change the key photo, scan through the stack using the cursor trick described above. When you see the picture you want to use as the key photo, tap the space bar. You can also Control-click the thumbnail and then, from the shortcut menu, choose Make Key Photo.

NOTE You can designate a key photo while you're surveying the photos *inside* an Event, too. See the Tip on page 37.

- **Rename an Event.** To rename an Event, just click its existing name and then type away. Press Return, or click somewhere else, when you're finished.

- **Merge Events.** You can combine two (or more) Events into one simply by dragging one Event thumbnail onto another. iPhoto instantly combines the two sets of photos. (The one you dragged vanishes; the combined pile assumes the name and key photo of the one you dragged *onto*.) You can also select multiple Events in All Events view and then choose Events→Merge Events.

- **Delete an Event.** To remove an entire stack of pictures from your hard drive, click the Event's thumbnail and then press ⌘-Delete. (Or drag the Event's thumbnail onto the Trash icon in the Source list.) Later, you can empty iPhoto's Trash as described on page 69.

NOTE There are other ways to merge, split, create, delete, rename, and move photos between Events—but you do all that in Photos view, described later in this chapter.

UP TO SPEED

Defining an Event

When you import photos from a camera or your hard drive, iPhoto autosplits them into Events. When the importing is over, you might wind up with two, five, or 10 stacks of photos in the All Events view shown in Figure 2-1, depending on how long it's been since the last time you downloaded pictures.

Initially, iPhoto defines an Event as one day. So if you import pictures you took on June 1, 2, and 3, then you wind up with three Events.

You might consider that breakdown too rigid, though. It's not an especially logical grouping if, for example, you were away for a wedding weekend, a three-day trip to a theme park, or a weeklong cruise. In those cases, you'd probably consider all the photos from that trip one Event.

In other, less common situations, you might consider one day to be too long a window. If you're a school photographer who conducts two shooting sessions a day—morning and afternoon, say—you might want iPhoto to split up the incoming photos into smaller time chunks, like a new Event every 4 hours. (Also, some photo-sharing websites limit the number of pictures that can go in a single album.)

In any case, iPhoto can accommodate you. Choose iPhoto→Preferences→General. From the "Autosplit into Events" menu shown at the bottom of Figure 2-2, choose "One event per day," "One event per week," "Two-hour gaps," or "Eight-hour gaps." (Those "gap" options are iPhoto's way of saying, "If more than that many hours have elapsed since the last batch of photos you took, then I'll call it a new Event.")

As you'll learn later in this chapter, it's extremely easy to split, merge, slice, and dice Events, move photos around between Events, and so on. But you may as well let iPhoto do the bulk of the grunt work when you import the pictures.

Opening an Event

Double-clicking an Event expands its stack so you see thumbnails of all the pictures within it, as shown in Figure 2-3. From here, you can search, sort, edit, and pick photos for inclusion in slideshows, prints, books, and so on. To change the thumbnails' size, use the Zoom slider at the bottom of the iPhoto window.

> **TIP** Once you've opened an Event, you have another, even better chance to choose a key photo for it (the one that appears at the top of the stack in All Events view). Just Control-click the thumbnail of the photo you want to exalt to that special position, and then choose Make Key Photo from the shortcut menu that appears. (Clicking a thumbnail and choosing Events→Make Key Photo does the same thing.)
>
> If the Info panel is open, you can also move your cursor sideways across the Event thumbnail that appears at the top right of your screen; when you see the pic you want to use as the new key photo, click once to make it so.

FIGURE 2-3

When you double-click an Event to see inside it, iPhoto displays the Event's name, date, and total number of photos at the top of the window. It also tallies how many photos you've temporarily hidden from view (page 47).

To see the previous or next Event without returning to All Events view, click the arrows circled here.

You can return to All Events view by clicking Events in the Source list (even though it's already highlighted), clicking the All Events arrow at the top left of the photo-viewing area (labeled in Figure 2-3), or pressing ⌘-left arrow.

Creating Events Manually

Events are such a convenient way of organizing your photos that Apple lets you create them *manually,* out of any pictures you choose.

This feature violates the sanctity of the original Event concept: that all the photos taken in a certain time period are one Event. Still, in this case, usefulness trumps concept—and that's a good thing.

To create an Event, select any bunch of pictures in your library (using any of the techniques described on page 46) and then choose Events→Create Event. iPhoto removes the photos from their original Events, creates and selects the new one, and

gives it a generic name ("untitled event"); just click this placeholder name and then enter a new, more meaningful one.

> **TIP** If you've *flagged* photos in your collection (page 73), you can also choose Events→Create Event From Flagged Photos. That's a great way to round up pictures that currently sit in different Events—but nonetheless belong together. (iPhoto removes them from the old Event.)
>
> Alternatively, you can gather up all your flagged photos and add them to an existing Event. To do that, click Events in the Source list, click the destination Event's thumbnail to select it, and then choose Events→Add Flagged Photos To Selected Event.

Splitting and Renaming Events

Here's yet *another* way to create a new Event: Split off a bunch of photos from another Event. You can either ask iPhoto to do it automatically, based on when the pictures were taken, or you can do it manually:

* **The automatic way.** Suppose you turned off the Split Events setting (page 9) when you imported your pictures, and now you're having second thoughts. You wound up importing hundreds of photos taken over the course of several weeks, and now you realize that it *would* be sort of handy if they were broken up by day or by week.

 First, make sure you've told iPhoto what time period you want to serve as the cutoff point for Event groups (a day, a week, 2 hours, or 8 hours, as the box on page 36 explains). Next, click Events in the Source list, and then select the Event(s) that you want to split (skip ahead to page 46 for selection techniques). Finally, choose Events→Autosplit Selected Events to have iPhoto automatically divide the selected Events into *more* Events based on the date or time period you requested.

* **The manual way.** You can also chop an Event in two, subdividing it at any point that feels right. For example, iPhoto may have grouped 24 hours' worth of photos into a single Event, even though you road-tripped through *three* states and you'd prefer those photos to appear in *separate* Events, thank you very much. Figure 2-4 has the details.

As you know from Chapter 1, iPhoto gives you the opportunity to name each Event as it's created—that is, at the joyous moment when a new set of photos becomes one with your iPhoto library. If you don't type anything into the Event Name box when you import photos, iPhoto just labels each Event with a date. Fortunately, you can change any Event's name anytime, *anywhere* it appears. To rename an Event, click its existing name and then start typing.

FIGURE 2-4

Top: To split this Event in two so bird shots are in one and flower shots in another, open the Event, scan through the thumbnails, and then click the photo that marks the beginning of what you'd like to become the new, separate Event. Next, choose Events→Split Event, or press the S key on your keyboard. iPhoto moves the selected photo and all the ones after it into the new Event.

Bottom: Return to All Events view to see the new Event (it's next to the original and named by date); in Photos view, you see all your Events in a list. To rename the Event, click its name and type something else. To rename the next Event, press Tab to highlight its name so you can type away (pressing Shift-Tab highlights the previous Event's name).

Merging Events

You can *merge* Events with one quick swipe, too—a great technique when your photo collection starts to get enormous. Also, if you shoot a lot of *multiday* events (such as weddings or soccer tournaments) and you always keep "Split Events" turned on when you import pictures, you'll end up with a *slew* of Events. In that case, it may make sense to combine the individual days of that particular shoot into a single Event.

Start in All Events view (click Events in the Source list), and then proceed as shown in Figure 2-5.

TIP In All Events view, you can also merge Events by ⌘-clicking to select more than one, and then choosing Events→Merge Events.

FIGURE 2-5

You can combine Events by dragging one Event's thumbnail onto another, as shown here. The Event you moved disappears into the other one. If you change your mind about the merger, undo it by pressing ⌘-Z. (If only that keyboard shortcut worked in real life!)

Photos View

When you click Photos in the Source list, you see *all* your photos, instead of the representative stacks you get in All Events view. Here, every photo has its own thumbnail and each Event is shown as a collapsible header in the list (see Figure 2-1, bottom). By scrolling through the list, you can survey your *entire* collection, one glorious thumbnail after the next.

You can do everything in Photos view that you can do when you're viewing a single Event: You can mark thumbnails with keywords, ratings, and descriptions; pick a photo to edit; or choose several to include in an album, slideshow, book project, and so on. iPhoto also lets you rename Events in this view, as well as move photos *between* Events (though you can't split or merge Events in this view).

In short, this is the view where you'll spend the majority of your organizational time.

Collapsing Events

As your collection grows, Events become excellent visual aids, even in Photos view, to help you locate a certain photo—even months or years after the fact.

Furthermore, as your library becomes increasingly massive, you can use these Event stacks to preserve your sanity. By collapsing the stacks you're *not* looking at right now (Figure 2-6), you speed up iPhoto considerably. Otherwise, you may spend hours scrolling through ever more photos. (These days iPhoto can manage up to a million pictures in a single library! Of course, you can always start new libraries, as described in Chapter 12.)

Which leads us to one of the best tips in the whole chapter: *Option-click* an Event's flippy triangle to hide or show the contents of *all* your Events in one fell swoop. When all your Events are collapsed, you see nothing but their names, and scrolling is almost instantaneous no matter *how* many photos you have.

FIGURE 2-6

This tidy arrangement is a fast way to use iPhoto, as it displays all photos grouped by Event. Click the flippy triangle next to an Event's header (circled) to expand or collapse that Event.

Click anywhere on an Event's header to select all photos inside it. This is handy when you want to do things like apply a keyword to the whole Event ("flowers," say).

Moving Photos Between Events

The fact that iPhoto groups photos into Events by time period is a handy starting point. But it's *only* a starting point. You can, and should, freely drag photos among your Events according to any logic that suits you.

In Photos view, select any photos you want to move and then drag them onto another Event's name in a header bar (Figure 2-7) or, if the Event's flippy triangle points down, directly *into* the Event alongside its other thumbnails. Poof! The deed is done.

Size Control

You can make the thumbnails in iPhoto grow or shrink using the Zoom slider in the toolbar below the photo-viewing area. Drag the slider all the way to the left, and you get micro-thumbnails so small that you can fit hundreds of them in the iPhoto window. Drag it all the way to the right, and you end up with—you guessed it—large thumbnails.

> **TIP** You don't have to *drag* the Zoom slider; just click anywhere along the slider to make it jump to a new setting. You can also scale all the thumbnails to their minimum or maximum size by clicking the tiny icons at either end of the slider.

FIGURE 2-7

When you're dragging photos between Events in Photos view, it's easy to accidentally plop them into the wrong one. Because iPhoto doesn't indicate which Event they're headed for (hello, Apple?!), be mindful of where your cursor is positioned before releasing your mouse button. If you make a mistake, don't panic—just press ⌘-Z to undo the move.

In Photos view, you can rename an Event by clicking its name in the header bar.

To make your photo large enough to fill the iPhoto window, give the image a double-click or tap the space bar. To get out of this zoomed-in view and back to your thumbnails, double-click the photo or tap the space bar again. You can also click the left-pointing Photos button at the top left of the main viewing area to return to Photos view, or press ⌘-left arrow.

By the way, you might notice that this Zoom slider performs different functions depending on which *mode* iPhoto is in. For example, when you're editing a photo, it zooms in and out of an individual image. But when you're designing a photo-book layout or any other project (Chapter 9), it magnifies or shrinks the book, calendar, or card's page.

Sorting Photos

Your main iPhoto window may look like a broad, featureless expanse of pictures, but they're actually in a logical order. iPhoto starts out sorting your photos chronologically, with the oldest ones at the top of the window.

> **TIP** If you prefer the newest items to appear at the top of the iPhoto window instead of the bottom, choose View→Sort Photos→Descending.

Using the View→Sort Photos submenu, you can make iPhoto sort all the thumbnails in the main window in a number of useful ways:

- **By date.** This sort order reflects the dates the photos were taken. iPhoto gets this info from the photos' *metadata* (info embedded into the pictures by your camera; though it's changeable, as the next section explains).

- **By keyword.** This option sorts your photos alphabetically by the keywords you've assigned to them (page 80).

- **By title.** This arrangement is alphabetical by the photos' names. (To rename your photos, see page 63.)

- **By rating.** If you'd like your masterpieces to appear at the top of the window, and the less-desirables farther down below, choose this option. (Page 86 explains how to rate your photos.)

- **Manually.** This option is available only when you're viewing the contents of an album, as it lets you drag the thumbnails around freely, placing them in any order you want. To conserve your Advil supply, however, pay close attention to exactly *where* you are in your Source list; if you're in Events or Photos view, you can't drag photos into a specific order, no matter *how* much you curse. See the box on page 34 for details.

Renaming and Redating Photos

To make every photo's name appear beneath its thumbnail, choose View→Titles. (When you do, the photo's name also appears in the Info panel's Title field.) Turning on titles works great if you don't mind referring to your pictures as IMG_09231.JPG, DSC_0082.JPG, and so on. If you don't rename your photos, viewing their titles is pretty pointless.

That doesn't mean you *should* rename all your photos, but if you're inclined to rename the keepers individually, you'll find that task really easy in iPhoto. You can rename just about anything by double-clicking its existing name and typing over it: Events, albums, slideshows, projects—and photos (see Figure 2-8).

> **TIP** If you create an album that you intend to use as the basis for a slideshow, then renaming the photos in the album can come in handy. As page 163 explains, you can have iPhoto display each photo's name during the slideshow by turning on the Show Captions option and choosing Titles.

You can make a photo's name as long as you want, but it's smart to keep it short (about 10 characters or so). That way, you can see all or most of the name in the Title field (or under the thumbnails).

> **TIP** You can find a faster method for renaming photos at the bottom of page 64. It's handy if you're plowing through an album, renaming (or redating) a ton of photos at once.

FIGURE 2-8

Turn on titles by choosing View→Titles, and then you can rename a photo by clicking its existing name and typing away. To rename the next one, press Tab to highlight its name. (To highlight the previous thumbnail's name, press Shift-Tab instead.) Proceed this way (Tab, type; Tab, type) until you're finished.

To change a photo's *date,* on the other hand, you'll need to enlist the help of a dialog box. Doing so can help your thumbnails appear in the correct chronological order.

In either All Events or Photos view, select the thumbnail of the photo that you want to change, and then choose Photos→"Adjust Date and Time." In the resulting dialog box, the existing date and time appear, along with a text box where you can enter a new one, as shown in Figure 2-9.

NOTE You can change the date of *all* the photos in an Event en masse. Just choose Events in the Source list and then select the *Event thumbnail* that you want to alter, instead of a photo thumbnail.

FIGURE 2-9

As long as you don't turn on "Modify original files," the real shot date of your photo remains intact as part of its metadata (page 43). To change the date of an Event, select its thumbnail in All Events view and then open this dialog box. This kind of thing is handy if you got the photos from someone else and they were modified in another program, or if your camera's date/time stamp is off kilter.

To learn how to rename *multiple* photos at once, skip ahead to page 64.

Scrolling Through Your Photos

Enough learning about iPhoto already—now it's time to start *using* it!

Happily, browsing, selecting, and opening photos is straightforward. In fact, here's everything you need to know:

- You can use the vertical scroll bar on the right side of the iPhoto window to navigate through your photo thumbnails.

NOTE If your scroll bar disappears when you *stop* scrolling, you can make it hang around permanently by going to →System Preferences→General and setting "Show scroll bars" to Always.

If you have a laptop, Apple Magic Mouse, or Magic Trackpad, you can also scroll by swiping up or down with one or two fingers, depending on how your "Mouse and Trackpad" system preferences are set up. Using the Page Up and Page Down keys works, too (they scroll one screen at a time). If your mouse has a scroll wheel on top (or a scroll pea, like Apple's old Mighty Mouse), you can use that to scroll, too.

TIP iPhoto can display a translucent "heads-up display" that shows, chronologically or alphabetically, where you are as you scroll. See page 71 to turn it on.

- Even though iPhoto is faster than ever, scrolling can still take awhile if you have a huge library. But you can use this standard OS X trick for faster navigation: Instead of dragging the scroll bar, *Option-click* the spot on the scroll bar that corresponds to the location you want in your library. If you want to jump to the bottom of the library, for example, Option-click near the bottom of the scroll bar.

NOTE You can make this the standard behavior for all OS X scroll bars by going to →System Preferences→General and turning on "Jump to the spot that's clicked." With that setting turned on, you won't need the Option key—simply clicking the scroll bar will do the trick. If you *do* use the Option key, you'll jump to the next page instead.

- *If* your keyboard includes a Home or End key, press the Home key to jump to the very top of your photo collection, or the End key to leap to the bottom. (You have to hold down the fn key *plus* Home or End on some keyboards.)

■ Selecting Photos

To select a single picture in preparation for dragging, opening, duplicating, deleting, and so on, click its thumbnail once.

That much may seem obvious. But many Mac novices have no idea how to manipulate *more* than one icon at a time—an essential survival skill. To select *multiple* photo (or Event) thumbnails in preparation for doing anything with them en masse, use one of these techniques:

- **Select all the photos in the window.** To select all the pictures in the Event or album you're viewing, press ⌘-A. (That's the equivalent of the Edit→Select All command.)

> **TIP** In Photos view, you can select all the photos in one Event by clicking the Event's name in the header bar, as shown in Figure 2-6 on page 41.

- **Select several photos by dragging.** You can drag diagonally to select a group of nearby photos. You don't even have to enclose the thumbnails completely; your cursor can touch any part of a thumbnail to select it. If you keep dragging past the edge of the iPhoto window, the program scrolls automatically.

> **TIP** If you include a particular thumbnail in your dragged group by mistake, ⌘-click it to remove it from the selected cluster.

- **Select consecutive photos.** Click the first thumbnail you want to highlight, and then Shift-click the last one. iPhoto selects all the files in between, along with the two photos you clicked (Figure 2-10, top). This trick mirrors the way Shift-clicking works in word processors, the Finder, and many other programs.

- **Pick and choose photos.** If you want to highlight, for example, only the first, third, and seventh photos in a window, start by clicking the first photo's thumbnail. Then ⌘-click each of the others. Each thumbnail sprouts a yellow border to indicate that you've selected it (Figure 2-10, bottom).

- **Deselect a photo.** If you're selecting a long string of photos and then click one by mistake, you don't have to start over. Instead, just ⌘-click it, and the yellow border disappears. (If you *do* want to start over from the beginning, then just deselect all the photos by clicking in any empty part of the window.)

 The ⌘-click trick is especially handy if you want to select *almost* all the photos in a window. Simply press ⌘-A to select everything in the folder, and then ⌘-click any unwanted photos to deselect them. You'll save a lot of time and clicking.

> **TIP** You can also combine ⌘-clicking with Shift-clicking. For instance, you could click the first photo, and then Shift-click the tenth to select all 10. Next, you could ⌘-click photos 2, 5, and 9 to remove them from the selection.

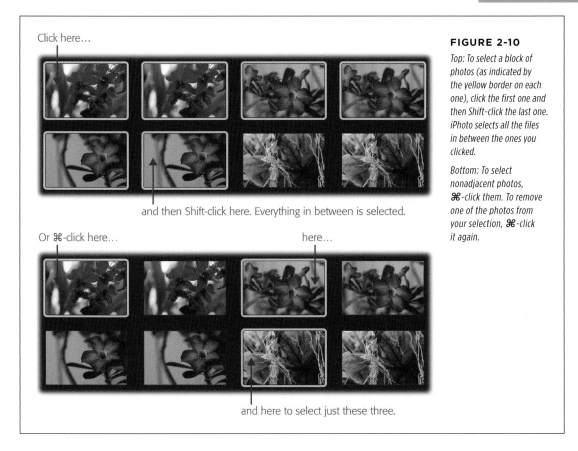

Click here...

and then Shift-click here. Everything in between is selected.

Or ⌘-click here...

here...

and here to select just these three.

FIGURE 2-10

Top: To select a block of photos (as indicated by the yellow border on each one), click the first one and then Shift-click the last one. iPhoto selects all the files in between the ones you clicked.

Bottom: To select nonadjacent photos, ⌘-click them. To remove one of the photos from your selection, ⌘-click it again.

Once you've selected multiple photos, you can manipulate them all at once. For example, you can drag them en masse out of the window and onto your desktop— a quick way to export them. (Actually, you may want to drag them into a *folder* in the Finder to avoid spraying their icons all over your desktop.) You might also give them keywords or a star rating. Or you can drag them into an album in the Source list. Just drag *one* of the selected photos, and all the others go along for the ride.

In addition, when multiple photos are selected, the commands in the File, Edit, Photos, and Share menus—including Duplicate, Print, Revert to Original, Move to Trash, Email, and so on—apply to *all* of them simultaneously.

▇ Hiding Photos

For years, you had only two choices when confronting a so-so photo in iPhoto: Keep it or delete it.

Keeping it isn't a satisfying solution, because it's not one of your best, but you're still stuck with it. You have to look at it every time you open iPhoto, skip over it every time you're making a photo book or a slideshow, and so on. But deleting it isn't such a great solution, either. You just never know when you might need *exactly* that photo again, years later.

Fortunately, there's a happy solution to this quandary: You can *hide* a photo. It's still there behind the scenes, and you can always bring it back into view should the need arise. In the meantime, you can pare your *visible* collection down to the really good shots, without being burdened every day by the ghosts of your less impressive work.

To hide some photos, select them as explained in the previous section, and then take one of these steps:

- Press ⌘-L, or choose Photos→Hide Photos.

- Click the down-pointing triangle at the bottom right of any selected photo's thumbnail to reveal its shortcut menu, and then click Hide (see Figure 2-11).

FIGURE 2-11

Top: When you point your cursor to a photo's thumbnail, you see a black, down-pointing triangle appear inside a white circle at its bottom right. Click it to reveal the shortcut menu shown here, which includes a Hide option.

Bottom: When you choose View→Hidden Photos, the hidden pictures reappear. iPhoto lets you know that you're viewing hidden photos by displaying an X on each one, and by saying so in the Events header bar and at the top of the iPhoto window; notice how iPhoto added the word "showing" to its count at upper right.

The selected photos vanish from sight. They're still taking up disk space, of course, but they no longer bog down iPhoto when you're scrolling or depress you when they stare out at you every day.

But don't worry: iPhoto doesn't let you forget that they're there. Whenever you open an Event, the words "(121 more hidden)"—or whatever the number is—appear in the title bar; you can see this at the top of Figure 2-11 (this notation also appears in Photos view).

Seeing Hidden Photos

To bring all your hidden photos back into view for a moment, choose View→Hidden Photos or press Shift-⌘-H.

Either way, all the hidden photos reappear, bearing little X's on their corners (see Figure 2-11, bottom). This is your chance to reconsider—either to delete them for good, or to welcome them back into society.

Of course, you can rehide the hidden photos whenever it's convenient by choosing View→Hidden Photos again.

Unhiding Photos

Just marking a photo as hidden doesn't mean you can't change your mind. At any time, you can unhide a hidden photo, turning it back into a full-fledged photographic citizen.

To do that, first make your hidden photos visible, as described above. Then select the photos you want to unhide, and then repeat whatever step you took to hide them in the first place. For example:

- Press ⌘-L, or choose Photos→Unhide Photos.
- Click the down-pointing triangle at the bottom right of any selected photo's thumbnail and then click Show.

Three Ways to Open a Photo

iPhoto wouldn't be terribly useful if it let you view only postage-stamp versions of your photos (unless, of course, you *like* to take pictures of postage stamps). Fortunately, the program offers three ways to view your pictures at something much closer to actual size.

You'll use these methods frequently when you start editing photos as described in Chapter 5. For the moment, it's useful to know about these techniques simply for the more common act of viewing the pictures at larger sizes.

Method 1: Right in the Window

The easiest way to open a photo is simply to double-click its thumbnail, or select a photo and then tap the space bar. In both instances, the photo opens in the main iPhoto window, scaled to fit the viewable area (Figure 2-12).

NOTE It used to be that you could tweak iPhoto settings so a double-click switched you to Edit mode, but you can't do that anymore. Apple (correctly) assumes you'll do most of your editing in Full Screen view.

Whenever you've opened a photo this way, the bottom of the window displays a parade of all the *other* photos' thumbnails. This is the *filmstrip* or *thumbnail browser.* You can use it to jump to a different photo, as described in Figure 2-12.

TIP iPhoto lets you see only one photo at a time in this view. To see multiple photos simultaneously (and at a smaller size), you have to be in Edit mode, as explained on page 120.

FIGURE 2-12

Top: Here's how most people open pictures, at least at first. It's comforting to see landmarks like the Source list and the toolbar. The downside is that those other screen elements limit the size of the enlarged photo; that's why you might want to consider Full Screen view.

Bottom: When you point your cursor at the filmstrip at the bottom of the window, it enlarges it so you can see the other photos in that Event or album; to view another photo at the same size, give it a click. Use the scroll bar handle beneath the filmstrip (circled) to cruise around inside the Event or album to pick another photo to scrutinize.

Method 2: Full Screen View

Here's another way to take a good long gander at a photo: Full Screen view. A selected photo in this view fills your *entire* monitor, edge to edge.

There's no Source list stacked with icons down the left side—everything you need shrinks down to the smallest possible size at the top and bottom of your monitor, letting you focus on your glorious photo, blown up as big as it can be (Edit mode lets you zoom in further, which is handy when you're doing detailed work such as removing blemishes). Heck, even the *menu bar* disappears, though pointing your cursor at the top of your monitor temporarily brings it back.

To enter Full Screen view, click the ⬈ at the top right of the iPhoto window (in earlier versions, this button lived at the bottom left). The filmstrip at the bottom expands when you point your cursor at it, making it easy for you to pick a different photo to view, though you can also use the left and right arrow keys on your keyboard to see a different one.

This mode is fantastic when you're editing photos or creating projects—honestly, it's great anytime you're in iPhoto. To exit Full Screen view, tap the Esc key on your keyboard or point your cursor at the top-right edge of your monitor to reveal the menu bar, and then click the Full Screen icon again.

Method 3: In Another Program

Apple knows there's other software out there—big, burly photo-editing programs like Adobe Photoshop or its friendlier sibling, Photoshop Elements. That's why you can tell iPhoto that you'd rather use a different program for manipulating the finer points of your photos. To do so, choose iPhoto→Preferences→Advanced. From the Edit Photos menu, choose "In application," and then pick another program installed on your Mac. Chapter 5 has more info on editing your photos elsewhere.

The Blurry-Photo Effect

Hey, what's the deal? When I open a photo for editing, it appears momentarily in a coarse, low-resolution version. It takes a second to fill the window so I can get to work. Do I need to send my copy of iPhoto in for servicing?

Nope, your copy of iPhoto is fine.

Today's digital photos are pretty big, especially if you've got a camera that takes giant-sized photos (20 megapixels, for example).

Now, as it turns out, that's a lot more pixels than even the biggest computer screen has. So your Mac not only has to "read" all the photo information off your hard drive, but it also must

then compute a scaled-down version that's exactly the size of your iPhoto window. Naturally, all this computation takes time, though now that iPhoto is 64-bit (see the box on page 22), the lag is far less noticeable, and typically only in Full Screen view.

Apple has tried to disguise this moment of computation by first displaying a full-sized but blurry, low-resolution photo, filling in the sharpened details a moment later. You can't begin editing until the full-window computation is complete. On the other hand, you do get to see, clearly enough, which photo you've opened. And if you've opened the wrong one, you don't have to wait any longer; you can click over to a different photo, having wasted no more time than necessary.

■ Albums

In the olden days of film cameras and drugstore prints, most people kept their pictures in the paper envelopes they were in when they came home from the drugstore. You might have put a photo in an album or physically mailed it to somebody—but then the photo was no longer in the envelope and couldn't be used for anything else.

But you're digital now, baby. You can use a single photo in a million different ways, without ever removing it from its original "envelope" (that is, its Event) or duplicating it.

In iPhoto terminology, an *album* is a collection of pictures—drawn from a single Event or many different ones—that you group together for easy access and viewing. Represented by a little album-book icon in the Source list at the left side of the screen, an album can consist of any photos you select. It can even be a *smart album* that iPhoto assembles automatically by matching certain criteria you specify—all pictures with the keyword "sunset," for example, or all photos that you've rated four stars or higher.

While your iPhoto library as a whole might contain thousands of photos from a hodgepodge of unrelated family events, trips, and time periods, an album has a single focus: Cutest Cat Pics, City Skylines, and so on.

As you probably know, mounting snapshots in a *real* photo album is a pain—that's why so many people still have stacks of Kodak prints stuffed in envelopes and shoeboxes. But with iPhoto, you don't need mounting corners, double-sided tape, or scissors to create an album. In the digital world, there's no excuse for leaving your photos in hopeless disarray.

Of course, you're not *required* to group your digital photos in albums with iPhoto, but consider the advantages of doing so:

- **You can find specific photos faster.** By opening only the relevant album, you can avoid scrolling through thousands of thumbnails in the library to find the picture you want—a factor that takes on added importance as your collection expands.

- **You can drag photos into a different order.** To manually change the order of your photo thumbnails, you first have to create an album. This is *especially* handy when you're preparing a slideshow or a print project like a book or a calendar, and you want the pictures to be displayed in a certain order (see Chapters 6 and 9 for details).

The single most important point about adding photos to an album is this: Putting photos in an album doesn't really *move* or *copy* them. It makes no difference where the thumbnails start out—whether it's the library or another album. You're just creating *references,* or pointers, back to the photos in your master photo library.

This feature works a lot like aliases in OS X; in fact, behind the scenes, iPhoto actually creates aliases of the photos you're dragging. (It stashes them in the appropriate album folders within the iPhoto library.)

What this means is that you don't have to commit a picture to just one album when organizing; one photo can appear in as many different albums as you want. So, if you've got a killer shot of Grandma surfing in Hawaii and you can't decide whether to drop it into the Hawaiian Vacation album or the Grandma & Grandpa album, the answer is easy: Put it in *both.* iPhoto just creates two references to the same original photo in your library.

Creating an Empty Album

To create a new, completely *empty* photo album, open the File menu, and then press and hold the *Shift* key. When you do, the New Album command changes to New Empty Album instead; click it. (You can also create an empty album by pressing Shift-⌘-N.)

When you create an album this way, it appears at the bottom of the Albums section of the Source list with its name highlighted—"untitled album"—so you can type a new one (*Best of Bermuda, Marching Band Mayhem,* or whatever). You can see several albums on display in Figure 2-13.

You can populate your newly spawned album by dragging thumbnails into it from the photo-viewing area (also shown in Figure 2-13). It doesn't matter what's selected in your Source list—Events, Photos, Last Import, another album, or whatever; as long as you can see thumbnails, you can drag them into an album. There's no limit to the number of albums you can add, either, so feel free to make as many as you need in order to achieve your own brand of organizational nirvana.

Creating an Album by Dragging

Creating a new, empty album isn't always the best way to start. Usually it's easier to create an album *and* fill it with pictures in one fell swoop. Here are a couple of ways you can create a new album by clicking and dragging:

- Drag a thumbnail (or a batch of them) from the photo-viewing area onto an empty spot in the Source list. When you let go of your mouse, iPhoto creates a new album named "untitled album" that contains all the photos you dragged.

- Similarly, you can drag a folder of image files from the *Finder* (the desktop behind iPhoto) directly into the Source list (handy if you've created an organizational structure on your hard drive in lieu of in iPhoto). In one step, iPhoto imports the photos, creates a new album, names it after the folder you dragged in, and plops the newly imported photos into that album.

TIP You can also drag photos directly from the Finder onto an *existing* album icon in the Source list; iPhoto imports the photos and includes them in that album.

FIGURE 2-13

When you drag multiple photos into an album, a little red numeric badge appears at the bottom of the ghosted thumbnail as you drag, telling you exactly how many items you've got selected. In this example, six pictures are being dragged into an album.

New albums always appear at the bottom of the Source list's Albums section, but you can drag them up or down within that section. You can also make iPhoto put them in alphabetical order by Control-clicking any album and choosing Sort Albums from the shortcut menu.

Creating an Album by Selecting

For the fastest album creation-and-filling in the West, select some photos *first* using the methods described on page 46. (If you're cruising through Photos view, the images don't have to be from the same Event, or even the same year.) Then:

- **Choose File→New→Album or press ⌘-N.** iPhoto adds the photos to the album and selects the album's name so you can change it.

- **Click Add To** in the toolbar, and then choose Album, as shown in Figure 2-14.

- **Click the Share button** in iPhoto's toolbar, and then choose Album.

You can also create an album from flagged photos (page 73). Flag the images you want to include in your new album, and then click Flagged in your Source list (it's in the Recent category). Press ⌘-A to select all the flagged photos, and then choose File→New Album. Of course, if you've previously flagged photos for another project, they'll end up in your new album, too.

TIP To rename an existing album, click it in the Source list to select it and then single-click its name. When you do that, iPhoto highlights the text so you can edit it.

Adding More Photos

To add photos to an existing album, just drag them onto its icon in the Source list. Figure 2-13 illustrates how you can select multiple photos and drag them into an album in one batch. (If you're paid by the hour, you can also select some photos, click Add To at the bottom of the iPhoto window, click Album, and then click the name of the album you want to add them to. Those extra seconds add up!)

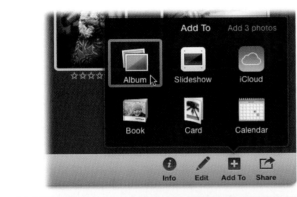

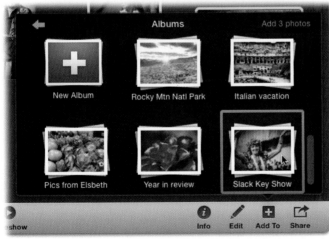

FIGURE 2-14

Top: When you click the Add To icon at the bottom of your iPhoto window, a menu opens that lets you add the selected photos (or Event) to an album, slideshow, project, and so on.

Bottom: When you click Album, another menu appears that lets you create a new album or pick an existing one to receive the selected photos.

Viewing an Album

To view the contents of an album, click its name or icon in the Source list. All the photos included in the selected album appear in the photo-viewing area, while the ones in your library are hidden.

You can even browse *more* than one album at a time by selecting them in the Source list:

- To view the contents of several adjacent albums in the list, click the first one, and then Shift-click the last one.

- To view the contents of albums that aren't consecutive in the list, ⌘-click each of them.

> **TIP** Viewing multiple albums at once can be extremely useful when it's time to share your photos. For example, you can make slideshows or calendar projects containing the contents of multiple albums.

Remember, adding photos to albums *doesn't* move them from the original Events or Photos view where they started out. So if you lose track of which album contains a particular photo, just click Events or Photos in the Source list to return to the overview of your *entire* photo collection.

Changing an Album's Key Photo

You can change an album's representative key photo the same way you change an Event's key photo; flip back to page 35 for details. (That said, you can't change the key photos of *smart* albums, which you'll learn about on page 59.)

Moving Photos Between Albums

There are two ways to transfer photos from one album to another:

- To *move* a photo between albums, select it and then choose Edit→Cut (or press ⌘-X) to remove the photo from the first album. Next, click the destination album's name or icon, and then choose Edit→Paste (or press ⌘-V). The photo is now a part of the *second* album.

- To *copy* a photo into another album, drag it onto the destination album's icon in the Source list. Now the photo belongs to *both* albums.

Removing Photos from an Album

If you change your mind about the way you've organized your photos and want to remove a photo from an album, first open the album and select the photo. (Caution: Check your Source list to be *sure* you're viewing the contents of an *album* and not your main library, the Last 12 Months collection, or the Last Import collection. Deleting a photo from those sources really does move it to iPhoto's Trash.) Then do one of the following:

- Choose Edit→Cut (or press ⌘-X). With this method, the photo remains in your Mac's temporary memory (the *Clipboard*), giving you the opportunity to paste the photo into another album by choosing Edit→Paste or pressing ⌘-V.

- Drag the photo's thumbnail onto the little Trash icon in the Recent section of your Source list.

- Press the Delete key.

- Point your cursor at the selected photo(s) and click the down-pointing triangle that appears in the lower-right corner. In the resulting shortcut menu, click Trash.

In all but the last option, iPhoto asks if you're sure you want to remove the photo (notice it doesn't say "delete"). (If you don't see this confirmation message, you or someone else probably turned on the Don't Ask Again checkbox.) Click Remove Photo. The thumbnail disappears from the album, but of course it's not really gone from iPhoto; it's still in your library.

Duplicating a Photo

iPhoto doesn't let you drag the same photo into an album twice. When you try, the thumbnail simply *leaps* stubbornly back into its original location, as though to say, "Nyah, nyah, you can't drag the same photo into an album twice!"

It's often useful to have two copies of a picture, though. As you'll discover in Chapter 7, a photo whose dimensions are appropriate for a slideshow or photo book (that is, a 4:3 proportion) is inappropriate for ordering prints (4" × 6", 8" × 10", or whatever). To use the same photo for both purposes, you really need to crop two copies independently.

In this case, the old adding-to-album trick isn't going to help you. Instead, you truly have to duplicate the file and consume a little more hard drive space behind the scenes. To do this, select the photo, and then choose Photos→Duplicate (or press ⌘-D). iPhoto switches briefly into Import mode, copies the file, and then returns to your previous mode. The copy appears next to the original, bearing the same name plus the words "Version 2." (If you don't see the name, choose View→Titles.)

> **NOTE** If you duplicate a photo in an album, you'll see the duplicate in the album *and* in the library. If you duplicate a photo in the library, that's the only place you'll see its twin.

Putting Photos in Order

If you plan to turn your album into a slideshow, a calendar, or a printed book, then you'll have to tinker with the order of the pictures, arranging them in the most logical and compelling sequence. Sure, photos in an Event or a smart album (page 59) are locked into a strict sort order—either by creation date, rating, or name (title)—but once they're in a photo album, you can shuffle them *manually* by dragging. Figure 2-15 shows how.

> **TIP** Straight from the factory, iPhoto lets you arrange photos inside an album manually. However, if iPhoto seems to be misbehaving, select the album and then choose View→Sort Photos→Manually.

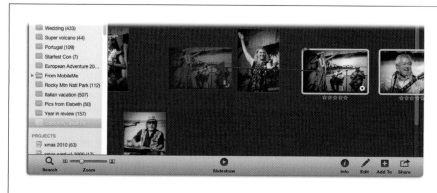

FIGURE 2-15

Drag to reorder photos within an album. When you do, surrounding photos scoot apart to make room. Here, two photos are being dragged leftward (the red circle indicates the number being moved). Release your mouse button when you've got them in the right spot.

Duplicating an Album

It stands to reason that if you have several favorite photos, you might want to use them in more than one iPhoto slideshow, book, or what have you. That's why it's often convenient to *duplicate an entire album* so you can create two different sequences for the photos inside.

Just select an album, and then choose Photos→Duplicate or press ⌘-D. iPhoto does the duplicating in a flash—after all, it's just copying a bunch of tiny aliases and not chewing up precious hard drive space. Now you're free to rearrange the order of the photos inside the duplicate album, to add or delete photos, and so on, independently of the original album.

> **TIP** For quick duplication, you can Control-click an album in the Source list and then choose Duplicate from the shortcut menu.

Merging Albums

Suppose you have three albums containing photos from different trips to the beach, named Spring Break at the Beach, Summer Beach Party, and October Coast Trip. Wouldn't it make sense to merge them into a single album called Beach Trips?

Unfortunately, there's no "merge albums" command in iPhoto, though it's easy to do manually. Start by selecting all three albums in your Source list (⌘-clicking or Shift-clicking each, for example); the photos from each appear in the photo-viewing area. Select all visible thumbnails by pressing ⌘-A, and then press ⌘-N to create a new album.

You now have one *big* album containing the photos from all three original albums. You can delete the three source albums, if you like, or keep all four hanging around. Remember, albums contain only *references* to your photos—not the photos them-

selves—so you're not wasting space by keeping the extra albums. The only penalty you pay is that you have a longer list of albums to scroll through.

Deleting an Album

To delete an album, just click its icon in your Source list and then press the Delete key. You can also Control-click an album and then choose Delete Album from the shortcut menu. Either way, iPhoto asks you to confirm your intention. If you really want it gone, then click Delete.

Remember, deleting an album doesn't delete any *photos*—just the references to those photos. So even if you delete *all* your albums, your library remains perfectly intact.

Smart Albums

Albums, as you now realize, are a primary organizational tool in iPhoto. But it can take a fair amount of work to get the right images into the right albums yourself, one at a time, using the methods described in the previous section.

But thanks to *smart albums,* iPhoto can populate albums *for* you. Smart albums are self-updating folders containing pictures that meet criteria you set up—all pictures with "sunset" as a keyword, for example, or all the photos you've rated four stars and higher. (If you've ever used smart playlists in iTunes, you'll recognize the idea immediately.)

> **TIP** Smart albums can take advantage of Faces and Places tags, too. For example, by using Faces tags, you could quickly create a smart album containing photos of all your kids. Page 99 tells you how.

To create a smart album, choose File→New Smart Album or press Option-⌘-N. Whichever method you use, the Smart Album options slide down from the top of the iPhoto window (Figure 2-16).

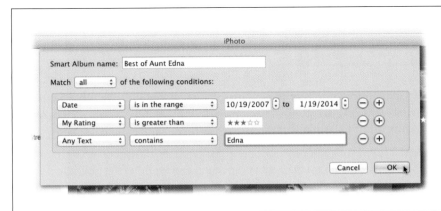

FIGURE 2-16

This panel is really just a powerful search command that lets you specify your search criteria. For example, with the settings shown here, iPhoto will hunt for highly rated photos taken during a certain time period that also include certain text.

The controls here are designed to set up a search of your entire photo library. Figure 2-16 illustrates how to find pictures that you took from 2007 to 2014, have four- or five-star ratings, *and* mention Edna in their titles, keywords, or comments.

Click the **+** button to add a new criterion row and be even more specific about which photos you want iPhoto to include in the smart album. Use the first pop-up menu to choose a type of photo feature (see the following list for details) and the second pop-up menu to tell iPhoto whether you want to match it ("is"), eliminate it ("is not"), and so on. The third part of the criterion row is another pop-up menu or a search field where you finally tell iPhoto what to look for.

Here are your options in the pane's first menu:

- You can limit the smart album's reach by limiting its search to a certain **Album**. Or, by choosing "is not" from the second pop-up menu, you can *eliminate* an album from consideration. When you choose this option, all your albums are listed in the third pop-up menu.

> **TIP** You can also use a smart album to find all the photos that you *haven't* put into an album (a great way to rediscover forgotten photos or to find candidates for deletion). To do so, create a new smart album and name it something like "Not in any album." Then set the pane's menus to "Album," "is not," and "Any."

- **Any Text** searches your library for words or letters that appear in the title, comments, or keywords that you've assigned to your photos. If you can't remember how you spelled a word or whether you put it in the Description or Title field, choose "Any Text," pick "contains" from the second pop-up menu, and type just the first few letters of the word ("am" for Amsterdam, for example) in the search field. You're bound to find some windmills now!

- **Description, Filename, Keyword,** and **Title** work the same way, except that they search *only* that part of the photo's information. Search for "Keyword" "is" "sunset" (type "sunset" into the text field where the third pop-up menu used to be), for example, to find only those pictures to which you specifically assigned the *keyword* "sunset," and not just any old photos where you've typed that word somewhere in the comments.

- **Date** was once one of iPhoto's most powerful search criteria. By choosing "is in the range" from the second pop-up menu, you can use it to create an album containing, for example, only the pictures you took on December 24 and 25 of last year, or during that five-day stretch two summers ago when your best friends were in town. These days, however, the Calendar's date search serves this function much more conveniently (see page 77).

- **Event** lets you make iPhoto look only in, for example, the last five Events (choose "is in the last" from the second pop-up menu and type *5* in the box). Or, if you're creating an album of old shots, you can eliminate the latest few Events from consideration by choosing "is not in the last."

- If you've tagged photos with iPhoto's Faces or Places info (Chapter 4), then the **Face** and **Place** options let you make smart albums based on *who's* in the photos or *where* they were taken.

- The **My Rating** option really puts the fun into smart albums. Let's suppose you've been dutifully giving your pictures star ratings from one to five, as described on page 86. It's payoff time! You can use this option to collect, say, only those with five stars to create a quick slideshow of just the highlights. Another option is to choose "is greater than" two stars for a more inclusive slideshow that leaves out only the real duds.

- **Photo** lets you include (or exclude) photos according to whether they're hidden, flagged, geotagged, or edited. When you choose this option, the third pop-up menu lets you pinpoint raw photos or digital movies. These are *fantastically* useful options; everyone should have a smart album just for movies, at the very least.

- **Aperture, Camera Model, Flash, Focal Length, ISO,** and **Shutter Speed** are behind-the-scenes data bits that your camera automatically records with each shot, and embeds in the resulting photo file. Thanks to these options, you can use a smart album to round up all your flash photos, all photos taken with an ISO (light sensitivity) setting of 800 or higher, all pictures with a certain shutter speed, and so on. (If you choose Camera Model, the third pop-up menu conveniently lists every camera you've ever used to take photos.)

Click the − next to a criterion to take it out of the running. For example, if you decide that date shouldn't be a factor, delete any criterion row that tells iPhoto to look for certain dates.

Once you have all the settings just right, click OK, and your smart album is ready for viewing. When you click its name in the Source list (you can tell it's a smart album because its icon has a little ✿ on it), the main window displays thumbnails of the photos that match your criteria. The best part is that iPhoto keeps this album updated whenever your collection changes—as you change your ratings, take new photos, tag more people, and so on.

Folders

Obviously, Apple hit a home run when it invented the album concept. Let's face it: If there were a Billboard Top Software-Features Hits chart, iPhoto's albums feature would have been number one for months on end.

Albums may have become *too* popular, however. It wasn't long before iPhoto fans discovered that their long list of albums had outgrown the height of their Source lists. As a result, people grew desperate for some way to organize albums *within* albums.

Apple's response consisted of one word: *folders.*

If you choose File→New Folder, iPhoto promptly creates a new, folder-shaped icon in the Source list called "untitled folder" (type a name for it, and then press Return). Its sole purpose in life is to contain *other* Source list icons—albums, smart albums, saved slideshows, book layouts, and so on.

What's really nice about folders is that they can contain *other* folders. That is, iPhoto is capable of more than a two-level hierarchy; you can actually create folders within folders within folders within folders, as shown in Figure 2-17.

Otherwise, folders work exactly like albums. You rename them the same way, drag them up and down the Source list the same way, delete them the same way, and duplicate them the same way.

> **TIP** If you've put something into a folder by accident, no problem; you can easily drag it back out again. Just drag it upward directly onto the Albums heading in the Source list, and then release your mouse button.

FIGURE 2-17

A folder is a convenient container for other kinds of Source list icons. Once you've created a folder, you can drag related albums, saved slideshows, projects, and so on, into it. After that, you can make your Source list tidier by collapsing the folder, thereby hiding its contents. To collapse or expand a folder, click the flippy triangle to its left.

■ The Info Panel

At the bottom right of your iPhoto window, you'll find a set of four buttons. The first one, Info, hides or shows the *Info panel,* which displays general data about a photo, album, Event, or whatever else you've selected.

When the Info panel is visible, you may see any number of different displays (Figure 2-18):

- When a single photo is selected, iPhoto displays that picture's name, rating, creation time and date, dimensions (in pixels), file size, and camera settings; any description you've typed; as well as the photo's Faces, keywords, or Places tags (if you've added any).

 If you've published the photo to your Facebook, Flickr, or iCloud account, or sent an email from within iPhoto (page 190), you see that info here, too, in the Sharing section. If someone leaves a comment on a photo, it shows up in the Comments section the next time the photo is synced (which happens automatically when you click an icon in the Shared section of your Source list and then double-click the album containing the photo).

- When multiple photos are selected, you see the *range* of their creation dates, plus how many photos are selected, how much disk space they occupy, as well as any Faces, keywords, and Places tags.

- When *no* photos are selected, the Info panel displays information about whatever *container* is selected in the Source list—the current album or Event, for example. You see the name of the container, the range of dates of its photos, the number of photos, and their total file size on your hard drive. You can change an Event or regular album's key photo here, too: mouse over the container's thumbnail and click when you see the picture you want to use.

- When your iCloud, Flickr, or Facebook icon is selected in the Source list (see Chapter 8), you see the number of albums or sets you've published, the date range, number of photos, and their total file size.

To close the Info panel, click the Info button again. The panel slides out of sight.

Renaming Photos

Just about everything in iPhoto has its own title: every photo, album, folder, Event, photo book, slideshow, and so on. You can rename most of them by double-clicking the existing name in the Source list.

That said, you can also rename items in the Info panel; simply single-click the first field beneath the camera info (where it says "2013-10 maui-0809" in Figure 2-18), and then type a new name. Done deal.

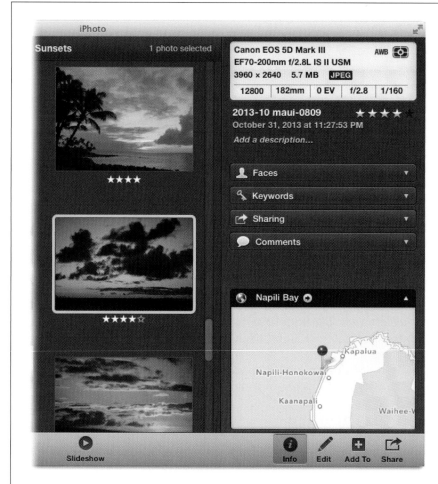

Canon EOS 5D Mark III AWB
EF70-200mm f/2.8L IS II USM
3960 × 2640 5.7 MB JPEG

| 12800 | 182mm | 0 EV | f/2.8 | 1/160 |

2013-10 maui-0809 ★ ★ ★ ★ ★
October 31, 2013 at 11:27:53 PM
Add a description...

👤 Faces ▼

🔍 Keywords ▼

↪ Sharing ▼

💬 Comments ▼

🌐 Napili Bay ⊕ ▲

Kapalua
Napili-Honokowai
Kaanapali
Waihee-

Slideshow Info Edit Add To Share

FIGURE 2-18

*When you open the
Info panel with a photo se-
lected, you see all manner
of details, including the
camera info, the photo's
name and date, and its de-
scription (if you've added
one). If you select a photo
with Faces, keywords, or
Places tags, you see those
here, too.*

*If the photo has been
published to Facebook,
Flickr, iCloud, or emailed
using iPhoto, the panel
includes a Sharing section
(as shown here). Click any
section's name—Faces,
Keywords, Sharing, Com-
ments, or Places—to ex-
pand or collapse it, though
only one section can be
expanded at a time.*

*Alas, you'll find no Info
panel when viewing
projects or slideshows.*

■ Changing Titles and Dates En Masse

The trouble with naming photos is that hardly anybody takes the time. Yes, the Tab trick described back on page 44 certainly makes it easier to add a custom name with reasonable speed—but are you really going to sit there and make up individual names for 50,000 photos?

Mercifully, iPhoto lets you change the names of several photos at once, thanks to a "batch processing" command. No, each photo won't have a unique, descriptive

name, but at least they can have titles like *Spring Break 2* and *Spring Break 3* instead of *IMG_1345* and *IMG_1346*.

To use it, select an Event or album—or multiples thereof—and then choose Photos→Batch Change (Shift-⌘-B). The Batch Change pane drops down from the top of the iPhoto window, as shown in Figure 2-19. To create the kind of naming scheme mentioned above, set the first pop-up menu to Title and the second one to Text, enter the name you want to use for the whole batch ("Spring Break," for example), and then turn on "Append a number to each photo."

TIP Don't be fooled by the command name *Batch Change.* iPhoto still can't edit a batch of photos. You can't, for example, apply the Enhance filter to all of them at once. (Though you can copy and paste edits from one photo to another, as explained in Chapter 5.)

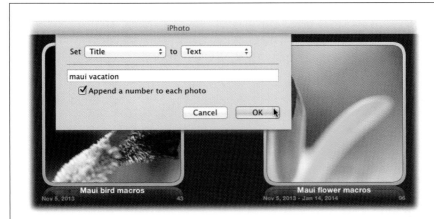

FIGURE 2-19

iPhoto's batch-processing feature lets you specify titles, dates, and descriptions for any number of photos you select. When you title a batch of pictures, be sure to turn on "Append a number to each photo" to number them in sequence, too.

When Title is selected in the first Batch Change pop-up menu, peek inside the *second* pop-up menu for these options:

- **Empty.** Set the titles to Empty if you want to un-name the selected photos so they're all blank. You might appreciate this option when, for example, you're working on a photo book (Chapter 9) and you've opted for titles to appear with each photo, but you really want only a few pictures to appear with names under them.

- **Text.** This option produces an empty text box into which you can type, for example, *Ski Trip.* When you click OK, iPhoto names all of the selected pictures to match. If you turn on the "Append a number to each photo" setting, then iPhoto adds digits after whatever base name you choose—for example, *Ski Trip 1, Ski Trip 2,* and so on.

- **Event Name.** Choose this command to name all the selected photos after the Event they're part of—"Grand Canyon," for example. iPhoto automatically adds a hyphen and a number after this base name.

- **Filename.** If you've been fooling around with naming your photos and now decide that you want their original, camera-given names to return (*IMG_1345* and so on), then choose this option.

- **Date/Time.** Here's another approach: Name each photo for the exact time it was taken. The dialog box gives you a wide variety of formatting options: long date, short date, time of day, and so on.

■ CHANGING PHOTO DATES EN MASSE

You can also use the Batch Change command to rewrite history, resetting the dates of a group of photos all at once.

Choose Date from the first Batch Change pop-up menu and turn on "Add 1 Minute between each photo" to give each one a unique time stamp, which could come in handy later when you're sorting them. iPhoto changes only its internal time stamps; it doesn't actually modify the photo files on your hard drive unless you also turn on "Modify original files."

We trust you won't use this feature for nefarious ends, such as "proving" to the jury that you were actually in Disney World on the day of the office robbery.

NOTE Actually, if you just want to fix the date and time stamps on a few photos, or a whole Event, the Photos→"Adjust Date and Time" command is more direct. It opens the "Adjust date and time of selected photos" dialog box, where you can choose a new date and time of the *first* selected photo. Any other selected photos are adjusted, too, by proportional amounts. For example, if you change the first photo's time stamp to make it 10 minutes later, then all other selected photos are shifted by 10 minutes. You can see it in action back in Figure 2-9 (page 44).

Adding Descriptions

Sometimes you need more than a one- or two-word title to describe the contents of a photo, album, folder, book, slideshow, or Event. If you want to add a lengthier description, you can type it in the Description field in the Info panel, as shown in Figure 2-20.

Even if you don't write full-blown captions for your pictures, you can use the Description field to store other details associated with your photos.

The best thing about adding a description is that it's searchable. After you've entered all this free-form data, you can use it to quickly locate a photo using iPhoto's Search command.

TIP If you speak a non-English language, iPhoto makes your life easier. As you're typing comments, you can choose Edit→Special Characters. OS X's Characters panel opens, where you can add international letters like É, ø, and ß. Of course, it's also ideal for classic phrases like "I ♥ my cat."

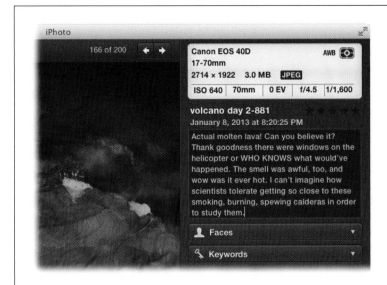

FIGURE 2-20

Got a picture that's worth a thousand words? The Description field can handle it, but you'll need to collapse the other sections in order to see all of it. To add a description, click below the photo's date, where it says "Add a description," and then start typing away.

Keep the following in mind as you squirrel away all those bits and scraps of photo information:

- You don't have to manually *type* to enter data into the Description field. You can paste information in using the standard Paste command, or even drag selected text from another program (like Pages) right into the Description box.

- If no photos, or several photos, are selected, then the notes you type into the Description box get attached to the current *album,* rather than to pictures.

- You can add the same comment to a group of photos using iPhoto's Batch Change command. For example, ⌘-click all the pictures of your soccer team. Next, choose Photos→Batch Change, choose Description from the first pop-up menu, and then type a list of your teammates' names in the text box. Years later, you'll have a quick reminder of everyone's names.

You can just as easily add comments for an album, folder, slideshow icon, book, or Event whose name you've highlighted.

TIP For a real thrill, try using OS X Mavericks' built-in dictation feature. Visit *https://support.apple.com/kb/ HT5449* to learn how.

■ DESCRIPTIONS AS CAPTIONS

While the Description field is useful for storing little scraps of background info about your photos, you can also use it to store the *captions* that you want to appear with

your photos. In fact, some of the book layouts included with iPhoto's book-creation tools (Chapter 9), as well as slideshows (Chapter 6), can use the text in the Description field to generate a caption for each photo.

(On the other hand, you don't *have* to use the Description field's text as captions. You can always add unique captions when you're editing your photo book.)

Deleting Photos

As every photographer knows—well, every *good* photographer—not every photo is a keeper. So at some point, you'll want to take a deep breath and prune your photo collection. Same goes for albums, projects, and so on.

The iPhoto Trash

iPhoto has a private Trash can that works just like the Finder's Trash. It's sitting there in the Source list (under the Recent heading, for some reason). When you delete a picture, iPhoto puts it into the Trash "folder," awaiting permanent disposal via the Empty Trash command. This feature gives you a layer of protection against accidentally deleting a precious picture.

In iPhoto, you can relegate items to the Trash by selecting one or more thumbnails within your library (not in an album, but in All Events or Photos view), and then doing one of the following:

- Dragging the thumbnails onto the Trash icon in the Source list.

- Pointing your cursor at a thumbnail and clicking the down-pointing triangle at its bottom right, and then clicking Trash in the shortcut menu.

- Pressing the Delete key on your keyboard, or choosing Photos→Move to Trash. This maneuver also works when you're in Edit mode.

TIP To delete a photo from a smart album, you have to press Option-⌘-Delete instead.

To view the photos that you've sentenced to the great shredder in the sky, click the Trash icon in the Source list, as shown in Figure 2-21. If you change your mind, you can always resurrect the photo(s) using these techniques:

- Select them and then press ⌘-Delete (or choose Photos→"Put Back"). Think of this as the un-Trash command.

- Drag the thumbnails out of the Trash and onto the Photos icon in the Source list.

- Control-click the photo or photos and, from the shortcut menu, choose "Restore to Photo Library."

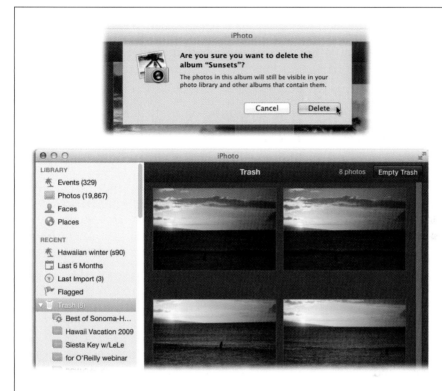

FIGURE 2-21

Top: When you try to delete a picture, iPhoto asks if you're sure (though you can bypass the confirmation message by turning on Don't Ask Again); if you click Delete Photo to confirm that you are, then iPhoto merely plops the file into its Trash folder. However, when you try to delete an album or a project, iPhoto always asks for confirmation, as shown here.

Bottom: Clicking the Trash icon in the Source list shows you all the photos awaiting obliteration and displays the total number of files at the top right of the iPhoto window. If you really want to delete them from your hard drive, click Empty Trash.

> **NOTE** To delete an album, smart album, project, or slideshow, simply select it and then press the Delete key. You won't see these items in the photo-viewing area when you click the Trash icon in the Source list, but you *can* see them by clicking the Trash icon's flippy triangle (see Figure 2-21). To undelete one of these goodies, select it in the list and choose Photos→Put Back (or press ⌘-Delete), or just drag it to another spot in the Source list.

You've just rescued them from photo-reject limbo and put them back into your main photo collection.

To *permanently* delete what's in the Trash, choose iPhoto→Empty iPhoto Trash, or Control-click the Trash icon to access the Empty Trash command via a shortcut menu. iPhoto then displays a message warning you that emptying the Trash removes these photos permanently and irreversibly. *Only when you click OK does your iPhoto library actually shrink in size.*

(Of course, if you imported the photos from files on disk or haven't deleted them from your camera, you can still recover the original files and reimport them.)

Whatever pictures you throw out by emptying the Trash also disappear from any albums you've created.

> **NOTE** If you use iPhoto to track photos that aren't actually in iPhoto (they remain "out there" in folders on your hard drive), deleting them in iPhoto doesn't do much. They no longer show up in iPhoto, but they're still on your hard drive, right where they always were. See page 15 for more on this external photo-tracking feature.

■ Customizing the Shoebox

iPhoto's Photos view starts out looking just the way you probably see it now, with each picture displayed as a small thumbnail against a dark-gray background. This view makes it easy to browse through photos and work with iPhoto's various tools.

But, hey, this is *your* digital shoebox. With a little tweaking and fine-tuning, you can completely customize the way iPhoto displays your photos.

Start with a visit to iPhoto→Preferences→Appearance.

> **TIP** You can open the iPhoto Preferences window anytime by pressing ⌘-comma. This keystroke is blissfully consistent across most Mac programs.

Changing the View

The controls in the Preferences window's Appearance panel (Figure 2-22) let you make some pretty significant changes to the overall look of your library.

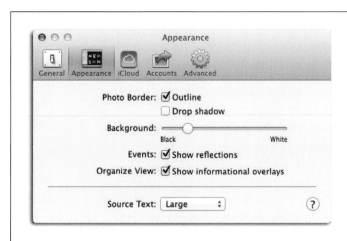

FIGURE 2-22

You can revert to the look of iPhotos of yore by changing the background color to light gray (it remains dark gray in All Events view), but would you really want *to?*

If you're tempted, consider that Apple gave iPhoto a dark-gray background for a reason—it's easier on your eyes and gives you a more accurate sense of color (by eliminating other distracting colors).

Here are your options:

- **Add or remove an outline or a shadow.** From the factory, both Photo Border settings are turned on. Outline puts a thin black or white frame around your photos (whichever contrasts best with the screen background).

 The "Drop shadow" setting puts a soft black shadow behind each thumbnail in the photo-viewing area, a subtle touch that gives your library an elegant 3D look. As pretty as this effect is, however, there are those who say that on slow Macs, it can bog iPhoto down slightly, as the program has to continually redraw or resize the fancy shadows behind each thumbnail whenever you scroll or zoom. In that case, turning off the drop shadow might grant you *slightly* faster scrolling.

- **Change the background color.** The Background slider lets you adjust the background color of the photo-viewing area. Actually, the term "color" is a bit of an overstatement, since your choices include only white, black, or any shade of gray in between.

- **Show reflections when viewing Events.** Turn on the "Show reflections" setting to make the key photos of your Events look like they're reflecting off a glassy surface. (If your computer starts to lag when you're scrolling through Events, turn this setting back off.)

- **Show informational overlays.** This option is well worth keeping turned on. It makes a big, see-through "heads-up display" appear whenever you use the iPhoto scroll bar to scroll through, well, anything (it does *not* appear if you're using gestures or a scroll wheel on your mouse). It shows where you are, chronologically or alphabetically, as you scroll. See Figure 2-23 for an example.

NOTE The heads-up display *doesn't* appear when you've chosen *Manual* sort mode for an album (though honestly, how could it?).

- **Source Text.** Use this pop-up menu to control the size of the text in your Source list. Your choices are Large and Small.

Showing/Hiding Titles, Ratings, and Keywords

If you want your thumbnails to appear with their titles, ratings, and keywords, or all three, then choose View→Titles (Shift-⌘-T), View→Ratings (Shift-⌘-R), or View→Keywords (Shift-⌘-K). Titles, ratings, and keywords appear under each thumbnail. (See Chapter 3 for more on keywords.) To show or hide Event titles, choose View→Event Titles or press Shift-⌘-F.

As with most of iPhoto, your formatting options are limited. You can't control the font, style, color, or size of this text. Your only choice is to display the titles, ratings, and keywords or keep them hidden.

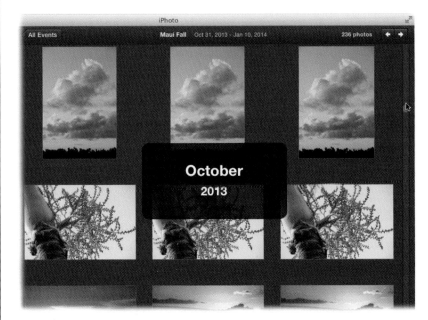

FIGURE 2-23

As you drag the vertical scroll bar, this heads-up display shows where you are in the collection. What you see here depends on the current sorting method.

For example, if you've sorted by name, you see letters of the alphabet as you scroll. If you've sorted by rating, you see stars that indicate where you are in your scroll through the ratings.

Five Ways to Flag and Find Photos

The more you get into digital photography, the more pictures you'll store in iPhoto. And the more pictures you store in iPhoto, the more urgently you'll need ways to *find* them again—to pluck certain pictures out of this gigantic, seething haystack of digital files.

Fortunately, iPhoto is equally seething with search mechanisms. You can find pictures by the text associated with them (name, location, description, Event, and so on); by the date you took them; by the keywords you've tagged them with; or by the ratings you've given them. You can also use iPhoto's flagging feature to find, and later round up, any photos you like.

This chapter covers all five methods and gives you strategic suggestions on how you might use them together.

NOTE You can easily track down photos by tagging them with Faces and Places info, too. Those features are covered in Chapter 4.

Flagging Photos

Here's a simple, sweet iPhoto feature: You can *flag,* or mark, a photo.

So what does the flag mean? Anything you want it to mean; it's open to a multitude of personal interpretations. The bottom line, though, is that you'll find this marker extremely useful for *temporary* organizational tasks.

For example, you might want to cull only the most appropriate images from a photo album for use in a printed book or slideshow. As you browse through the images, flag each shot you want. Later, you can round up all the images you flagged so you can drag them all into a new album. Another idea is to flag photos for deletion and then obliterate them en masse. Yet another use is to flag images that you want to apply a certain creative effect to, like an edge vignette. The possibilities are endless, though this much is certain: The more you use flags, the more uses you'll discover for them.

How to Flag a Photo

You can flag a selected photo, or a bunch of selected photos, by choosing Photos→Flag Photo (or pressing ⌘-period). You can also flag a photo by pointing to its thumbnail and clicking the ghostly pennant that appears on its top-left corner.

Either way, a little orange flag appears at the upper-left corner of the photo's thumbnail, as shown in Figure 3-1.

FIGURE 3-1

When you point your cursor at a thumbnail, you see a ghostly gray flag appear at its top left (circled); just click it to flag the photo.

When you do, the flag turns orange. You can think of this as temporarily marking the photo so you can add it to a grouping of like-minded pictures later. One of the most common uses for flags is for marking photos for deletion, as explained on page 76.

How to Unflag Photos

You can remove photos' flags by selecting thumbnails and then choosing Photos→Unflag Photos (or pressing ⌘-period again). You can also click the orange pennant at the top left of the photo's thumbnail (at which point it turns ghostly again).

TIP You can also remove the flags from *all your photos at once,* everywhere in your library, by using a secret command. Open the Photos menu, hold down the Option key, and marvel as the Clear All Flags command appears. You can also point your cursor at the number to the right of the Flagged item in your Source list; when you do, the number turns into a clickable, albeit microscopic, X.

How to Use Flagged Photos

Suppose you've worked through all your photos for some purpose, carefully flagging them as you go. Here's the payoff: rounding them up so that you can delete them all, hide them all, incorporate them into a slideshow, finally sit down and geotag them (page 105), use them in a book, export them as a batch, and so on.

■ SEE THEM ALL AT ONCE

If you click Flagged in the Source list, then iPhoto shows you all flagged photos in your entire library. You can select them all and drag them into a *regular* album (not a smart album), if you like, in readiness for making a slideshow, a book, or anything else where you'd like the freedom to rearrange their sequence.

■ PUT THEM INTO AN EVENT

iPhoto can generate a new Event that contains only the photos you've flagged in all your *other* Events. This method isolates the flagged photos instantly into a single, handy subset, and removes them from their original Events (photos can live inside only one Event at a time).

All you have to do is choose Events→Create Event From Flagged Photos. A box appears to warn you that you're about to remove the photos from their *original* Events; nod understandingly and click Create. In a flash, your new Event appears, filled with flagged photos and ready to rename.

TIP You don't have to create a *new* Event to hold your flagged photos, either. If you click Events in the Source list and then click an Event in the photo-viewing area, you can then choose Events→Add Flagged Photos To Selected Event. That way, you add the flagged photos to the *existing* Event—a handy option when you've put all the flagged photos into an Event and later added flags to *more* photos that really belong with their brethren.

■ CREATE A SMART ALBUM

You can easily set up a smart album (page 59) to round up all the flagged photos in your entire collection, but iPhoto already has one: the Flagged item in the Source list (it's actually a built-in smart album).

Nevertheless, there are some creative opportunities here. You could create a new smart album to collect flagged photos and incorporate some *additional* criteria, such as "Rating is greater than 4 stars," or "Date is in the last 30 days." If you shoot a lot, the latter criteria would let you corral all the flagged photos you've taken within the last 30 days in order to spend more time on them, say, to produce a black-and-white or sepia effect (a fancy way of saying "brown overlay"), prepare them for your blog, and so on. Once 30 days pass, the shot would automatically disappear

from the smart album, letting you skip any irrational guilt for not getting around to processing it further.

To make a new smart album for flagged photos, choose File→New Smart Album, and in the dialog box that appears, set up the pop-up menus to say "Photo" "is" and "Flagged." Click the + at the far right if you want to add another line of criteria.

■ HIDE THEM ALL AT ONCE

Here's another sneaky hidden iPhoto command: Open the Photos menu, and then hold down the Control key; the Hide Flagged Photos command appears. When you choose it (or just press Control-⌘-L), iPhoto designates all of your flagged photos as hidden (page 47), so you don't see them in your iPhoto library (though they're still there).

■ MOVE THEM ALL TO IPHOTO'S TRASH

The parade of sneaky hidden iPhoto commands never stops. If you open the Photos menu and hold down the Control key, you also get the "Move Flagged to Trash" command, which does just what it says.

For a large number of iPhoto fans, this is the most logical use for flags. When used in conjunction with the assessment process you'll learn about in the "Ratings" section of this chapter (page 86), flagging photos for deletion will save you *tons* of time and help keep your iPhoto library lean and mean (provided, of course, that at some point you remember to empty iPhoto's Trash!).

■ Searching for Photos by Text

Flags are a great way to *temporarily* tag photos, but there are other ways, too. For example, the name you give a picture might be significant; its original filename on the hard drive might be important; or maybe you've typed some helpful clues into its Description field or given its Event a meaningful name.

Finding that kind of information is the purpose of the search icon (⌕) at the bottom left of the iPhoto window. Start by selecting the container you want to search—the Event, album, folder, or whatever—and then proceed as shown in Figure 3-2.

TIP iPhoto can search your photos' *metadata,* too—the photographic details like camera manufacturer, f-stop, flash status, exposure settings, and so on. But you don't use the Search box for that; you have to create a smart album instead, as described on page 59.

NOTE Keep in mind that iPhoto restricts each search to the currently selected container in the Source list. For example, to search your entire photo library, be sure to select Events or Photos before you trigger the search.

THE CALENDAR

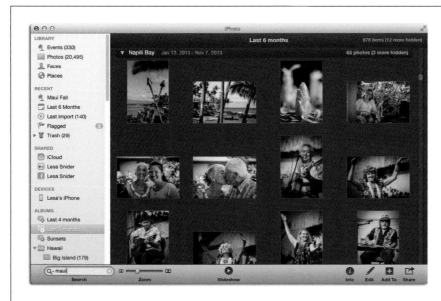

FIGURE 3-2

Click Search at the left end of iPhoto's toolbar to open the Search box. As you type, iPhoto hides all the pictures except ones that have your typed phrase somewhere in their titles, keywords, descriptions, Faces, Places, filenames, or Event names. In this case, the word "maui" appears somewhere in every photo.

To cancel your search and see all the pictures again, click the X on the right side of the Search box.

The Calendar

iPhoto offers a plethora of ways to find certain photos: visually, by Event, by album, by searching for text in their names or comments, and so on. But it also offers what seems like an obvious and very natural method of finding specific pictures: by consulting a *calendar.*

After all, you might not know the filenames of the pictures you took during your February 2013 trip to Poughkeepsie, and you might not have filed them away in an album. But one thing's for sure: You know darn well you were there in February because it was so cold! The iPhoto calendar can help you find those pictures fast.

To use the calendar, start by heading to the Source list and selecting the container you want the calendar to search: an album or a folder, for example, or one of the items under the Library or Recent headings.

Next, click Search in the iPhoto toolbar, and then make the calendar appear by clicking the tiny ⚲ at the left edge of the Search box. From the pop-up menu, choose Date (Figure 3-3).

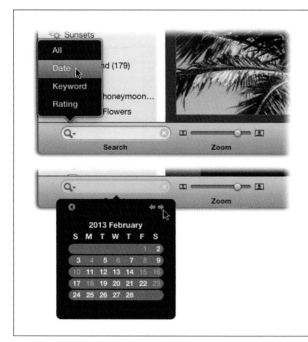

FIGURE 3-3

Top: If you click the search icon in iPhoto's toolbar, you'll see the search field shown here. To summon this pop-up menu, click the tiny magnifying glass icon; choose Date to display the calendar.

Bottom: Click a day, week, month, or year in the calendar to round up only the photos taken in those time intervals. Text or numbers shown in bold mean you took photos in that month, in that year, and on those days.

The little calendar may look small and simple, but it holds a *lot* of power—and, if you look closely, a *lot* of different places to click.

For example, the calendar offers both a Year view (showing 12 month buttons) and a Month view (showing 28 to 31 date squares). Click the tiny triangle in the calendar's top-left corner to switch between these two views. You can also use the arrows in the top-right corner to move through months or years (depending upon which view you've chosen). And you can double-click a month's name (in Year view) to open the month, or double-click the month title in Month view ("March 2013") to return to Year view.

Here's how you can use the calendar to pinpoint photos taken in a certain time period:

- **Photos in a certain month.** See the names of the months in Year view? The names in bold type are the months when you took some photos. Click a bold-faced month to see thumbnails of those photos; they appear in the main viewing area. (To scroll to a different year, click the arrows at the top right of the calendar, as shown in Figure 3-3.)

- **Photos on a certain date.** In Year view, the calendar changes to show you the individual dates within each month. As you scroll through the months, bold type lets you know that photos are waiting. Click a date to see the photos you took that day. (Here again, the arrows above the calendar let you scroll to different months.)

- **Photos in a certain week.** Once you've drilled down into Month view, as described above, you can round up the photos taken during an entire week: Just double-click anywhere within the week in question. iPhoto highlights the horizontal week bar of the calendar in light gray, and the photos taken during any of those seven days appear in the photo-viewing area.

It's possible to develop some fancy footwork when you work with this calendar since, as it turns out, you can select *more* than one week, month, or day at a time. In fact, you do that using the exact same keyboard shortcuts that you would use to select individual photo thumbnails. For example:

- You can select **multiple adjacent time units** by clicking the first and then Shift-clicking the last. For example, in Year view, you can see all the photos from June through August by first clicking June, and then Shift-clicking August. (You can use the same trick to select a series of days or weeks in Month view.)

> **TIP** Alternatively, you can just drag your cursor across the dates in Month view or the months in Year view to select consecutive time periods.

- You can select **multiple time units that *aren't* adjacent** by ⌘-clicking them. For example, in Month view, you can select November 1, 5, 12, 20, and 30 by ⌘-clicking those dates. In the photo-viewing area, you see all the photos taken on all of those days.

- Here's an offbeat shortcut that might actually be useful someday: You can round up all the photos taken during a specific month, week, or day *from every year in your collection* by holding down the Option key as you select. For example, you can round up six years' worth of Christmas shots by Option-clicking the December button in Year view. Or you can find the pictures taken every year on your birthday (from all years combined) by Option-clicking that date in Month view.

Apple *really* went the extra mile on behalf of shortcut freaks when it designed the calendar. Here are a few more techniques that you probably wouldn't stumble upon by accident:

- In Year view, select all the days in a month by double-clicking the month's name. In Month view, you can do the same by triple-clicking any date.

- Return to Year view by quadruple-clicking any date, or by clicking the month's name.

- Skip ahead to the next month or year (or the previous month or year) by turning the scroll wheel on your mouse, if it has one.

- Deselect anything that's selected in the calendar by clicking any empty spot in the calendar.

Once you've made a date selection, faint gray type in the Search box reminds you of the date range you've selected.

In any case, you can close the calendar and return to seeing *all* your pictures by clicking the X on the right side of the Search box.

Keywords

Keywords are descriptive words—like Food, Vacation, Sunsets, or Fido—that you can use to label and categorize your photos, regardless of which album or Event they're in.

The beauty of iPhoto keywords is that they're *searchable.* Want to comb through all the photos in your library to find every closeup picture of seashells you've ever taken during summer vacation? Instead of browsing through multiple photo albums, just perform a search for photos containing the keywords Closeup, Seashell, Summer, and Vacation. You'll have the results in seconds.

NOTE The next chapter explains how to tag your photos with the *names* of the people in them (Faces) or the *locations* where the photos were taken (Places). Needless to say, you can search using that info, too.

Editing Keywords

To get started with keywords, first view some photos—click Photos in your Source list or double-click an Event to see inside it. Then choose Window→Manage My Keywords or press ⌘-K. The weird and wonderful Keywords window shown in Figure 3-4 appears.

Apple offers you a few sample entries in the Keywords list to get you rolling: Birthday, Family, Favorite, Kids, and Vacation. But these are intended only as a starting point. You can add as many keywords as you want—or delete any of Apple's—to create a meaningful, customized list.

To add, delete, or rename keywords, click Edit Keywords. Then proceed as shown in Figure 3-4.

NOTE As usual in iPhoto, you can select multiple keywords for deletion by Shift-clicking or (for nonconsecutive ones) ⌘-clicking them in the list; then click the minus sign at the bottom of the dialog box to remove them. When you remove a keyword from the list, iPhoto also removes it from any *pictures* you've applied it to.

Be careful about renaming keywords after you've started using them; the results can be messy. If you've already applied the keyword *Fishing* to a batch of photos but later decide to replace it with *Romantic* in your keyword list, all the *Fishing* photos automatically inherit the keyword *Romantic.* Depending on you and your interests, this may not be what you intended.

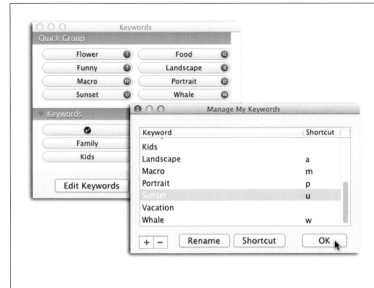

FIGURE 3-4

Left: The first time you open the Keywords window, you won't see anything in the Quick Group section at the top, but as soon as you add keywords of your own (described next), they appear there.

Right: Click Edit Keywords to summon this window, where you can add keywords of your own. Click + to create a new one, give it a name, and then press Return. iPhoto automatically chooses a one-letter keyboard shortcut for new keywords (usually the first letter of the word), allowing you to apply it to photos quickly, without fussing with this window.

You can change a keyword or its keyboard shortcut by double-clicking the entry in its respective column.

It may take some time to develop a really good master set of keywords. The idea is to assign labels that are general enough to apply across your entire photo collection but specific enough to be meaningful when you conduct searches. You might find it helpful to think of adding keywords as attaching "what" info to your photos. Of the four W's in journalism—who, what, when, and where—iPhoto knows the "when" because that info is captured by your camera and, if you're using Faces and Places tags (Chapter 4), it knows the "who" and the "where," too. That leaves the "what" up for grabs, which is a perfect use for keywords.

That said, iPhoto's facial-recognition feature doesn't work well on animals, making pet names prime keyword candidates, too.

NOTE iPhoto automatically creates the checkmark keyword. It's just a little checkmark inside a circle that, when applied to your thumbnails, can mean anything you want. In fact, it works *exactly* like the flag feature described earlier in this chapter.

The only reason the checkmark keyword still exists, in fact, is to provide compatibility with older versions of iPhoto, to accommodate people who used to use the checkmark keyword for purposes now much better served by the flag.

Here are some rules of thumb: Use *albums* to group pictures for specific projects—a calendar, a slideshow, or a book, for example. Use *Events* to group pictures by time or Event. And use *keywords* to focus on general characteristics that are likely to appear throughout your entire photo collection—words like Concert, Food, Soccer, Beach, and Sci-Fi Convention.

Suppose your photo collection includes a bunch of shots taken during a once-in-a-lifetime trip to Rome last summer. You might be tempted to assign *Rome* as a keyword—but don't. Why? Because you probably won't use it on anything other than that one set of photos. It'd be easier to pop into Places (described in the next chapter) and create a smart album called "Trip to Rome" to collect those pictures. Then use keywords to tag the same pictures with descriptors like Travel or Ancient Ruins.

It's also useful to apply keywords that describe *attributes* of the photos themselves, such as Closeup, Landscape, Portrait, Architecture, or Macro (extreme closeup).

Assigning and Unassigning Keywords

You can apply as many keywords as you like to an individual photo. So a picture of your cousin Rachel at a hot-dog-eating contest in London might bear all these keywords: Relatives, Travel, Food, Humor, and Medical Crisis. Later, you'll be able to find that photo no matter *which* of these categories you search for.

iPhoto offers three ways to apply keywords: the mouse way, the keyboard way, and the *other* keyboard way.

- **Mouse method.** Open the Keywords window by pressing ⌘-K. Select the photo(s) you want to bless with a keyword, and then click the appropriate keyword(s) in the Keywords window.

- **Keyboard method, with Keywords window.** Open the Keywords window by pressing ⌘-K. Highlight the photo(s) you want to bless with a keyword, and then press the keyboard shortcut letter for the keyword you want to apply (M for Mexico, for example).

NOTE When you use the two methods listed above, you get visual feedback that the keyword was actually applied—it appears briefly in the center of the photo-viewing area, like the informational overlays described on page 71.

- **Keyboard method, with Info panel.** Choose View→Keywords and then open the Info panel by clicking Info in iPhoto's toolbar. Then proceed as shown in Figure 3-5.

NOTE If you import photos into iPhoto from your hard drive, they may come with keywords you didn't assign. The additional blurbs came from the program you used to import them from your camera to your computer, or someone else added them (a stock photographer, say). For example, you can have Adobe Photoshop Elements automatically assign keywords (Raw, Blurry, Closeup, Longshots, and so on) when i's importing and analyzing images. Since that info is stored inside your photo as part of its metadata (see page 43), those keywords come along for the ride into iPhoto.

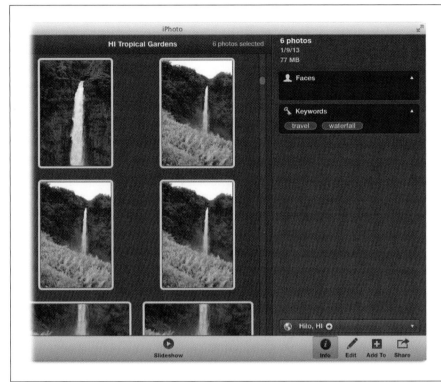

FIGURE 3-5

To add a keyword in the Info panel, first select the photo(s). Next, click the word Keywords to expand that section (if it's not already expanded), and then click inside the field beneath it that reads "Add a keyword."

Begin typing the keyword you want to assign or press its keyboard short-cut; iPhoto completes the word for you. Press Return to accept the suggestion.

To unassign a keyword you've applied, just repeat the steps you used to assign it, or open the Info panel, click the keyword, and then press the Delete key. If you've got the Keyword window open, you see the keyword appear in red in your photo-viewing area. It even "explodes" with the same animation you see when you remove an icon from your Mac's Dock.

Keyboard Shortcuts

The business of applying keywords using keyboard shortcuts makes the whole keywording business a lot easier to manage. You can let iPhoto choose one-letter keystrokes for your keywords automatically, or you can create them yourself:

- **To have iPhoto assign shortcuts.** In the Keywords window, drag your most frequently used keywords up into the Quick Group area. As you can see at left in Figure 3-4, iPhoto automatically assigns a letter to each one. (It uses the first letter of the keyword. If that's already assigned to another keyword, it uses the *second* letter. And so on.)

- **To assign shortcuts yourself.** For more control, open the Keywords window, and then click Edit Keywords. Double-click in the Shortcut column and then

press the key you want to assign. (iPhoto lets you know if you pick a key that's already in use.) When you do, the newly shortcutted keyword appears in the Quick Group area of the Keywords window.

> **WARNING** There's a keyboard shortcut for splitting Events while you're in Events view, and it's the letter S. That means if you (or iPhoto) assign S as a keyword keyboard shortcut (for the keyword Sunset, say), you need to make sure the Keywords window is *open* when you press the S key or you'll wreak Event-splitting havoc on your photo collection.

Viewing Keyword Assignments

Once you've tagged a few pictures with keywords, you can see them in either of two ways:

- **Open the Keywords window.** When you select a photo, its assigned keywords turn light blue in the Keywords list.

- **Choose View→Keywords (or press Shift-⌘-K), and then open the Info panel.** Click the little triangle to the right of the word "Keywords" to expand that section (if it isn't already expanded) and iPhoto lists the keywords you've assigned (as shown in Figure 3-5).

There's no way to view keywords below the photo thumbnails in iPhoto (imagine how chaotic the photo-viewing area would get). Happily, there's a better way of rounding up photos that don't yet have keywords: Use a smart album. This incredibly useful technique is explained in the box below.

Finding Photos That Don't Have Keywords

In older versions of iPhoto, you could choose View→Keywords to make keywords appear below their thumbnails. To the dismay of many, that feature isn't in iPhoto anymore, which makes it tough to see photos that don't yet have keywords applied.

Happily, there's a smarter way to locate them.

To find all the photos that don't have keywords, choose File→New Smart Album and name it "No keywords." Then set the pop-up menus to "Keyword," "is," and "None," and then click OK. iPhoto scours your entire library for photos that don't have any keywords applied and plops them into your new smart album. The next time you've got a hankerin' to go keywordin', those photos will be waiting for you. And as soon as you add a keyword, they'll dutifully remove themselves from the smart album. Who knew?!

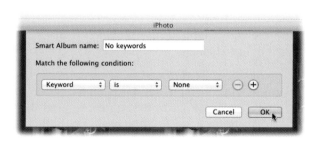

Using Keywords

If you have the diligence to tag your photos with keywords, a big payoff arrives the second you need to find a certain set of photos, because iPhoto lets you *isolate* them with one click.

Start by clicking Search in the iPhoto toolbar, and then click the tiny magnifying glass that appears at the left of the Search box. In the menu that appears, click Keyword.

A little palette of all your keywords appears (see Figure 3-6), and here's where the fun begins. When you click one of the keyword buttons, iPhoto rounds up all the photos labeled with that keyword, displays them in the photo-viewing area, and hides all your other images (remember, the results are dictated by what container you've chosen in the Source list).

Here are the important points to remember when using iPhoto's keyword searches:

- To find photos that match multiple keywords, click additional keyword buttons. For example, if you click Travel and then click Holidays, iPhoto reveals all the pictures that have *both* of those keywords. To find photos that have *either* keyword (but not necessarily both), Shift-click the keyword buttons instead.

 Every button stays "clicked" until you click it a second time; you can see two keyword buttons "clicked," and thus highlighted in gray, in Figure 3-6.

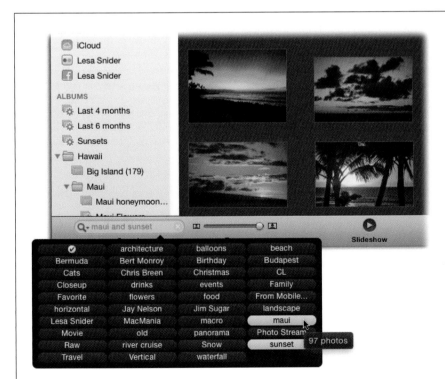

FIGURE 3-6

As you click keyword buttons, iPhoto hides photos that don't match. The gray lettering in the Search box identifies, in words, what you're seeing. In this example, the keywords "maui" and "sunset" were clicked, so the search field says "maui and sunset."

If you point to one of these buttons without clicking, a pop-up balloon tells you how many photos have been assigned that keyword. By pointing to the keyword "maui," for example, you can see that 97 photos contain that keyword.

- Suppose you've rounded up all your family pictures by clicking the Family keyword. The trouble is, your ex-spouse is in half of them, and you'd really rather keep your collection pure.

 No problem: *Option*-click the keyword button for his name (Casey, say). iPhoto obliges by removing all photos with that keyword from whatever is currently displayed. In other words, Option-clicking a keyword button means "Find photos that don't contain this keyword." (In that case, the Search box says, in faint gray lettering, "Vacation and *not* Casey," or whatever.)

- You can confine your search to a single album (or other container) by selecting it in the Source list *before* searching. Similarly, clicking Events (or even Last Import) in the Source list *before* searching means you want to search only that photo collection. You can even select multiple albums and search only in those (⌘-click each album).

- In the Search box, click the X to restore the view to whatever you had visible before you performed the search.

▓ Ratings

iPhoto offers another way to categorize your pictures: by how great they are! You can assign each picture a rating of one to five stars and then use the ratings to sort your library, or gather only the cream of the crop into a slideshow, a smart album, or a photo book.

NOTE Why, you might ask, would you bother to rate your photos if you just spent hours giving them all keywords? To give yourself another level of filtering. By using a smart album, you can filter your photos by keyword *and* rating to find the best photos of a subject even faster. You can even use ratings in conjunction with Faces or Places tags to find the best pictures of Aunt Edna or your Roman holiday!

Here's how to rate your digital masterpieces:

- Select a photo (or several) and then choose Photos→My Rating; from the submenu, choose from one through five stars. You can even do this while you're editing a single photo. (To give your photography skills room to grow, you might start by assigning a three-star rating to the best ones.)

- If you're not a mousy sort of person, you can perform the same stunt entirely from the keyboard, which is handy in iPhoto's Full Screen view (page 22). Press ⌘-1 to assign a rating of one star, ⌘-2 for two stars, and so on.

- Choose View→Ratings and then point your cursor at a photo's thumbnail; you see little hollow stars appear beneath it. Just click the star for the rating you want to apply, as Figure 3-7 (top) explains.

- Click the triangle in the lower-right corner of any photo to summon the shortcut menu shown in Figure 3-7, bottom. In the shortcut menu that appears, click the star for the rating you want to assign.

- To remove a rating, select the photo and then choose Photos→My Rating→None. You're saying, in effect, "This photo has not yet been rated." Better yet, use the keyboard shortcut: ⌘-0.

Once you've rated your photos, you can make that effort pay off in any number of ways:

- **Sort by ratings.** Select an Event and then choose View→Sort Events→By Rating, and iPhoto displays all the thumbnails in that Event in ratings order. If the View→Sort Events→Ascending option is checked, then the worst photos (no stars or one star) appear at the top, and the best ones (five stars) at the bottom. Choose View→Sort Events→Descending to put the five-star prize-winners at the top.

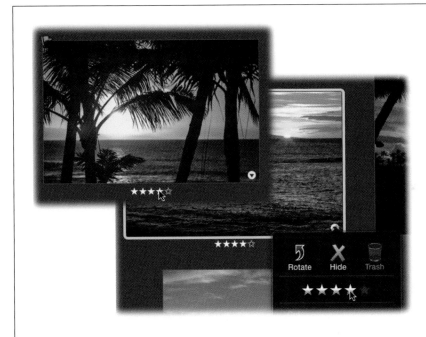

FIGURE 3-7

Top: By choosing View→Ratings, you can see the star ratings you've assigned to each photo. And, if you point to a thumbnail without clicking, iPhoto displays a row of hollow stars you can use to rate that photo. Click the star that represents the rating you'd like to bequeath. For example, to apply a three-star rating, click the third star (you don't have to click each individual star). To remove the rating, click just left of the first star.

Bottom: The stars in this shortcut menu work the same way—just click the one that represents the rating you want to apply, or click to the left of the stars to remove the rating.

- **Find by ratings.** You can round up all the five-star photos in the current container (Event, album, or whatever is selected in the Source list) by clicking Search in the toolbar, clicking the ۹ in the search field, choosing Rating from the pop-up menu, and then clicking the fifth star. iPhoto hides all your photos *except* the ones with five stars. (Of course, you can use the same technique to find the one-, two-, three-, or four-star photos.) Click the X in the search field to see all your photos again.

- **Create a smart album of the best.** You can *easily* create a self-updating smart album that contains your best work at all times. After all, you never know when the Popular Photography contest-committee judges might come knocking. Page 59 has the details.

Assessing Photos

With myriad ways to mark your images, developing an easy-to-use strategy for assessing your photos when you import them can be tough.

The star rating system works great, though problems can occur. Typically, it goes something like this: You look through your photos and find a great shot so you give it three stars. You keep perusing photos and find an even *better* shot, so you give it three stars and then you backtrack to find the previous 3-starred shot and give it a 2-star rating instead. This time-consuming process can repeat itself for hours until you vow never to use star ratings again.

Consider this as one possible solution: Give all the keepers a 1-star rating, filter the photos so you see only those with a 1-star rating and reassess from there, adding a 2-star rating to the best ones, and then *delete* all the photos with no stars or a 1-star rating. Here's how that might go:

1. As soon as you import photos, click Last Import in the Source list.
2. Press Shift-⌘-R or choose View→Ratings to display ratings.
3. Click the double-arrow icon at the top right of the iPhoto window to enter Full Screen view.
4. Adjust the Zoom slider in the iPhoto toolbar so you can see at least five thumbnails to a row. This is big enough to determine whether each photo is a keeper, but not so big that you get distracted and enter *Edit* mode, where you'll spend 30 minutes messing with a shot that isn't even the best of the bunch.
5. Make a *first* pass through the photos, ⌘-clicking the thumbnails of keepers and then pressing ⌘-1 to give them a 1-star rating.
6. Use the search field in the iPhoto toolbar to search by

Rating and then click one star. Now you're seeing only the photos from the last import with a 1-star rating or higher.

7. Make a *second* pass through the photos and assign a 2-star rating to those deserving. As you go, click the flag icons—or press ⌘-period (.)—to flag the 2-star photos that you want to do something special with (say, add to your blog, make a print, email, turn into a black-and-white, or whatever).
8. Use the search field to see photos with a rating of two stars or higher.
9. Press ⌘-A to select all and then press ⌘-N to plop the 2-star shots into a new album (you can always continue your assessment within the album).
10. In your Source list, click Last Import again, and then choose View→Sort Photos→By Rating. Pick Ascending so the *unrated* thumbnails appear at the top and the highest-rated photos appear at the bottom.
11. Click to select the first thumbnail at the top of the photo-viewing area, and then scroll down until you see the last 1-star photo. With informational overlays turned on (see page 71), you'll know the second you scroll into multi-starred photo territory. Shift-click to select the last 1-star photo, as well as all thumbnails in between.
12. At this point, only photos with no stars or a 1-star rating should be selected. Press the Delete key on your keyboard. The rejected photos are now in iPhoto's Trash, awaiting deletion.

Having a strategy such as this goes a long way toward keeping your iPhoto library manageable. And if nothing else, it's a great starting point for creating an assessment strategy of your own. After all, the more you use it, the more you'll be able to tweak it to your liking.

Faces and Places

iPhoto gives you plenty of ways to organize pictures into neat little collections, but so far most of the methods you've learned involve doing it *manually.* Manually apply keywords. Manually drag things into albums. Drag, drag, drag.

Happily, iPhoto comes with two features that organize your photos *automatically.* You'd call it artificial intelligence if it didn't seem so much like *real* intelligence.

One feature uses facial recognition to group your photos based on who's in them. It can be extremely handy when, say, you need to quickly round up a bunch of pictures of Tyler for that last-minute, surprise birthday party slideshow or your parents' 50th wedding anniversary. This isn't the crude sort of facial recognition that you find in lesser programs or even in digital cameras, which can really only tell you *if* there's a face in the picture. iPhoto goes a step further and tells you *whose* face it is.

If your camera captures location info (and your iPhone does), you can also round up photos based on *where* they were taken. Imagine the joy of instantly locating pictures from a recent vacation—*without* keywording them—in order to show them off during a dinner party. And how easy would it be to create a calendar or book from your family's Yellowstone vacation if those pictures just naturally migrated together?

Meet Faces and Places, two iPhoto superpowers that have become favorites of people who *really* want to get to the who and the where of their photos as painlessly as possible.

▨ Faces

Here's the Faces feature in a nutshell: By analyzing the unique properties of each face in a photo—nose, mouth, hair color (or lack of hair), distance between the eyes, and so on—iPhoto attempts to distinguish among the people in your pictures and group them together into tidy stacks. Once the setup process is complete, you'll see these stacks when you click the Faces icon in your Source list.

iPhoto makes a *first* pass at this automatically, which is downright amazing. It's not a perfect process, however; after its initial try, iPhoto prompts you to review each photo and confirm its subject's identity. (It sounds boring, but it's actually quite fun and the payoff is huge.) After that initial coaching, iPhoto groups your photos by *the people in them,* automatically and forever, plus it'll add to the groupings each time you import pictures. Hallelujah!

Step 1: Analysis

When you open iPhoto for the first time, even if you're upgrading from an earlier version (see page 5), the program doesn't waste any time: it immediately gets to work searching your images for the telltale signs of human faces.

> **NOTE** Depending on the number of photos you're importing, iPhoto takes a few moments to perform its initial face hunt. You'll spot a tiny twirling icon to the right of Faces in your Source list (it looks like two curved arrows). To pause the analysis, click this icon so that it turns into a tiny Pause button; to start it back up again, click the Pause button.

This part of the Faces setup doesn't require any effort from you, and it happens each time you import photos.

After completing its scan, iPhoto has a good idea of what your social circle looks like. But it still has no idea what those people's *names* are, as you can see in Figure 4-1.

> **NOTE** If iPhoto doesn't detect any faces in your photos, you see an empty corkboard with a giant yellow sticky note about getting started. If you've used Faces in previous versions of iPhoto, you see a corkboard with a slew of Polaroid-style headshots with names underneath (shown in Figure 4-3).

Tagging Faces Automatically

After iPhoto does its face-detection dance, you can introduce it to your friends and family. Once you label a face, the program looks around and tries to match it up with other *similar* faces in the library. The whole face-tagging process is incredibly easy:

1. **Click Faces in your Source list.**

 iPhoto displays thumbnails of a few faces it found in your library.

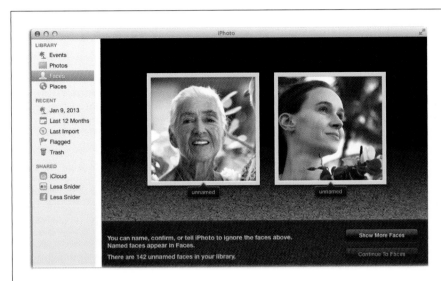

FIGURE 4-1

If you've never used Faces before, this is the first view you see when you click Faces in the Source list. Now that iPhoto has plowed through your photo library detecting faces, you can start telling it who those faces belong to...all 142 of 'em.

2. **Click the "unnamed" label below a thumbnail, type the person's name, and then press Return.**

 While you can type any name you want—like *Dad* or *Uncle Robin*—it's a good idea to stick with the person's real name, as iPhoto automatically tries to match it with the contents of your Contacts app (your address book, so to speak) and, if you've added your Facebook account to iPhoto (page 208), it searches those names, too (see Figure 4-2). This is especially handy because it makes emailing from *within* iPhoto fast and easy, because your acquaintances' contact info is always at the ready (see Chapter 8 for details).

TIP To enter names faster, skip the mouse and just use your keyboard. Name one thumbnail and then press the Tab key to move to the next one; iPhoto highlights the name field automatically. (To go backward—say, if you accidentally skipped a thumbnail or you named it incorrectly—press Shift-Tab instead.) Enter another name and then press Tab to highlight the Show More Faces button, and then press Return to move on to the next set of thumbnails.

You can also use the keyboard to *confirm* names: Press Tab to highlight the name field and then press Return to confirm the name (the ✔ has a blue circle around it and is shown at the bottom of Figure 4-2). To tell iPhoto it made a mistake, press Tab again, and when you see a blue circle around the ✘, press Return.

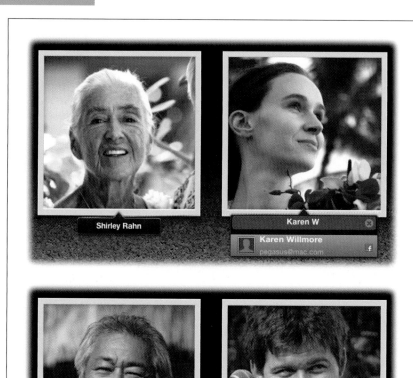

FIGURE 4-2

Top: The second you start typing a name, iPhoto tries to match it with one in your Contacts or Facebook Friends list (if you've added your Facebook account to iPhoto). If the person isn't in one of those lists, you can type anything you want.

Bottom: After you've tagged some faces, iPhoto begins making suggestions. If it guesses correctly, click the ◉ *; if not, click the* ⊗ *and enter a new name. Tap the Tab key to highlight each icon with a blue circle, as shown here; just press Return when the correct one lights up.*

The more faces you confirm, the better iPhoto gets at tagging them in other pictures.

Here are a few things to remember as you're naming faces:

- **Focus on tagging photos that have a clear, frontal view of the person.** iPhoto will try to match other pictures in the library with this initial one, and it works best when there's plenty of face to recognize.

- **Tag faces shown in profile, too.** While it's important to name full-face photos, naming profile shots helps iPhoto recognize those, too.

- **Tag faces of different ages.** If you've got several years' worth of photos in your library, chances are that you'll have photos of the same person at a variety of ages.

- **Don't waste time tagging blurry or poorly lit photos, or those with microscopic faces.** Each time you tag a photo with a name, iPhoto broadens its range of suggested photos for that person. Naming bad shots can make it harder for iPhoto to recognize people.

Alas, iPhoto can get a little overzealous. It may tag faces in paintings, framed photos, statues, *Star Trek* action figures, or shadows on drapery. In these cases, you can help train its facial-recognition powers by pointing the cursor at the top-left corner of the thumbnail and clicking the X to delete the tag, and then move on to tagging the actual humans in the shot. The thumbnail doesn't disappear; it just dims slightly. Theoretically, it won't show up as a face next time you go tagging.

When you've had your fill of tagging faces, click Continue To Faces at the bottom right of the iPhoto window. As shown in Figure 4-3, iPhoto displays a corkboard with Polaroid-style shots of each person you've tagged so far, labeled with the names you just assigned. It's like being the casting director in the movie of your life.

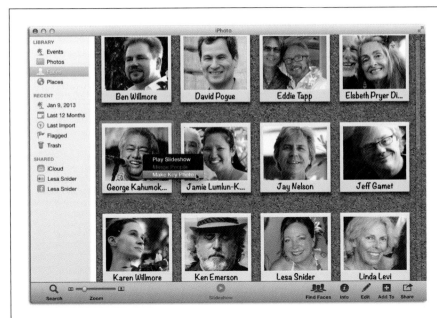

FIGURE 4-3

As you tag more pictures, more headshots appear on your Faces corkboard. You can click the ◱ at the top right of your iPhoto window to make the corkboard take over your monitor, too.

Point your mouse at a face and you see glimpses of the individual photos of that person. To change the key photo (the representative photo of that person's stack), Control-click it and choose Make Key Photo, as shown here. Want an instant slideshow of that person? Choose Play Slideshow from the menu.

Use the Zoom slider in the iPhoto toolbar to increase or decrease thumbnail size and thus the number of headshots in a row. To see the individual pictures of each person, double-click a face. To go back to the Faces corkboard, press ⌘-left arrow or click All Faces at the top left of the photo-viewing area.

Tagging Faces Manually

If iPhoto fails to detect a face during import or a rescan (see the box below)—a fairly rare occurrence—you can always tag it yourself manually (though doing so doesn't improve iPhoto's ability to detect faces). Start by selecting the photo and then opening the Info panel. In the panel, click Faces to expand that section, and then click "Add a face," as shown in Figure 4-4.

TIP iPhoto won't let you manually tag faces when you're zoomed in on a photo (weird but true). So if you click "Add a face" and nothing happens, drag the Zoom slider in iPhoto's toolbar all the way left, and then have another go at it.

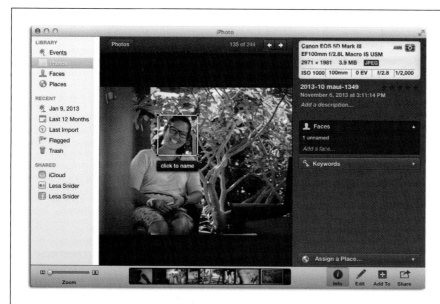

FIGURE 4-4

If iPhoto can't find a face for whatever reason, click "Add a face" in the Info panel's Faces section. When you do that, a little white square appears that you can resize and position around your subject's face. When you get it just right, click the text field below the square and enter the person's name.

If there's more than one face in the photo, keep clicking "Add a face" to add more white squares.

Rescanning Photos for Missing Faces

If you fear iPhoto may have missed a few faces during the import process, you can always ask it to *rescan* your photos. Just select the offending photo(s) using one of the techniques described on page 46, and then choose Photos→Detect Missing Faces. Over in your Source list, you see a tiny spinning icon appear to the right of the word "Faces" to let you know that iPhoto is taking another look at your photos. To find more faces, iPhoto uses looser facial-recognition criteria, so it may tag more *objects* than people.

Once iPhoto is finished scanning, you can see if it found anything by selecting one photo at a time, and then clicking Info in the toolbar. (If you only had one photo selected, the Info panel opens automatically.) If the scan was successful, you see the additional names listed in the Faces portion of the Info panel, along with other detected-but-unknown faces labeled "unnamed"—just click to add a name.

If iPhoto *still* didn't find a face, you can point it out manually, as shown in Figure 4-4.

A fresh white square appears, which you can drag over that poor, undetected face. Drag the corners of the box to resize it. (Dragging a corner causes both sides of the square to change size, making it a little awkward to get perfectly centered over the face. To better control your box resizing, hold down the Option key as you drag a corner. This stops both sides of the box from moving around and lets you manipulate the size from just the corner you're dragging.)

When you've got the white square right where you want it, click the "click to name" balloon and enter the person's name. Repeat as necessary with any other people you know in the picture.

NOTE While it's not quite as sophisticated as the software the FBI and Interpol are using these days, iPhoto's face-detection feature generally gets better the more you work with it. But there are some cases when you'll have to plod through manually.

For example, the program may not recognize shaggy dogs as actually having faces, but you can sail through those pictures of Skipper and use the Info panel's "Add a face" link to add your pet to the Faces corkboard. Babies, identical twins, and people wearing sunglasses (or posing at odd angles) may also require manual intervention.

Adding More Pictures to a Name

Once you've put at least one name to a face, iPhoto's powers of recognition really kick in. Here's how to help it match up the rest of your collection's faces with their names:

1. **Double-click a person on the Faces corkboard.**

 iPhoto displays all the photos you've already tagged with that person's name. At the bottom of the window, a note tells you how many *other* pictures iPhoto thinks contain this same person.

2. **In iPhoto's toolbar, click Confirm Additional Faces.**

 A screen full of thumbnails appears, each containing a closeup of that person's face culled from a different photo. The caption "click to confirm" appears beneath each one (see Figure 4-5). This is your chance to tell iPhoto's face-detection software how it did.

TIP To see the whole photo instead of a closeup of the face in question, click the little slider in the upper-right corner of the iPhoto window to set it to Photos; to switch back to viewing closeups, set the slider to Faces.

3. **Click a photo once to confirm that iPhoto has correctly matched this face with the name.**

 When you click a face, the "click to confirm" bar turns green and displays the *name* of the person—for example, Chris. Behind the scenes, iPhoto learns from your selection. "Ah, OK—that's Chris," it says to itself. You've just helped it refine its recognition smarts for next time.

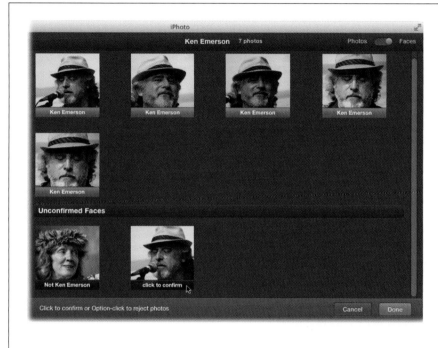

FIGURE 4-5

You can give iPhoto a hand by confirming its correct guesses and rejecting its incorrect ones. Photos above the horizontal bar are confirmed pictures of this face; photos below it are ones that iPhoto wants you to confirm (they're listed in order of certainty). Click a picture to confirm it, or Option-click to reject it.

The more you work with iPhoto here, the better it gets at identifying people. If you come to a point where you're seeing more misses than hits, click Done and move on to confirming someone else's face.

> **TIP** If most of the thumbnails contain the correct person, you can accept them all at once: Just drag the mouse over a whole batch of photos to select them, and their captions will turn green.

4. **When you encounter a thumbnail of somebody else—iPhoto has picked the wrong person—either Option-click it or double-click it.**

 The "click to confirm" caption turns red, and the text says, "Not Chris" (or whomever).

> **TIP** Here again, you can reject a whole bunch of thumbnails at once. This time, hold down the Option key as you drag your cursor over the erroneous faces. You can then Control-click one of the selected thumbnails and choose Name from the shortcut menu in order to tag it correctly.

5. **When you're finished accepting or rejecting thumbnails, click Done.**

 The more guidance you give iPhoto in identifying people in your photos, the more accurate it gets at recognizing them in *new* images that you import. With enough input, the program has a better chance of telling babies from bald men, and even differentiating among your various bald friends.

▩ NAMING FACES ANYTIME

Any time you select Faces in your Source list, the Find Faces button appears on the iPhoto toolbar, even after your initial burst of face tagging. Click it to return to the original Faces window, where you can tag two photos at a time (see in Figure 4-1).

As you stroll around your photo library in All Events or Photos view and come upon photos of people you want to tag, the "Add a face" link awaits you in the Info panel, as shown on page 94. In fact, iPhoto is *always* trying to guess who the people in your pictures are.

For example, if you open a shot from a family reunion, click the Info button, and then take a peek at the Faces section, iPhoto offers a guess if the face looks familiar. You see the customary white square around the face, but instead of "unnamed" appearing beneath it, you get a polite question like, "Is this Leroy?" (see Figure 4-6).

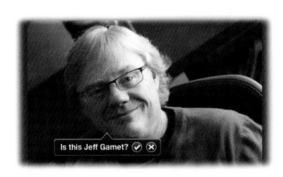

FIGURE 4-6

If you open the Info panel and iPhoto recognizes someone it's seen before, it asks you to verify the person's identity. Click ✔ if iPhoto guessed the right name. Click the ✘ if iPhoto missed, and then enter the correct name for that person.

If you're zoomed in on a photo, you won't see any of iPhoto's guesses; just drag the Zoom slider in iPhoto's toolbar all the way left to get it back in the guessing game.

If it is indeed Cousin Leroy, then click ✔ to confirm and add the picture to Leroy's Faces album. If iPhoto has guessed wrong, then click the ✘ and type in the correct name.

As you add more names to your Faces library, iPhoto tracks your typing and cheerfully offers a drop-down list of potential, previously typed names (as well as names that are in your Contacts) that you can select from to save keystrokes. Either click the correct name or use the arrow keys on your keyboard to select it, and then press Return.

When naming or confirming names using the Info panel in All Events or Photos view, you can click the ❯ next to the name to leap into that person's Faces album (see Figure 4-7).

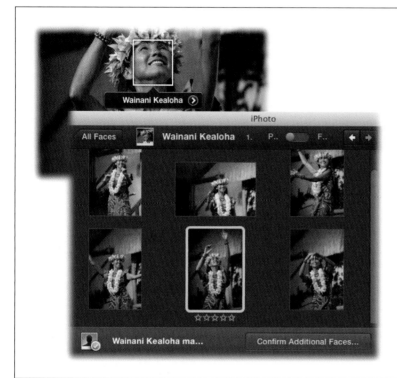

FIGURE 4-7

The ❱ after the name is your shortcut to this person's Faces album. Click it to jump there.

Once you land, you can always confirm the name on a few more photos iPhoto thinks this person might be in (page 95).

The Payoff

Between iPhoto's own analysis and your patient confirmation of faces, you gradually refine iPhoto's facial recognition.

Eventually, you wind up with a whole array of mugshots on the Faces corkboard, as shown back in Figure 4-3 (page 93). The next time you need to gather pictures of Suzy, just click Faces in your Source list and then double-click her Polaroid on the corkboard; iPhoto displays closeups of all the photos she's in. (To see the whole photo instead of her face, click the little slider at the top right of the iPhoto window to set it to Photos rather than Faces.) This kind of thing is a real time-saver when you need to, say, make that monthly book of grandkid pictures for your parents or a slideshow of your hubby's ever-evolving facial hair for his 50th birthday blowout.

> **TIP** You can also create an instant slideshow from the Faces corkboard. It's crazy simple: Control-click a Polaroid and then pick Play Slideshow from the resulting menu. Who knew?!

To return to the corkboard array of faces, click All Faces at the top left of the iPhoto window.

You can also drag a corkboard snapshot directly into your Source list to create a smart album for that person (see Figure 4-8). iPhoto continually updates this album, adding any confirmed photos of the person that enter your library in the future. You can also drag a snapshot onto an *existing* Face-based smart album to make one that updates with *both* people—convenient for corralling all those pics of the kids or the bowling team into one place.

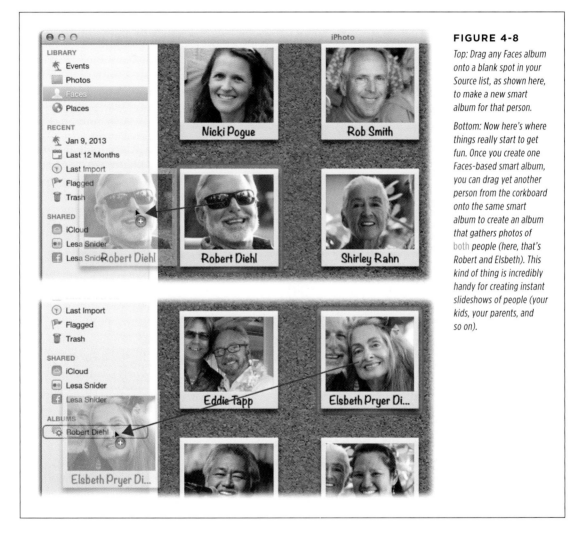

FIGURE 4-8

Top: Drag any Faces album onto a blank spot in your Source list, as shown here, to make a new smart album for that person.

Bottom: Now here's where things really start to get fun. Once you create one Faces-based smart album, you can drag yet another person from the corkboard onto the same smart album to create an album that gathers photos of both *people (here, that's Robert and Elsbeth). This kind of thing is incredibly handy for creating instant slideshows of people (your kids, your parents, and so on).*

Deleting Faces

OK, so you got a little excited by iPhoto's face-detection technology and tagged your annoying coworker Madge. Look, there she is on the Faces corkboard next to pictures of people you actually *like.* Yikes!

Don't panic. If you want to remove a face from the corkboard, select it and press ⌘-Delete (just as if you were deleting an Event). iPhoto asks if you're sure you want to remove this person from Faces. If you are, then click Delete Face and wave goodbye.

If you want to zap *multiple* people from the Faces corkboard, ⌘-click each undesired person, and then press ⌘-Delete. Again, iPhoto asks you to confirm your action. (If you want to delete a whole row of people, Shift-click the first and last faces in the row to select them *and* everyone in between.)

NOTE Deleting a face from the Faces corkboard doesn't delete any pictures from your iPhoto library.

Adding More Details to a Face

In addition to neatly lining up mugshots of all your family and friends, Faces helps you keep track of your pictures (and the people in them) in several other ways.

Click any face on the corkboard, and then click Info in the iPhoto toolbar to open the Info panel. As Figure 4-9 shows, you see the number of photos you have of this person (and the date range when they were taken), a spot to type the person's full name and email address, a map of where those photos were taken (if you've added that info), and iPhoto's guess of how many more photos *might* contain this person.

Why would you want to add the person's email address here, you ask? No, it doesn't automatically add the photo to that person's entry in your Mac's Contacts app (although it'd be very nice if Apple made that happen...*hint, hint*).

No, by giving you a place to add your friend's email address, you get to use iPhoto's gorgeous, graphic email option that lets you send emails from *inside* iPhoto. The program is also betting that this same name and address are used for your *friend's* account on Facebook, the social-networking site (rather, gigantic time vacuum) used by over 1 billion people. When you use iPhoto to post pictures on Facebook, the names you've so carefully assigned go along for the ride, saving you the trouble of tagging them all over again in Facebook.

For more on merging your iPhoto and Facebook lives, skip ahead to Chapter 8.

Organizing the Faces Album

Seeing your friends and family lined up all neat and tidy in Faces view gives you a wonderful sense of organization. (A few years ago, those pictures would have been falling out of physical photo albums—or still in their envelopes from the drugstore and shoved into the back of a closet!) But even on the corkboard, you can organize the faces still further.

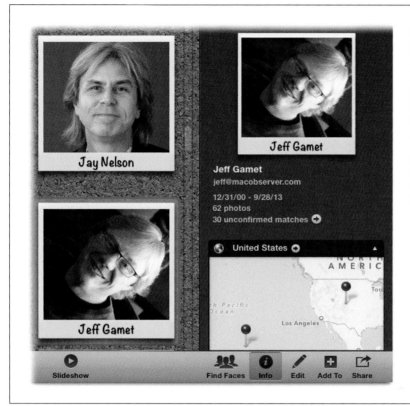

FIGURE 4-9

By selecting a face and then opening the Info panel, you can edit your buddy's name and email address.

If you take the time to enter that info here, any future photos you confirm in iPhoto and upload to Facebook will be tagged automatically tagged if that person uses the same email address for his Facebook account. This gives you more time to do other stuff on Facebook, like SuperPoking your buddies.

■ CHANGING THE KEY PHOTO

The key photo is the one that represents a person on your Faces corkboard; it's typically the first one you tagged (see Figure 4-10). If that photo doesn't do your friend justice, there are at *least* three easy ways to change it:

- **Click Faces in your Source list.** As you slowly move your cursor (don't click) over a face on the corkboard, all the tagged pictures of that person flit by in the frame. When you see the one you want to use, tap the space bar to make it the key photo.

- **Double-click a face in the Faces corkboard.** Scroll through and select a photo you like better, and then choose Events→Make Key Photo. Even if it's a group shot from a distance, iPhoto is savvy enough to zoom in on the person's face. Alternatively, point your cursor at the photo and click the tiny triangle that appears at its bottom right, and then choose Make Key Photo from the shortcut menu.

- **If you have a face-tagged photo selected, Control-click it,** and then choose Make Key Photo from the shortcut menu shown in Figure 4-10.

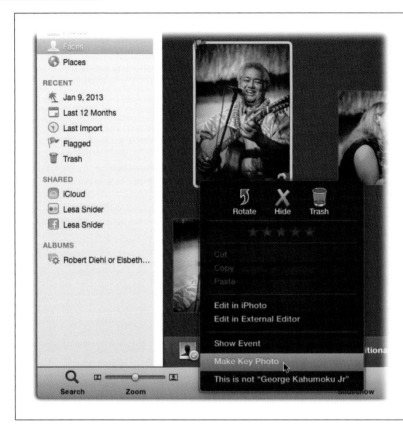

FIGURE 4-10

The key photo is the one you see on your Faces corkboard; it's the picture on the top of that person's stack of pictures. One easy way to change it is to open the person's stack and then Control-click the photo you want to use and choose Make Key Photo from the shortcut menu, as shown here.

An even faster way is to wave your mouse over the person's stack, and then tap the space bar when you see the one you want to use instead. You can do this in the Info panel, too; just click when you see the photo you want to use.

▉ REARRANGING THE ORDER

Would you like to put Mom and Dad together on the Faces corkboard, or arrange your kickboxing pals in a row? No problem; you can drag the Faces snapshots around on the corkboard. To move someone, drag her album to a new place on your corkboard; the other faces politely slide over to make room.

Be careful where you drop that face, though. If you accidentally drop the person on somebody *else's* snapshot, you *merge* their two sets of photos, and iPhoto applies the wrong name to all the faces in the stack you dropped. (If that happens, press ⌘-Z immediately to undo your last move.)

> **TIP** iPhoto also lets you merge Faces albums. Why would you want to? Well, say you make a typo in someone's name when tagging photos and inadvertently create *two* Faces albums for the same person. You can merge the two by dragging the snapshot of the typo-filled name onto the snapshot of the correct name and not have to rename a thing. You can also select two Faces albums and then Control-click one of them to reveal a shortcut menu; choose Merge People and call it a day.

If it's too late for ⌘-Z, double-click the merged stack. Then click the Confirm Name button and reject (and eject) the wrong face out of the photo collection, as described on page 96. (Or Control-click each unwanted photo and choose "This is not [name]" from the shortcut menu.)

<hr>

TIP You can also organize faces alphabetically, though by first name only; just choose View→Sort Photos→By Name. (That applies A to Z order; you can be ornery and go from Z to A by choosing Descending from the same menu.) Switching to name sorting, however, means you can't drag your pals around manually—at least, not until you choose View→Sort Photos→Manually.

<hr>

■ EDITING NAMES

Want to change the spelling or fix a typo in a name displayed on your Faces cork-board? Just click the name to highlight it and then type whatever you want. Clicking the ⊗ at the right of the text box clears the existing name, but since clicking the name highlights it anyway, you can just start typing right over the old one.

■ Places

Geotagging has been a hot feature of digital photography for several years. That's when your camera buries latitude and longitude coordinates into each picture it takes (invisibly, the same way it records the time and date) so you'll always be able to pinpoint where a picture was taken.

There are only two problems with this scenario.

First, not all cameras contain the necessary GPS circuitry to geotag photos. Second, what happens after you geotag them? What are you going to do, say, "Oh, yes, I remember that romantic evening at 41° 30′ 18.48″ N, 81° 41′ 55.08″ W"?

iPhoto solves the second problem, at least. When you import pictures, it scours them for location info and translates those coordinates to the much more recognizable "Cleveland," or even more precisely, a street address, like "100 Alfred Lerner Way, Cleveland, Ohio" (which happens to be the address of Cleveland Browns Stadium)—and shows that spot with a red pin on a map right in iPhoto.

This can be really convenient if you've made several trips to London and want to see *all* the pictures taken there over the years, not just ones from a particular album or Event. It's also a great way to learn geography—slideshows, books, and calendars take advantage of this info, and include themes that make a quick map of your trip.

Automatically Geotagging Photos

Your photos are probably geotagged when you shoot them if you're using one of the following gadgets:

- A digital camera with a built-in GPS chip, like the Canon PowerShot S120.

- A GPS-enabled cellphone, like an iPhone.

- The Eye-Fi Mobi card. This is a remarkable SD memory card, the kind you put into most camera models, with built-in wireless networking and a pseudo-GPS feature (as of this writing, it costs $50 for an 8 GB card). See *www.eye.fi* for details.

- A small GPS-enabled box like the $115 ATP GPS PhotoFinder Mini that tracks the time and your coordinates as you snap photos—and marries them up with the time stamps on your pictures when you insert the camera's memory card. See *http://photofinder.atpinc.com* for more information.

If that's your situation, then all you have to do is import the pictures into iPhoto (page 7) and smile smugly. When the images appear in the photo-viewing area, you can check the location by opening the Info panel (click Info in the iPhoto toolbar) shown in Figure 4-11.

In the Places section of the Info panel, you can see the location's name and a pin on a miniature map; if the map is generally correct, then iPhoto has done its job.

However, GPS coordinates can sometimes be off by yards. Or, if the place is wrong and you know it (because you forgot to turn on the Location Services function of your iPhone, for example), don't worry; you can *manually* assign the photo to a place, as described in the next section.

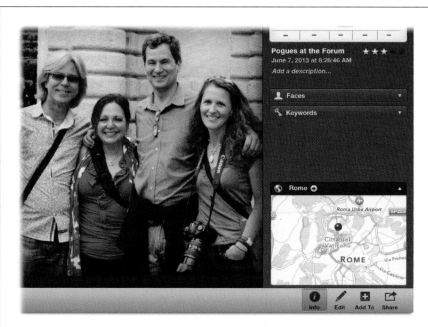

FIGURE 4-11

If your photos are geo-tagged, the Info panel's Places section displays a map of where they were taken. A red pin marks the spot where you took the photo.

If all the photos in an Event have been geo-tagged and no photos are selected, you get a map with multiple pins show-ing the various locations you photographed.

Manually Geotagging Photos

But what about photos that don't have geographical information embedded—like the 300 billion photos that have been taken with non-GPS cameras? In that case, you can geotag them manually.

1. **Select a photo (or an Event) and then click the Info button in iPhoto's toolbar.**

 The Info panel opens to reveal several juicy tidbits of info.

2. **Click "Assign a Place" and start typing the name of the town, city, or land-mark where the picture was taken (such as *Washington Monument*).**

 As shown in Figure 4-12, iPhoto tries to guess what you're typing, to save you some effort (and spelling). If you see the correct location in the list, use the arrow keys on your keyboard to select it and then press Return to confirm your choice, or just click the correct name.

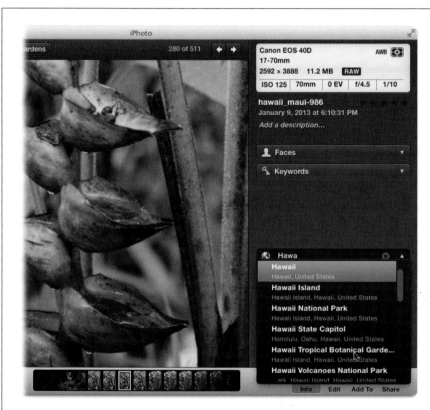

FIGURE 4-12

As you type, iPhoto tries to guess where you're going. If the program can't find the location on its own maps, it tries to find the location using Apple Maps (Google Maps was used in previous versions of the program).

If, for some bizarre reason, you have the latitude and longitude of your location, you can enter those numbers instead of a name. Just type the coordinates separated by a comma, such as 38, –9 (the latitude always goes first). Here again, a menu appears with iPhoto's best guess as to where on the map those coordinates actually are.

3. **If the place you're typing doesn't appear on the list, pick one that's close and then move the red marker pin.**

In the off chance that iPhoto *and* Apple Maps can't find your location, just pick a location that's close. Then click the red pin on the map and drag it to the right spot, as shown in Figure 4-13.

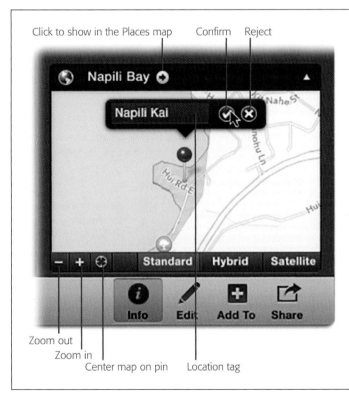

Click to show in the Places map Confirm Reject

Zoom out
Zoom in
Center map on pin Location tag

FIGURE 4-13

If you don't see your locale on the list, pick a place that's close and then fine-tune it by moving the pin on the map. Drag the pin to the correct spot and then click to rename it. If you're lucky, iPhoto updates the location tag itself, though in most cases you have to enter the info manually.

You can zoom in and out of the map as needed with the buttons labeled here. You can also drag the map itself to see another area.

You can only move marker pins using the tiny map in the Info panel; you can't move them when you're looking at the big map in Places view (described on page 103).

If you've accidentally relocated a photo that was taken in Paris, France, to Paris, Texas, you can revert to the photo's original *location by choosing Photos→"Rescan for Location."*

4. **When the pin is in the right spot, click the ⊘ next to the location tag to confirm it.**

You can also refine and/or delete locations by choosing Window→Manage My Places. This command summons a list of *all* the places you've tagged in iPhoto—or captured with your GPS-enabled phone or camera—with a handy map that lets you move location pins to and fro, as well as reduce or widen the region of a particular pin (represented by a circle) by dragging the triangles that automatically appear to the pin's right on the edge of the region circle.

■ **RENAMING PLACES**

Geotagging photos is usually enough for most people. However, if you want to add a *personal* touch to the names of your places tags, you can rename them in the Info panel.

Once iPhoto finds your location (or you find it yourself), click the red pin to summon the location tag. Once the tag appears, highlight its text and then enter a new name, such as *Uncle George's House.* Click the ✔ to confirm the new name (or just press Return). Later, you'll be able to use iPhoto's Search box to round up all the pictures that were taken at Uncle George's place just by typing *uncl.*

TIP Once you've pinpointed the right location for a photo, you can copy that info to *other* photos. Just select the photo with the correct locale and choose Edit→Copy. Next, select the photo(s) you want to copy the location *to,* and then choose Edit→Paste Location.

FREQUENTLY ASKED QUESTION

When You Don't Feel Like Sharing

I'm all for having machines do things for me automatically, but what if I don't want iPhoto revealing where my iPhone pictures were snapped?

These days, privacy concerns run deep; sometimes, you may not want iPhoto blabbing about where you've been.

In such cases, you have a couple of options. The first—if you remember to do it in time—is to turn off the GPS feature on your camera or smartphone. On the iPhone, for example, go to the Home screen and tap your way through Settings→General→Location Services→Off. (Just remember to turn Location Services back *on* the next time you want to use Maps or another location-aware app.)

Second, you can tell iPhoto not to look up the GPS coordinates embedded in the file. Choose iPhoto→Preferences→ Advanced, set the "Look up Places" menu to Never, and then click OK.

You also have the option of keeping locations secret for *published* photos only (those you send off to photo-sharing sites like Facebook, Flickr, and so on). If that sounds more agreeable, you can leave the "Look up Places" menu set to Automatically but leave "Include location information for published photos" turned off.

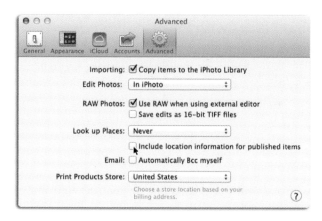

However, if you're part of the Witness Protection Program, you might want to *delete* location information that's already been added to a photo or an Event. Just click Info in iPhoto's toolbar and in the Places section of the resulting panel, click the location tag and then click the X to its right to remove it (it's labeled in Figure 4-13). To delete location info for *multiple* photos or Events, select them using the techniques described on page 46 before using this technique.

Adding Additional Info to a Photo or Event

As you may have noticed, the Info panel's Places section is littered with controls. Here's a quick roundup of what the other goodies labeled in Figure 4-13 let you do:

- **Zoom the map.** Just below the map, click the + and – buttons to zoom in and out of the map, to get anything from a closeup street view to a world map. (These controls appear only when you point your cursor to the map.)

- **View on the Places map.** At the top of the Info panel's Places section is a tiny ➜ that you can click to see the location on iPhoto's large and incredibly gratifying Places map.

- **Change the look of the map.** When you point to the map, three buttons appear near the bottom. They let you see the map in three different ways: a Standard view that shows street names and tiny lines for roads, a Hybrid view that combines Satellite view and Standard view, and a Satellite view that's an overhead photo of the area.

> **TIP** Once you've geotagged your photos, you can use iPhoto's Search box to find them. First, click Events or a particular album in the Source list. Then, in iPhoto's toolbar, click Search and type what you're looking for, such as *San Francisco* or *Napili Kai.* Press Return to see your results.

Going Places with Places

Now that your photos are properly geotagged, you can see how they look in iPhoto's *Places view*: a wonderfully large world map. To display it, click Places in the Source list or, if the Info panel is open, click the ➜ above the map.

iPhoto treats you to a map of the entire globe (see Figure 4-14), festooned with little red pins representing all the pictures you've geotagged. (If you click the ⬲ at the top right of the iPhoto window, the map takes over your whole monitor!) To see the photos attached to a pin, click the pin itself and then click the ❷ next to the place's name.

As with any map, you need a way to navigate. Here are your controls:

- **Zoom in** by double-clicking a spot until you get as close as you want.

- **Zoom out** of the map by Option-clicking twice.

- **Zoom in or out** by dragging the Zoom slider in the iPhoto toolbar.

> **TIP** If you own a Magic Trackpad or a Magic Mouse, you can use the two-finger pinch and spread gestures to zoom into and out of the map, respectively.

- **If you want to travel more incrementally,** drag the map itself to get to the part you want to see.

- **See all your pins on the map at once** by clicking the Home button at the top left of the iPhoto window (it looks like a little house). Oddly, this seems to work only with photos that are automatically geotagged; pins that you've added manually seem to appear offscreen.

- **See all the countries, states, cities, and places you've visited** by clicking the lists at the top of the map. These let you view photos by region, as discussed in the next section.

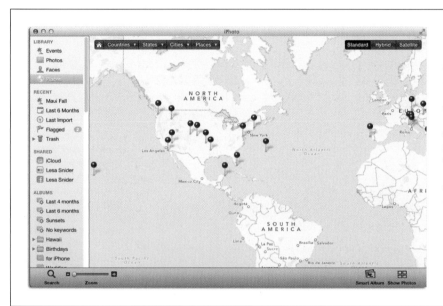

FIGURE 4-14

Click the Home icon (the little house) to see all your tagged locations in Places view. Red pins mark each spot on the map where you (or your camera) have added Places tags to your pictures. To see the name of any location, click a pin. You can then click the ❯ next to the name to see the photos taken there.

Along the top-right edge of the iPhoto window are buttons for the same three map types you can see in the Info panel: Standard, Hybrid, and Satellite.

To see all the photos you've lovingly tagged in the *region* of the map that's currently visible, click Show Photos in iPhoto's toolbar.

TIP iPhoto understands *gestures,* those little motions you make atop your Magic Mouse, Magic Trackpad, or the trackpad on your MacBook. For example, you can use two-finger zooming to dig into iPhoto's maps, just as you can with (for example) Google Maps online. If your mouse has a scroll wheel or a scroll pea, you can use that for zooming, too.

■ VIEW PHOTOS BY REGION

Places view is fun and all, but sometimes you want to see all your location tags grouped together in a good, old-fashioned list. Easy: Use the lists at the top of the Places map, shown in Figure 4-15.

Longtime fans of iTunes should instantly recognize this look: a series of lists in the top part of the window, and the locations (countries, states, cities, or places—not songs) in each list underneath. The four lists break your locations down into smaller and smaller subcategories.

As shown in Figure 4-15 (top), the left-hand list has the big overall location: the countries where you've tagged photos. As you move to the right, countries get divided into states or provinces, which get narrowed down to cities or towns. It can get as specific as a street address or a landmark, if you've gone that far in your geotagging frenzy.

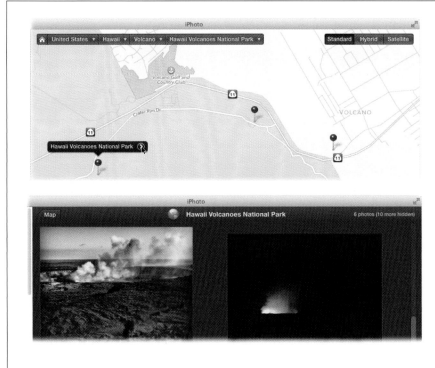

FIGURE 4-15

Top: These lists let you see Places tags by country, state/province, town, and even down to a landmark. To see all the places you've pinned in Hawaii, for example, click United States in the Countries list and then pick Hawaii from the States list. To drill down to a particular city, click its name in the Cities list (here, it's set to Volcano). Keep making choices from the individual lists to narrow your view.

Bottom: To see the photos pinned to a certain spot, click the pin and then click the ❱ to its right (or click Show Photos in the toolbar). Here, you see photos from Halema'uma'u Crater in Hawaii Volcanoes National Park.

Places for Smart Albums

Want a self-updating album of all the photos you've taken in a certain state or city? Smart albums (page 59) work with Places tags, so setting up a location-aware smart album is easy, as long as you have an Internet connection to keep the map info flowing from Apple.

To set up a smart album based on location, follow these steps:

1. **In your Source list, click Places and then click the Home button at the map's top left.**

 Your own personal map of the world appears, complete with a red pin for every location you've tagged in a photo.

2. **Find the location you want using the lists at the top left of the map or by zooming, and then click its red pin.**

 If you're making a smart album to contain all the photos you've ever taken in Italy, for example, choose it from the Country list (circled in Figure 4-16).

 If you're making a smart album based on Florence, you can drill down through the other region lists until you find a pin for Florence, and then click it. The point is to keep drilling down until you see *only* the pins for locations you want included in the smart album.

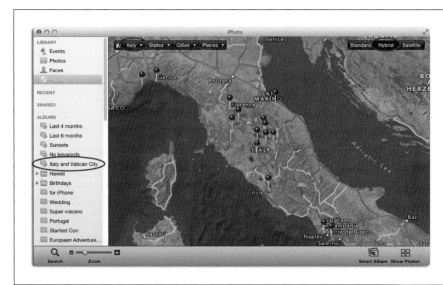

FIGURE 4-16

To make a smart album based on a country, you can use the region lists in the map's top left. Simply choose a country (or state, or city) and then click Smart Album in iPhoto's toolbar. Once you do that, the Source list displays a new smart album named after the country you picked (circled).

Here, the Places map is shown in Hybrid view (circled at top right).

3. **Click Smart Album in iPhoto's toolbar.**

 A fresh, new smart album appears in the Source list based on the pins shown on your map, sporting the name of the location you just picked.

TIP To make a smart album based on multiple locations, zoom in until the map shows all the pinned places you want to include. Then click Smart Album in the iPhoto toolbar to make a self-updating album that includes photos from all those places. It appears in the Source list under an unwieldy name like "United Kingdom, France and more," but you can click to rename it something a little catchier, like "Europe."

If you don't happen to be online at the time (*the horror!*), you can still set up a smart album without looking at the map:

4. **Choose File→New Smart Album (or press Option-⌘-N).**

 The Smart Album settings slide down from the top of the iPhoto window.

5. **Enter a name for the album, and then set up the pop-up menus to "Place" and "contains." In the remaining box, type the location you want to see, like *Texas* or *Grand Canyon*, and then click OK.**

 Your new smart album rounds up all the photos that match the criteria you entered. It also keeps an eye out for any *new* photos you import that contain matching geotags.

TIP You can commemorate all this geotagging work with a custom map that you can include in a printed, hardcover book of your photos. Chapter 9 has the scoop.

Editing and Sharing

Editing Your Shots

R are is the digital photo that doesn't need a bit of correction. The shot might be too dark or too light, or the colors may have a blue or yellow cast. The focus may also be a little blurry, skin tones might look a little too red, the camera may have been tilted slightly, or the composition may be somewhat off.

Fortunately, one of the amazing things about digital photography is that you can use software to fine-tune your pictures in ways that, in the world of traditional photography, would require a fully equipped darkroom, several bottles of smelly chemicals, and an X-Acto knife.

While iPhoto is no Adobe Photoshop, it's still a *powerful* photo editor with an incredible array of easy-to-use tools. In this chapter, you'll learn how to use each one of those tools to perfect your photos, as well as how to send them over to *other* programs for more radical surgery.

NOTE To perform stunts like removing whole objects from a photo or swapping backgrounds (even heads), you need a way to tell the editing program what *portion* of the image you want to change, usually by creating a *selection,* which you can't do in iPhoto for Mac—the majority of the editing you do here affects the *whole* photo. However, the iPhoto for iOS app is another story; it includes a set of tools that let you paint changes onto your pictures. See Chapter 14 for the lowdown.

▧ Editing in iPhoto

The good news is that iPhoto is equipped to handle the most common photo-fixing tasks, like rotating, cropping, straightening, removing red-eye and blemishes, reducing noise, creating special effects (like making a photo black and white or adding a sepia tone), adding edge vignetting (a soft oval fade around the photo's edge), as well as tweaking brightness, contrast, saturation, color tint, white balance, exposure, shadows, highlights, and sharpness.

The *not* so great news is that you can't add text (save for slideshow captions), make collages or otherwise combine images, create partial color effects, remove complex objects (like your ex), or apply special effects filters like you can with more expensive—and far more difficult to use—editing programs such as Photoshop or Photoshop Elements.

> **NOTE** When you edit a picture in iPhoto, your changes are visible wherever that particular photo appears—in every album, slideshow, calendar, or book project. But you can tweak the way a photo *prints* on your printer without having those changes appear anywhere else. Details on that trick lie in Chapter 7. However, the one place your changes *never* appear is in your iCloud photo stream , that is, unless you save them to your device's Camera Roll, as the box on page 346 explains.

In iPhoto's Edit view, all the editing tools are conveniently parked in a panel on the right side of the window. But in the hopes of accommodating every conceivable working style and skill level, Apple has designed iPhoto to offer an alternate editing-window style, as well as a quick path to editing your images in other programs.

Choosing an Editing Setup

iPhoto gives you three ways to edit photos:

- **Right in the iPhoto window, in Edit view.** *Pros:* You don't lose your bearings; all the familiar landmarks, including the Source list, remain visible. Simple and reassuring. *Cons:* The picture isn't very big, since it has to fit inside the main iPhoto window.

- **In Full Screen view.** *Pros:* The photo fills your entire screen, as big and dramatic as it can be (at least without upgrading to a bigger monitor). The menu bar and Source list are hidden, giving you more screen real estate. *Cons:* It takes a little time to get the hang of using iPhoto's buttons to navigate to other Events, albums, projects, and so on.

- **In another program.** This is one of iPhoto's slickest tricks: You can set things up so that clicking the Edit button opens the photo in a totally different program, such as Photoshop Elements. You edit, you save your changes, you return to iPhoto—and presto, the changes you made in the other program are visible. You can even use the "Revert to Original" command (page 147) to bring back the original photo later, if necessary.

TIP You can't change the photo's file name, location or file format (it has to be a JPEG file); if you do, the edited version won't be visible in iPhoto.

Pros: Other programs have a *lot* more editing power than iPhoto. For example, the Auto Levels command in Photoshop and Photoshop Elements is a better color fixer than iPhoto's Enhance button. And you need a Photoshop-type program if you want to scale a photo up or down to specific pixel dimensions, add text to a photo, combine several photos into a collage, do some head-swapping, whiten teeth, or adjust colors in just a *portion* of a photo.

Cons: You're using two programs instead of one. And nobody ever said Photoshop was cheap—these days, it requires a subscription—although Photoshop Elements has much of the power with a lower price tag. Also, you lose the ability to back out of your changes edit by edit, because iPhoto can't track individual edits made in the other program; your only choice is to revert to the original photo. And, when you're editing a raw file, iPhoto opens a JPEG copy of it, meaning the changed version will show up in iPhoto only if you don't change its filename or location. If, however, you choose to edit the original raw file by tweaking iPhoto's preferences (page 149), the altered version won't automatically show up in iPhoto; you have to reimport it.

NOTE iPhoto veterans may notice that Apple retired yet another way of opening a photo for editing—in a floating window of its own. Evidently, enough was enough.

▓ GETTING INTO EDIT VIEW

When you switch to Edit view, you see three editing tabs at the top right of the iPhoto window with a series of buttons underneath, as Figure 5-1 shows. To use Edit view, select one or more photos and then do one of the following:

- **Click Edit in the toolbar.**

- **Press Return** (pressing Return *again* spits you out of Edit view).

- **Choose Photos→Edit Photo or press ⌘-E.**

- **Control-click a thumbnail or a photo** and, from the shortcut menu, choose "Edit in iPhoto."

▓ USING FULL SCREEN VIEW

Mac screens come in all sizes and resolutions these days, but one thing is for sure: Even the biggest ones usually can't show you an entire digital photo at full size. A 5-megapixel photo (2784 × 1856), for example, is still too big to fit entirely on Apple's 30-inch Cinema Display (2560 × 1600 pixels) without shrinking the photo (though the Retina 15-inch MacBook Pro comes close at 2880 × 1800 pixels).

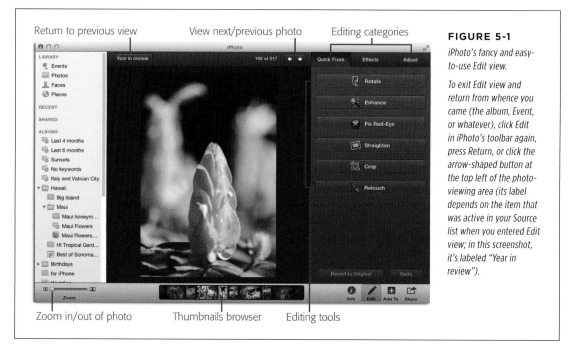

Return to previous view View next/previous photo Editing categories

Zoom in/out of photo Thumbnails browser Editing tools

FIGURE 5-1

iPhoto's fancy and easy-to-use Edit view.

To exit Edit view and return from whence you came (the album, Event, or whatever), click Edit in iPhoto's toolbar again, press Return, or click the arrow-shaped button at the top left of the photo-viewing area (its label depends on the item that was active in your Source list when you entered Edit view; in this screenshot, it's labeled "Year in review").

The bottom line: For most of your iPhoto career, you'll be working with scaled-down versions of your photos. That's a shame when it comes to *editing* those photos, when you need as much clarity and detail as possible. That's why the addition of Full Screen view in iPhoto '11 was such a big deal, and it's a whole lot better in the current version. In this view, iPhoto magnifies the selected photo to fill your entire screen, (minus the Source list and toolbar). As Figure 5-2 illustrates, it's *awesome.*

NOTE Remember, the menu bar disappears when you're in Full Screen view, but you can temporarily bring it back by moving your cursor to the very top of your screen.

To use Full Screen view when you're *already* in Edit view, click the ⛶ at the top right of the iPhoto window (or press Control-⌘-F); your photo takes over your entire monitor. (If you're not in Edit view already, click the ⛶ *and then* click Edit at the bottom of your screen.) To exit Full Screen view, just click the same button again or tap the Esc key.

FIGURE 5-2

Top: Editing photos in Full Screen view makes them huge and removes distractions from view.

You can jump back to your original Source list item (Events or Photos view, an album, project, or whatever) by pressing Return, double-clicking the photo you're editing, clicking the arrow button at the top left of the screen, or pressing ⌘-left arrow.

Bottom: Go back two views and you see big Source icons at the bottom of your monitor for Events, Places, Faces, Albums, and Projects. When you click one, thumbnails of those items appear in a scrollable list (like the albums shown here).

■ EDITING IN ANOTHER PROGRAM

If you own another image-editing program such as Photoshop or Photoshop Elements, you can have iPhoto open your masterpieces *there* any time you enter Edit view. However, this requires a bit of prep work in iPhoto.

Choose iPhoto→Preferences→Advanced. From the Edit Photos pop-up menu, choose "In application…" as shown in Figure 5-3.

> **NOTE** In earlier versions of iPhoto, you could tweak the program's Preferences to control what happened when you double-clicked a photo's thumbnail. These days, double-clicking zooms in on the photo so you can take a closer look—period.

FIGURE 5-3

In the Advanced pane of iPhoto's Preferences, you can use the Edit Photos pop-up menu to specify your favorite editor: "In iPhoto" or "In application...." Clicking the latter summons the Open dialog box shown here, where you can navigate to the other program (in this case, Photoshop Elements). Once you pick the program, iPhoto chooses it for you in the pop-up menu.

From now on, entering Edit view will launch the other program (if it's not already running) and open your photo as a new document there. While you can't step back through the changes you make in the other program, iPhoto lets you revert to the original photo.

Using the Thumbnail Browser

Another useful feature in Edit view is the *thumbnail browser* parked at the bottom of your window or monitor (it appears in both the standard and full-screen versions of Edit views). You can use it to move to another photo for editing, or to choose *multiple* versions of the same shot in order to compare them and pick which one to edit.

> **TIP** If your camera is set to burst mode (consult your camera's manual to learn how to turn it on), it fires off several shots each time you press the shutter button. This is handy for making sure at least *one* photo is nice and sharp, because the very act of pressing and releasing the shutter button can jiggle the camera. Unfortunately, shooting in burst mode also means having several versions of the same photo in your library. That's why the ability to compare different versions in iPhoto *while you're editing* is so useful.

Using the thumbnail browser is easy, as Figure 5-4 explains. To choose another photo to edit, click its thumbnail. To compare the original photo with a different shot, ⌘-click the comparison shot in the thumbnail browser; iPhoto opens it alongside the photo you were originally editing. (You have to be in Edit mode to compare photos.)

You're not limited to comparing *two* photos side by side. You can compare three, four, or however many your screen can hold, though the thumbnails become smaller and smaller the more photos you select.

TIP You can use the Zoom slider in iPhoto's toolbar to see deeper into the photos you're comparing, though the slider affects only *one* photo at a time. To zoom into *all* the photos you're comparing, click each one individually in the photo-viewing area and then set the zoom level. To reposition the photo while zoomed in, use the Navigator panel discussed in the next section. To get the exact same zoom level for each photo, zoom *numerically* (also explained in the next section).

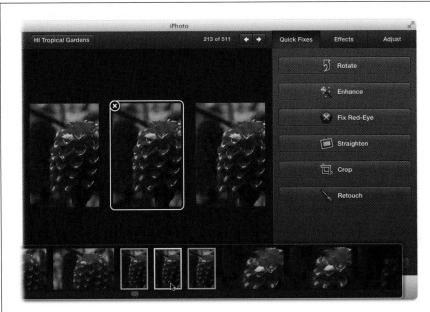

FIGURE 5-4

Worried that you can't see the tiny thumbnails well enough to pick one? Don't panic—the thumbnail browser enlarges when you point at it, as shown here. Use the gray scroll bar at the bottom to move back and forth through the thumbnails.

When you're done comparing photos, you can restore the single-photo view by ⌘-clicking the comparison shot's thumbnail again, or by clicking the photo you want to dismiss and then clicking the X in its top-left corner.

If you're *already* in Edit view, just ⌘-click or Shift-click to select additional photos in the thumbnail browser, and iPhoto makes room for all of them. (To remove a photo from the comparison, click the tiny X in its top-left corner or ⌘-click its thumbnail again.)

Notes on Zooming and Scrolling

Before you get deeply immersed in the editing process, it's worth knowing how to zoom and scroll around, since chances are you'll be doing quite a bit of both.

By now, you know that double-clicking an image (or pressing the space bar) gives you a closer look, and that you can then use the Zoom slider in the toolbar to go deeper. However, there are many other ways to adjust your point of view. The following methods work in both the standard and full-screen versions of Edit view.

NOTE iPhoto is fully gesture-aware, meaning you can use a Magic Mouse, Magic Trackpad, or MacBook trackpad to pinch (move two fingers together) to zoom out of a photo, or spread (move two fingers apart) to zoom in.

Using the Navigator

The biggest problem with zooming way in on a photo is that it's tough to know *where* you are in the photo. That's where the Navigation panel comes in—it's a little floating panel that appears the second you use the Zoom slider, or when you use the numeric shortcuts described below. The Navigation panel lets you reposition the enlarged photo *while* you're zoomed in. Figure 5-5 has the scoop.

FIGURE 5-5

As soon as you touch the Zoom slider in iPhoto's toolbar, the Navigation panel appears to help you find your way around the picture. To move to a different area of the photo (like the stamen of this flower), drag the tiny "You are here" rectangle within the Navigation panel.

You can also scoot the Navigation panel around by clicking and dragging near its name. (If you've got two monitors, try dragging the Navigation panel to the second one.)

Zooming Numerically

Touch typists will love this one: In Edit view, you can press the number keys on your keyboard—0, 1, and 2—to zoom in or out of photos. Hit 1 to zoom in so far that you're viewing every single pixel (every tiny colored square) in the photo; that is, one pixel of the photo occupies one pixel of your screen. The photo is usually bigger than your screen at this point, so you're now viewing only a portion of the whole—but it's great for detail work.

Hit 2 to double that magnification level. Now each pixel of the original picture consumes *four* pixels of your screen, a handy superzoom level when you're trying to edit individual skin cells.

Finally, when you've had enough superzooming, tap the zero (0) key to zoom out again so the whole photo fits in the window.

Note that these numeric zooming tricks work in Edit view only; they do different things in All Events and Photos view. (For a secret decoder list of keyboard shortcuts, choose Help→Keyboard Shortcuts.)

Scrolling Tricks

Once you've zoomed into a photo, you can reposition your view in any direction by pressing the space bar as you drag the mouse (your cursor turns into a tiny hand). This method is a little more direct than fussing with the Navigator panel.

If your mouse has a scroll wheel (or a scroll pea, like Apple's old Mighty Mouse), you can scroll images up and down while zoomed in on them by turning that wheel. To scroll the zoomed area *horizontally,* press Shift while turning.

TIP If you're using a laptop trackpad, an Apple Magic Mouse, or a Magic Trackpad, you can swipe to the left or right with two fingers to scroll in any direction while you're zoomed into a photo (this is all controlled by your mouse or trackpad system preferences). Point your cursor at the thumbnail browser to scroll through it, too.

The "Before and After" Keystroke

After making any kind of edit, it's incredibly useful to compare the "before" and "after" versions of your photo. So useful, in fact, that Apple has dedicated a whole key to that function: the Shift key on your keyboard. Hold it down to see your un-enhanced "before" photo; release it to see the "after" image.

By pressing and releasing the Shift key, you can switch between the two versions of the photo to assess the results of your enhancement. This keyboard shortcut is *well* worth memorizing.

Backing Out

As long as you remain in Edit view, you can back out of your changes, one by one, no matter how many of them you've made. For example, if you've cropped a photo, you can uncrop it by choosing the Edit→Undo Crop command (or by pressing ⌘-Z).

The only catch is that you have to back out of the changes *one at a time.* In other words, if you rotate a photo, crop it, and then change its contrast, you have to use the Undo command three times—first to undo the contrast change, then to uncrop, and finally to unrotate.

But once you *leave* Edit view—either by choosing another photo in your thumbnail browser, or by returning to an album, or to All Events or Photos view—you lose the ability to undo *individual* edits one at a time. At this point, the only way to restore your photo is to click "Revert to Original" in Edit view or choose Photos→Revert to Original. Either way, iPhoto removes *every* edit you've made to the photo since you imported it.

▨ The Quick Fixes

iPhoto's editing tools are divided into three logical categories: Quick Fixes, Effects, and Adjust.

The Quick Fixes category contains the most commonly used editing tools. To see those options, pop into Edit view and then click the Quick Fixes tab in the top right of the iPhoto window.

> **TIP** You can also dive into the Quick Fixes panel by tapping the Q key while you're in Edit view.

Rotating

Unless your digital camera has a built-in orientation sensor, iPhoto imports all photos in landscape orientation (wider than they are tall). To get all your photos right-side up (if you didn't do so during your first perusal of them, as described in Chapter 1), just select the sideways ones and rotate them into position by clicking Rotate in the Quick Fixes panel.

> **TIP** The Quick Fixes panel's Rotate button turns photos 90 degrees counterclockwise. If you want to turn them the *other* way, hold the Option key while clicking this button.

Remember, you don't have to be in Edit view to rotate photos. You can also use one of the following methods to turn them right-side up:

- Choose Photos→Rotate Clockwise (or Rotate Counterclockwise).

- Press ⌘-R to rotate selected photos counterclockwise, or Option-⌘-R to rotate them clockwise.

- Control-click a photo in Edit view and choose Rotate Clockwise (or Rotate Counter Clockwise) from the shortcut menu. (If you're in any other view, you'll see a Rotate button instead.)

> **TIP** Believe it or not, you can customize the direction in which iPhoto rotates your pictures. If you're not in Edit view, clicking Rotate in a photo's shortcut menu (or pressing ⌘-R) rotates photos *counterclockwise,* while Option-clicking that option (Option-⌘-R) rotates them clockwise. Now think about how you hold your camera when you take a vertical shot—do you rotate the camera to the right or to the left? If the answer is to the right, you can swap iPhoto's rotation directions by choosing iPhoto→Preferences→General and changing the Rotate setting.

If you've just imported a *batch* of photos, you can save a lot of time and mousing around by selecting all the thumbnails that need rotating (by ⌘-clicking each, for example). Then use one of the rotation commands above to fix *all* the selected photos in one fell swoop.

Enhancing

The Quick Fixes panel's Enhance option gives you a simple way to improve the appearance of less-than-perfect digital photos. You click this one button to make colors brighter, skin tones warmer, and details sharper (see Figure 5-6).

FIGURE 5-6

The Enhance command works particularly well on photos that are slightly dark and lack contrast, like the original photo on the top here. In some cases, a single click of the Enhance button may be all the picture needs.

Clicking Enhance makes iPhoto analyze the relative brightness of all the pixels in your photo and attempt to "balance" the image by dialing the brightness or contrast up or down and intensifying dull or grayish-looking areas. In addition to this overall brightness, contrast, and color adjustment, the program also makes a particular effort to identify and bring out the subject of the photo. Usually, this makes pictures look somewhat richer and more vivid than they did originally.

You'll see the effects of your Enhance button–clicking in the histogram (page 137)—a great way to learn about what, exactly, the Enhance button is *doing.*

TIP If clicking Enhance improves your photo somewhat but not quite enough, open the Adjust panel (page 135) to see which sliders iPhoto moved and then tweak them slightly to amplify its effect. Because these sliders all have a uniform starting position—the first three sliders start out in the middle and the rest all the way to the left—it's easy to see which ones iPhoto moved.

iPhoto's image-correcting algorithms are just guesses at what your photo is supposed to look like. The program has no way of knowing whether you've shot an overexposed, washed-out picture of a vividly colored sailboat or a perfectly exposed picture of a pale-colored sailboat on an overcast day. So you may find that Enhance has no real effect on some photos and only minimally improves others. Remember, too, that you can't enhance just one part of a photo—it's all or nothing. If you want to *selectively* adjust specific portions of a picture, you need a true pixel-editing program like Aperture, Lightroom, or Photoshop Elements.

NOTE iPhoto for iOS has a set of brushes you can use to edit certain portions of your photo. Skip ahead to page 352 for details.

If the Enhance button fails to coax the best possible results from your digital photos, you can use the Adjust panel instead, as described on page 135.

Fixing Red-Eye

Let's say you snap a near-perfect family portrait: The focus is sharp, the composition is balanced, and everyone is smiling. And then you notice that Uncle Bob, dead center in the picture, has glowing red eyes.

You're the victim of *red-eye,* a common problem in flash photography (especially with older cameras). This creepy, possessed look has ruined many an otherwise-great photo (see Figure 5-7).

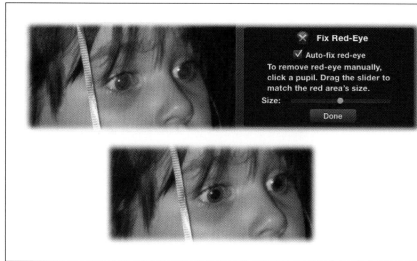

FIGURE 5-7

Top: When you click Fix Red-Eye in the Quick Fixes panel, instructions appear telling you what to do: Click carefully inside each affected pupil.

Bottom: Friends and family members look more attractive—and less like Star Trek characters—after you touch up their phosphorescent red eyes with iPhoto.

Red-eye is caused by light reflected back from your subjects' eyes. The bright light of your camera's flash illuminates the blood-red retinal tissue in their eyes. That's why red-eye problems are worse when you shoot pictures in a dim room: Your subjects' pupils are dilated, allowing even *more* light from your flash to reach their retinas. Turning up the room's lights or using the camera's red-eye reduction feature can help prevent devil eyes. But if it's too late for that, iPhoto can help digitally remove the unsettling red pixels. (It won't fix pet eye problems, though, because animal eyes reflect white or green light instead.)

Truth be told, the red-eye tool doesn't know an eyeball from a pinkie toe. It just turns any red pixels black, regardless of what body part they're associated with. So your job is to tell iPhoto exactly what needs fixing. Start by opening your photo and zooming in, if necessary, so that you have a closeup view of the eye with the crimson problem. Then click Fix Red-Eye.

Most of the time, you can leave the Auto-fix checkbox turned on and, if iPhoto senses a face in the photo, it zaps the red eye for you. If it doesn't, then use the crosshairs cursor to click inside each red-tinted eye; with each click, iPhoto neutralizes the red pixels, painting the pupils solid black. To adjust the size of the cursor, drag the Size slider. When everything looks good, click Done.

Straightening

Many a photographer has remarked that it's harder to keep the horizon straight when composing images on a digital camera's LCD screen than when looking through an optical (eyepiece) viewfinder. Whether that's true or not, off-axis, tilted photos are a fact of photography, and especially of scanning—and iPhoto makes fixing them incredibly easy. Figure 5-8 shows the secrets of the Straighten slider.

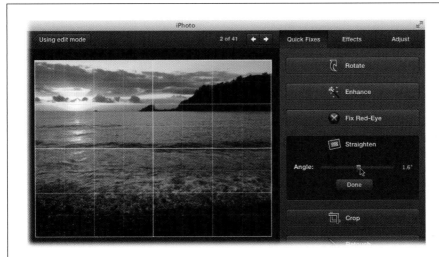

FIGURE 5-8

When you click the Straighten button, iPhoto superimposes a yellow grid on your picture, as shown here. By moving the Angle slider in either direction, you rotate the image.

You can use the yellow grid to help you align the horizontal or vertical lines in your photo.

If you think about it, you can't rotate a rectangular photo without introducing skinny empty triangles at the corners of its "frame." Fortunately, iPhoto sneakily eliminates that problem by very slightly magnifying the photo as you straighten it. That means you *lose* skinny triangles at the corners, but at least you don't see empty triangular gaps when the straightening is over.

In other words, the straightening tool isn't a free lunch. Straightening an image decreases the picture quality slightly (by blowing up the picture, thus lowering the resolution) and clips off tiny scraps at the corners. You have to view the before and after pictures side by side at high magnification to see the difference, but it's there.

So, as cool as the straightening tool is, it's not a substitute for careful composition with your camera. However, it can help you salvage an otherwise wonderful image that's skewed. (And besides—if you lose a tiny bit of clarity in the straightening process, you can always apply a little sharpening afterward. Read on to learn how.)

Cropping

Think of iPhoto's cropping tool as a digital paper cutter. It neatly shaves off unnecessary portions of a photo, leaving behind only the part you really want.

You'd be surprised at how many photographs can benefit from selective cropping. For example:

- **Eliminate parts of a photo you just don't want.** This is a great way to chop your brother's ex-girlfriend out of an otherwise perfect family portrait (provided she's standing at the end of the lineup).

- **Improve a photo's composition.** Trimming a photo lets you adjust where your subject matter appears within the frame of the picture. If you inspect the professionally shot photos in magazines or books, you'll discover that many pros get more impact from a picture by cropping tightly around the subject, especially in portraits.

- **Get rid of wasted space.** You can eliminate huge expanses of sky (or grass) that add nothing to a photo, for example, keeping the focus on your subject.

- **Fit a photo to specific proportions.** If you're going to place your photos in a book layout (Chapter 9) or turn them into standard-size prints (Chapter 7), you may need to adjust their proportions. That's because there's often a substantial discrepancy between the *aspect ratio* (length-to-width proportions) of your digital camera's photos and those of *film* cameras—a difference that will come back to haunt you if you order prints (though it's fixable).

■ HOW TO CROP A PHOTO

Here are the steps for cropping:

1. **Open the photo in Edit view.**

 You can use any of the methods mentioned earlier in this chapter, like clicking a thumbnail and then pressing Return.

2. **Press the C key on your keyboard or, in the Quick Fixes panel, click Crop.**

 The Constrain pop-up menu appears in the Quick Fixes panel, and a light-gray crop box appears around your photo (Figure 5-9).

 You can adjust the crop box by dragging its edges. You can also create a new crop box, if you like, by dragging diagonally up or down.

 As you drag, a tic-tac-toe grid appears, just in case you want to crop according to the Rule of Thirds. (The Rule of Thirds is a photographic guideline that imagines a photo divided into thirds, both horizontally and vertically. Better composition, the Rule contends, comes from putting the most interesting parts of the image at these four points, as shown in Figure 5-9.)

3. **If you like, make a selection from the Constrain pop-up menu.**

This menu controls the crop tool's behavior. When the Constrain checkbox is turned off, you can draw a crop box of any size and proportions, in essence going freehand.

When you choose one of the options in this pop-up menu, however, iPhoto constrains the crop box you draw to preset proportions, which prevents you from coloring outside the lines, so to speak.

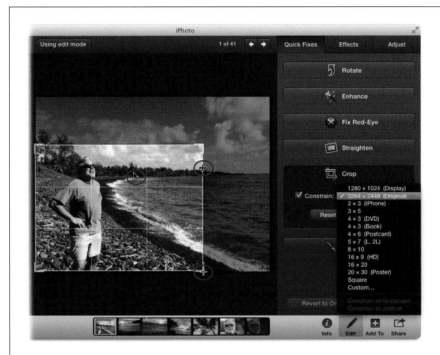

FIGURE 5-9

In this improbable illustration are the three different cursor shapes you may see, depending on where you move the pointer: the + crosshair for the initial drag, the double arrow for reshaping when you're near a boundary, and the arrow pointer for sliding the entire crop box around the photo.

Once you click Done, the excess margin falls to the digital cutting-room floor, enlarging your subject. (You can always get it back by clicking "Revert to Original.")

The Constrain option is especially important if you plan to order prints of your photos (Chapter 7). Prints come only in standard photo sizes: 4 × 6, 5 × 7, 8 × 10, and so on. You may recall, however, that most digital cameras produce photos whose proportions are 4:3 (width to height). This size is ideal for DVDs and iPhoto books, because standard TV and book layouts use 4:3 dimensions, too—but it doesn't divide evenly into standard print sizes for photographs.

That's why the Constrain pop-up menu offers you canned choices like 4 × 6, 5 × 7, and so on. Cropping to one of these preset sizes guarantees that your cropped photos will fit perfectly into Kodak prints. (If you *don't* constrain your cropping this way, Kodak—not you—will decide how to crop them to fit.)

Another crop-to-fit option in the Constrain menu lets you crop photos for use as a desktop picture; this option is named something like "1024 × 768 (Display)"

(or whatever your actual monitor's dimensions are). You'll also find an Original option here (which maintains the proportions of the original photo even as you make it smaller), and a Square option.

> **TIP** Here's a bonus feature: the Custom item in the Constrain pop-up menu. Select it and then, in the two text boxes that appear, you can type *any* proportions you want: 4 × 7, 15 × 32, or whatever your eccentric design calls for.

As soon as you make a selection from this pop-up menu, iPhoto draws a preliminary crop box—of the proper dimensions—on the photo, and darkens everything outside it.

By the way, iPhoto thinks hard about how to display this box—that is, whether it starts out in either landscape (horizontal) or portrait (vertical) orientation. The crop box always starts out matching the photo itself: landscape for landscape photos, portrait for portrait photos. You can, however, reopen the Constrain pop-up menu and choose "Constrain as landscape" or "Constrain as portrait" to flip the crop box 90 degrees. In order to use these two commands, you *first* have to choose an aspect ratio from the menu.

At this point, the cropping area that iPhoto suggests with its dark-margin rectangle may, as far as you're concerned, be just right. In that case, skip to step 6. More often, though, you'll probably want to give the cropping job the benefit of your years of training and artistic sensibility by *redrawing* the cropping area.

4. **Drag the crop box to adjust its size and shape, or create a new crop box by starting at a point outside the current one and dragging diagonally across the portion of the picture that you want to** *keep.*

 As you drag, iPhoto dims the part of the photo that it will eventually trim away (see Figure 5-9).

> **TIP** Even if you turned on one of the Constrain options in step 3, you can override the constraining by pressing the Shift key after you start dragging.

Don't worry about getting your selection perfect; iPhoto doesn't actually trim the photo until you click the Done button.

5. **Adjust the crop, if necessary.**

 If the shape and size of your crop box is OK, but you want to adjust which *part* of the image is selected, then you can move the crop box without redrawing it. Position your cursor inside the box so the pointer turns into an arrow, and then drag the box where you want it.

 You can also change the box's size. Point your cursor at any edge or corner so that it changes to a + shape (near the corner) or a double-headed arrow (near the edge)—see Figure 5-9—and then drag to reshape the box.

If you get cold feet, you can cancel the operation by tapping the Esc key or clicking Reset.

NOTE Despite its elaborate control over the relative dimensions of your crop box, iPhoto doesn't tell you the size, in pixels, of the end result. If you want to crop a photo to precise pixel dimensions, you have to use another program, like Photoshop Elements. Page 146 explains how to open photos in a different editing program.

6. **When the crop box is just the way you want it, click Done or press Return.**

 If throwing away all those cropped-out pixels makes you nervous, relax. If you realize immediately that you've made a cropping mistake, then you can click the Undo or "Revert to Original" button, or choose Edit→Undo to go back one editing step. If you have regrets *weeks* later, on the other hand, then you can always select the photo and choose Photos→"Revert to Original." After asking if you're sure, iPhoto promptly reinstates the original photo from its backup, discarding every change you've ever made to it.

NOTE When you crop a photo, you're changing it in all the albums and projects in which it appears. If you want a photo to appear cropped in one album but not in another, you have to *duplicate* it (select it and then choose Photos→Duplicate), and then edit each version separately. (You can also Control-click a photo in Edit view and choose Duplicate from the resulting menu.)

UP TO SPEED

When Cropping Problems Crop Up

Remember that cropping always shrinks your photos. Remove too many pixels, and your photo may end up too small—that is, with a *resolution* too low to print or display properly. Resolution controls *pixel size* by determining how many pixels are in your photo per square inch (you've likely heard it expressed as *ppi* for "pixels per inch").

Here's an example: You start with a 1600 × 1200-pixel photo. Ordinarily, that's large enough to be printed as a high-quality, standard 8 × 10 portrait.

Then you go in and crop the shot. Now the composition is perfect, but your photo measures only 800 × 640 pixels. You've tossed out nearly a million and a half pixels!

The photo no longer has a resolution high enough to produce a top-quality 8 × 10 print. The printer is forced to blow up the photo to fill the specified paper size, producing visible, jagged-edged pixels in the printout. The 800 × 640 pixel version of your photo would make a great 4 × 5 print (if that were even a standard-size print), but pushing the print's size up noticeably degrades the quality because the pixels are big enough to see individually.

This is an example of a situation where having a high-resolution digital camera (at least 10 megapixels) offers a significant advantage. Because each shot starts out with such high pixel dimensions, you can shave away a few hundred thousand pixels and still have enough left over for good-sized, high-resolution prints.

Another way to avoid cropping problems is to turn off your camera's digital zoom option (if it has one). If you use that feature, your camera crops photos before saving them to the memory card. You'll get better results by cropping in iPhoto yourself.

Moral of the story: Know your photo's size and intended use— and don't crop out more photo than you can spare.

Retouching Blemishes, Scratches, and Hairs

Sometimes an otherwise perfect portrait is spoiled by the tiniest of imperfections—a stray hair or an unsightly blemish, for example. Professional photographers, whether working digitally or in a traditional darkroom, routinely remove such minor imperfections from their final prints—a process known as *retouching*, for clients known as *self-conscious* or *vain.* (Kidding!)

> **TIP** One of the most common retouching tasks is lightening teeth. You can't do that in iPhoto for Mac, but you *can* do it in iPhoto for iOS. Page 354 tells you how.

iPhoto's Retouch brush lets you do the same thing with your digital photos. You can paint away scratches, spots, hairs, or any other small flaws with a few quick strokes.

The operative word here is *small.* The Retouch brush can't completely erase somebody's mustache. It's intended for tiny touch-ups that don't involve repainting whole sections of a photo. (For that kind of overhaul, you need a pixel-editing program like Photoshop Elements.)

The Retouch brush works its magic by blending the colors in the tiny area that you're fixing. It doesn't cover the imperfections you're trying to remove, but rather *blurs* them out by softly blending them into a small radius of surrounding pixels. You can see the effect in Figure 5-10.

▦ USING THE RETOUCH BRUSH

Once you've clicked Retouch in the Quick Fixes panel, your cursor turns into a dashed circle. Find the imperfection and "paint" over it, either by dabbing or dragging to blend it with the surrounding portion of the photo. You can use the Size slider to make the Retouch brush's size match the size of the item you're fixing. When you're finished, click Done.

> **TIP** You can adjust the size of the Retouch brush using your keyboard, too: Press the left bracket key ([) repeatedly to make it smaller, or the right bracket key (]) to make it bigger.

Don't overdo it: If you apply too much retouching, the area you're working on will look noticeably blurry and unnatural, as if someone smeared Vaseline on it. Fortunately, you can use the Undo button at the bottom of the panel to take back individual brushstrokes (you can also choose Edit→Undo or press ⌘-Z). When you're finished, click Done. If you don't like the results, click the Undo button a few times or click "Revert to Original" to obliterate *all* the edits you've made.

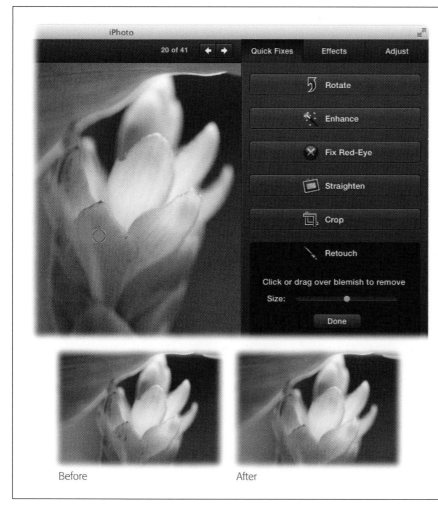

FIGURE 5-10

*Top: As you use the Re-
touch brush, iPhoto marks
the area you've painted
across with a light brown
overlay. Most of the time,
the Retouch brush works
like magic, but sometimes
it creates bizarre results. In
those cases, press ⌘-Z to
undo your latest stroke.*

*Bottom: Overall, though,
the Retouch brush does
a good job of removing
the imperfections in this
flower or, in the case of a
portrait, hiding blemishes
and softening wrinkles
(like digital Botox!).*

*The Retouch brush is
particularly useful if your
photo library contains pic-
tures that you've scanned.
In that case, you can use
it to wipe away the dust
specks and scratches that
often appear on film nega-
tives and prints, or those
that are introduced by the
scanner itself.*

If you've used the Retouch brush in earlier versions of iPhoto, you'll be amazed at
how much better it works now. Apple borrowed from its professional photo-editing
program (Aperture) to give iPhoto's tools a huge upgrade; the Retouch brush in
iPhoto is now very powerful indeed. You can paint out not just zits and wrinkles,
but even entire shirt stains.

NOTE On high-resolution photos (especially raw files), it can take a moment or two for iPhoto to process
each individual stroke of the Retouch brush. If you don't see any results, wait a second for iPhoto to catch up
with you.

The Effects Panel

iPhoto offers three lighting effects, three effects that alter color intensity, five color effects, and three effects that soften a photo's borders. These effects can be incredibly useful for creating artistic images or saving photos with terrible color that you can't fix any other way.

No matter which version of Edit view you're in (normal or full-screen), click the Effects tab or tap the E key on your keyboard to open the Effects panel (Figure 5-11).

> **TIP** In most cases, you can click an Effects panel button repeatedly to intensify its impact. Some effects (Antique, Matte, Vignette, Edge Blur, Fade, and Boost) even display a number to let you know how many times you've applied it (Figure 5-11 shows an example). You can use the left and right arrows on either side of the digit to decrease or increase the effect, respectively. You don't see anything like that when you click the panel's first two rows of buttons, but clicking them repeatedly still adds to the effect (watch your photo to see the change).

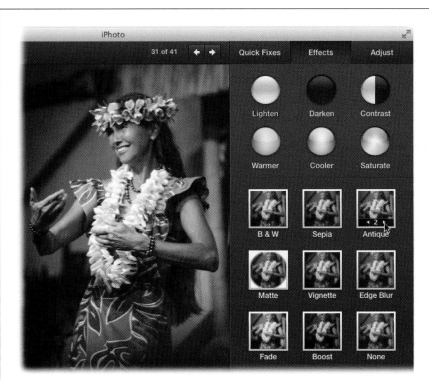

FIGURE 5-11

The Effects panel offers 14 different clickable effects, good for a solid 10 minutes of photo-editing fun.

The Antique effect is shown here, at a strength of 2.

Applying these effects is probably the easiest thing you'll ever do in iPhoto: Just click a button to apply its effect to your photo. Here's what each one does:

- **Lighten.** Brightens photos that are too dark (underexposed).

- **Darken.** Darkens photos that are too light (overexposed).

- **Contrast.** If your photo looks flat, use this effect to bring out details. It makes the dark parts of the photo a little darker and the light parts a little lighter.

- **Warmer.** If your photo looks too blue (cold), use this effect to add golden tones and warm it up.

- **Cooler.** Introduces more blue tones if your photo is riddled with red or gold.

- **Saturate.** Want to make the colors in your flower photos pop off the page? Give this button a few clicks (up to 20) to intensify the color. Try not to use this effect on photos of people, though—it can turn their skin a very unflattering hot pink.

- **B & W (Black and White), Sepia.** These effects drain the color from photos. B & W converts them into moody grayscale images (a great technique if you're going for that Ansel Adams look); Sepia repaints them entirely in shades of antique brown (as though they were 1865 daguerreotypes). Click once to apply the effect; click again to remove it.

- **Antique.** A heck of a lot like Sepia, but not quite as severe. It still makes photos light brownish, but preserves some of the original color—like, say, a photo from the 1940s. Figure 5-11 shows this effect in action.

- **Matte.** This effect whites out the outer portion of the photo, creating an oval-shaped frame around the center.

- **Vignette.** Same idea as Matte, except that iPhoto *darkens* the outer edges.

- **Edge Blur.** Same idea again, except the outer edges lose focus rather than changing color. The central portion of the photo stays in focus.

- **Fade Color.** The colors get faded quite a bit, like a photo from the 1960s.

- **Boost Color.** Increases the color saturation, making colors more vivid.

- **None.** Click this button to undo all the playing you've done so far, taking the photo back to the way it was when you first opened the Effects panel.

▧ The Adjust Panel

For thousands of people, the handful of basic image-fixing tools described on the previous pages offer plenty of power. But power users don't like having to hop over to a program like Photoshop to make more advanced changes to their pictures, like fiddling with exposure (the intensity of light), adjusting shadows and highlights, sharpening, and so on.

That's where the Adjust panel comes in (Figure 5-12). To see it, click the Adjust tab in Edit view.

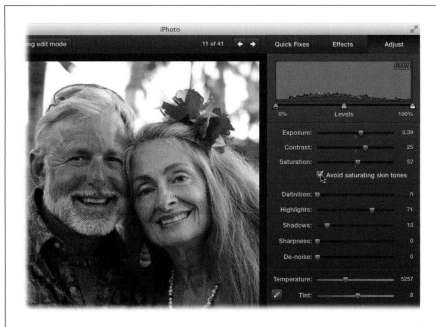

FIGURE 5-12

When the Quick Fixes panel's Enhance option doesn't do the trick, summon the Adjust panel, which gives you much finer control over color and lighting.

There are two ways to manipulate the panel's sliders, depending on the degree of fine-tuning you need to do. You can drag a slider's handle or click the slider itself, which makes the handle jump to that spot.

Before you let the following pages turn you into a tweak geek, here are some preliminary words of advice concerning the Adjust panel:

- **When to use it.** Plenty of photos need no help at all; they look fantastic right out of the camera. And others are ready for prime time after a single click of the Enhance button (page 124).

 The beauty of the Adjust panel, though, is that it permits infinite *gradations* of the changes that the Enhance feature makes. For example, if a photo looks too dark and murky, you can bring details out of the shadows without over-lightening the highlights. Or if the snow in a skiing shot looks too bluish, you can de-blue it. Or if the colors are blown out in your sunset shot, you can recover detail in the highlights without affecting the shadows.

 In short, the Adjust panel can make fixes that no one-click magic button can touch.

- **How to play.** You can fiddle with the Adjust panel's sliders in two different ways, as explained in Figure 5-12.

- **Backing out.** You can always click the panel's "Revert to Original" or Undo buttons. The first one takes you back to the original photo you shot, while Undo lets you take back individual changes you made with the Adjust panel.

TIP While in Edit view, press and hold the Option key to turn the Undo button into a Redo button. This lets you resurrect an edit after undoing it.

If you've tweaked the photo in one panel [say, Quick Fixes] and then you tweak it in another panel [Adjust] during the same editing session, the "Revert to Original" button changes to read "Revert to Previous." This is handy if you succumb to the temptation of using the Adjust panel on a photo a second time and then decide it looked just fine before. Essentially the "Revert to Previous" button means "Undo all the Adjust-panel changes I've made during this editing session."

Introducing the Histogram

While you can certainly make a bad photo look good by dragging the Adjust panel's sliders to and fro, learning to use them *effectively* involves learning about its *histogram:* the colorful graph at the top of the panel.

The histogram is the heart of the Adjust panel. It's a self-updating representation of the dark and light tones that make up your photograph. If you've never encountered a histogram before, this may sound complicated. But the histogram is a *terrific* tool, and it'll make more sense the more you use it.

Within each of the histogram's superimposed graphs (red, blue, and green), the scheme is the same: The amount of the photo's darker shades appears toward the left side of the graph; the lighter tones are graphed on the right side.

So if you're working on a very dark photograph—a coal mine at midnight, say—you'll see big mountain peaks at the left side of the histogram, trailing off to nothing toward the right. A shot of a brilliantly sunny snowscape, on the other hand, will have lots of information on the right side of the histogram and very little on the left.

The peaks represent the areas in the photo where there's a lot of information. A histogram with peaks throughout the graph indicates a photo that's balanced, with no super-dark or super-light areas (which would cause steep peaks stacked against the left or right sides of the graph). These middle mountains are fine, as long as you have some visual information in other parts of the histogram, too.

The histogram for a *bad* photo, on the other hand—a severely under- or overexposed one—has mountains all bunched at one end or the other. Rescuing those pictures involves spreading the mountains across the entire spectrum, which is what the Adjust panel is all about.

TIP Technically speaking, the histogram is a collection of tiny bar graphs; the taller the bar, the more pixels you have in the photo at that particular level of brightness and color. Another way to think of it is to imagine that your photo is a *mosaic,* and that the individual tiles have been separated into same-color stacks. The taller the stack, the more tiles you have of that particular color.

■ THREE CHANNELS

As noted above, the histogram actually displays three superimposed graphs at once. These layers—red, green, and blue—represent the three "channels" of a color photo.

When you make adjustments to a photo's brightness values—by dragging the Exposure slider just below the histogram, for example—you'll see the graphs in all three channels move in unison. Despite changing shape, they essentially stick together. Later, when you make color adjustments using, say, the Temperature slider, you'll see those individual channels move in different directions.

■ ADJUSTING THE LEVELS

If the mountains of your histogram seem to cover all the territory from left to right, you already have a roughly even distribution of dark and light tones in your picture, so you're probably in good shape. But if the graph comes up short on either the left (dark) or the right (light) side of the histogram, you need to make an adjustment to spread out the photo's information.

To do so, drag the right or left handle on the Levels slider *inward,* toward the base of the "mountain" (Figure 5-13). If you're moving the *right* handle inward, for example, you'll notice that the whites become brighter, but the dark areas stay pretty much the same; if you drag the *left* handle inward, the dark tones change, but the highlights remain steady.

> **TIP** Instead of dragging these handles, you can click the outer base of the mountain to move the handle to that location. It's a tiny bit faster and gives you better control of the handle's landing point.

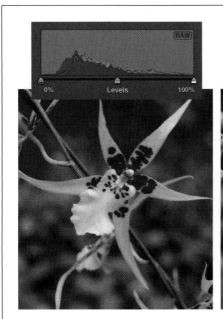

FIGURE 5-13

Left: One way to fix a photo that looks too "flat" is to adjust the Levels slider below the histogram. Notice how the tonal information is bunched up in the middle of this histogram, meaning the photo has no true highlights or shadows.

Right: Move the slider's left and right handles inward, toward the edges of the histogram data, to improve both highlights and shadows.

In general, you should avoid moving these endpoint handles inward *beyond* the outer edges of the histogram's "mountains." Doing so adds contrast, but it also throws away whatever data is outside the handles, which generally makes for a lower-quality printout.

Once you adjust the shadows and highlights handles, turn your attention to the middle handle, which controls the photo's midtones. The general rule is that you *center* the midtone handle between the shadow handle on the left and the highlight handle on the right. Often, the result is a pleasing rendition of the photo. But you can adjust it to taste; inching the handle to the left lightens the midtones (and reduces contrast); moving it to the right darkens them (and increases contrast).

Exposure

In the simplest terms, the Exposure slider makes your picture lighter when you move it to the right and darker when you move it to the left. That said, its effects differ slightly depending on your photo's file format:

- When you're editing a **JPEG** (that is, most photos from most cameras), the Exposure slider primarily affects the middle tones (as opposed to the brightest highlights and darkest shadows). If you're used to Photoshop, you may recognize this effect as a relative of its *gamma* controls. (Gamma refers to the relationship between a pixel's *numerical* brightness value and the brightness our eyes perceive.)

- When you're working with **raw** files (page 19), Exposure is even more interesting. It actually changes the way iPhoto *interprets* the dark and light information that your camera recorded when it took the picture. The effect is like changing the ISO setting (the camera's sensitivity to light) before taking the picture—except that you can make this kind of change long *after* you snap the shutter.

 This is one of the advantages of shooting in raw format: iPhoto has a *lot* more information to work with than in a JPEG. As a result, you can make exposure adjustments without sacrificing the photo's overall quality.

Watch the histogram as you move the Exposure slider. Make sure you don't wind up shoving any of the "mountain peaks" beyond the edges of the histogram box. If that happens, then you're discarding precious image data; when you print, you'll see a loss of detail in the darks and lights.

NOTE If you've already adjusted your image using the Levels slider (as described in the previous section), then you probably won't need to play with the Exposure and Contrast sliders. Most images can be fine-tuned with *either* set of controls (the three handles on the Levels slider, or the dynamic duo of Exposure and Contrast). But very few pictures require both approaches.

Contrast

The Contrast slider changes the shape of the histogram by pushing the data out in both directions. Contrast is the difference between the darkest and lightest tones

in your picture. If you increase the contrast, you "stretch out" the shape of the histogram, creating darker blacks and brighter whites, as shown in Figure 5-13. If you decrease the contrast, you scrunch histogram's data inward, shortening the distance between the dark and light endpoints. Since the image data now resides in the middle of the graph, the overall tones in the picture are duller. Photographers call this look "flat" or "muddy."

Contrast works especially well on "flat" shots because this single slider moves the histogram in two directions at once (outward toward the edges). You can create a similar effect with the Levels slider by moving the outer handles inward toward the edges of the histogram.

Which approach is better? If the histogram data is centered in the middle of the graph, then Contrast is the easier adjustment because it pushes the data outward evenly. But if the histogram data is skewed to one side or the other, then Levels is the better choice because you can adjust the highlights and shadows independently.

Saturation

When you increase the saturation of a photo's colors, you make them more vivid; essentially, you make them "pop." You can also use this setting to improve photos that have harsh, garish colors by dialing *down* their saturation so the colors end up looking a little less intense. That's a useful trick in photos whose *composition* is so strong that the colors are almost distracting (think super-bright objects, like ceramics or flowers). You can increase or decrease the intensity of a photo's colors by moving the Saturation slider right or left, respectively.

The Adjust panel can save you from yourself, at least when it comes to saturation. If you're trying to crank up the color of Cousin Jack's orange shirt—but want to avoid drenching Uncle Jack's face in hyped-up hues—then turn on the "Avoid saturating skin tones" setting before tweaking the Saturation slider. When you do, this setting becomes a *vibrancy* slider (even though its name doesn't change) that intensifies the colors of pixels that aren't *already* highly saturated. In fact, it works *so* well that you might consider leaving the "Avoid saturating skin tones" setting turned on indefinitely.

Battle of the Sliders

All right, first you said that I can create a well-balanced histogram with the Levels slider. Then you said that the Exposure and Contrast sliders do pretty much the same thing. So which should I use?

Photography forums everywhere are overflowing with passionate comments advocating one approach over the other.

The bottom line is, for most normal JPEG photos, you can use whichever you prefer, as long as you wind up creating a histogram whose peaks generally span the entire graph.

If you have no preference, you may as well get into the habit of using the Levels slider. One day, when you begin editing super-high-quality raw files (page 19), you'll appreciate the clever way these controls interpret the data from the camera's sensors with virtually no loss of quality.

NOTE iPhoto's Enhance feature (page 124) automatically adjusts saturation, but it doesn't give you a way to control the *degree* of its adjustment.

Definition

The result of moving iPhoto's Definition slider is tough to describe. Dragging it to the right can make a hazy or muddy photo appear sharper, but it's not the same as using the Sharpness slider (described below). The Definition slider has more in common with the Contrast slider, though it specifically increases contrast in the *midtones,* the parts of a photo that contain small details. In doing so, it makes your photo look sharper (if you've ever used the Unsharp Mask filter in Photoshop or Photoshop Elements, that's the gist).

You'd be hard-pressed to find a photo that doesn't benefit from at least a *little* extra definition, save for portraits (*nobody* needs extra definition in their skin!). Try moving this slider up to 20 or so and see what you think.

Highlights and Shadows

The Highlights and Shadows sliders are designed to recover lost detail in the highlights and shadows of your photos, turning what once might have been unsalvageably overexposed or underexposed photos into usable shots.

Sure, you can find these kinds of sophisticated adjustments in Adobe Camera Raw or Aperture—but in a program designed for regular folks?

Suppose you've got everything in the photo looking good, except that you don't have any detail in either the brightest parts of the shot or in murky, dark areas. All you have to do is drag the appropriate slider and marvel as details magically appear. Suddenly, you'll see texture in what was once a washed-out white wall or sky, or details in what used to be a nearly black shadow (Figure 5-14).

Be a careful, though: If you drag either the Highlights or Shadows slider too far, then everything takes on a strange, radioactive sheen. But used in moderation, these sliders work real magic, especially if you're editing raw files.

Sharpness

The Sharpness slider seems awfully tempting. Can iPhoto *really* solve the problem of blurry, out-of-focus photos?

Well, no.

Instead, the Sharpness slider works by subtly increasing the contrast among pixels in your photo, which seems to enhance the crispness. In pro circles, adding a pinch of sharpening to a photo is a regular part of the routine.

To sharpen in iPhoto, drag the Sharpness slider to the right. If you don't like what you see, drag the slider back to the left to reduce the effect. (There's no way to remove sharpness captured in the original photo—in other words, there's no *Softness* slider per se, though you could use the De-noise slider [described next] to blur the photo a little.)

FIGURE 5-14

Left: The Highlights and Shadows sliders are just more examples of the power tucked into the Adjust panel. Even though the photo on the left looks pretty good, there's a lot of detail that's being lost in the highlights.

Right: Drag the Highlights slider to the right and presto! A whole world of detail emerges.

Be careful, though: Too much sharpening can *ruin* a photo, since eventually the pixels become grainy and weird-looking. Fortunately, Apple has mostly protected you from this sort of disaster by keeping both the effects and the *side effects* of the Sharpness control to a minimum. You can help matters by moving the slider in small increments.

Generally speaking, sharpening should be the last Adjust-panel tweak you make to your photo. If you apply other corrections after sharpening, you may discover that you have to sharpen it *again.*

NOTE Keep in mind that photos with a lot of hard lines—landscapes, architecture, or fur-filled pet photos—benefit from a stronger dose of sharpening than, say, portraits, where a lot of sharpening makes imperfections *leap* out of the photo.

And if you're going to *print* the photo, it's OK if it looks a little too sharp onscreen because the printing process will soften it a little.

De-noise

In photographic terms, *noise* means graininess—colored or grayscale speckles. Noise is a common problem in digital photography, especially in low-light shots taken with older cameras. Some cameras, for example, claim to have "anti-blur" features that turn out to be nothing more than goosed-up ISO (light-sensitivity) settings in low light. But go above ISO 800 or so, and the resulting digital noise can be truly hideous.

If a photo looks noisy (grainy), you can lessen the effect by moving the Adjust panel's De-noise slider to the right, which blurs the photo slightly. To gauge how much, first

zoom in on your image to 100 percent size (press the 1 key), and then keep an eye on a dark area or the sky as you move the slider. Generally speaking, moving the slider more than halfway softens your image too much.

The De-noise slider can't work wonders. But by subtly smoothing neighboring pixels, it does a reasonable job of removing noise from low-light photos, which, on grainy shots, can be a definite improvement if your subject is worth saving.

> **TIP** The De-noise slider is also handy to use if you've lightened shadows, as described on page 141, which can introduce noise into the photo.

Color Balance

If all you ever shoot are black-and-white photos, then the Adjust panel's Levels or Exposure/Contrast sliders may be all you ever need. But if you're like *most* people, you're concerned about a little thing called color.

Truth is, digital cameras (and scanners) don't always capture color accurately. Digital photos sometimes have a slightly bluish or greenish tinge, producing dull colors, lower contrast, and sickly looking skin tones. In fact, the whole thing might have a faint green or magenta cast. Or perhaps you just want to take color into your own hands, not only to get the hues right, but also to create a specific mood. For example, maybe you want a snowy landscape to look icy blue so friends back home realize just how darned cold it was!

In addition to the Saturation slider (page 140), the Adjust panel offers two other sliders that wield power over this sort of thing: Temperature and Tint. And it offers two ways to apply such changes: the manual way and the automatic way.

■ MANUAL COLOR ADJUSTMENT

The sliders at the bottom of the Adjust panel provide plenty of color-adjustment power. The Temperature and Tint sliders govern the *white balance* of your photo. Different kinds of light—fluorescent lighting, overcast skies, and so on—lend different color casts to photographs. White balance is a setting that eliminates or adjusts the color cast according to the lighting.

For best results, start with the Tint slider and *then* adjust the Temperature slider:

- **Tint.** Like the tint control on a color TV, this slider adjusts the photo's overall tint along the red-green spectrum. Nudge the slider to the right for a greenish tint, or left for red. As you go, watch the histogram to see how iPhoto is applying the color.

 Adjusting this slider is particularly helpful for correcting skin tones and compensating for difficult lighting situations, like fluorescent lighting.

- **Temperature.** This slider, on the other hand, adjusts the photo along the blue-orange spectrum. Move the slider to the left to make the image "cooler," or slightly bluish. Move the slider to the right to warm up the tones, making them more orangeish—a particularly handy technique for breathing life back into subjects

who have been bleached white with a flash. A few notches to the right on the Temperature slider, and their skin tones look healthy once again!

Professional photographers *love* having color-temperature control; in fact, many photographers can handle the bulk of their image correction with nothing but the Exposure and Temperature settings.

■ AUTOMATIC COLOR CORRECTION

Dragging the Tint and Temperature sliders by hand is one way to address color imbalances in a picture. But there's an *easier* way: Use iPhoto's Automatic Color Adjustment tool to adjust both sliders *automatically.*

It relies on your ability to find, somewhere in your photo, an area of what *should* be medium gray or white (you can use either). Once you find the gray or white point, iPhoto takes it from there—it can adjust all the other colors in the photo accordingly, shifting color temperature and tint with a single click. This trick works amazingly well on some photos.

Before you use this feature, though, make sure you've already adjusted the photo's overall *exposure,* using the techniques described on the previous pages.

Next, scan your photo for an area that should appear as a neutral gray or clean white (something that really *is* white, and not a white reflection). Slightly dark grays are better for this purpose than bright, overexposed grays.

Once you've found such a spot, click the eyedropper next to the Tint slider. Your cursor turns into a + that you can position over your gray or white sample, as shown in Figure 5-15 (left). Then simply click, and iPhoto automatically adjusts the color-balance sliders to balance the photo's overall color (Figure 5-15, right).

If you don't like the results, click the Undo button and then click a different neutral area. You can keep doing this until the photo looks good.

FIGURE 5-15

Left: Click the eyedropper to activate the Automatic Color Adjustment tool, and then position the + cursor on a neutral gray or white area and click once.

Right: iPhoto adjusts the whole photo's color for you, as shown here, and eradicates the yellow color cast.

Thankfully, there's an easy way to check how well iPhoto corrected the photo. Take a look at an area that should be plain white. If it's clean (no green or magenta tint), then you're probably in good shape; if not, then undo the adjustment and try again.

TIP If you're a portrait photographer, here's a trick for magically correcting skin tones. The key is to plan ahead by stashing a photographer's gray card somewhere in the composition that can be cropped out of the final print. Make sure the card receives about the same amount of lighting as the subject.

Later, in iPhoto, click the gray card in the composition with the automatic color corrector, and presto: perfect skin tones! Now crop out the gray card and make your print, grateful for all the time you just saved.

Copy and Paste

Working an image into perfect shape can involve a lot of time and slider-tweaking. And, sometimes, a whole batch of photos require the same fixes—photos you took at the same time, for example.

Fortunately, you don't have to recreate your masterful slider work on 200 photos individually, spending hours performing repetitive work. You can *copy* your adjustment settings from one photo and paste them onto others.

First, make sure you're in Edit view, and then open a photo you've previously edited. Then choose Edit→Copy Adjustments or press Option-⌘-C. Now, move to the next shot (using the thumbnails browser, for example) and then choose Edit→Paste Adjustment or press Option-⌘-V, and iPhoto applies all your corrections to the new picture. You can apply those copied settings to as many photos as you wish.

This is a *gigantic* timesaver when you're correcting several photos shot in the same lighting conditions.

POWER USERS' CLINIC

Coping with Fluorescent Lighting

You can correct most pictures using iPhoto's automatic color-correction tool or its Tint, Temperature, and Saturation sliders. Some images, however, will drive you insane—no amount of tweaking will seem to make their colors look realistic. Pictures taken under fluorescent lighting can be particularly troublesome.

The problem with fluorescent bulbs is that they don't produce light across the entire color spectrum; there are, in effect, spectrum gaps in their radiance. Your best color-correction tool, the Temperature slider, works only on images where your camera captured a full spectrum of light, so it doesn't work well on fluorescent-lit shots.

You'll have some luck moving the Tint slider to the left to remove the green cast of fluorescent lighting. But the overall color balance still won't be as pleasing as with pictures shot under full-spectrum lighting, such as outside on a sunny day.

The best time to fix fluorescent-light color-balance problems is when you take the picture. One solution is to use your camera's flash, and to ensure that it's the dominant light source where possible (its light helps to fill in the gaps in the fluorescent spectrum, making color correcting in iPhoto much easier). Another option is to change your camera's white balance (the setting that controls the color of light) to fluorescent light. Consult your owner's manual to learn how.

TIP You can also Control-click a photo in Edit view and choose Copy Adjustments or Paste Adjustments from the shortcut menu that appears.

Beyond iPhoto

Thanks to the Adjust panel, iPhoto's editing tools have come a long, long way. These days, there's a lot less reason now to invest in a dedicated editing program.

But that doesn't mean that there are *no* reasons left. The Auto Levels command (in Photoshop and Photoshop Elements) is still a better color-fixer than iPhoto's Enhance button, and some people really like the "I'm Feeling Lucky" button in Picasa. You also need a Photoshop-type program to superimpose text on a photo, to combine several photos into one (a collage or a composite), to create partial-color effects (where everything but a single object is black and white)—the list goes on.

Adobe Photoshop is by far the most popular tool for the job, but these days it's available only by subscribing to Adobe's Creative Cloud, and it's also one of the most complicated pieces of software known to man. Fortunately, you can save yourself a lot of money by buying Photoshop Elements instead. It's an easier to use, trimmed-down version of Photoshop with all the basic image-editing stuff and just enough of the high-end features. It costs less than $100, is available without a subscription, plus you can get a free, 30-day trial version from *www.adobe.com*.

TIP Looking to spend a little less? Another great editing program is Pixelmator ($30). You can download a free trial from *www.pixelmator.com*.

The Official Way

As noted at the beginning of this chapter, iPhoto makes it easy to open a photo in another program for editing: You can either use iPhoto's Preferences to specify that you *always* want to edit photos in an external program, or you can Control-click a thumbnail whenever the spirit moves you, and then choose "Edit in external editor" from the shortcut menu.

Either way, the photo opens in the other program. After you make your changes, use the other program's Save command—be sure to pick JPEG as the file format and *don't change the photo's filename or location*—and then return to iPhoto, where you see the changes. If, however, you're editing a raw file, iPhoto opens a *copy* of the file as a JPEG instead (unless you've specifically told iPhoto to open the raw file, as page 149 explains).

The Quick-and-Dirty Way

If you don't want to bother with setting up an external editor in iPhoto's Preferences, then you can also open a photo in another program by dragging its thumbnail *right out of the iPhoto window* and onto the other program's Dock icon. In fact, you can drag *several* thumbnails at once to open all of them simultaneously.

Either way, they open in that other program, and you can happily edit away.

> **WARNING** When you edit a photo in another program the "quick-and-dirty" way, you're essentially going behind iPhoto's back; meaning you're sacrificing your ability to use the "Revert to Original" command (described below) to restore your photo to its original state in case of disaster.

Reverting to the Original

iPhoto includes built-in protection against overzealous editing—a feature that can save you much grief. If you end up cropping a photo too much, cranking up the brightness of a picture until it seems washed out, or accidentally turning someone's lips black with the red-eye tool, you can undo all your edits at once with the "Revert to Original" command. This command strips away *every change you've ever made* since the picture arrived from the camera, leaving you with your original, unedited photo.

The secret of the "Revert to Original" command: Whenever you use any editing tools, iPhoto—without prompting and without informing you—creates a *list* of your changes and records them in its database; those changes aren't really *applied* to the image until you export it for use *outside* of iPhoto. With this system, you can remain secure in the knowledge that, in a pinch, iPhoto can always restore an image to the state it was in when you first imported it.

To restore an original photo (undoing all cropping, rotation, brightness adjustments, and so on), select a thumbnail and then choose Photos→"Revert to Original," or Control-click a photo and choose "Revert to Original" from the shortcut menu. (When you're editing a photo, the command reads "Revert to Previous" instead; choosing it removes the changes you've made during this editing session.) iPhoto swaps in the original version of the photo, and you're back where you started.

As noted earlier, iPhoto keeps a running list of your changes whenever you edit your pictures (a) within iPhoto or (b) use a program that you've set up to open when you enter Edit view. It does *not* create a list of changes when you drag a thumbnail onto another program's Dock icon. In that event, while you can still *choose* "Revert to Original," nothing happens.

> **NOTE** In earlier versions of the program, unedited originals were stored in an Originals folder inside the iPhoto Library package (page 25) and the edited versions (duplicates, really) were stored in a folder called Modified, which doesn't exist anymore. These days, iPhoto tracks edits in its database, which is far more efficient than duplicating files.

■ Editing Raw Files

Happily, iPhoto can work with files shot in raw format—the special, unprocessed file type that takes up a lot of space on your memory card but offers astonishing amounts of control when editing. Raw is generally available on most newer cameras over $300, and all SLR cameras (those that can handle interchangeable lenses).

> **TIP** Don't know which photos are raw files? You could pop open the Info panel to find out or take a peek at the top right of your histogram in the Adjust panel, but there's a faster way. In fact, you can gather up *all* your raw files by creating a smart album. Choose File→New Smart Album and set the pop-up menus to "Filename," "contains," and, in the text field, type the file extension that your particular camera gives to raw files (Canon uses *cr,* Nikon uses *nef,* Olympus uses *orf,* and so on). When you click OK, iPhoto corrals all the raw files in your library into a single album.

Actually, iPhoto can do more than *handle* raw files. It can even edit them...sort of.

iPhoto is, at its heart, a program designed to work with JPEG files. Therefore, when it grabs a raw file from your camera, it creates a JPEG version of it. The raw file is there on your hard drive, deep within the labyrinth known as the iPhoto Library package. But when you open the photo in iPhoto, what you see onscreen is a JPEG *interpretation* of that raw file. (This conversion to JPEG is one reason iPhoto takes longer to import raw files than other formats.)

This trick of using JPEG look-alikes as stand-ins for your actual raw files has two important benefits. First, it lets you work with your photos at normal iPhoto speed, without the lumbering minutes of calculations you'd endure if you were working with the original raw files. Second, remember that your iPhoto photos are also accessible from within iMovie, Pages, and so on—programs that don't understand raw files.

So the question naturally comes up: What happens if you try to *edit* one of these raw-file stunt doubles?

No problem. iPhoto accepts any changes you make to the JPEG version of the photo. Then, behind the scenes, it reinterprets the original raw file, applying your edits. Finally, it generates a new JPEG for you to view.

POWER USERS FORUM

The Secret Recovery Slider

As Chapter 1 explains, photos captured in raw format contain far more information than their JPEG brethren (page 19). And as you learned in this section, iPhoto was really built to handle JPEG files. Even so, a little more raw editing power seems to sneak into the program now and then.

Case in point: If you open a raw file in Edit view and then open the Adjust panel, you can hold down the Option key to make the Exposure slider change to a *Recovery* slider. If you continue to hold down Option as you drag the slider to the right, you can recover hidden details in the highlights that iPhoto didn't initially display (alas, it doesn't work on shadows). Who knew?!

External Raw Editors

It's nice that iPhoto comes with such powerful editing tools, and that you can use them to work with raw files. Nevertheless, iPhoto doesn't offer *every* conceivable editing tool. So what happens if you want to edit your raw files in another program, while still using iPhoto to organize them? Here, life can get a little complicated.

NOTE iPhoto 9.5 shares its library with Aperture 3.3 and later (Apple's pro-level photo editing program). That means you can share files *between* the two without having to import or export them. See the box on page 314 for more info.

First, choose iPhoto→Preferences→Advanced, and turn on "Use RAW when using external editor." You've just told iPhoto that you want to work with raw files in a different program, probably Adobe Camera Raw (the raw-file editor that comes with Photoshop and Photoshop Elements), Lightroom, Aperture, or the raw editor that came with your camera (if you installed the manufacturer's software, that is).

Now, when you open a raw file for editing, one of two things may happen:

- **If you've never edited the raw file,** it opens in Adobe Camera Raw (or whatever raw-editing program you use), ready for editing.

- **If you *have* edited the file in iPhoto,** then iPhoto sends the edited *JPEG* file to Camera Raw (or your raw editor of choice) instead of the raw file! And that's probably not what you want.

 You can correct this case of mistaken identity by closing the photo and returning to iPhoto. Click the raw file's thumbnail and then choose Photos→Reprocess RAW. (This command replaces the "Revert to Original" command when you're working with raw files.) iPhoto strips away your previous edits, and now you can double-click the picture to open it in your external raw editor.

But beware! You can't just click the Save button and smile, confident that you'll see the edited version of the photo when you return to iPhoto. That's how things work with JPEG files, as described earlier in this chapter, but not with raw files.

Instead, you have to use Camera Raw's Save As command to save the edited picture as a *new file* on your hard drive. You'll probably want to export it as a JPEG file, because that's the easiest format to work with in the iMovie, email, on the Web, and so on. (Remember, your original raw file is still tucked away safely in the iPhoto library if you want to revisit it. All you have to do is double-click its thumbnail again, and you're right back in Camera Raw.)

When you click Save, a JPEG version of your edited raw file is waiting for you on the desktop. Click Done in Adobe Camera Raw to make it go away.

Your last step, believe it or not, is to *reimport* the edited JPEG file back into iPhoto. First, though, you may want to make sure that the file number (IMG_6268.jpg, say) is the same as the original raw version in iPhoto (IMG_6268.CR2). Why? Because

you're going to wind up with the edited JPEG *and* the original raw file side by side in your library.

This roundabout method of editing a raw file is not, ahem, the height of convenience. However, if you want to use high-level image controls for your raw files—in a program *other* than Aperture (page 314)—then this is the path you must take, Grasshopper.

16-Bit TIFF Files Instead of JPEGs

For some time, high-end iPhotonauts bearing fancy cameras and memory cards full of raw files have groused a bit about their choices. They could keep sending their raw files on that clumsy roundtrip to Photoshop, they could use Aperture (page 314), or they could work with iPhoto's converted, lower-quality JPEG files instead.

But for a few versions now, there's been a third option: They can tell iPhoto to convert those raw files into TIFF files instead of JPEGs.

TIFF is an extremely high quality graphics format that's frequently used in professional printing. (All the illustrations in this book, for example, are TIFF files.) If you intend to print high-quality enlargements directly from iPhoto, then it might be worth telling iPhoto to convert your raw files into TIFFs instead of JPEGs.

To make this switch, choose iPhoto→Preferences→Advanced, and then turn on "Save edits as 16-bit TIFF files."

However, you pay a price for making this switch.

First, if you've already edited some of your raw files, then iPhoto has *already* converted them to JPEG format. You'll have to strip away your edits by selecting the thumbnails and choosing Photos→Reprocess RAW (you'll see that command only if you've edited raw files in another program or in an earlier version of iPhoto). *Now* when you open those files for editing, they'll turn into fully editable 16-bit TIFF files within iPhoto.

Second, you'll pay an enormous price in hard drive space.

Suppose that you start with a raw file that takes up about 8 megabytes of space in your iPhoto library. You make a few edits; iPhoto generates a working JPEG that adds another 1.2 megs; fine.

But then you decide to reach for the brass ring of quality, so you instruct iPhoto to reprocess that raw file and convert it into a TIFF instead. That TIFF version will add *62 megabytes* to your library, just for that one picture!

The moral: Save the TIFF-conversion business for your most prized photos, the ones that really merit that file format and all that quality. And once you've finished working with them, return to the Preferences menu and turn off the checkbox.

iPhoto Slideshows

Photo's slideshow feature offers one of the world's best ways to show off your digital photos (and videos, for that matter). Slideshows are incredibly easy to set up, they're free, and they make your photos look *fantastic.*

In the current version of iPhoto, you'll find six slideshow themes that include flying, animated visual effects, and one that uses Places tags (Chapter 4) to make your photos emerge from different spots on a spinning globe. Several themes come with their own soundtracks, so the animations and music match, while others merely feature semi-recognizable tunes. And all the themes also take advantage of iPhoto's face-recognition smarts—they try to center your subjects' faces onscreen during the slideshow.

> **NOTE** You can also send your slideshows over to iTunes in order to sync them with your iPhone or iPad. Skip ahead to page 323 to learn how.

This chapter details not only how to put together an iPhoto slideshow, but also how to create presentations that make you *and* your photos look their absolute best.

> **NOTE** In the past, instead of running a slideshow directly from iPhoto, you could send it—music and all—from iPhoto to iDVD, Apple's DVD-authoring program. But Apple has discontinued iDVD; you can't get it anymore. If you happen to still have a copy, you can download the PDF "iDVD Slideshows" from this book's Missing CD page at *www.missingmanuals.com/cds*.

About Slideshows

When you run an iPhoto slideshow, your Mac presents the pictures in Full Screen view—no windows, no menus, no borders—with your images filling every inch of your monitor. Professional transitions take you from one picture to the next, producing a smooth, cinematic effect. If you want, you can change or turn off the music that accompanies the presentation (each theme comes with its own soundtrack). The overall effect is incredibly polished, yet creating a slideshow requires very little setup.

> **NOTE** If you're lucky enough to have more than one monitor—or if you've got a laptop plugged into an external monitor or a TV—the slideshow plays on the monitor containing the iPhoto window. The other monitor displays solid black. To create a slideshow that uses *both* screens, you'll need to use a screensaver instead (page 285 tells you how).

Start by picking the pictures you want to include—by selecting an album or an Event, for example. You can also make slideshows based on a particular person on your Faces corkboard or a location in Places (both features are covered in Chapter 4). Once you've done that, you can kick off a slideshow in two different ways:

- **Instant.** Click the Slideshow button in the middle of the iPhoto toolbar. Your screen goes black and the Themes panel appears, asking you to pick a visual animation style for your slideshow, as described in the next section. Click a theme's thumbnail to choose it. If you're feeling feisty, you can also change the music and other settings using the tabs at the top of the panel. But if you just want to see the show, click Play.

 In Faces view, you can kick off an instant slideshow by Control-clicking a Faces album and choosing Play Slideshow from the shortcut menu.

- **Saved.** In the early days of iPhoto, each album had its own slideshow settings. The album was, in essence, the container for the slideshow.

 That was a convenient approach, but not the most flexible. For example, it meant that if you wanted a slideshow that displayed only *half* the pictures in an album, then you had to make a new album just for that purpose. It also meant that you couldn't create different slideshow versions of the same album's worth of photos—a 2-seconds-per-shot version for neighbors, for example, and a 10-seconds-per-shot version for adoring grandparents.

 These days, iPhoto offers *saved* slideshows, which appear in the Source list and are independent of any album. They work a lot like an album in many ways. For example, the photos inside are only "pointers" to the real photos in your library, and you can drag them into any order you like. On the other hand, unlike an album, a saved slideshow contains special advanced controls for building a shockingly sophisticated slideshow.

This chapter covers both techniques.

Slideshow Themes

One of iPhoto's most fun features is *themed slideshows,* and Apple frequently adds new ones. Peppered with fancy graphics and animation, these visual presentation styles spice up your slideshows with a minimum of effort on your part.

As shown in Figure 6-1, the first thing iPhoto wants you to do when you play an instant slideshow is to pick a theme from the Themes panel. Your choices include these:

- **Ken Burns.** If you like that slow pan-and-zoom approach that made the documentary filmmaker famous, you can use it yourself. There's more on the man and his technique in the box on page 155.

- **Origami.** This theme displays your photos by folding them open into a variety of different sized squares and rectangles. This effect made its debut on the iPad, but is even better here in iPhoto because any faces the program detects are *centered* within each shape instead of being clumsily cropped.

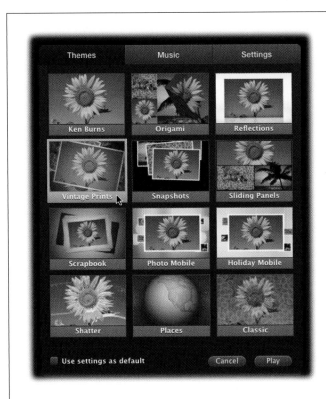

FIGURE 6-1

Click the Slideshow button on the iPhoto toolbar, and you see this panel, where you can pick a theme for your show. To preview a theme, simply point your cursor at its thumbnail.

Click a theme's thumbnail to select it, and then click Play to see your photos, accompanied by iPhoto's default music. You can also click the Music and Settings tabs in the panel to tinker with the options before the first slide even plays.

- **Reflections.** This one pairs the Ken Burns zoom effect with photos (or groups of photos) on a white background. Look closely and you'll see a pretty little reflection near the bottom of your screen.

- **Vintage Prints.** One of the most beautiful and artistic themes in the bunch, this one displays your photos as if they were the white-bordered prints of yester-year, and puts them in a big messy stack that fills your screen. The photo on top appears in color, and the rest are black and white. The stacks then zoom in and rotate, à la Ken Burns.

- **Snapshots.** This theme also puts white borders around your photos, and slides the old-style photos into the *center* of the screen, as if they were stacked semi-neatly on your coffee table. As the next photo arrives, it appears to land on top of the previous few shots, which fade to black-and-white in the background.

- **Sliding Panels.** Another motion-filled theme, Sliding Panels lives up to its name by slipping your photos onto the screen from several directions. It also displays multiple pictures at once, sort of like the typical layout in a celebrity magazine. It's trendy.

- **Scrapbook.** In this theme, your photos are cleverly displayed in the textured pages and frames of an old-fashioned scrapbook, just like Grandma used to make out of paper and glue. The camera pans across these scrapbook pages, pausing to admire each photo.

- **Photo Mobile, Holiday Mobile.** These motion-packed themes make your photos swing in and out of view, bobbing and dangling as if they were attached to a real mobile. The Holiday version even has snowflakes falling in the background.

- **Shatter.** This theme colorfully smashes apart your photos across the white expanse of screen—only to *reassemble* them into the next photo. This hyperki-netic theme works great for slideshows filled with action shots. For weddings or memorials? Not so much.

- **Places.** Perhaps the most animated of the slideshow themes, this one begins with a huge, spinning, 3D globe. Next, it zooms into a slightly tilted map displaying red marker pins and small thumbnails of the photos you took in those spots, and then zooms in on each photo. It's impressive, but if you haven't geotagged any of your photos (as described in Chapter 4), you'll see the slightly depressing message shown in Figure 6-2.

- **Classic.** It worked for Coca-Cola, so Apple has rebranded the old iPhoto slide-show style as "Classic." It's classic indeed: Each slide appears for a couple of seconds, filling the screen, and then fades into the next. You have lots of control over this theme's transitions and other effects.

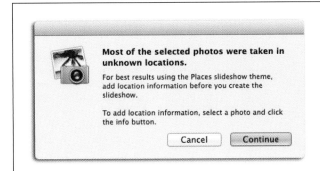

FIGURE 6-2

iPhoto hates for you to be disappointed, so you see this message if you choose the Places theme and haven't yet geotagged the photos you selected. Bummer!

Instant Slideshows

An *instant* slideshow is one that you begin by clicking Slideshow in the iPhoto toolbar, as shown in Figure 6-3. Instant slideshows aren't quite as instant as they used to be in early versions of iPhoto, but with the built-in themes, you get a slick, fancy slideshow in just a couple of clicks.

> **TIP** You can also create an instant slideshow by Control-clicking a Faces album and choosing Play Slideshow from the shortcut menu.

The Ken Burns Effect

Who's this Ken Burns guy, and what's his effect?

Apple first introduced what it calls the "Ken Burns effect" in iMovie, not iPhoto. It's a special effect designed to address the core problem associated with using still photos in a movie—namely, that they're *still!* They just sit there without motion or sound, wasting much of the dynamic potential of video.

For years, professional videographers have addressed the problem by using special sliding camera rigs that produce gradual zooming, panning, or both, to bring photographs to life. Among the most famous practitioners of this technique is Ken Burns, the creator of PBS documentaries such as *The Civil War, Baseball,* and *The National Parks*—which is why Apple, with Burns' permission, named the feature after him.

And now your own humble slideshows can have that graceful, animated, fluid Ken Burns touch or even a whole Ken Burns theme. No photo ever just sits there motionless on the screen. Instead, each one flies gracefully onscreen or off, sliding and zooming.

It's a great effect, but it can occasionally backfire. Every now and then, for example, the photo's subject won't be centered, or the photo won't make it completely onto the screen before the next one appears. (One of the virtues of the *saved* slideshow, described on page 164, is that *you* control where the Ken Burns panning and zooming begins and ends.)

FIGURE 6-3

The quickest way to kick off a slideshow in iPhoto is to click the Slideshow button at the bottom of your iPhoto window (or monitor, if you're in full-screen view).

TIP While there's no keyboard shortcut for starting a slideshow, you can press the space bar to *pause* it, or use the arrow keys to move through the show manually, photo by photo. To stop a show once it's running, either press the Esc key or wiggle your mouse so the slideshow controls appear, and then click the X.

Picking Photos for Instant Slideshows

Among the virtues of instant slideshows is the freedom you have to choose which pictures you want to see. For example:

- If no photos are selected when you start the show, iPhoto exhibits all the pictures currently in the photo-viewing area, starting with the first photo in the album, Faces stack, or Event.

- Most of the time, people want to turn an *album* into a slideshow. That's easy: Just click the album before starting the slideshow. It can be any album you've created, a smart album, the Last Import album, or one of iPhoto's Recent collections. As long as no individual thumbnails are selected, iPhoto displays all the pictures in the album.

TIP You can also create an instant slideshow from *multiple* albums by selecting more than one album simultaneously (by ⌘-clicking them). When you click Play, iPhoto creates a slideshow from *all* of their merged contents, in order.

- If *one* photo is selected, iPhoto uses that picture as its starting point for the show, ignoring any that come before it. If you've got the slideshow set to loop continuously (page 164), then iPhoto will eventually circle back to display the first photo in the window.

- If you've selected more than one picture, iPhoto includes *only* the selected pictures.

Photo Order

iPhoto displays your pictures in the same order you see them in the photo-viewing area. In other words, to rearrange your slides, drag the thumbnails around within their album. Just remember that you can't drag pictures around in an Event, Faces, Places, smart album, the Last 12 Months collection, or the Last Import folder—only within a *regular* album.

NOTE If iPhoto appears to be shamelessly disregarding the order of your photos when running a slideshow, it's probably because you've got the "Shuffle slide order" option turned on in the Settings panel, as described on page 164.

Adjusting the Slideshow's Settings

After you click the toolbar's Slideshow button, the iPhoto window expands to fill your monitor, turns black, and displays the Themes panel. Here's what to do next:

1. **Click to select one of the 12 themes shown back in Figure 6-1.**

 Point to a theme's thumbnail without clicking to see a tiny preview of what it does. If you turn on "Use settings as default," then iPhoto saves these settings, but only for *this* slideshow—not for all your slideshows from here on out.

2. **Adjust the music and transitions by clicking the Music and Settings tabs.**

 Each theme comes with its own soundtrack. In fact, Apple paid a lot of money for them, and they include such famous copyrighted tunes as "You've Got a Friend in Me" by Randy Newman and the theme from "Peanuts" by Vince Guaraldi. In fact, iPhoto includes a number of songs that were scientifically engineered to work well with its animated themes. But if you don't care for the canned music or preselected transitions, click the appropriate tabs and make your own adjustments. The following sections explain how.

3. **Click Play.**

 The slideshow starts, beginning with the title of the album. Sit back and enjoy the fruits of your clicking.

What to Do During a Slideshow

Aside from appreciating the sheer beauty of the thing, if you wiggle your mouse while the slideshow is playing, you get the control bar shown in Figure 6-4. Here's what you can do while this bar is onscreen:

- Click **II** to pause the show, or click the arrow buttons to skip forward or back.

- Click the two-slide icon to reopen the Themes panel shown in Figure 6-1, and then click to pick another theme if the current one isn't rocking your world.

- Click the musical notes to open the Music chooser, shown on page 159.

- Click the ✿ icon to open the Settings panel, where you can change the slide-show's timing and transitions (page 161).

- Finally, click the X to close Full Screen view, end the slideshow, and go back to the regular iPhoto window.

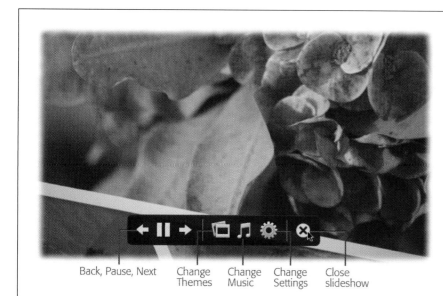

FIGURE 6-4

As the slideshow progresses, you can pause the show, go backward, or get to the panel for Themes, Music, and Settings, all courtesy of this onscreen control bar.

The Vintage Prints theme was used here (it's visible near the bottom). Nifty, isn't it?

Back, Pause, Next Change Change Change Close
 Themes Music Settings slideshow

If you wait long enough without clicking anything, the control bar eventually disappears, returning the slideshow to its full-screen glory.

Music: Soundtrack Central

Perhaps more than any other single element, *music* transforms a slideshow, turning ordinary photos into a cinematic event. When you pair the right music with the right pictures, you do more than just show off your photos; you create a mood that can stir the emotions of your audience. So if you really want your friends and family to be transfixed by your photos, then add a soundtrack. That's especially easy if, like many Mac fans, you've assembled a collection of your favorite music in iTunes, the music-playing program that comes with every Mac.

For the background music of an iPhoto slideshow, you have the choice of an individual song from your iTunes library or an entire *playlist.* Gone are the days of listening to the same tune repeating over and over again during a lengthy slideshow—a sure way to go slowly insane.

The possibilities of this feature are endless, especially combined with iPhoto's smart albums (page 59). You can create a smart album that contains, say, only photos of your kids taken in December, choose the Holiday Mobile theme, give it a soundtrack composed of holiday tunes (created effortlessly using a smart playlist in iTunes), and you've got an instant holiday slideshow!

Your first iPhoto slideshow is born with several ready-to-use soundtracks—as noted earlier, they include expensively licensed songs by Randy Newman, Miles Davis, and Vince Guaraldi. And if you choose one of the animated themes, the song syncs perfectly with the animation (or, at least, it's supposed to).

iPhoto includes a multitude of songs. To see them all, open the Themes panel and then click the Music tab (Figure 6-5). In that tab's Source menu, selecting Theme Music shows you all the built-in theme soundtracks included in iPhoto. You can also choose Sample Music to find 11 more slideshow-worthy tracks, including two hits from J.S. Bach and some other instrumentals from various musical genres.

TIP Inspired to make a playlist right here in iPhoto's Music panel? Turn on the "Custom Playlist for Slideshow" setting and drag song titles from the list above into the field that appears.

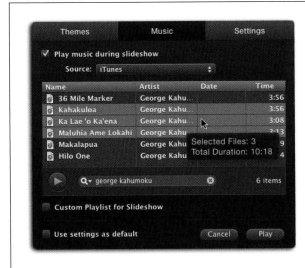

FIGURE 6-5

The Music panel lets you choose a playlist or individual songs from your iTunes library (depending on what you pick from the Source menu shown here). By clicking the column headings, you can sort the song list by name, artist, date, or length. You can also use the Search box to pinpoint an individual song or artist, as shown here. To select several songs, ⌘-click each one. Point your cursor at a song to have iPhoto tell you the duration of the songs you've chosen.

If you have a long slideshow, you can use the Source menu to choose an iTunes playlist rather than a single song. iPhoto repeats the song (or playlist) for as long as your slideshow lasts.

Of course, you can also choose music from your own collection. If you choose GarageBand from that Source menu, you can select any musical masterpieces you've created yourself, using GarageBand, Apple's music-recording program.

Most people, however, choose iTunes from this menu. When you do that, every track and playlist in your iTunes library automatically appears in the Music panel's list. You can search and sort through your songs and playlists, just as if you were in iTunes itself. In other words, you can use this list either to select an entire playlist to use as your soundtrack, or to call up a playlist and then select individual songs within it.

Here are a few other tricks you can use in the Music panel:

- To listen to a song before committing to it as a soundtrack, double-click it, or click its name in the list, and then click ▶. Click the same button when you've heard enough.

- To use an entire playlist as a soundtrack for your slideshow, select it in the list. At slideshow time, iPhoto begins the slideshow with the first tune in the playlist and continues through all the songs before starting over.

- To use an individual song as a soundtrack, click its name in the list. That song will loop continuously for the duration of the slideshow.

- To use more than one song as a soundtrack, ⌘-click each one in the list.

- Rather than scroll through a huge list, you can locate the tracks you want by using the capsule-shaped Search box below the song list. Click the Search box, and then type a word (or part of a word) to filter your list. iPhoto searches the Artist, Name, and Album fields of the iTunes library and displays only the matching entries. To clear the search and view your whole list again, click the X in the Search box.

- Click one of the three headers—Name, Artist, or Time—to sort the iTunes music list by that header.

- You can change the arrangement of the three columns by grabbing the headers and dragging them into a different order.

- The "Custom Playlist for Slideshow" setting lets you whip up a mini-playlist right here, right now. When you turn on this option, an empty field appears below the list of songs. Scroll through the songs in the top part of the panel; when you find one you want to include in the soundtrack, drag it down into the lower field. Drag the tracks up and down within the playlist to rearrange them.

Once you've settled on (and clicked) an appropriate musical soundtrack for the current slideshow, you can turn on "Use settings as default" (to memorize that choice without starting the slideshow) or Play (to begin the slideshow). From now on, that song or playlist plays whenever you run an instant slideshow from that album.

Alternatively, if you decide you don't want any music to play, then turn off "Play music during slideshow."

Different Shows, Different Albums

You can save different slideshow settings for each item in your Source list.

To save settings for a specific album, for example, first choose the album in the Source list, and then click the Slideshow button in the iPhoto toolbar to open the slideshow panel (Figure 6-1). On the Music and Settings tabs, you can pick the speed, order, repeat, and music settings you want; finally, turn on "Use settings as default." The settings you saved *automatically* kick in each time you launch a slideshow from that particular album.

▩ Slideshow Settings

With the theme and music taken care of, the Settings tab of the slideshow panel handles just about everything *else* that makes a great presentation. On this tab, you can fiddle with the timing between slides, the Hollywood-style transitions between each shot, titles and captions, and other elements that influence the slideshow's look and feel. The options available depend on which theme you're using.

Slide Timing

If left to its own devices, iPhoto advances through your pictures at the rate of one photo every 3–7 seconds, depending on the theme. These durations are fine for most purposes, but you can change the rate.

On the Settings tab of the slideshow panel, use the "Play each slide for a minimum of __ seconds" option to specify a different interval, as shown in Figure 6-6. Or, if you want your slideshow to last exactly as long as the song or playlist you chose for the soundtrack, select "Fit slideshow to music."

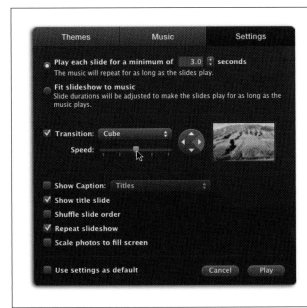

FIGURE 6-6

The controls in the Settings panel let you fine-tune the timing and transitions between slides. (Depending on your theme, you may not see all these options.) Turn on the Transition setting and then use the pop-up menu to test different effects for getting from one slide to the next.

In the lower part of the panel, you can tell iPhoto whether to display the titles, locations, and descriptions you may have spent hours adding to your photos.

Turn on "Use settings as default" if you want to save your tinkerings. "Default" here doesn't mean that iPhoto will use these settings for all your slideshows—just this one.

Transitions

Themes like Shatter and Sliding Panels use special transition effects between images. But if you're using the Classic or Ken Burns theme for your show, you can choose from 14 different types of transitions—for example, the classic crossfade or dissolve, in which one slide gradually fades away as the next "fades in" to take its place. Here's a summary:

- **Random.** iPhoto uses a combination of its various transitions throughout the slideshow.

- **None.** An abrupt switch, or simple cut, to the next image.

- **Cube.** Imagine that your photos are pasted onto the sides of a box that rotates to reveal the next one. If you've ever used OS X's Fast User Switching feature, you've got the idea.

- **Dissolve.** This is the classic crossfade.

- **Droplet.** This wild effect resembles animated, concentric ripples expanding from the center of a pond; the new image forms as the ripples spread.

- **Fade Through Black.** After each slide has strutted and fretted its time upon the stage, the screen momentarily fades to black before the next one fades into view. The effect is simple and clean, like an old-fashioned living-room slideshow. Along with Dissolve, this effect is one of the most *natural* and least distracting choices.

- **Flip.** The first photo seems to flip over, revealing the next photo pasted onto its back.

- **Mosaic Flip Large, Mosaic Flip Small.** iPhoto divides the screen into squares, each of which rotates in turn to reveal part of the new image, like puzzle pieces turning over. (The two options refer to the size of the puzzle pieces.)

- **Move In.** Photos slide in un-dramatically from the edges of the screen.

- **Page Flip.** Apple is just showing off here. The first photo's lower-right corner peels up like a sheet of paper, revealing the next photo "page" beneath it.

- **Push, Reveal, Wipe.** Three variations of "new image sweeping onto the screen." In Push, Photo A gets shoved off the screen as Photo B slides on. In Reveal, Photo A slides off, revealing a stationary Photo B. And in Wipe, Photo A gets covered up as Photo B slides on.

- **Twirl.** Photo A appears to spin furiously, shrinking to a tiny dot in the middle of the screen—and then Photo B spins onscreen from that spot. The whole thing feels a little like the spinning-newspaper effect used to signify breaking news in old black-and-white movies.

In most cases, choosing a transition effect makes two additional controls "light up" just below the pop-up menu:

- **Speed.** Move the slider to the right for a speedy transition, or to the left for a leisurely one. Take into account your timing settings: The less time your photo is onscreen, the better off you are with a fast transition, so that your audience has time to see the picture before the next transition starts. However, moving the Speed slider *all* the way to the right produces a joltingly fast change.

- **Direction.** This arrow-covered wheel determines the direction the new image enters from. Click the corresponding arrow to choose right to left, top to bottom, left to right, or bottom to top. As soon as you click, iPhoto shows you what the transition will look like in the preview area to the right of the wheel. (Most people find left to right the most comfortable, but a slow top-to-bottom wipe is pleasant, too.)

Show Caption

Need some words to go with the music? Use this pop-up menu to show text like descriptions, places, dates, or titles.

As you know from Chapter 2, every photo in your collection can have a name—a title, in other words. And if you want to show off your geotagged pictures (page 103) from your cross-country trip, it's easy to put all those place names and descriptions up on the big screen. If you turn on this option, iPhoto superimposes the selected text in big white letters on the lower corner of the image, as shown in Figure 6-7.

NOTE The Show Caption option works only with themes that *aren't* animated, meaning you can use it only on the Ken Burns and Classic themes. After all, rotated or bouncing text is pretty tough to read.

FIGURE 6-7

If you don't feel like narrating your slideshow, then fill in the title and description fields in the Info panel (page 63).

When it comes time to set up the slideshow, turn on Show Caption in the Settings panel, and then choose the text you want to display (titles and descriptions are turned on here). When you play the slideshow, iPhoto lets your viewers know what they're looking at, and if you're clever with what you enter, you can do a wee bit o' branding!

Needless to say, the cryptic filenames created by your digital camera (like *IMG_0034. jpg*) usually don't add much to your slideshow. But if you've taken the time to give your photos helpful, explanatory titles ("My dog, age 3 months"), then by all means turn on the Show Captions checkbox and choose the text you want to display.

Show Title Slide

Show titles? Sure—*Fiddler on the Roof! West Side Story! Cats!*

Just kidding.

Turn on "Show title slide" if you want the first slide in the show to display the name of the album, face, or place you're basing the slideshow on. (Try it before you chuck it; it's actually a great way to start a slideshow.)

Shuffle Slide Order

An iPhoto slideshow normally displays your pictures in the order they appear in the photo-viewing area. But if you'd like to add a dash of surprise and spontaneity to the proceedings, then turn on "Shuffle slide order." Now iPhoto displays the pictures in whatever random order it pleases.

Repeat Slideshow

When iPhoto is done running through all your photos in a slideshow, it ordinarily starts playing the whole sequence from the beginning again. If you want your photos to play just once through, then turn off "Repeat slideshow."

Scale Photos to Fill Screen

If any photos in your slideshow don't match your screen's proportions, then you may want to turn on "Scale photos to fill screen." For example, if your slideshow contains photos in portrait orientation—that is, pictures taken with the camera rotated—iPhoto normally fills up the unused screen space on each side with vertical black bars.

Turning on this setting makes iPhoto enlarge the picture so much that it completely fills the screen. This option, however, comes at a cost: Now the top and bottom of the picture are lost beyond the edges of the monitor.

When the middle of the picture is the most important part, this option works fine. But if it's not and the black bars bother you, then the only other alternative is to crop the odd-sized pictures in the saved slideshow (or album) to match your monitor's shape. (See "Cropping" on page 128.)

> **NOTE** This option doesn't mean "Enlarge smaller photos to fill the screen"—iPhoto always does that. This option affects only photos whose *proportions* don't match the screen's.

▓ Saved Slideshows

iPhoto also offers *saved* slideshows, each of which appears as an icon in your Source list. The beauty of this system is that you can tweak a slideshow to death—you can even set different transition and speed settings for *each individual slide*—and then save all your work as a clickable icon, ready for playback whenever you've got company. Saved slideshows are also a snap to shuttle over to your iPad, iPhone, or iPod for musical memories on the go (page 321).

TIP Saved slideshows are a great way to create a pro-level portfolio of your artwork or photography, especially since they're so easily shared with your iPad (page 322).

Here's how you create and fine-tune a saved slideshow:

1. **Select the photos you want to include.**

 You can select either a random batch of thumbnails (using any of the techniques described on page 46) or an icon in the Source list (like an album, Place, or Face).

TIP By Shift-clicking or ⌘-clicking, you can actually select *several* icons in the Source list simultaneously. When you proceed to step 2, iPhoto merges their contents into one glorious slideshow.

2. **Choose File→New Slideshow.**

 Thunder rumbles, the lights flicker—and you wind up in the slideshow-editing mode shown in Figure 6-8, which has some features of Edit view and some features of regular old thumbnail-organizing mode. The first thing you see is a title slide with the name of the album superimposed atop your first photo.

NOTE While the title of your slideshow appears on a solid black slide in the thumbnail browser at the top of your screen, that's not how it'll play: It'll be superimposed atop your *first photo* instead. Feel free to change the font, size, or text itself; just highlight it and then press ⌘-T to summon OS X's Fonts dialog box.

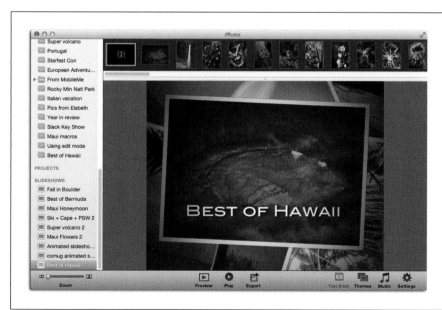

FIGURE 6-8

In the slideshow editor, the window shape is designed to mimic the shape of your Mac's monitor (or whatever screen proportions you've specified in the Settings panel); that's why gray bars may appear on the left and right sides of your slides. The Themes, Music, and Settings options in the toolbar let you finesse the slideshow as you go. Click Preview to play the show in the iPhoto window.

In addition, a new icon with the name of the album appears in the Slideshow section at the bottom of the Source list, selected so you can rename it.

3. **Choose a playback order for your pictures.**

The trick here is to drag the thumbnails at the top of the window horizontally into the order you want them to play (it's much easier to reorder them in the *album* before you create the slideshow). You can move them en masse, too. For example, click slide number 1, Shift-click slide number 3, and then drag the three selected thumbnails to a different spot in the lineup.

4. **Click Themes in the toolbar to choose one of the 12 themes (page 153).**

Each theme's thumbnail image gives the vaguest hint of what to expect; point at it without clicking to see an animated preview. If you don't like the theme, you can always change it later.

5. **Click Music and Settings in the toolbar to set up the global playback options.**

These options let you choose settings that affect *all* slides in the show (like timing and transitions). You can read about what these controls do in the next section.

6. **If you like, walk through the slides one at a time, and set up their individual characteristics.**

For example, you can choose to have one slide linger longer on the screen, have another dissolve (rather than wipe) into the next picture, and so on. This kind of thing is great for creating a pro-level portfolio of your photography or other artwork.

7. **Preview the show.**

Click Preview in the toolbar, and iPhoto plays a miniature version of the slideshow. If you have a photo selected, iPhoto starts the preview there.

8. **Roll it!**

When everything looks ready, click Play in the toolbar to watch the slideshow in full-screen view. Here again, if a photo is selected, that's where iPhoto starts the show.

When it's over, you can do all the usual things with the saved slideshow that now resides in your Source list:

- **Delete it.** Drag it onto the iPhoto Trash icon, as you would an album. When you're asked if you're sure, click Delete or press the Return key.

- **File it away.** Drag it into an iPhoto folder (page 62) to keep it organized with the related albums and books.

- **Rename it.** Click its name and then type away.

- **Edit it.** Click its icon and then use the toolbar settings to tweak it.

Global Settings

As indicated by the preceding steps, you can make *two* kinds of changes to a saved slideshow: global ones (which affect all slides) and individual ones.

You access most of the global options by clicking Settings in the toolbar, which summons the panel shown in Figure 6-9. Clicking the Themes and Music buttons call up panels, too, as you'd expect.

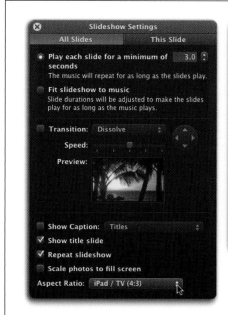
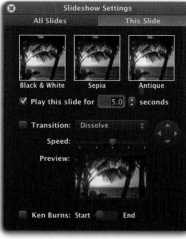

FIGURE 6-9

Left: The Slideshow Settings panel's All Slides pane offers a few options that you don't see when creating an instant slideshow. Everything here is wired for a single purpose: to establish the standard settings for every slide in the show.

Right: Of course, you can override these settings on a slide-by-slide basis. The This Slide panel lets you change the color-treatment of individual slides to black & white, sepia, or antique; adjust the speed of a transition; and control the amount of time a slide stays onscreen.

■ THE THEMES PANEL

This is the same panel with the same 12 themes you saw before (Figure 6-1). If you decide the Snapshots theme just doesn't work for a slideshow of the high-school football game, then pick another one here.

■ THE MUSIC SETTINGS PANEL

The Music Settings panel should look familiar; it's identical to the panel shown in Figure 6-5. This is where you choose the music to accompany your superbly custom-ized slideshow, as described on page 158.

■ THE SLIDESHOW SETTINGS PANEL

The All Slides tab of this panel (Figure 6-9, left) should look familiar. If you're using the Classic or Ken Burns theme, the All Slides tab contains many of the same op-tions described earlier (transition style and duration, whether to fit the slideshow to the soundtrack, the ability to show your photos' titles and ratings, and so on). See page 161 for details.

> **NOTE** The animated themes—Shatter, Sliding Panels, Scrapbook, and so on—handle their *own* transitions and so offer fewer options in the Slideshow Settings panel.

Down at the bottom of the panel, you also get an Aspect Ratio setting that lets you tell iPhoto what *shape* the screen will be. Now, this may strike you at first as a singularly stupid setting. After all, doesn't the Mac know what shape its own screen is? But there's more to this story: Remember that you can build slideshows that aren't intended to be played on your Mac's monitor.

For example, you might want to export a slideshow to play on other people's screens, or even on their TV sets, by burning the slideshow to a DVD. That's why this pop-up menu offers four choices: This Screen; HDTV (16:9) for high-definition TV sets and other rectangular ones, iPad/TV (4:3) for iPads and standard squarish TV sets, and iPhone (3:2) for slideshows you plan to export to your iOS devices (page 321).

In any case, the changes you make here affect *all* photos in the slideshow. Click the X at the top left of the panel when you're done, confident in the knowledge that you can always override these settings for individual slides.

Individual-Slide Options

The Slideshow Settings panel's All Slides tab offers plenty of control, but the changes you make there affect *every* slide in the show. But by selecting a thumbnail at the top of your window and then clicking the panel's This Slide tab (Figure 6-9, right), you gain control over that *particular* slide.

■ COLOR OPTIONS

Certain photos may have more of an impact with a creative color treatment. Using the options at the top of the This Slide tab, you can change the color of the selected photo to Black & White, Sepia (brownish, old-fashioned monochrome), or Antique, which lends a sort of faded, flattened look to the photo's colors. (These options are a great way to save a photo whose colors seem a bit off.)

■ SLIDE TIMING

As you know, the All Slides tab is where you specify how long you want each slide to remain onscreen. But if you want to override that setting for a few particularly noteworthy shots, the This Slide tab has the solution. (Photographers love this kind of thing.)

With the specially blessed photo on the screen before you, summon the Settings panel and click This Slide. Then use the "Play this slide for __ seconds" control to specify this slide's few seconds of fame.

■ TRANSITION

The options in this pop-up menu are the various effects (Cube, Dissolve, and so on) that you can use for the transition from one slide to another. (Whatever you choose here governs the transition *out* of the currently selected slide; every slideshow *starts* with a fade-in from black.)

You can also control the speed of the transitions on a slide-by-slide basis, and even which direction the transition effect proceeds across the screen (for transition styles that offer a choice, that is).

THE KEN BURNS CHECKBOX

If you flip back a few pages, you'll be reminded that the Ken Burns effect is a graceful, panning, zooming effect that animates the photos in your slideshow so they float and move instead of just sit there.

You'll also be reminded that when you apply the effect to an entire slideshow, you have no control over the pans and zooms. iPhoto might begin or end the pan too soon, causing the primary subject to get chopped in half. Or maybe it zooms too fast, so your viewers never get the chance to soak in the scene—or maybe it pans or zooms in the *wrong direction* for your creative intentions.

Fortunately, the Ken Burns controls located here let you adjust every aspect of the panning and zooming for one photo at a time (see Figure 6-10). Here's how it works:

> **NOTE** The settings you're about to make in the This Slide tab *override* whatever global Ken Burns setting you've made.

1. **Select the photo, click Settings in the toolbar, click the This Slide tab, and then turn on the Ken Burns setting circled in Figure 6-10.**

 If more than one photo is selected, iPhoto applies the effect to the first one only.

2. **Click Start in the This Slide tab, and then adjust the photo's position and zoom level so it's the way you want it at the *beginning* of its time onscreen.**

 In other words, you're setting up the photo the way it will first appear. Often, you won't want to do anything to it at all—you want it to start at its original size and then zoom in from there. But if you want to create a zooming *out* effect, then use the toolbar's Zoom slider to magnify the photo, and then drag the picture itself to center it properly (your cursor turns into a hand).

3. **Click End in the This Slide tab, and then set up the picture's zoom level and position.**

 You've just set the photo's starting and ending conditions. iPhoto interpolates, calculating each intermediate frame between the positions you specified.

 Take a moment now to click Preview in the toolbar. The animated photo goes through its scheduled motion, letting you check the overall effect. Repeat steps 2 and 3 as necessary.

> **TIP** If you accidentally set the End position when you meant to set the *Start* position, then Option-click the word "Start." iPhoto graciously copies your End settings over to the Start settings. Now both Start and End are the same, but at least you can edit just one setting instead of two. (The same trick works in the other direction, as well.)

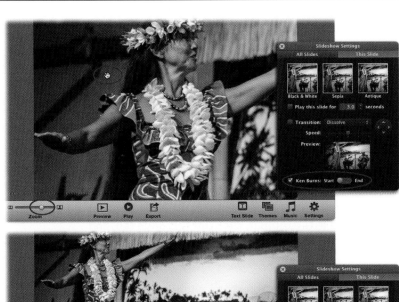

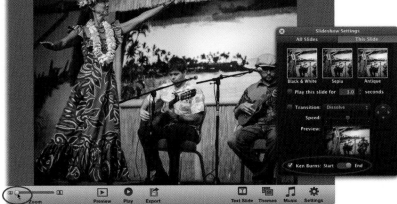

FIGURE 6-10

You set the start and end points for the Ken Burns effect's gradual zooming/panning, and iPhoto automatically supplies the in-between frames, producing a gradual shift from the first position to the second.

Top: In the Slideshow Settings panel's This Slide tab, turn on the Ken Burns checkbox and then click Start. Use the Zoom slider in iPhoto's toolbar to magnify the photo, and then drag the photo to reposition it in the viewing area (you see the grabbing-hand cursor circled here).

Bottom: In the This Slide tab, click End. Once again, use the Zoom slider and drag the photo to specify the final zoom level and position. In this example, the Ken Burns effect lets you save the "punch line" (the guitarists) of this story-telling photo for the end of its time onscreen.

Slideshow Tips

The following guidelines will help you build impressive slideshows that truly showcase your talents as a digital photographer.

Picture Size

Choosing photos for your slideshow involves more than just picking the photos you like best. You also have to make sure you've selected pictures that are the right *size.*

iPhoto always displays slideshow photos at full-screen dimensions—and on Apple's monitors, that means 1366 × 768 pixels at the *very* least. If your photos are smaller than that—because you cropped them or had your camera set to low quality, say— then iPhoto stretches them to fill the screen, often with disastrously pixelated results.

Although iPhoto blows up images to fill the screen, it always does so proportionately, maintaining each photo's vertical-to-horizontal aspect ratio. As a result, photos often appear with vertical bars at the left and right edges when viewed on long rectangular screens like the Apple Cinema Display or iMac. To eliminate this effect, see "Scale Photos to Fill Screen" on page 164.

■ DETERMINING THE SIZE OF YOUR PHOTOS

If you're not sure whether your photos are big enough to be slideshow material, open the Info panel by clicking Info in iPhoto's toolbar, and then look at the panel's top left. You'll see something like "1600 × 1200." That's the width and height of the photo, measured in pixels. As you might imagine, tiny photos are horribly blocky and blurry when blown up to full-screen size. Big ones look just fine, though if they're humongous, iPhoto might take longer to *display* them and, as a result, the transitions may not be as smooth.

Here are a few other ways to make sure your slideshows look their best:

* Try to stick with photos whose proportions roughly match your screen. If you have a traditionally shaped screen, use photos with a 4:3 width-to-height ratio, just as they came from the camera. However, if you have a widescreen monitor (a recent Cinema Display, iMac, MacBook, and so on), then photos cropped to 6:4 proportions are a closer fit.

* If you don't have time to crop all your odd-sized or vertically oriented photos, then consider using the "Scale photos" feature described on page 164. It makes your pictures fill the screen nicely, although you risk cutting off important elements (like heads and feet).

POWER USERS' CLINIC

Cropping and Zooming

Here's a totally undocumented iPhoto feature: While creating a saved slideshow, you can choose to present only *part* of a photo, in effect cropping out portions of it, without actually touching the original.

To enlarge the photo (thus cropping out its outer margins), just drag the Zoom slider at the lower-left corner of the iPhoto window (you don't have to have any panels open to do it). Whatever photo size you determine this way controls what will appear during the slideshow.

What you may not realize, though, is that you can also drag the picture itself to shift its *position* onscreen. Simply click within the photo-viewing area and *drag the image where you want it.* Sounds crazy, but it works.

Between these two techniques—sizing and sliding—you can display just a portion of the photo. (Heck, you could even present the photo *twice* in the same slideshow, revealing half of it the first time and half of it the next.)

- Preview images at full size before using them. You can't judge how sharp and bright an image is going to look based solely on its thumbnail.

- Keep the timing brief when setting the playing speed—maybe just a few seconds per photo. Better to have your friends wanting to see more of each photo than to have them bored, mentally rearranging their sock drawers as they wait for the next photo. Remember, you can always pause a slideshow if someone wants a longer look at one picture.

- Consider the order of your photos. An effective slideshow should tell a story. You might want to start with a photo that establishes a location—an overall shot of a park, for example—and then follow it with closeups that reveal the details. (Remember, it's easier to reorder photos in an *album* before creating the slideshow.)

- If your viewers fall in love with what you've shown them, you have several options: Save the slideshow as a QuickTime movie that you can send to them via Dropbox (page 274) or burn onto a CD or DVD for their at-home enjoyment (page 281); create a web journal on your iOS device (page 383); or make your admirers buy their own Macs.

NOTE iPhoto for iOS lets you create slideshows, too; however, it also lets you *transfer* them onto another iOS device by beaming it or using AirDrop. And if you've got an iCloud account, you can post the slideshow on the Web and share it with others. You can also export the slideshow as HTML files by using iTunes' file-sharing feature. Chapter 15 has the scoop.

You can also export a slideshow to iTunes so you can sync and then play it on an iPod, iPhone, iPad, or Apple TV (Chapter 10). In fact, the newest Apple TV (the tiny black one) can *see* your iPhoto library and play saved slideshows (though it uses its own transitions).

FREQUENTLY ASKED QUESTION

Slideshow Smackdown: iPhoto vs. iMovie

I've read that iMovie is a great slideshow program, too. Supposedly, I can import my photos, add music, and play it all back, fullscreen, with cool cross-dissolves, just like you're describing here. Which program should I use?

The short answer: iPhoto for convenience, iMovie for control.

In iMovie, you can indeed import photos. Just as in iPhoto, you have control over their individual timings, application of the Ken Burns effect, and transitions between them.

But the soundtrack options are much more expansive in iMovie. Not only can you import music straight from a CD (without having to use iTunes as an intermediary), but you can actually record *narration* into a microphone as the slideshow plays. And you have a full range of title options, as well as credit-making and special-effects features at your disposal, too.

Still, iPhoto has charms of its own. Creating a slideshow is far less work in iPhoto, for one thing. Remember, too, that iPhoto is beautifully integrated with your various albums. Whereas building an iMovie project is a serious, sit-down-and-work proposition that results in one polished slideshow, your Photo library has as many different slideshows as you have albums—all ready to go at any time.

That said, you can learn a little more about using iMovie in Chapter 10.

Making Prints

There's a lot to love about digital photos that remain digital. You can store thousands of them on a single DVD; you can send them anywhere on earth by email; and they won't wrinkle, curl, or yellow until your monitor does.

Sooner or later, though, most people want to get at least *some* of their photos on paper. You may want printouts to paste into your scrapbooks, to put in picture frames on the mantel, to use in homemade greeting cards, or to share with your Luddite friends who don't use computers.

With iPhoto, you can create such prints using your own printer. Or, for prints that look, feel, and smell like the kind you get from a photo-finishing store, you can transmit your digital files to Kodak Print Services, an online photo-processing lab. In return, you receive an envelope of professionally printed photos on Kodak paper that are indistinguishable from their traditional counterparts.

This chapter explains how to use each of iPhoto's printing options, including the features that let you print greeting cards, contact sheets, and other special items from your digital photo collection. (*Ordering* greeting cards, postcards, calendars, and books is covered in Chapter 9.)

Making Your Own Prints

Using iPhoto to print your pictures is pretty easy. But making *great* prints—the kind that rival traditional film-based photos in their color and image quality—involves more than simply choosing the Print command.

One key factor, of course, is the printer itself. You need a good printer that can produce photo-quality color printouts. Fortunately, getting such a printer these days is pretty easy and inexpensive. Even some of the cheapo inkjet printers from Epson, HP, and Canon can produce amazingly good color images—and they cost less than $100. (Of course, what you spend on those expensive ink cartridges can easily double or triple the cost of the printer in a year.)

TIP If you're really serious about producing photographically realistic printouts, consider buying a model that's specifically designed for photo printing, such as one of the printers in the Epson Stylus Photo series or the slightly more expensive Canon printers. What you're looking for is a printer that uses six, seven, or eight different colors of ink instead of the usual "inkjet four." The extra colors do wonders for the printer's ability to reproduce a wide range of colors on paper.

Even with the best printer, however, you can end up with disappointing results if you fail to consider at least three other important factors when trying to coax the best possible printouts from your digital photos: the resolution of your pictures, your printer settings, and your choice of paper.

Resolution and Shape

Resolution is the number of individual pixels squeezed into each inch of your digital photo, and therefore how large the individual pixels are in size. The basic rule is simple: The higher your photo's resolution, or *ppi* (pixels per inch), the smaller the pixels become, and the sharper, clearer, and more detailed the printout will be. If the resolution is too low, the pixels will be large enough to see individually, so you'll end up with a printout that looks like it was made from Legos.

Low-resolution photos are responsible for more wasted printer ink and crumpled photo paper than any other printing snafu, so it pays to understand how to calculate a photo's ppi when you want to print it.

■ CALCULATING RESOLUTION

To calculate a photo's resolution, divide the horizontal or vertical size of the photo (measured in pixels) by the horizontal or vertical size of the print you want to make (usually measured in inches).

Suppose a photo measures 1524 × 1016 pixels. (How do you know? See Figure 7-1.) If you want a 4 × 6-inch print, take the longest edge in pixels and divide it by the longest edge of the desired print size in inches: 1524 pixels divided by 6 inches = 254 ppi. That means you'll be printing at a resolution of 254 ppi, which will look fantastic on paper. (Photos printed on inkjet printers look their best when printed at a resolution of 200 ppi or higher.)

But if you try to print that same photo at 8 × 10 inches, you'll get into trouble. By stretching those pixels across a larger print area, you're now printing at just 152 ppi—and you'll see a *noticeable* drop in image quality.

While it's important to print photos at a resolution of 200 to 300 ppi on an inkjet printer, there's really no benefit to printing at higher resolutions—600 dpi, 800 ppi, or more. It doesn't *hurt* to print at a higher resolution, but you probably won't notice any difference in the printed photos, at least not on inkjet printers (though it'll take longer for your printer to get the job done). That said, some inkjets can spray ink at finer resolutions—720 ppi, 1440 ppi, and so on—and using these settings produces very smooth, fine printouts.

FIGURE 7-1

To select the best size for a printout, you need to know the photo's pixel dimensions. iPhoto reveals this information in a convenient spot: at the top of the Info panel (circled) whenever you select a single thumbnail in the photo-viewing area (obviously, you have to open the Info panel to see it!).

■ ASPECT RATIO

You also have to think about your pictures' *aspect ratios*—their proportions. Most digital cameras produce photos with 4:3 proportions, which don't fit neatly onto standard photo paper (4 × 6 and so on). You can read more about this problem on page 128. (Just to make sure you're completely confused, some sizes of photo paper are measured *height by width,* whereas digital photos are measured *width by height.*)

If you're printing photos on letter-size paper, the printed images won't have standard Kodak dimensions. (They'll be, for example, 4 × 5.3 inches.) You may not particularly care. But if you're printing onto, say, precut 4 × 6-inch photo paper (which you choose in the Print pane, explained next), you can avoid ugly white bands at the sides by first cropping your photos to standard print sizes.

Tweaking the Printer Settings

Just about every inkjet printer on earth comes with software that adjusts various print quality settings. You can find the controls for these settings right in the Print pane that appears when you choose File→Print. Printing in iPhoto has been greatly simplified, and you don't have to fiddle and fuss with additional menus or panels. *This* version of the program knows that if you're printing in iPhoto, you're going to be making a photographic print, and it gives you precious few yet extremely practical options (see Figure 7-2).

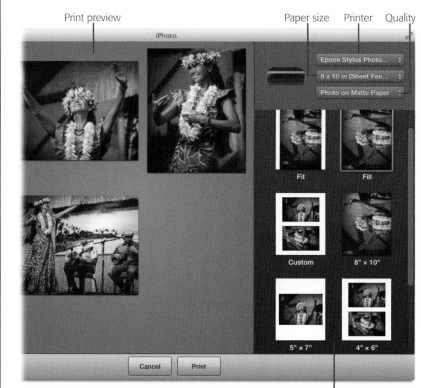

Print preview Paper size Printer Quality

iPhoto

Epson Stylus Photo...

8 x 10 in (Sheet Fee...

Photo on Matte Paper

Fit Fill

Custom 8" x 10"

5" x 7" 4" x 6"

Cancel Print

Themes (layout styles)

FIGURE 7-2

Apple recently (and mercifully) simplified iPhoto's Print pane. Mission-critical printer settings are perched at the top right in three handy pop-up menus.

Previous versions offered a multitude of layout styles (called themes), including "mat" frames that you could print right onto the paper. Due to the simpler process, most of those fancy options are now extinct. Instead, you get the option to fit or fill the photo to the page, some common size options, and the ability to print photo thumbnails as a contact sheet (page 178). The preview area shows you exactly what—and how many pages—iPhoto will print.

Before you print, get these settings right. Using the pop-up menus at the top right of the Print pane, check that you've got the correct printer selected from the first one and that you've picked the appropriate paper size from the second one. Use the third pop-up menu to choose between matte and glossy papers at normal or high quality (fine), and then make sure you load the printer with the paper you've specified here.

Choose the wrong settings, and you'll waste a lot of ink and paper. Even a top-of-the-line Epson photo printer churns out awful photo prints if you feed it plain paper when it's expecting high-quality glossy stock; you'll end up with a smudgy, soggy mess. So each time you print, make sure you've selected the right printer, paper, and quality settings.

Paper Matters

When it comes to inkjet printing, paper is critical. Regular typing paper—the stuff you'd feed through a laser printer or copier—is too thin and absorbent to handle the amount of ink that gets sprayed on when you print a photo. You may end up with flat colors, slightly fuzzy images, and paper that's rippled and buckling from all the ink. For really good prints, you need paper designed expressly for inkjets.

Most printers accommodate at least five grades of paper:

- **Plain paper.** The kind used in most photocopiers.

- **High-resolution paper.** A slightly heavier inkjet paper—not glossy, but with a silky-smooth white finish on one side.

- **Glossy photo paper.** A stiff, glossy paper resembling the paper that developed photos are printed on.

- **Matte photo paper.** A stiff, non-glossy stock.

- Most companies also offer an even more expensive **glossy film**, made of poly-ethylene rather than paper (which feels even more like traditional photographic paper).

These better photo papers cost much more than plain paper, of course. Glossy photo paper, for example, might run $25 for a box of 50 sheets, which means you'll be spending about 50 cents per 8 × 10-inch print—not including ink. Still, by using good photo paper, you'll get much sharper printouts, more vivid colors, and results that look and feel like professional prints.

TIP To save money, use your printer's Printing Utility to print its test page (usually a series of colored lines) on plain paper before printing any photos (this utility is typically found in your Applications folder). If the test print indicates a problem with ink or the print heads, you'll know it *before* you feed the expensive photo paper through your printer.

Printing from iPhoto, Step by Step

Here's the sequence for printing in iPhoto:

■ PHASE 1: CHOOSE PHOTOS TO PRINT

Select the thumbnails of the ones you want, using the techniques described on page 46.

You can also print a photo right from Edit view; the Print command is accessible in all of iPhoto's views.

When you're ready, choose File→Print, or press ⌘-P. The wonderfully simplistic, everything-you-need Print pane shown in Figure 7-2 appears.

■ PHASE 2: CHOOSE YOUR PRINTER, PAPER SIZE, AND QUALITY

At the top right of the Print pane, specify which printer you'll use, what paper size you're putting into the printer, and what kind and quality of paper it is. (See Figure 7-2 for a refresher on how to do this.)

Most of the time, if you have a standard photo inkjet printer, the paper size you pick and the theme size (discussed next) will be one and the same. You'll want 4 × 6-inch prints on 4 × 6-inch paper, for example. But as noted in Figure 7-3, if the paper size is larger than the print size, you might be able to get more than one print per sheet.

> **TIP** If you want to create a print that extends to the paper's edges, be sure to pick a paper size that includes the word "Borderless." That lets your printer know it's OK to print to the edges of the paper, if it's *capable* of edge-to-edge printing (if it isn't, you won't see any Borderless options in the paper-size menu). For example, instead of choosing Letter Size, pick 8 × 10 Borderless.

■ PHASE 3: CHOOSE A PRINTING STYLE (THEME)

iPhoto has become a lean, mean printing machine, so these days there are precious few themes to choose from (gone are the themes of earlier versions that included colored borders or captions). Here are your options:

- **Fit.** Choose this theme to fit your photo to the paper size you picked. iPhoto doesn't enlarge your print when you use this option, so you'll get a white margin that you might need to trim away with an X-Acto knife.

- **Fill.** This option makes your photo fill the entire page. If you've picked a paper size that includes the word "Borderless," this theme will print your photo all the way to the paper's edge (provided your printer has the ability to *print* to the edges, and these days most of them do). Depending on the paper size you picked from the pop-up menu labeled in Figure 7-2—say, "8 × 10 borderless (auto expand)" vs. "8 × 10 borderless (retain size)"—this option may *enlarge* the photo so it actually reaches the paper's edges, causing it to be cropped in unexpected ways.

- **Custom.** Want to print at a size that's not listed in iPhoto's theme presets or squeeze more photos onto the page? No problem. Pick this theme and you can enter any size you want, as Figure 7-3 shows.

- **8 × 10, 5 × 7, 4 × 6.** These themes print single or multiple photos at these common print sizes—as many as iPhoto can squeeze onto the paper size you picked (assuming you selected more than one photo before opening the Print pane).

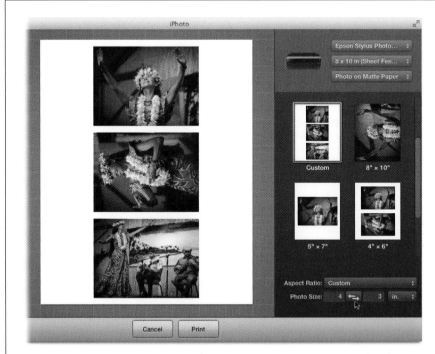

FIGURE 7-3

By choosing the Custom theme, you can change the aspect ratio and print size to anything you want. Here, the print size is 4 × 3-inches, which means iPhoto can fit three photos onto a single 8 × 10-inch piece of paper (three thumbnails were selected prior to summoning the Print pane).

To flip-flop the measure-ments you entered—say, to print a 3 × 4 instead of 4 × 3—click the button between the numeric fields.

- **Contact Sheet.** This means thumbnails—many of them—on each printed sheet (Figure 7-4). You control how many rows and columns appear and what infor-mation appears beneath each thumbnail (date, name, camera model, shutter speed, and so on). This theme prints out a *grid* of photos, tiling as many as 180 pictures onto a single letter-size page (eight columns of 14 rows, for example).

By printing several pictures side by side on the same page, you can easily make quality comparisons among them without using several sheets of paper (handy for showing friends or family so they can decide which shots they want you to print).

You can also use contact sheets to make test prints, saving ink and paper. Some-times a 2 × 3 print is all you need to determine if a picture is too dark or if its colors are wildly off when rendered by an inkjet printer. Don't make expensive full-page prints until you're sure you've adjusted your photo and print settings so they'll print correctly.

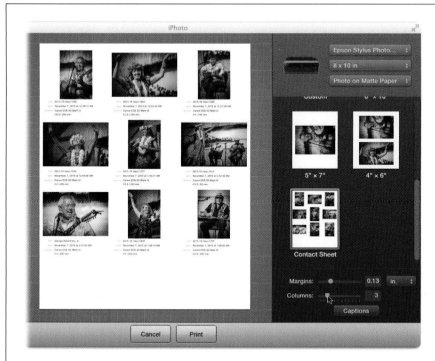

FIGURE 7-4

When you choose Contact Sheet, iPhoto lets you specify the margins (space) between the photos (which can affect photo size), as well as the number of columns. Using the slider at the bottom of the Print pane, you can choose from 1 to 12 columns, which also affects the size at which the thumbnails will print.

Click Captions to instruct iPhoto what info to print beneath each thumbnail. You can choose from things like the photo's title, the date it was taken, the camera type, as well as the aperture setting. (The Captions dialog box is shown in Figure 7-5.)

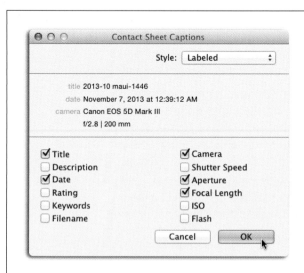

FIGURE 7-5

When you click the Captions button shown in Figure 7-4, iPhoto opens this dialog box. Use the pop-up menu to pick a formatting style for the captions beneath each thumbnail. Your choices are Basic (standard, left-aligned info), Labeled (shown here, where each piece of info gets a light-gray title), and Condensed (info is centered). For the most professional look, go with Labeled. You see a preview of what the info will look like in the middle of the dialog box.

Use the checkboxes to tell iPhoto which pieces of info to display.

Click the theme you want on the right side of the Print pane to see what the print will look like in the print preview area labeled back in Figure 7-2. iPhoto will print as many pages as necessary to accommodate the number of pictures you selected, at the paper size and theme size you've picked. How many pages is that? Just count the number of pages you see in the print preview area.

> **TIP** Until you either print or click Cancel, a new Printing item appears in your Source list (it's visible in Figure 7-6). While you're preparing your printout, you can click other Source list items and do other iPhoto work. You can return to your printout-in-waiting anytime by clicking that Printing item.
>
> You can also add *new* photos to the printout by dragging their thumbnails from Events or albums onto the Printing item in your Source list.

■ PHASE 5: PRINT

When the print preview looks good, click Print in iPhoto's toolbar. Only now do you see the more standard Print dialog box shown in Figure 7-6.

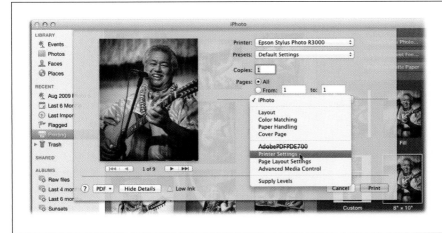

FIGURE 7-6

Click Show Details to expand this dialog box and, from the pop-up menu shown here, choose Printer Settings (or the similarly worded option) to view settings for to your printer. Doing so lets you pick fancy paper (if your printer can use it) and control resolution, print speed, and more.

> **NOTE** On the left side of Figure 7-6, you can see the temporary Printing item in the Source list. It stays perched there until you click either the Cancel or the Print button in the Print dialog box (or iPhoto's toolbar).

This is where you can specify how many copies and exactly *which* pages you want to print. Typically you'll print all of them, though if you change your mind about printing a certain one, you can always skip it (for example, to print the first three pages, enter 1 and 3 in the From and To fields, respectively). This kind of thing is handy for testing how well an 8 × 10 is going to turn out before committing to printing *all* of them.

Finally, click Print (or press Return); your printer scurries into action, printing the photos as you've requested.

TIP The PDF button, a standard part of all OS X Print dialog boxes, lets you save a printout-in-waiting as a PDF file instead of printing it on paper. You can convert any kind of iPhoto printout to PDF (technically they become JPEGs in a PDF wrapper). Click the button, choose "Save as PDF" from the pop-up menu, name the PDF in the Save dialog box, and then click Save. (Saving the file can take a while if you're converting several pages of photos into a single PDF.)

■ Ordering Prints Online

If you don't have a high-quality color printer, or if the thought of *wrestling* with it makes you cringe, traditional prints of your digital photos are only a few clicks away—if you have an Internet connection and you're willing to spend a little money, that is.

GEM IN THE ROUGH

Portraits & Prints

While iPhoto's themes offer some practical print layouts, they don't offer much flexibility. You can't specify that you want multiple sizes of the *same* photo per sheet, for example, like the print packages you used to get in grade school.

Fortunately, a free companion program called Portraits & Prints nicely compensates for iPhoto's printing weaknesses (it's not an iPhoto plug-in; it's a completely separate program that can tap into your iPhoto library). As of this writing, you can download it from *www.tinyurl.com/ portraits-prints*.

The idea is that you drag selected photos directly out of the iPhoto window and into the Portraits & Prints window (or click the Add iPhotos button to tunnel into your iPhoto al-

bums). There, you can boost or reduce color intensity, sharpen, crop, rotate, add brightness, and remove red-eye. (If you designate Portraits & Prints as your preferred external editing program [page 146], then changes you make in Portraits & Prints will be reflected in iPhoto's thumbnails.)

But all that is just an appetizer for the main dish: a delicious variety of printing templates, like the one shown here. The program comes with several "portrait sets" that let you arrange different pictures at different sizes on the same sheet. You can even save your layouts as *catalogs,* so you can reuse them or reprint them at a later date.

Thanks to a deal between Apple and Kodak, you can order prints from within iPhoto. After you select the size and quantity of the pictures you want printed, one click is all it takes to have iPhoto transmit your photos to Kodak Print Services and bill your credit card for the order. The rates range from 12 cents for a single 4 × 6-inch print to about $18 for a 20 × 30-inch poster. Within a couple of days, Kodak sends you finished photos printed on high-quality glossy photo paper.

Here's how the print-buying process works:

1. **Select the photos you want to print.**

 Click an album to order prints of everything in it, or select specific photos.

 TIP If you plan to order prints, first crop your photos to the proper proportions (4 × 6, for example) using the Crop tool, as described in Chapter 5. Most digital cameras produce photos whose shape doesn't quite match standard photo-paper dimensions. So, if you send photos to Kodak uncropped, you're leaving it up to Kodak to decide which parts of your pictures to lop off to make them fit. (More than one photographer has opened an envelope from Kodak to find loved ones missing the tops of their skulls.) By cropping the pictures to photo-paper shape before you place the order, *you* decide which parts get eliminated. (You can always restore the photos to their original, uncropped versions using iPhoto's "Revert to Original" command.)

2. **Choose File→Order Prints or click Share in the toolbar and choose Order Prints (see Figure 7-7).**

FIGURE 7-7

Ordering prints through iPhoto is incredibly easy and, in some cases, is far less of a hassle than printing them yourself. It all starts by selecting photos, and then clicking Share→Order Prints.

Your Mac goes online to check in with the Kodak processing center, and the Order Prints window shown in Figure 7-8 opens. (If your computer isn't online, then the Order Prints window doesn't open.)

3. **Select the sizes and quantities you want.**

 If you want a certain size print of *every* photo (say, 4 × 6-inch), just use the Quick Order pop-up menu at the top right of the window. Pick a size and then use the up and down arrows to the right of the menu to choose your quantity.

For more control over sizes and quantities, scroll down the list and fill in the numbers *individually* for each photo (press the Tab key on your keyboard to move from one field to the next). The total cost of your order is updated as you alter quantities.

As you order, heed the alert icons (little yellow triangles) that may appear on certain lines of the order form (visible in Figure 7-8). These are iPhoto's standard warning symbols, declaring that certain photos don't have a high enough resolution to be printed at the specified sizes. A photo that looks great at 5 × 7 inches may look terrible as a 16 × 20-inch enlargement. Unless you're the kind of person who thrives on disappointment, *never* order prints in a size that's been flagged with a low-resolution alert. (See the box on page 186 for more about these warnings.)

> **TIP** You'll see the same warning icon when you print your own photos and order photo books, cards, or calendars (Chapter 9). As always, you have few attractive choices: You can order a smaller print, not order a print at all, or accept the lower quality and order the print anyway.

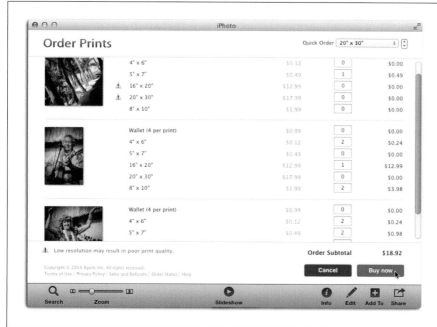

FIGURE 7-8

The Order Prints window lets you order six different types of prints of your photos—from a set of four wallet-sized prints to mammoth 20 × 30-inch posters. Use the scroll bar on the right to skim through all the photos you've selected and specify how many copies of each one you want to order.

Note the yellow alert triangles next to certain print sizes. iPhoto is telling you that the photo you're ordering is too low resolution for the size in question.

4. **Click the "Buy now" button.**

Another screen appears, listing the total for your order and various shipping methods.

5. **Click Check Out and, if necessary, sign in with your Apple ID, or create a new one.**

If you already have an account to buy music and movies at the iTunes Store, then you don't need to set up a new Apple ID to buy photo prints. If you're not already signed in, you may need to enter your user name and password here; Apple will happily bill the same credit card.

If you've never ordered anything from Apple, click "Create Apple ID now" to visit a series of screens where you surrender your identity and credit card info. You'll also see the option to turn on the "1-Click Ordering system," which is mandatory if you want to order prints. (All of this is a one-time task designed to save you time when you place subsequent orders.) For details on the process, see page 258. When the Summary screen finally appears, click Done to return to the Order Prints window.

Either way, your photos are transferred, your credit card is billed, and you go sit by the mailbox.

A batch of 24 standard 4 × 6-inch snapshots costs about $3, plus shipping, which is probably less than what you'd pay to print them at home or at the local drugstore. (You also don't have to pay for the gas to fetch more photo paper, ink, or visit the drugstore, nor do you have to deal with the hassles of traffic and parking.)

Better yet, you get to print only the prints you actually want, which is far more convenient than the drugstore method, and it's a handy way to send top-notch photo prints directly to friends and relatives who don't have computers. Furthermore, it's ideal for creating high-quality enlargements that would be *impossible* to print on the typical inkjet printer.

> **NOTE** If you want to use someone *other* than Apple for printing your photos—say, your local camera store or the online lab *www.mpix.com*—you'll need to *export* your photos as JPEGs first. See page 290 for details.

How Low Is Too Low?

When you order photos online, the Order Prints form automatically warns you when a selected photo has a resolution that's too low to result in a good-quality print. But just what does Kodak consider too low?

Here are Kodak's official resolution recommendations:

TO ORDER THIS SIZE PICTURE:	YOUR PHOTO SHOULD BE AT LEAST:
Wallet-sized	640 × 480 pixels
4 × 5 inches	768 × 512 pixels
5 × 7 inches	1152 × 768 pixels
8 × 10 inches	1536 × 1024 pixels

These are *minimum* requirements, not suggested settings. Your photos will look better in print if you *exceed* these resolution settings.

For example, a 1536 × 1024 pixel photo printed at 8 × 10 inches meets Kodak's minimum recommendation but has an effective resolution of 153 ppi (or 128 ppi once it's cropped)—a relatively low resolution for high-quality printing. A photo measuring 2200 × 1760 pixels, printed at the same size, would have a resolution of 220 ppi—and look much better on paper, with sharper detail and subtler variations in color.

Emailing, Sharing, and Web Galleries

Holding a beautiful, glossy print created from your own digital image is a glorious feeling. But unless you have an uncle in the inkjet cartridge business, you could go broke printing your own photos. Ordering high-quality prints with iPhoto is terrific fun, too, but between printing and mailing, you'll spend a few days waiting for them to arrive.

For the discerning digital photographer who craves both instant gratification and economy, the solution is to put your photos *online*—by posting them on social media sites, creating web galleries, exporting web pages that you can post on your *own* website, or sharing them with others through iCloud (Apple's online storage and synchronization service). If you go the social media or iCloud route, any comments your admirers have left even show up in iPhoto's Info panel.

> **NOTE** If you've got an iCloud account (page 12) and an iOS device (iPad, iPhone, or iPod Touch), you can also create gorgeous *web journals,* with highly customizable layouts, captioning opportunities, and more. This fun feature is covered in Chapter 15.

All of this is particularly easy and satisfying in iPhoto, *especially* if you're an iCloud member or a fan of Facebook, Flickr, or Twitter. And if you'd rather send electronic photos directly to your fan base (instead of requiring them to visit a website), you can fire off an instant message or email from *inside* iPhoto, where you'll find a plethora of graphical email themes. iPhoto even remembers each instant message and email it sends on your behalf, so you can see when you sent which pictures to whom.

This is where iPhoto gets really fun. So read on—your adoring public awaits!

Instant Messaging Photos

Somewhere between email and the telephone lies the joyous communication tool called *instant messaging* (if you don't know what that is, there's a teenager near you who does). Basically it combines the privacy of email with the immediacy of the phone. You type messages in a chat window, and your friends type replies back to you in real time.

Plenty of instant messenger programs run on the Mac, but Mavericks comes with *Messages* (which used to be called iChat). It's built right into the system and is ready to connect to your friends on the Yahoo, AIM, Jabber, Facebook, or Google Talk networks.

As luck would have it, Messages is built into iPhoto, too. This makes sending photos to your pals—their *phones* included—while seated comfortably at your Mac an absolute breeze.

Getting Started with Messages

In order to use Messages in iPhoto, you need to set up a *chat account.* Open the Messages program by clicking its icon in your Mac's dock (it looks like two thought bubbles: one blue and one white) or by double-clicking its icon in your Applications folder.

When you open Messages for the first time, you're invited to enter your iCloud or Apple account login info. (If you don't have such an account, you can click "Create an Apple ID" to set one up.) Or, to use Messages with a different chat service, click Not Now; you then see a more generic Account Setup window where you can pick a service (Yahoo, AIM, Jabber, and so on), enter your name and password, and then click Continue. You can also enter your account info later—the setup assistant isn't your only opportunity, as Figure 8-1 explains.

> **TIP** If you and your conversation partner both have iCloud accounts (page 12), then you can move freely from phone to tablet to Mac—your conversation is auto-synced between gadgets (if you're signed in with the same iCloud account, that is). You don't even have to pay for a texting plan on your phone because the messages, which Apple calls *iMessages,* are routed through the Internet rather than a cell network. As far as your cellphone company is concerned, you're not texting at all.

Once you've set up a chat account in Messages, you're ready to start using it in iPhoto.

Using iPhoto's Messages

Instant messaging a photo in iPhoto starts like any other task: Select the thumbnail(s) of the pictures you want to send (up to 10). Then click Share in iPhoto's toolbar and, from the pop-up menu, choose Messages. A small Messages window appears atop the photo-viewing area (see Figure 8-2).

FIGURE 8-1

*Top: Choose Messages→
Preferences→Accounts to see this
window. Clicking the + at the bottom
left lets you add accounts. Once
you've set up your accounts, you can
turn them on and off here (handy
when you don't want to be bugged
by the rabble on a particular service).
Turn on "Send read receipts" if you
want your correspondents to know
when you've read each of their
messages.*

*Bottom: If you try to use Messages
in iPhoto but you haven't yet set up
a chat account, you see this friendly
note. Click Log In to have iPhoto turn
on the account for you. (Alternatively,
you can open Messages and set
up or activate an account there, as
described above.)*

At the top of the Messages window, start typing the lucky recipient's name in the To field (you can also enter an email address or a phone number). As you type, Messages sprouts a list of matching names from OS X's Contacts. You can also click the + button to get a pop-up version of your Contacts, complete with a search bar at the top. Select your recipients and add any text you want to include in your message. Once you're finished addressing and composing your message, click Send. If everything goes well, a note appears in the photo-viewing area confirming that your photos were sent.

iPhoto also records your Messages activity in the Info panel. Select the photo you sent and then click Info in the toolbar; you'll spot a new section on the right called Sharing, which lists the recipient and the date the message was sent (Figure 8-5 on page 195 shows this notation).

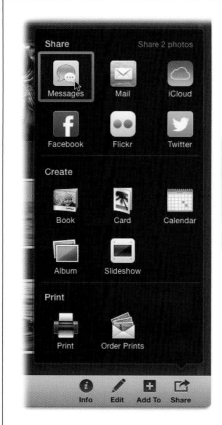

FIGURE 8-2

Left: Once you select some photos, click Share and choose Messages. But remember: With great power comes great responsibility; just because you can *instant-message up to 10 photos to your pals doesn't mean you* should. *Try to keep your messaging to fewer than five shots and use email (or a photo stream; page 196) to share more than that.*

Right: You can use the smiley-face pop-up menu at the bottom right of the Messages window to insert emoticons and smileys.

NOTE Messages comes ready to connect you with other people in your home or office via your wireless network, thanks to a technology called *Bonjour.* Unfortunately, Bonjour won't work for sending pictures from iPhoto. While iPhoto *reports* that it sent the photos, they never make it to the recipient (though any text you include arrives just fine). Bummer!

Emailing Photos

Emailing from iPhoto is perfect for quickly sending off a few photos—or even a handful of them—to friends, family, and coworkers. As you're about to learn, iPhoto lets you do it in a gloriously graphical way. However, if you have a whole *batch* of photos to share (11 or more), you're better off using iCloud's photo stream or the online-sharing features described later in this chapter.

Using iPhoto's Mail Command

Earlier versions of iPhoto handed your pictures off to your email program, where they appeared as attachments, and you can still send your photos that way. The downside of that method is that your recipients may not *see* the photos in the body of your message; they may have to open the attachments individually, which is a hassle for some (and beyond the technical skills of others).

That might be why Apple came up with iPhoto's embedded-photo email feature, in which your photos *are* the body of the message, complete with captions, frames, and other graphical niceties. iPhoto even does the *emailing* all by itself, without having to open your regular email program.

Here's how the embedded-email process works:

1. **Select the photo(s) you want to email.**

 You can use any of the picture-selecting techniques described on page 46. You can't, however, select thumbnails in a saved slideshow or project. You can send up to 10 photos in a single email. If you want to send more than that, skip ahead to the section on dragging and dropping (page 196).

2. **Click Share in iPhoto's toolbar, and then choose Mail.**

 If you already use Mail (Apple's email program), the screen changes to show a gigantic and customizable email message, along with several theme options.

 If you've *never* used Mail, you see a list of email providers instead: iCloud, Hotmail, Yahoo, Gmail, Aol Mail, and Other. Click the one you use and then click Setup. You're taken to another pane where you can enter your email address and password. Click Save and you're good to go.

 You can also add email accounts by choosing iPhoto→Preferences→Accounts, and then clicking the +.

3. **Choose a theme.**

 Apple believes emailing photos is an event worthy of graphics, descriptions, captions, and so on. You can choose among several designs in the Themes pane shown in Figure 8-3:

 - **Classic, Journal.** If you choose one of these no-nonsense themes, iPhoto inserts your photos into the email message without additional fanfare or extra graphics, circa iPhoto '09. You see the phrase "Insert Text Here" above each photo, prompting you to add a caption. In the Journal theme, you also see a spot to add a beautifully formatted title in the body of your email.

TIP If you don't add captions or a title before clicking Send, iPhoto displays an error message about *placeholder text*. It's nothing to worry about—if you don't add custom prose, that spot is simply blank.

- **Snapshots, Celebration.** These themes add a white border to each photo and place them on a light-colored background, complete with drop shadows. In Snapshots, you're prompted to add a message in a handwriting typeface, though you can change the typeface, size, and alignment using the pop-up menus that appear (they're labeled in Figure 8-3). Celebration uses an embossed "card" complete with whimsical border and party hats; there's also a spot where you can add a message. Neither theme includes captions.

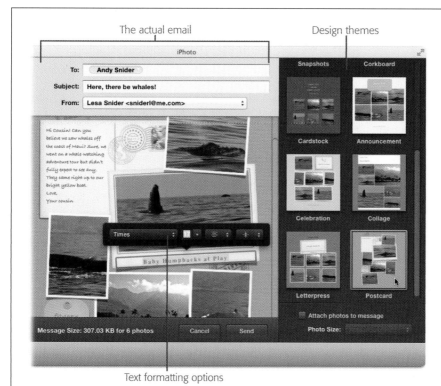

The actual email

Design themes

FIGURE 8-3

Behold, iPhoto's design themes for email! Choose one by clicking it in the Themes panel on the right. The left side of the window lets you fill in your email's blanks. The address field automatically pulls from OS X's Contacts and attempts to fill in the correct address once you start typing. Click within the message area to see formatting options; the pop-up menus let you change the font, size, and alignment of the text in your message (you have to highlight the text to change it). This example uses the Postcard theme, which gives you a message and exactly one captioning opportunity (for your prized shot!).

Text formatting options

- **Corkboard.** Your message and photos are tacked onto a realistic-looking corkboard. The message area is on a piece of virtual graph paper, with your photos underneath in a filmstrip.

- **Cardstock, Letterpress.** These sleek themes display your photos in rows of squares, surrounded by a thin border that looks like it was *pressed into* a textured background. In the Letterpress theme, a "card" containing a message area and today's date is perched atop the first row; in Cardstock, there's an area for this info below the photos.

- **Announcement.** Similar to Cardstock and Letterpress, this theme displays slightly larger versions of your photos without borders. The images appear

inset into the background, and the message slot is on a rounded, "stitched" card, making it perfect for baby announcements.

- **Collage.** This theme truly showcases your photos—they're enlarged to fill the whole email. They're also placed side by side, just a few pixels apart, as a variety of rectangles. It's like the Origami slideshow, minus the animation. There are no captions in this theme.

- **Postcard.** This fun theme (shown in Figure 8-3) adds borders and drop shadows to your photos, which appear pasted onto a scrapbook page. A stamped postcard offers to hold your personal message and a coat-check tag automatically bears today's date. You can add a title to the largest photo, but that's it.

4. **Size and position your photos within their frames.**

It's incredibly simple to resize and reposition your photos inside each frame, as Figure 8-4 explains. To move photos *between* frames, drag one atop the desired frame; when you release your mouse button, iPhoto flip-flops them.

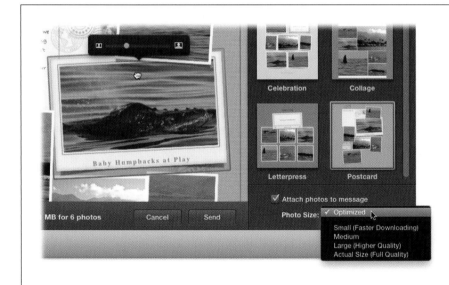

FIGURE 8-4

Click a photo to see its zoom slider; drag right to make the picture bigger or left to make it smaller. To move the photo within the frame, drag it into place (your cursor turns into a tiny hand, shown here).

Unless you tell it otherwise, iPhoto also attaches the original photo files to the email (the design arrives as a JPEG file, and the photos arrive as an attached .zip file). Pick an attachment size from the Photo Size pop-up menu, or turn off "Attach photos to message" to send just the JPEG.

5. **Tell iPhoto whether to attach your photo(s) to the email, and if so, at what size.**

Once you send the email (which you'll do in step 7), iPhoto converts the completed layout into a JPEG image and sticks it into the body of the message. And if "Attach photos to message" is turned on, then iPhoto *also* compresses the photos into a .zip file and attaches it to the message (which your recipient

can double-click to open it). The Photo Size menu shown in Figure 8-4 lets you control how big the attached images should be.

iPhoto encourages you to send scaled-down versions of your photos by including *Optimized* in the Photo Size menu. (The resulting photo resolution falls between Medium and Large, as discussed below.) In most cases, Optimized works just fine—big enough for onscreen display, just not for high-quality printing. But you also have four additional choices:

- Choose **Small** (Faster Downloading) to keep your email attachments super-small (320 × 240 pixels)—but only if you don't expect the recipient of your email to print the photo. (A photo this size can't produce a quality print larger than a postage stamp.) On the other hand, your photos will consume less than 100 K apiece, making downloads quick and easy for those with dial-up connections. (For more about photo sizes, flip to page 197.)

- Choosing **Medium** yields a file that will fill a nice chunk of your recipient's screen, with plenty of detail. It's even enough data to produce a slightly larger print—about 2 × 3 inches (640 × 480 pixels). Even so, the file size (and download time) is still reasonable; this setting can trim a 2 MB, 4-megapixel image down to an attachment of less than 150 K.

- The **Large (Higher Quality)** setting downsizes even your *biggest* photos, preserving enough pixels (1280 × 960) to make good 4 × 6-inch prints and to completely fill the average person's monitor. Use this setting sparingly. Even if your recipients have a cable modem or DSL, these big files may still overflow their email boxes.

- Despite all the cautions above, there may be times when a photo is worth sending at **Actual Size (Full Quality)**, like when you're submitting it for printing or publication. This works best when both you and the recipient have high-speed Internet connections and unlimited-capacity inboxes, as this option attaches a copy of your original photo at its original dimensions, with plenty of pixels for printing at high resolution (page 174 has more on resolution). That said, many email services limit attachments to 20 megabytes.

NOTE iPhoto retains each picture's proportions when it resizes them. But if a picture doesn't have 4:3 proportions (maybe you cropped it, or maybe it came from a camera that wasn't set to capture at that aspect ratio), then it may wind up *smaller* than the indicated dimensions. In other words, think of the choices in the Photo Size pop-up menu as meaning "this size or smaller."

6. **Include a personal message, caption, or title, if desired.**

 On the left side of the window is the actual email you'll send, and the body area is filled with text boxes you can customize; just click to change the text, or highlight it and then use the little pop-up menus to change the font, size, and so on (see Figure 8-3). iPhoto automatically inserts the photo's Event or album name in the email's subject line, though you can change it to anything you want.

7. **Enter your recipient's email address into the To field, and then click Send.**

When you start typing an address, iPhoto looks to see if it matches an entry in OS X's Contacts and tries to fill it in for you. You can type any address you want into this field.

As soon as you click Send, iPhoto processes your design and photos, converting the design into a JPEG image and—if you told it to—resizing and compressing your photo attachments. If everything went well, you see a message in the photo-viewing area saying however many photos were sent on their merry way.

When you click Send, iPhoto records the email in the Info panel. This is supremely useful if you can't remember which picture you sent to whom and when. Simply select a photo, click Info in iPhoto's toolbar, and if you used *iPhoto* to email that photo (and not another program), you see a *Sharing* section that lists the recipient and the date it was sent (Figure 8-5).

> **TIP** If you've got *more* than one photo selected, you won't see the Sharing section in the Info panel; it reveals itself only when a *single* photo is selected and only if you've shared that photo from *within* iPhoto.

FIGURE 8-5

Click to expand the Sharing section; you see a list of the photo emails and Messages (page 188) that include the selected photo. Click an email in the list to reopen that photo email so you can send it to someone else (nothing happens if you click a Messages entry).

Using Another Email Program

If you'd rather send photos as regular file attachments—as in older iPhoto versions, with no fancy graphics—you can tell iPhoto to hand them off to Mail (the email program that came with your copy of OS X) or Microsoft Outlook.

> **NOTE** As of this writing, no other email programs work with iPhoto's email command. If you want to use something besides Mail or Outlook, you can use the drag-and-drop method described in the next section.

To set this up, choose iPhoto→Preferences→General, and then choose the email program you want from the "Email photos using" menu. From now on, when you choose Email from the Share menu, you'll get the dialog box shown in Figure 8-6.

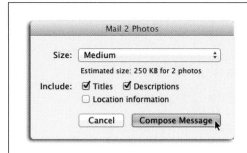

FIGURE 8-6

The Mail Photo dialog box not only lets you choose the size of photo attachments, but it also keeps track of how many photos you've selected and estimates how large your attachments are going to be. Turn on "Location information" to have the email display any Places tags you've added to your photos (see Chapter 4). You can also choose to include their titles and descriptions.

The Drag-and-Drop Method

There are three situations in which you'd want to avoid iPhoto's Mail command: when you want to send more than 10 photos, when you want to send the email to large groups of people, and when you want to retain the photo's original file format.

For example, iPhoto always converts photos into JPEG format when emailing them. So if you want to send raw files, for example, *don't* use iPhoto's Mail command. Instead, *drag* the thumbnails from iPhoto directly onto your email program's application icon (in the Dock, for example) to open a new message *and* attach them in one fell swoop.

Of course, raw files can be huge, and emailing huge files is a serious faux pas (see the box on page 197). However, exactly how you keep file sizes manageable depends on which email program you use. If you're using Mail, you can use the Size pop-up menu at the bottom right of the message window to pick an appropriate size for your attachments (to keep raw files from being converted to JPEGs, choose Actual Size). For any other email program, you'll want to export the photos from iPhoto first using the File→Export command, which offers you a choice of scaling options (see page 290). When you're finished, drag the exported photos onto your email program's icon or into the message window.

■ Using iCloud to Share Photos

iCloud is Apple's free syncing and storage service. It makes sharing photos between your Mac and your iPhone, iPad, or iPod Touch incredibly easy through a feature called *photo streams.* You can also create *shared* photo streams and invite up to 100 people to join them. It's a fantastic way for family members and other interested parties to keep up with your photographic life, with zero effort on their part and very little on yours. Shared photo streams also let you share photos in a more private way than the current crop of social media sites.

TIP If the person you want to share your photos with doesn't use a Mac or iOS device, you can post it as a public web gallery instead. Page 222 has more info.

Once people join your photo stream, they can obsess over your pictures and video to their hearts' content. And if they're iCloud members, they get to have even *more* fun. They can click a button to tell you they like something, add comments to your photos, and even upload their *own* pictures and videos to the stream (if you allow it), all from the comfort of their own Macs, iPhones, iPads, or iPod Touches (basically any gadget on which they've turned on iCloud Photo Sharing, as described on page 13). You can see their likes and comments in iPhoto's Info panel on your Mac.

The process of sharing photos via iCloud is fairly straightforward:

- Turn on iCloud Photo Sharing, as described on page 13.

- In iPhoto, select the photos and videos that you want to share.

- Create a shared photo stream and invite people to it. The invitees get an email asking if they'd like to join your photo stream. (The notification also appears in their copy of iPhoto.)

WORD TO THE WISE

Notes on Photo Size

The most important thing to understand about emailing photos with a program other than iPhoto is this: *Full-size photos are often too big to email.*

Suppose, for example, that you want to send three photos to some friends—terrific shots you captured with your 8-megapixel camera. First, a little math: A typical 8-megapixel shot consumes 3 megabytes of disk space. So sending along just three shots would make at *least* a 9-megabyte package. Why is that bad? Let us count the ways:

- It will take you a long time to send it.

- It will take your recipients a long time to download. And when you're done hogging their time, they might not consider what you sent worth the wait.

- Even if they do open the pictures you sent, the average high-resolution shot is much too big for a typical monitor. It does you no good to email somebody an 8-megapixel photo (for example, 3264 × 2448 pixels) when his monitor's maximum resolution is only 1280 × 800. If you're lucky, his graphics software will automatically

shrink the image to fit his screen; otherwise, he'll see only a gigantic nose filling his monitor. But you'll still have to contend with his irritation at having waited for so much superfluous resolution (as explained on page 174, resolution controls pixel size).

- The typical email account has a limited file-attachment size. If the attachment exceeds 20 MB or so, the message may bounce back or clog the mailbox. So your massive photo package could push your hapless recipient's mailbox over its limit, meaning she'll miss out on important messages and be very, very angry with you.

Of course, it's all different when you use iPhoto. Instead of unquestioningly attaching a multimegabyte picture to an email message and sending off the whole bloated thing, it offers you options for sending a scaled-down, reasonably sized version of your photo (see step 5 in the previous section). By taking advantage of this feature, your friends will savor the thrill of seeing your digital shots without enduring the agony of a 10-minute download.

- Folks join the photo stream by accepting your invitation via email or in their copy of iPhoto. From then on, the stream shows up in their copy of iPhoto, on their Mac, *and* on their iOS devices (if they have any).

- When you or the other person(s) adds a picture or video (if you've allowed that kind of collaboration), leaves a comment, or clicks "like," everyone in the stream gets notified.

The next few sections have all the details.

NOTE Shared photo streams are also a great way to share photos among iPhoto fans in the same household, as page 226 explains.

Creating a Shared Photo Stream

Once you've created an iCloud account and turned on iCloud Photo Sharing (see page 13), you're ready to get the photo-stream-sharing party started. Here's how:

1. **Choose the photos you want to share.**

 You can click an album or an Event, or select a batch using the techniques described on page 46. If you pick an album or Event, make sure no thumbnails are selected or you'll end up sharing only the selected photo(s).

2. **Choose Share→iCloud (or click the Share button in the toolbar and choose iCloud), and then click "New photo stream."**

 You see the message pane shown in Figure 8-7.

3. **Specify who can see your pictures and give the stream a name.**

 Enter the names or email addresses of up to 100 of your closest friends in the To field. Then type a title for your stream in the Name field and, if you wish, add a note in the Comment field to get the conversation started.

4. **Decide whether invitees can post to your stream, and whether you want the whole thing to be public.**

 The Subscribers Can Post setting means that *all* of your invitees can add their own pictures and videos to the stream, provided they have iCloud accounts. The stuff they post shows up in your copy of iPhoto. This is a great option for parties, as your guests can upload their *own* photos to the photo stream. Details are on page 203.

NOTE It's important to realize that iPhoto automatically performs a *two-way sync* with your photo stream. If you add photos to the shared stream, they show up in your invitees' streams, and if someone *else* adds photos, those pictures show up in the photo stream in *your* copy of iPhoto! If you want to add the new photo(s) to your iPhoto *library*—so it actually lives on your hard drive—drag it from the stream onto the Photos or Events item in your Source list.

The Public Website option is even more intriguing. If you're an iCloud member and you want to publish this particular set of pictures on the Web so folks *without* Apple devices can see them, turn on this setting. When you do, invitees receive the web address of your stream, where they can view your images as a visually pleasing, Tetris-style collage on a solid black background. Skip ahead to page 205 for the scoop.

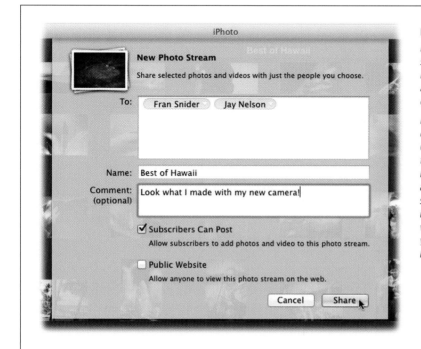

FIGURE 8-7

Here's where you decide who gets to see your photo stream and whether it's an art gallery that they can look at but not modify or a photo-exchange system.

In the To field, enter the names or email addresses of up to 100 people. Once you start typing, iPhoto tries to fill it in for you by accessing your Mac's Contacts. (You don't need to assign a password to your photo stream because the stream is by invitation only.) And if you want the whole world to see what you (and your invitees) post, then turn on the Public Website option.

5. **Click Share.**

 iPhoto sends your photos off to your invitees. This can take a few minutes, depending on the number of pictures and the speed of your Internet connection.

When it's all over, the photo-viewing area doesn't change a bit, which is kind of unsettling. (If you watch closely, you see miniatures of the thumbnails leap in unison into the iCloud icon in your Source list, but it happens really fast.)

However, once you've shared a photo stream, you'll spot an iCloud item in the Source list under the Shared heading. If you've got an iPhone, iPad, or iPod Touch and you've turned on iCloud Photo Sharing on those devices (page 13), then this item was already in your Source list, but clicking it displayed the contents of My Photo Stream—the most recent 1,000 photos taken with your iOS device(s) or that you've imported to your Mac. However, clicking it *now* shows My Photo Stream *plus* each photo stream you share.

For your invitees, however, all manner of bells and whistles start going off, as the next section explains.

Accepting a Photo Stream Invite

If your *invitees* have iPhoto 9.4 and OS X Mountain Lion (or later), they can accept the invitation to your photo stream, thereby *subscribing* to it. If you make changes to the stream—adding or removing pictures, say—those changes are automatically reflected in your subscribers' iPhoto libraries.

Once you've been invited to a shared photo stream, you can subscribe to it in a variety of ways:

- **In iPhoto, click "Show me."** If iPhoto is running when you get the invitation, a pane appears at the top of the window announcing the invitation, the sender's name, and the name of the photo stream. (If the program isn't running, you see the message the next time you launch it.)

 If this is the *first* photo stream invitation you've gotten, you see the message shown in Figure 8-8 (top). (For subsequent invitations, iPhoto drops the word "first.") When you click "Show me," iPhoto selects iCloud in the Source list and shows a generic icon of the stream in the photo-viewing area (Figure 8-8, bottom). Click Accept to begin the syncing.

 Clicking Preferences opens, well, iPhoto's preferences (so you can adjust your sharing settings, if necessary), and clicking Later temporarily dismisses the message (you can click the iCloud item in your Source list to accept or reject the invite later).

- **In the invitation email, click "Subscribe to this Photo Stream."** When you do, a dialog box appears announcing that, "[Sender] would like to share [Name of stream] with you." Click Ignore to make the message go away, though iPhoto displays a number to the right of the iCloud item in the Source list letting you know that a photo stream is waiting to be accepted (see Figure 8-8, bottom). Click Join and you're transported to iPhoto, which starts syncing the photo stream.

- **In any of the Notification Center message bubbles that appear, click Join**. The second you're invited to a photo stream, the Notification Center on your Mac and iOS devices kicks into high gear and assaults you with myriad message bubbles. (At least, any iOS devices where you've turned on iCloud Photo Sharing; see page 13.) Clicking Join in any message bubble accepts the photo stream invitation and gives iPhoto the all clear to sync photos.

Once you've subscribed to someone's photo stream, you can access it by clicking iCloud in your Source list; the stream's album appears in the photo-viewing area.

Double-click to open it, just like you would a regular album or Event. When you do, the photo-viewing area displays the stream's thumbnails. (It can take a while for the photo stream to sync the first time you open it. Best not to sit there waiting for it; go do something else and come back later.)

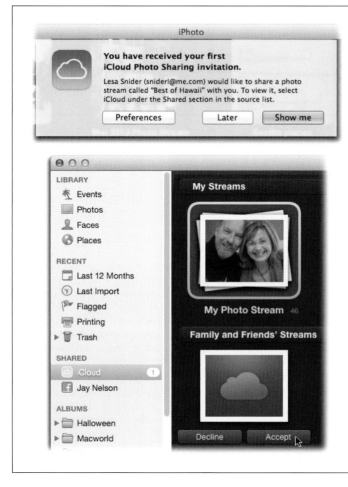

FIGURE 8-8

Top: No way is an invitee going to miss your photo stream invitation! Not only does she get an email and a message from the Notification Center (on their Mac and iOS gadgets), but she also sees a message in her copy of iPhoto.

Bottom: Clicking "Show me" selects the iCloud item in the Shared section of the invitee's Source list, and displays the new stream as a gray cloud. Once the person clicks Accept, iPhoto starts syncing the photo stream.

As mentioned in the previous section, simply viewing a photo in a shared stream doesn't mean that the photo is saved to your hard drive. If the person who owns the stream deletes a photo or the whole stream (page 206), that photo or stream disappears from your copy of iPhoto. You can avoid this possible catastrophe in two ways:

- **To download individual photos,** click iCloud in your Source list, double-click the stream's icon, select the photo(s) you want to download, and then drag them onto the Events or Photos in your Source list.

- **To download all the photos in a shared stream,** click iCloud in your Source list, and then *select* the stream but don't open it (in other words, single-click it). Click Add To in iPhoto's toolbar, and when the program asks if you want to import the photos to your library, click Import. (This trick also works when you've opened a photo stream but don't have any thumbnails selected.)

Viewing and Managing Photo Streams

Photo streams look like a stack of photos, just like albums and Events. To view a photo stream, click iCloud in the Source list, and all of your streams appear. The ones you create appear beneath the "My Streams" heading; the ones you subscribe to appear beneath the "Family and Friends' Streams" heading.

You can see who's joined a stream, invite more people to it, and even change its settings after you've shared it. Just click the stream's icon to select it, and then mouse down to the toolbar and click Info to reveal the options shown in Figure 8-9.

> **TIP** To remove a person from your photo stream, click the name in the Subscribers field and then press the Delete key on your keyboard. The stream disappears from that person's copy of iPhoto on all of his devices, though he gets no formal notification. To *reinvite* someone to a stream, delete his name from the Subscribers field and then add it back.

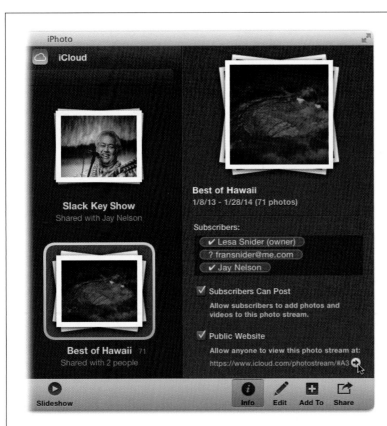

FIGURE 8-9

From here, you can invite more people to the photo stream by entering a name or email address in the Subscribers field; when you do that, iPhoto sends an email invite, complete with viewing instructions. Once an invitee accepts the stream, a checkmark appears next to her name; a question mark means she hasn't yet accepted the invitation.

You can also turn the Subscribers Can Post and Public Website options on or off. If you make the stream public, a web address appears that you can share with others (visible here). To visit the new web page, click the right arrow next to it (where the cursor is here); iPhoto opens the stream in your web browser.

As you might suspect, double-clicking a stream's icon opens it so you're viewing the individual photos. At the top of the photo-viewing area, iPhoto displays the name of the stream, the total number of people it's shared with, and the number of photos it contains.

ADDING AND DELETING PHOTOS

You can change the contents of your shared photo stream by adding or deleting the photos in it. When you do, iPhoto publishes your changes automatically (you'll see a little status bar appear at the top right of the photo-viewing area when iPhoto is making changes). The process for all this is the same whether you shared the stream yourself or whether you *subscribe* to it.

> **NOTE** See the box on page 204 for info about editing the images in photo streams.

To add a photo, select it (or more than one using the techniques described on page 46), and then use one of these techniques:

- **Drag the thumbnail(s) onto the iCloud item in your Source list.** A pop-up window appears next to the Source list so you can choose which stream you want to add the photo(s) to (Figure 8-10, bottom); click the appropriate one.

- **Click Add To in iPhoto's toolbar and choose iCloud.** A pop-up window appears at the bottom right of the iPhoto window containing all your photo streams. Click the one you want to add the photo(s) to.

FIGURE 8-10

Top: The most direct route for adding photos to an existing stream is to drag their thumbnails onto the iCloud item in your Source list.

Bottom: In the pop-up menu that sprouts from the Source list, click the photo stream you want to add the photo(s) to.

Either way, iPhoto asks for confirmation in the form of a message pane, where you can also add a comment. Click Publish; iPhoto syncs the photos with all of your subscribers' Macs and iOS devices.

To delete a photo, just pop open the photo stream and select the unfortunate thumbnail. Press the Delete key on your keyboard and, when iPhoto asks if you're *sure* you want to delete the picture from the stream, click Delete Photo.

■ ADDING AND VIEWING COMMENTS

Adding comments to a photo in a shared photo stream is easy: Open the photo stream, select a photo, and then open the Info panel by clicking Info in the toolbar. In the panel's Comments section, click "Add a comment" and type away. To "like" a photo, click the smiley face. When you're finished, click Post. Figure 8-11 explains how to view other people's comments and likes.

Once your subscribers start *interacting* with your photo stream, you hear about it in numerous ways:

- **On your Mac,** a message bubble appears at the top right of your screen; you also see message bubbles **on each of your iOS gadgets.** These notices are driven by the Notification Center.

Editing Photos in a Photo Stream

Because of the whole syncing process, iPhoto doesn't let you *edit* the photos in a photo stream. It doesn't matter whether you created the photo stream or you just subscribe to it; your only choice is to edit the version that lives in your *library* and then add the edited version to the stream.

The process is easy, though it differs slightly depending on whether you're the stream's creator or a subscriber:

If *you* created the stream, open it and select a thumbnail, and then click Edit in the toolbar. iPhoto asks if you'd like to use the version of the photo that lives in your library. Click "Show in Library"; you're transported out of the stream and into Edit view. Do your editing and then click Add To in iPhoto's toolbar (you can't drag the photo onto the Source list's iCloud item while in Edit view).

In the pop-up menu that appears, click iCloud, and then choose your photo stream. iPhoto displays a confirmation message and a box where you can add a comment explaining your edits (it's not mandatory, but it's a good way to let your subscribers know what you're up to). When you're done, click Publish. If you want to keep *both* versions of the photo in the stream, that's all there is to it. To delete the pre-edit version, click iCloud in the Source list, locate the stream, find the unedited photo, and then press the Delete key on your keyboard.

If you *subscribe* to the stream, the process is the same with one exception: The photo probably isn't in your library. If that's the case, then when you click Edit, iPhoto offers to *import* the photo. Click Import; in a second or two, iPhoto drops you into Edit view. Complete your edits and then use the Add To button in the toolbar to add the edited photo to the stream as described above. (Of course, you can do this only *if* the stream's creator gave you permission to add photos.) Subscribers aren't allowed to delete photos, so the original version gets to stay.

TIP If your photo streams get a lot of action—with comments, likes, or new photos or videos—the message bubbles may drive you insane. You can shut them up by Option-clicking the ≡ in your Mac's menu bar. That stifles all bubbles for the rest of the day (or until you Option-click it again). On an iOS device like an iPad, tap Settings→Notification Center.

Seen comments or "likes"

New comments or "likes" No comments or "likes"

FIGURE 8-11

To see a comment, select the photo and then open the Info panel. At the top of the panel, you see the aptly named Comments section, which contains the comment, along with the commenter's name and the date it was posted. (If the Comments section is collapsed, click it to expand it.) Unfortunately, you can't see comments or likes in iPhoto for iOS.

- **In your Dock,** a red circle appears atop the iPhoto icon. The microscopic number in the circle shows you how many notifications are lying in wait.

- **In iPhoto,** a number appears next to the iCloud item in your Source list. Click iCloud to view your shared streams; you see a blue dot to the left of the stream that wants your attention. Double-click the stream to open it, and then scour the thumbnails for a tiny, blue thought bubble at the bottom-left corner (see Figure 8-11).

■ SHARING STREAMS VIA PUBLIC WEBSITE

iPhoto's public website feature (page 199) is great for sharing photos with people who don't have iOS gadgets or a Mac. Streams you share this way sport far less interactivity than their iCloud-based cousins, but they're still incredibly useful.

Once your fans arrive at the web address that they received in their photo-stream invitation email or that you gave them (if you turned on the Public Website option after initially sharing the stream, say), they're in for a rollicking good time. They can view your images in a variety of ways, as Figure 8-12 shows.

FIGURE 8-12

Left: With a Public Website, your photos appear as a collage atop a black background. Unfortunately, you can't customize a single thing about it, but hey, it looks good!

Right: Visitors can click any thumbnail to see an enlargement, and use the arrows on either side to move back and forth through pictures. (If the arrows disappear, wiggle your mouse to get them back.) Better yet, click Slideshow and then click Fullscreen. Now sit back and enjoy the show.

If you click a photo in the collage, you see it at an enlarged size, with back and forward arrows on either side that let you see the next (or previous) photo. Once you're viewing an enlargement, you also see handy links above the photo:

- Click **Slideshow** to enlarge all the photos and view them one after the other—no clicking required. As soon as you click this link, it changes to read "Stop Slideshow"; it's pretty obvious what clicking *that* link does.

- **Click Download** to download the current photo. It's not the full, high-resolution original. For example, if the original photo weighs in at 5 MB, the version you're viewing comes in at a mere 768 KB. In other words, it's not big enough to create good prints, so you don't have to worry about people stealing photos from your stream and displaying them in galleries as their own work.

- **Fullscreen** is similar to Full Screen view in iPhoto: Clicking it fills your entire monitor with black, and you see the enlarged photo—or slideshow, if you've clicked that link—without distractions.

Your public website stays live until you either delete the photo stream or turn off the Public Website option in the Info panel.

Deleting a Shared Photo Stream

It's easy to find out how many photo streams you've shared: Just click iCloud in your Source list, and they're listed right in the photo-viewing area.

They're very easy to take down, too, once they've outlived their usefulness. To delete a photo stream, click its name and then press ⌘-Delete. (If your stream contains photos that were synced to your copy of iPhoto [for example, photos submitted by other people], a message warns you that those pictures are about to be obliterated, and you get an "Import photos to your library before deleting this stream" option.)

When you click Delete, the stream disappears from your Source list and from any subscribers' copies of iPhoto. (If you turned on the Public Website option, the stream's web incarnation disappears, too.) And you instantly reclaim some of your iCloud storage space.

Publishing Photos on the Web

Putting your photos on the Web is the ultimate way to share them with the world. If the idea of allowing the vast throngs of the Internet-using public to browse, view, download, save, and print *your* photos sounds appealing, read on.

NOTE Publishing photos to the Web is not a substitute for backing them up. Chapter 12 has the scoop for creating a *real* backup plan.

Aside from the Public Websites feature of iCloud photo streams described in the previous section (page 205)—wherein iPhoto builds your web gallery and lets you share its address *privately* with people you pick—iPhoto provides three *additional* roads to Webdom. The following methods let you post single or multiple photos (save for Twitter, which lets you post only one at a time), which are easily synced when you make changes.

However, the first few routes are decidedly more *public* than anything you've posted thus far. Your choices include these:

- **The easiest approach:** iPhoto makes it a snap to publish your pictures via Facebook, Flickr, or Twitter so that anyone with a web browser can admire your photography:

 - **Facebook.com** has become *the* destination for people to post news, gossip, and pictures. The site offers photo albums you can share with your Facebook friends. And since you have iPhoto, sharing photos and videos on Facebook is nearly a one-click affair.

 - **Flickr.com** is the world's most popular photo-sharing site. It's free, and it lets you upload a terabyte worth of photos (about 650,000 of them; that should cover your kids' first few birthdays). iPhoto gives you a quick route to posting images here. (Beware: For those concerned about image theft, Flickr is the scariest option of all; details on page 215.)

- **Twitter.com** is the free, microblogging phenomenon that lets you type short, 140-character messages that announce what you're doing. You can also use it to share individual photos straight from iPhoto.

> **TIP** Once you start publishing photos on Facebook, Flickr, or Twitter, iPhoto keeps track of which photos went where. That's a handy feature when you can't remember where you posted that photo of your latest facial piercing. The box on page 216 has the scoop.

- **More effort, more design options:** iPhoto on your iOS device has a neat feature called *web journals* that you can use to create gorgeous online galleries (you also need a free iCloud account). You can permit people to download your photos (though not at full size) and play them as a slideshow in a web browser. Chapter 15 has the full story.

- **For the experienced web page designer:** If you already have a website, you can have iPhoto generate HTML documents using the Export command. You can then upload these files, with the accompanying graphics, to your website. (Most Internet accounts, including those provided by your phone or cable company, come with free space for web pages uploaded in this way.)

 This is the most labor-intensive route, but it offers much more flexibility to create sophisticated pages if you know how to work with HTML. It's also the best option if you hope to incorporate the resulting photo gallery into an *existing* website.

> **NOTE** iPhoto used to let you create web galleries using a program called iWeb. Apple has discontinued iWeb, but if you still have a copy, you can find instructions on how to use it by visiting this book's Missing CD page at *www.missingmanuals.com/cds*.

Sharing Photos via Facebook

From its humble beginnings in 2004 as an online directory for Harvard students, Facebook has exploded into the world's most popular social-networking site, with over a *billion* members around the world. The concept is ingenious: You sign up for an account at *www.facebook.com*, create a profile page where you add resumé-like details, plus lists of your favorite books, movies, and quotes. You then link your profile to the profiles of your friends. Once you've "friended" someone this way, you can see each other's profile pages and socialize in the virtual realm.

You can also upload pictures and video to your Timeline (your public bulletin-board page, formerly called your "Wall"), and post photo albums to your profile page so your Facebook friends can see them. You can even "tag" people in those photos so you, your pal, and all the friends you *both* have can see those pictures.

With iPhoto, the whole photo-and-video-uploading part is a piece of cake. Heck, you can even change your Facebook *profile* picture using iPhoto.

Once you have a free Facebook account, you're ready to link it to iPhoto and start the photo-uploading frenzy:

1. **In iPhoto, select the photos you want to publish to Facebook.**

 You can select whole albums or arbitrary batches of photos (see page 46 for photo-gathering tips). If you're particular about the order of the photos, create an album and arrange the photos before posting the album.

2. **Choose Share→Facebook, or click Share in the iPhoto toolbar, and then choose Facebook.**

3. **Sign into your Facebook account.**

 If you're not already logged in, you're asked to supply your Facebook username and password (if you don't have an account, create one at *www.facebook.com*). Facebook also asks for permission to communicate with iPhoto.

4. **Choose where you want to put your photos on Facebook: in a new album, on your Timeline, or in an existing album.**

 Once iPhoto connects to your Facebook account, the Share menu displays the options shown in Figure 8-13 (top). To add photos to an existing album, click the album's thumbnail, and iPhoto automatically uploads your photos to that album.

 If you want to create a *new* Facebook album or publish the photo(s) to your Timeline, click the appropriate icon and then proceed to the next step.

5. **An iPhoto pane appears, asking you for more info.**

 If you clicked the Timeline icon, iPhoto displays a box where you can type a comment that will appear with the photo.

 If you clicked the New Album icon, you see the pane shown in Figure 8-13 (bottom), where you can give the album a name (if you selected an iPhoto album before starting the sharing process, the album's name automatically appears here, but you can edit it). You also get to choose who can see the soon-to-be-uploaded photos: only the people you've personally accepted as Facebook friends, friends of those friends, or any Facebook member who meanders by.

TIP If you change your mind about the permissions you set for a Facebook album, you can change them on the fly by selecting the album and then opening the Info panel. Use the "Album viewable by" option to set things right.

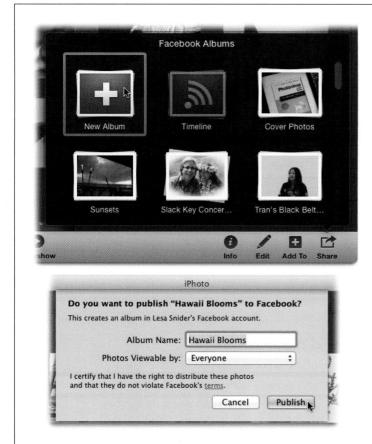

FIGURE 8-13

Top: Once you've logged into Facebook, the Share menu repopulates itself with the contents of your Facebook account (if you've posted a lot of photos, it'll take a moment or two). From here, you can add a new Facebook album, post the selected photos to your Timeline, or add them to an existing album.

Bottom: iPhoto lets you manage privacy options on a per-album basis, so you'll see this pane each time you upload photos to Facebook.

You can also use iPhoto to change your Facebook profile picture. Page 214 tells you how.

6. **Click Publish.**

 Sit back as iPhoto passes the pictures over to Facebook. While it's working, you can do other things in iPhoto, but it's best to let it finish publishing one album before you start publishing another.

 In iPhoto's Source list, your Facebook account appears under the Shared heading (Figure 8-14).

At this point, you're ready to view your handiwork.

To see *all* your photos on your Facebook page, make sure your Facebook account is selected in the Source list. Then, at the top of the iPhoto window, click the arrow next to the "[Your Name]'s Facebook Albums" heading (visible in Figure 8-14). To see a *single* Facebook album, double-click the album (they appear as stacks of photos, as shown in Figure 8-14), and then click the album link at the top of your iPhoto window.

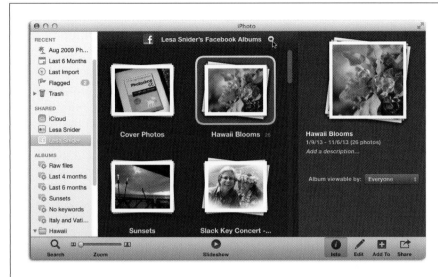

FIGURE 8-14

Once you connect iPhoto to your Facebook account, you see a new icon in the Shared section of your Source list, bearing your account's name. Click it to see every album you've ever published on Facebook, whether or not you did so via iPhoto (Timeline posts don't appear here).

Visit your Facebook page on the Web by clicking the arrow next to your Facebook account's name at the top of the iPhoto window.

■ EDITING PUBLISHED FACEBOOK ALBUMS

As with iCloud photo streams, syncing is a two-way street between Facebook and iPhoto: Anything you do in one updates the other. For example, to change the name of an album you've published to Facebook from iPhoto, click its name and then enter a new one. The new name appears on Facebook when you double-click the album in iPhoto to view it.

Likewise, you can change the album's name on Facebook by clicking the Photos link at the top of your profile page and then selecting the album you want to change. When the album opens to reveal all the pictures inside, click the Edit button near the album's name. Enter something clever into the Album Name field, and then click Done. You see the change in iPhoto when you double-click to view the album, which triggers syncing between the two.

> **NOTE** Unlike the photos you publish via iCloud photo streams, you *can* edit photos after publishing them to Facebook; iPhoto syncs the changes automatically. However, if you're editing the photo from within a published Facebook album, you'll need to *trigger* a sync by clicking the All Albums button at the upper left of the iPhoto window and then double-clicking to reopen the album. If you have Facebook open in your web browser, you might need to reload the page to see the changes.

Once you've published photos to a Facebook album, adding more photos is easy: In iPhoto, just select the photo(s) you'd like to add and then click Share in the toolbar. Click Facebook; the pop-up menu changes to reflect all the Facebook albums you've published. Click the album you want to add the photos to, and the deed is done.

iPhoto displays a message in the photo-viewing area letting you know how many photo(s) were published and the album's name.

This syncing process goes both ways. If you upload photos to this same album via Facebook (using Facebook's uploading tools or your smartphone), small, web-size copies of those photos show up in your iPhoto library. This syncing happens automatically when you double-click a previously published album in iPhoto.

Deleting photos from your Facebook albums works exactly like it does with iCloud photo streams (page 203). Before you delete anything, make sure you've selected the *Facebook* item in your Source list, and not Photos or Events (if either of those are selected, then you'll delete the pictures from *iPhoto.*) Then select the offending photo and press the Delete key; when iPhoto asks for confirmation, click Delete. Facebook and iPhoto do a little dance, you see a progress bar at the top of your iPhoto window, and then the photo goes offline. The original, however, is still safe in your iPhoto library.

■ DELETING ALBUMS FROM FACEBOOK

To delete a whole Facebook *album* via iPhoto, make sure Facebook is selected in the Source list. Then select the album and press ⌘-Delete. If you added any photos to the album via Facebook, you get the option to import those photos, as shown in Figure 8-15 (top). These aren't high-resolution versions, just small web editions. Turn on this checkbox, if you're so inclined, and then click Delete.

When you delete a Facebook album in iPhoto, it's removed from your Facebook page, too. If you want to delete the album from iPhoto only (so that it's still visible in Facebook), then you have to delete the Facebook *account* from iPhoto *before* you delete the album. To do so, choose iPhoto→Preferences→Accounts (Figure 8-15, bottom). Select your Facebook account in the list and then click the – sign.

■ MANAGING FACEBOOK ACCOUNTS

If there's more than one avid Facebooker in your household, you can let her upload albums to her *own* Facebook page by adding another Facebook account in iPhoto's Preferences. Likewise, if you want to remove someone's Facebook privileges, you can remove the account.

To do so, choose iPhoto→Preferences→Accounts tab (Figure 8-15, bottom). Click the + sign at the bottom of the pane and, from the resulting list, choose Facebook and then click Add. Enter the new account details when prompted. When you're finished, the Source list displays each member's Facebook account as a separate item in the Shared section.

■ AUTOMATIC PHOTO-TAGGING IN FACEBOOK

If you're always tagging your pals on Facebook, iPhoto can save you a ton of time. Remember how much fun you had back in Chapter 4 getting iPhoto to recognize your friends using the grinding analytic power of the Faces feature? If you took the time to add full names and email addresses to the albums on your Faces corkboard, then tagging your Facebook friends in photos is pretty much a done deal.

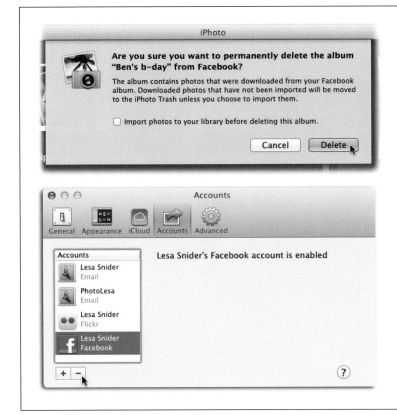

FIGURE 8-15

Top: You can delete a whole album from Facebook all at once. Select your Facebook account in iPhoto's Source list, click the offending album, and then press ⌘-Delete. In the confirmation message, turn on "Import photos to your library before deleting this album" to hang onto photos you've added directly to Facebook.

Bottom: The only way to delete a Facebook album from iPhoto while preserving it on Facebook is to delete the Facebook account from iPhoto first. Just click the – sign shown here to get it done.

Once you upload Faces-tagged photos to Facebook, friends you've identified in the pictures are also noted with *Facebook's* photo-tagging tool. In other words, if you've filled in Ralph's info in his Faces album in iPhoto, then when you upload a photo from that album, Facebook blabs to all your mutual friends that you've just tagged Ralph in one of your pictures.

Depending on your Facebook settings, all your Facebook friends may spot a thumbnail of the Ralph-tagged photo and be able to click a link to see it at full size.

NOTE If you know you've face-tagged someone in Faces view but the tags aren't showing up on Facebook, check the Info panel (page 63) to see what name and email address you entered for that person. For Facebook to understand iPhoto Faces tags, this info has to match the name and email address on the person's Facebook account.

■ ADDING AND VIEWING COMMENTS

One of the most rewarding aspects of publishing photos on Facebook is having people *interact* with them. Happily, you can now view those interactions without ever leaving iPhoto, as shown in Figure 8-16.

Use this menu to choose the source of comments: Facebook or iCloud

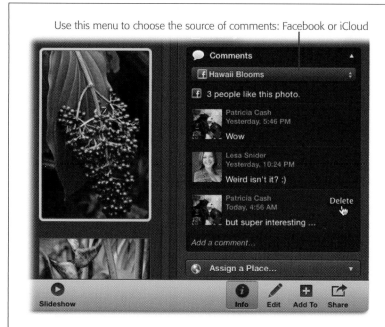

FIGURE 8-16

The Comments section of the Info panel is visible only when you have a single photo selected and that photo has been "liked" or commented upon. iPhoto keeps a tally of how many people "like" your photo. When you add or delete a comment in iPhoto, those changes are reflected in Facebook, too.

As you learned earlier in the chapter, people can also comment on photos shared via iCloud photo streams. So if the photo you're viewing is shared via iCloud and Facebook, a pop-up menu appears at the top of the Comments section to let you pick which comments you want to see.

When someone "likes" your photo on Facebook (by clicking the thumbs-up button near the photo), you can see this info in the Comments section of the Info panel whenever that photo is selected—no matter *what's* selected in your Source list (save for Projects and Slideshows). In other words, you don't have to view the photo in the published album to see "likes" and comments; you could be in Photos or Events view, or in an album or a smart album.

> **TIP** The Info panel's Comments section isn't very big (though it does have a scroll bar). To enlarge it so you can see more input from adoring fans, drag the bottom-right corner of your iPhoto window downward and to the right.

You can add your own comments to keep the conversation going; just click "Add a comment" at the bottom of the Comments section, type away, and then click Post. If you point your cursor at an existing comment (whether it's one that you wrote or that someone else added), a Delete link appears; just click it to obliterate the comment.

■ CHANGING YOUR FACEBOOK PROFILE PICTURE

iPhoto also lets you change your Facebook profile picture—the photo that appears at the top left of your profile page—without your having to visit Facebook on the Web.

Just select the photo you want to use and then click the Share button in iPhoto's toolbar. Choose Facebook; the Share menu changes to include a new option: Profile Picture. Figure 8-17 explains the rest.

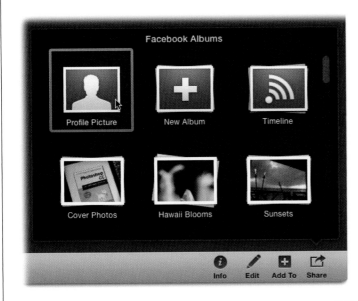

FIGURE 8-17

The Profile Picture option appears in the Share menu when you have just one photo selected. When you give it a click, iPhoto asks you to confirm your choice. In the resulting message pane (not shown), click Set.

Posting Photos to Flickr

Flickr.com is an insanely popular photo-sharing site; it's not uncommon for its members worldwide to upload 30,000 photos and videos a *minute.* The site recognizes geotagged photos and displays them on a map, so those pictures you so carefully pinpointed back in Chapter 4 using iPhoto's Places feature take their location information with them.

iPhoto can send photos directly to your Flickr page—no special software required. All you need is a Flickr account. To get one, visit *www.flickr.com* and sign up (you can also log in with your Facebook or Google account, if you have one).

These days, Flickr is free. Gone are the days when you had to pay for more uploads. Absolutely anyone can upload a *terabyte* of photos and videos at full resolution—hundreds of thousands of them. Photos are limited to 200 MB each (no problem) and video files are limited to 1 GB (meaning that you can't post the entire school play in high definition).

When you join Flickr, you're in for quite a ride. Flickr isn't just a place to post your photos on the Web for your friends and family to see, although it's great for that. It's also a place for photo fans to comment on your photos (though unfortunately, you can't see the comments in iPhoto), link to one another's photo pages, search for photos by keyword (before visiting a place, for example), and so on. You can

also order printed *books* of your photos, complete with a hard cover and matching dust jacket.

> **NOTE** Flickr's privacy settings let you keep personal photos out of the public view. Through the site, you can set up lists of friends and family so that only the people you place on these lists can see specified sets of pictures. Details live at *www.flickr.com/help/faq.*

■ ONE-TIME SETUP

Once you have your Flickr account, it's time to link it to iPhoto and then transfer some photos. Here's the gist of the one-time process:

1. **In iPhoto, select the pictures you want to share on Flickr.**

 You can select whole albums or choose individual photos in your library using the selection techniques on page 46.

2. **Click Share in iPhoto's toolbar, and choose Flickr.**

 iPhoto displays a message at the top of the photo-viewing area asking if you'd like to set it up to publish to your Flickr account.

The Info Panel Knows

Once you start sharing and publishing photos publicly via iCloud, Facebook, Flickr, and Twitter, it can be tough to remember where you shared each one. Sure, you can choose one of the items in the Shared section of the Source list and root around through albums to see what's where, but there's a *faster* way: using the Info panel.

In addition to details about when, how, and where you took a photo, the Info panel also keeps track of what services you shared the photo with, and to whom you've sent the photo via instant message (page 188) or email (page 190).

To find out exactly where that photo of your latest tattoo ended up, select the photo in your library and then click Info in iPhoto's toolbar. (This won't work if you select multiple photos or an entire album; the Info panel's Sharing section is visible only when a single

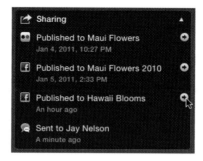

photo is selected *and* you've shared or published it to the services mentioned above.)

The Info panel opens and, if the photo has been published outside of iPhoto, you'll see a section called Sharing. Give it a click; the pane expands to show you all the places the photo lives. In the example shown here, the photo has been shared on Flickr, in *two* Facebook albums, and once via instant message—whew!

If you need to *quickly* delete the tattoo shot from Facebook—in the hopes that Grandma hasn't yet seen it—click the arrow next to the service's listing in the Sharing section. iPhoto opens the web page where the photo lives. There, you can cross your fingers and search for the service's Delete command. Or you can follow the instructions on page 68 for deleting the item within iPhoto. (Alas, you can't take back a photo that you've sent via instant message or email.)

3. **Click Set Up, and then sign into your Yahoo account.**

 iPhoto opens your web browser and asks for your Yahoo username and password (Yahoo owns Flickr). If you forgot to sign up for an account in your excitement about this whole Flickr thing, you can actually sign up here. And if you've got a Facebook or Google account, you can use that instead.

4. **Authorize your Flickr account to talk to iPhoto.**

 This is where you agree to let Flickr snag copies of your photos. Once you agree by clicking the *second* Next button (the one that says you arrived here through iPhoto), you get *another* screen confirming your choice. Click "OK, I'll authorize it."

 Finally, you see a screen saying you can close the browser window and safely return to iPhoto, where the authorization pane promptly disappears.

■ POSTING TO FLICKR

Once your account is in order, you're ready to send pictures from iPhoto to Flickr:

1. **Select individual photos or an album, click Share in the toolbar, choose Flickr, and then click New Set or Photostream.**

 Figure 8-18 explains the difference between these options.

2. **An iPhoto pane appears so you can choose privacy and file-size settings.**

 You can specify who in your Flickr realm will be able to view the uploaded pictures—You, Friends, Family, Family *and* Friends, or Anyone. (To change your audience settings later on, log into *www.flickr.com*.) You can also pick the size—Web, Optimized, or Actual—as shown in Figure 8-18.

WARNING If you post your photos online at actual size, there's nothing to stop other people from downloading and printing them, or even passing them off as their own. If you worry about such things, scaling down your photos makes them far less attractive to photo thieves.

3. **Click Publish.**

 iPhoto hands the pictures off to Flickr so that the world (or the subset of the world you've specified) can see them. A status bar at the top of the iPhoto window shows the program's progress (see Figure 8-19). Depending on the number of photos you're uploading, this process can take awhile. (It's best to let iPhoto finish publishing one set before you ask it to publish another.)

As Figure 8-19 shows, the name of your Flickr account now appears in iPhoto's Source list under the Shared heading. Any set or photos you've uploaded appear in the main viewing area in a stack, like an album or Event.

TIP If you change a Flickr set's name in iPhoto, it changes on Flickr, too. (Just click your Flickr account in iPhoto's Source list, click the set in the photo-viewing area, and then type a new name.) It works the other way, too: Changing the set's name on Flickr also changes it in iPhoto.

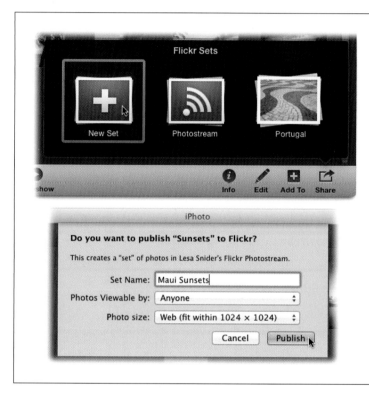

FIGURE 8-18

Top: What iPhoto calls "albums" Flickr calls "sets," and you can create as many of them as you want. They're great for organizing images, especially if you plan to upload often. Alternatively, you can just publish photos straight into your Flickr photostream (think of it as a giant bucket that stores all your uploaded photos, similar to Facebook's Timeline).

Bottom: Before it publishes the photos to your Flickr page, iPhoto wants to know what size to make them. Web and Optimized upload the fastest. Actual Size takes time if you have a lot of big shots to publish.

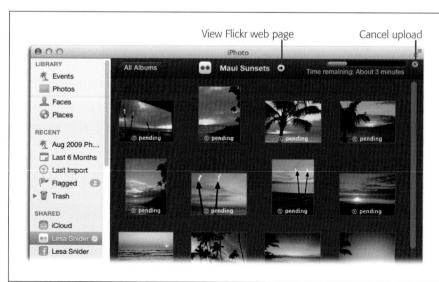

FIGURE 8-19

At the top of the photo-viewing area, a status bar lets you know how long it'll take to upload your photos (in this example, about 3 minutes). A tiny "pending" notation also appears on each thumbnail as it's being processed (resized).

Your Flickr account name also appears in the Source list and you see a spinning arrow to its right when you're uploading photos (visible here).

Any keywords you've applied to your pictures in iPhoto (page 80) are converted into Flickr tags when you publish them on the site. So, if you've added the keywords *sunset, beach,* and *island* to all your sunset pictures while lounging on the beach in Maui, other Flickr members doing searches for photos tagged with *sunset, beach,* or *island* will see your pictures in their search results—*if* you've got your privacy settings configured to let anyone see your photos.

The same thing happens with Places tags (Chapter 4). If you took the time to add location data to your photos, it travels with them when they migrate to Flickr.

> **TIP** You can even set up *multiple* Flickr accounts in iPhoto. To do so, choose iPhoto→Preferences→Accounts. Then click the + sign and, from the resulting list, choose Flickr and click Add. iPhoto then prompts you for your account details. When you're finished authorizing the new account, each Flickr account shows up as a separate icon in your Source list.

■ ADDING MORE PHOTOS TO PUBLISHED FLICKR SETS

Once you've published photos to a Flickr set, adding more photos to the set is easy: Just select the photos(s) you'd like to add and then click Share in the toolbar, choose Flickr, and then select the set you want to add the photos to, as shown in Figure 8-20. iPhoto summons the privacy pane shown at the bottom of Figure 8-18 again. Click Publish, and your photos appear on Flickr.

FIGURE 8-20

After you've created a Flickr set, you can easily add more photos to it. However, iPhoto doesn't let you drag and drop them or use the Add To button; you have to click the Share button in the toolbar (or choose Share→Flickr instead).

If you upload a photo to this same set via Flickr (using Flickr's own uploading tools or your smartphone), small web-size copies of those photos show up in your iPhoto

library. This syncing happens automatically when you double-click a previously published set in iPhoto.

> **NOTE** Feel free to edit your photos after publishing them to Flickr; iPhoto is happy to update them. After you've finished making changes, you can sync your iPhoto and Flickr sets by exiting the published set (click the All Albums button at the top left of the iPhoto window), and then double-clicking it to reopen it. When you do, a status bar appears at the top of the window letting you know that a sync is in progress.

■ DELETING PHOTOS FROM FLICKR

Freeing your photos from Flickr is simple: Select a photo and then press Delete, or select a Flickr *set* and press ⌘-Delete. (Just be sure to take a quick peek at your Source list beforehand to make sure you're deleting them from *Flickr* and not from Photos or Events.) iPhoto then gives you the choice of *leaving* your pictures on the Flickr website. Figure 8-21 has the details.

FIGURE 8-21

Deleting a Flickr set from iPhoto doesn't mean you have to delete those pictures from the Flickr website. Click "Delete Set and Items" to get rid of the set and remove the photos from your Flickr photostream. To delete the set from iPhoto while leaving your Flickr photostream intact, click Delete Set instead.

When you delete photos on the iPhoto end, any photos you added to the set *via Flickr* get moved to iPhoto's Trash; to restore them to your library, just drag them onto the Photos or Events item in your Source list.

Uploading Photos to Twitter

Posting your photos on Twitter is a piece of cake, though it takes a tiny bit of setup. To get started, you need to let iPhoto know about your Twitter account. Oddly, you do this via your *Mac's* preferences instead of iPhoto's. Choose →System Preferences→Internet Accounts, and then click Twitter. Figure 8-22 has the rest.

Now on to the fun part: the actual *tweeting.*

Back in iPhoto, select a thumbnail to share with the Twitterverse, and then click Share in iPhoto's toolbar and choose Twitter (you can also choose Share→Twitter). You see the window shown in Figure 8-23. Type your message and then click Send. iPhoto displays a message letting you know that your tweet was sent. If you listen carefully through your speakers, a little bird whistles, too.

NOTE You can tweet only one photo at a time. If you have more than one photo selected when you choose Twitter from the Share menu, you get an error message.

FIGURE 8-22

Enter your Twitter username and password, and then click Next. When you do, another pane appears announcing all the wonderful places in OS X from which you can tweet. Click Sign In.

As you can see in the background here, you can set up all manner of social media accounts via your Mac's system preferences.

FIGURE 8-23

A counter helps you keep your message under the legal limit of 140 characters. The photo's link takes up 21 characters, so you really only have 119 to play with. If you type an emoticon, iPhoto changes it into an icon, like the smiley face shown here.

As with any shared or web-published picture, iPhoto keeps track of it in the Sharing section of the Info panel; just select a single photo, and then click Info in iPhoto's toolbar. For tweeted photos, the Info panel displays your *entire tweet,* not just the fact that it *was* tweeted.

Exporting iPhoto Web Pages

If you already have your own website, you don't need iCloud to create an online photo album, though you can still enlist iPhoto's help. By using iPhoto's Export command, you can generate HTML pages that you can upload to any web server. You're still saving a lot of time and effort—and you even get a handy thumbnail gallery page.

The web pages you export from iPhoto don't include any fancy designs or themed graphics. In fact, they're kind of stark; just take a look at Figure 8-24. But this is the best method if you plan to post the pages you create to a website of your own—especially if you plan on *tinkering* with the resulting HTML code.

FIGURE 8-24

Here's what a web page exported straight from iPhoto looks like. Just click any photo to see a larger version of it.

This no-frills design is functional, but not particularly elegant. The only things you can control are the number of photos per row, the text and background colors, and whether the photos' titles or descriptions are displayed. On the other hand, the HTML code behind this page is 100 percent editable.

Here are the basic exporting steps:

1. **In iPhoto, select the photos you want to include in the web gallery.**

 The Export command puts no limit on the number of photos you can export in one go, so select as many as you want. iPhoto will generate as many pages as needed to accommodate all the pictures in your specified grid.

 If you don't select any photos, iPhoto assumes you want to export all the photos in the current *album,* even if it's the Library or the Last Import album (yikes!). So pay close attention to what's selected in your Source list.

2. **Choose File→Export, or press Shift-⌘-E.**

 The Export dialog box appears.

3. **Click the Web Page tab (Figure 8-25).**

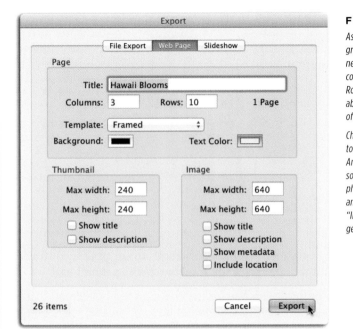

FIGURE 8-25

As you change the size of the thumbnails or the grid, iPhoto updates the number of pages it will need to generate to handle the images. (The page count for your current settings appears next to the Rows field.) The total number of the photos you're about to export appears in the lower-left corner of the dialog box.

Choose Framed from the Template pop-up menu to put a little frame around each thumbnail. And if you turn on "Show metadata," then when someone clicks a thumbnail to open the full-size photo, its camera, shutter, aperture, exposure, and other photographic data appear. Turn on "Include location" to include the location info in geotagged pictures.

4. **Adjust the Page settings, including the title, grid size, and background color.**

 The title you set here will appear in the title bar of each exported web page, and as a header in the page itself.

> **TIP** For maximum compatibility with the world's computers and operating systems—if you're trying to get international visitors to check out your photos—use all lowercase letters and no spaces.

Use the Columns and Rows boxes to specify how many thumbnails you want to appear across and down your "index" page. If you'd like a background page color other than white, click the swatch next to the word "Background" and follow the instructions in Figure 8-26. You can also pick a color for the text on each page by clicking the Text Color swatch.

You can even choose a background *picture* instead of a solid background color. To do that, click the Image Palettes icon at the top of the Color Picker (it looks like a tiny snapshot). Then, from the pop-up menu near the bottom of the window, choose "New from File" to locate the graphics file on your hard

drive. But be considerate of your audience: A background graphic may make your pages take longer to load, and a busy background pattern can distract viewers from your photos.

FIGURE 8-26

Left: If you're not a fan of OS X's standard Color Picker layout, click one of the icons at the top of the dialog box. The crayon picker shown here is both easy to use and offers creative color names, like Eggplant.

Right: In the standard layout, drag the slider on the right up and down to view lighter and darker colors.

5. **Specify how big you want the thumbnail images to be, and choose a size for the enlargement that appears when someone clicks a thumbnail.**

 The sizes iPhoto proposes are fine *if* all your photos are horizontal (that is, in landscape orientation). But if some are wide and some are tall, you're better off specifying *square* dimensions for both the thumbnails and the enlarged photos—240 × 240 for the thumbnails and 640 × 640 for the biggies, for example.

6. **Adjust the remaining settings, as desired.**

 "Show title" draws upon the titles (filenames) you've assigned in iPhoto, centering each picture's name underneath its thumbnail. The larger version of each picture will also bear this name. Turning on "Show description" displays any text you've typed into the Description field in iPhoto. Depending on which checkboxes you turn on, you can have the description appear under each thumbnail, under each enlarged image, or both.

 "Show metadata" displays reams of photographic data (shutter speed, aperture, flash status, and so on) beneath each enlargement.

 Finally, "Include location" makes the photo retain any Places tags (Chapter 4) showing where it was taken. If you have privacy concerns, it's best to leave this setting turned off.

7. **Click Export.**

 The Save dialog box appears.

8. **Choose a folder to hold the exported files (or click New Folder to create one), and then click OK.**

The export process gets under way.

When iPhoto is done exporting, you end up with a series of HTML documents and JPEG images—the building blocks of your website-to-be. A number of these icons automatically inherit the name of the folder where you saved them. If you export the files into a folder named Hawaii Blooms, for example, you'll see something like Figure 8-27:

- **index.html.** This is the main HTML page, containing the first thumbnails in the series that you exported. It's the home page, the index page, and the starting point for the exported pages. To preview the HTML pages in your browser, open this file. If you exported enough photos to require more than one page of thumbnails—that is, if iPhoto required *multiple* "home" pages—you'll see additional pages named *index2.html, index3.html,* and so on.

FIGURE 8-27

This is what a website looks like before it's on the Internet. All the pieces are filed exactly where the index page (home page) can find them.

- **Thumbnails.** This folder holds the actual thumbnail graphics that appear on each of the index pages.

- **Pages.** This folder contains the HTML documents (named *1.html, 2.html, 3.html,* and so on) that open when you click the thumbnails on the index pages.

- **Images.** This folder houses the larger JPEG versions of your photos. These are the *graphics* that appear on the *1.html, 2.html, 3.html* pages.

- **Resources.** This is where iPhoto puts the graphics used to *navigate* the web pages, such as next and back arrows, a Home icon, and so on.

Once you've created these pages, it's up to you to figure out how to post them on the Internet where the world can see them. To do that, you'll have to upload all the

exported files to a web server using an FTP program like the free RBrowser, which is available from *www.rbrowser.com*. For a fancier program, check out Transmit or Fetch. They're available from the Mac App Store for about $30 each; click the Mac App Store icon in your Dock to buy them.

■ ENHANCING IPHOTO'S HTML

If you know how to write HTML code, you're not stuck with the uninspiring web pages exported by iPhoto. You're free to tear into them with a full-blown web authoring program like Adobe Dreamweaver, Adobe Muse, or the free KompoZer (*www.kompozer. net*) to add your own formatting, headers, footers, and other graphics. Heck, even Microsoft Word lets you open and edit HTML documents—it's got plenty of power for changing iPhoto's layout, reformatting the text, or adding your own page elements.

If you're a hard-core HTML coder, you can also open the files in a text editor like BBEdit or even TextEdit to tweak the code directly. With a few quick changes, you can make your iPhoto-generated web pages look more sophisticated and less generic. Here are some of the changes you might want to consider making:

- Change the font faces, sizes, and alignment of titles.

- Add a footer with your contact information, copyright, and email address.

- Add *metadata* tags (keywords) to the page header so that search engines can locate and categorize your pages.

- Insert links to your other websites or relevant sites on the Web.

■ Sharing Photos on a Network

One of the coolest features of iTunes is the way you can "publish" certain playlists on your home or office network so that other people in the same building can listen to your tunes. Why shouldn't iPhoto be able to do the same thing with pictures?

Well, previous versions of iPhoto let you do that, but Apple has removed that feature. Now, Apple wants you to do your photo sharing via iCloud, its free syncing and storage service (page 196). By creating shared photo streams (page 198), you can easily access photos across multiple libraries at your home or office and then drag them into your own library.

And there are other ways to get photos from one Mac onto another:

- **Use AirDrop** to transfer the files. This method is fast, simple, and efficient. There's no setup or passwords involved, and no software to install. AirDrop, a feature of OS X since Mountain Lion, lets you copy files to another Mac that's up to 30 feet away, instantly and wirelessly; you don't need an Internet connection or even a WiFi network. It works on a flight, a beach, or a sailboat in the middle of the Atlantic.

Both parties need to have an AirDrop window open. To open one, open a Finder window and then click AirDrop in the Sidebar, or choose Go→AirDrop. After a moment, the window fills with icons for nearby Macs running Mountain Lion or later that also have an open AirDrop window. Simply drag the image files (or folder, if you stuffed them into one) onto your recipient's icon. When the Mac asks if you're sure, click Send or press Return.

Your recipient sees a message that says, "[Other guy's Mac] wants to send you [filename]." She has three options: Save and Open, Decline, and Save. If she clicks one of the Save buttons, then the file transfer proceeds and a progress bar wraps around the other person's icon in the AirDrop window. The file is encrypted, so evildoers nearby have no clue what you're transferring (or even *that* you're transferring). The file winds up in your recipient's Downloads folder.

TIP The Downloads folder generally sits in the Dock, so it's easy to find. But you can also choose Go→Downloads or press Option-⌘-L to jump there.

- **Copy the files onto an external drive or flash drive,** and then plug the drive into the other person's Mac and copy them into iPhoto.

NOTE If you're lucky enough to own an Apple TV—the small, black "puck" version—your iPhoto library is visible to it, too. It makes for a very impressive slideshow!

- **Use iPhoto Library Manager.** This $30 shareware program is described in Chapter 12. One of its best talents, however, is letting you access a single iPhoto library from multiple Macs on the same network. (The built-in Help screens show you how.) Very cool.

Books, Calendars, and Cards

A t first, gift-giving is fun. During those first 10, 20, or 40 birthdays, anniversaries, graduations, Valentine's Days, Christmases, and so on, you might actually *enjoy* picking out a present, buying it, wrapping it, and delivering it.

After a certain point, however, gift-giving becomes exhausting. What the heck do you get your dad after you've already given him birthday and holiday presents for 35 years?

If you have iPhoto, you've got an ironclad, perennial answer. The program lets you design and order a gorgeous, professionally bound photo book, printed at a real bindery and shipped to the recipient in a slipcover. Your photos are printed on glossy, acid-free paper, at 300 dots per inch, complete with captions (if you like). It's a handsome, emotionally powerful gift *guaranteed* never to wind up in the attic, at a garage sale, or on eBay. These books ($30 and up) are amazing keepsakes—the same idea as most families' photo albums, but infinitely classier and longer lasting (and not much more expensive).

And you're not just limited to books. iPhoto also lets you create equally great-looking calendars (covering any year or group of months that works for you)—a *fantastic* yearly gift—postcards, and even letterpress greeting cards (cards that have inked designs pressed into the paper). Your projects arrive beautifully wrapped in elegant, Apple-logoed envelopes that are a sight to behold in and of themselves.

Fortunately, you use the same designing and ordering tools for all of these photo-publishing projects. The whole process is remarkably easy and more visually pleasing than you can imagine (see Figure 9-1). This chapter begins with a tour of the book-making process and follows up with calendars and cards.

FIGURE 9-1

Once you've gotten a book, calendar, or card under your belt, Full Screen view reveals the world's coolest project bookshelf.

Click a project to see iPhoto illuminate it with a built-in shelf light. Point your cursor at a project to see its details.

Phase 1: Pick the Pix

The hardest part of the whole book-creation process is winnowing your photos to the ones you want to include. Many a shutterbug eagerly sits down to create his very first photo book—and winds up with one that's 98 pages long (and well over $100).

In *most* of Apple's ready-made book designs, each page can hold a maximum of six or seven pictures, though some designs (like Picture Book and Journal) can handle up to *16* pictures per page. Even the seven-per-page limit in most themes doesn't necessarily mean you'll get 120 photos into a 20-page book, however. The more pictures you add to a page, the smaller they have to be, and therefore the less impact they have (after all, you're not looking to create a catalog or a yearbook). The best-looking books generally have varying numbers of pictures per page—one, four, three, two, whatever. So in general, the number of pictures you'll fit in a 20-page book will likely be much lower than the maximum possible—50, for example.

Either way, sifting through your pictures and choosing the most important few can be an excruciating experience, especially if you and a collaborator are trying to work together. ("You can't get rid of that one! It's adorable!" "But, honey, we've already got 139 pictures in here!" "I don't care. I *love* that one.")

You can use any selection method to choose the photos you want to include in your book. You can open an Event, pick and choose among your entire library (page 46), or, better yet, file them in an *album.* You can even select a *group* of albums that you want to include, all together, in one book.

If you opt to start from an album, take this opportunity to set up a preliminary sequence by dragging the pictures around in the album to determine a rough order. You'll have plenty of opportunities to rearrange the pictures on each page later in the process, but the big slide-viewer-like screen of an album makes it easier. Take special care to place the two most sensational or important photos first and last, as they'll be the ones on the cover and the last page of the book. And if you're making a hardbound book (which includes a paper dust jacket), then you need special photos for the inside front and back flaps, and the back cover, too.

Phase 2: Publishing Options

Once you've selected an album or a batch of photos, click Share in the toolbar and then choose Book (Figure 9-2). You can also choose File→New Book.

FIGURE 9-2

You can use the Share menu to begin any project discussed in this chapter.

Creating a project is a fantastic excuse to use Full Screen view. Just click the ⬚ at the top right of iPhoto's window to gain tons of elbow room.

Your screen changes into a giant desktop where you can specify *exactly* what you want your book to look like. It's crawling with important design options.

Book Type

The Book Type buttons labeled in Figure 9-3 let you specify whether you want to publish your book as a hardbound volume (classier and more durable, but more expensive), as a paperback, or with a wire spiral binding. You also have a choice

of sizes for each option using the buttons in the bottom left of the project-design workspace:

- **Hardcover.** Your choices are 11 × 8.5 inches (large) or 13 × 10 inches (extra large). All hardcover books are printed with double-sided pages.

- **Softcover.** Choose between 11 × 8.5 inches (large), which feels the slickest and most formal; 8 × 6 inches (medium), which is more portable; and 3.5 × 2.625 inches (small), the smallest option of any book type.

 This last option gives you a tiny, wallet-size flipbook, with one photo filling each page, edge to edge. You have to order these in sets of three (for a total of $12), which suggests that Apple thinks of them as spontaneous giveaways to relatives, wedding guests, business clients, and so on. In any case, they're absolutely adorable (the booklets, not the business clients).

- **Wire-bound.** These books are available in 11 × 8.5-inch (large) or 8 × 6-inch (medium) sizes.

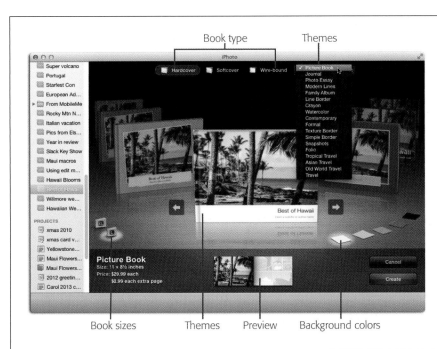

FIGURE 9-3

iPhoto's project-design workspace is easy to use. You can change all of these settings later, even after you've started laying out book pages. But if you have the confidence to make these decisions now, you'll save time, effort, and (if you want captions for your photos) a lot of typing.

As you scroll through the designs (by pressing the arrow keys on your keyboard or by using gestures), the bottom of the window displays a preview of what your book would look like if you pick that theme.

Theme

And now, the main event: choosing a *theme*—a canned design, including typography and color scheme—for your book. The carousel in the center of your iPhoto window contains 18 professionally designed themes, each dedicated to presenting your photos in a unique way.

Apple's book themes offer a variety of dynamic visual styles intended to make your photos pop off the page. Some have page backgrounds that include textures, shadows, passport stamps, ripped-out clippings, and other photorealistic simulations.

Here's a brief description of each theme:

- **Picture Book, Photo Essay.** The motto for these designs could be "maximum photos, minimum margins." There's little room for text and captions (save for on the book jacket), and the photos stretch gloriously from one edge of the page to the other—a *full bleed,* as publishers say. These dramatic designs can be emotionally compelling.

 In the Picture Book theme, you can opt to have a single caption appear at the bottom or on the side of a page no matter how many photos—from one to 16—appear on it. But full pages of photos can often speak—if not shout—for themselves. Plenty of people start out believing that captions will be necessary. But once they start typing "Billy doing a belly flop" or "Dad in repose," they realize they're just restating the obvious.

 The Photo Essay theme contains page layouts that can hold 1–12 photos and has a variety of roomier caption areas. It also has a more serious feel to it, which is sure to please even the most discerning photographer.

 You can also add map pages to either theme for custom cartography. (Remember all those photos you geotagged back in Chapter 4? There's another benefit on the horizon.) There are 10 map options in the Picture Book theme and a whopping 16 in Photo Essay.

- **Journal.** This theme pairs bordered photos with full-page beauties and includes a variety of captioning options. It has six different map layouts, with page designs that can accommodate up to 16 photos. You can choose among eight background colors, or use a photo as a page background.

- **Travel, Asian Travel, Old World Travel, Tropical Travel.** These festive themes make your photos look like they've been taped into a scrapbook, usually at a slight angle to the page. Five color choices are available for a variety of textured backgrounds, along with 17 different map layouts. (The texturing is just an illusion—the paper is the same acid-free, shiny stuff of every iPhoto book; it's just *printed* to look like it's textured.) Captions are optional; if you want them, they'll appear on strips that look like they've been ripped from a piece of stationery, jagged edges and all.

 These themes are casual and friendly—not what you'd submit to *National Geographic* as your photographic portfolio, of course, but great as a cheerful memento of a trip.

- **Simple Border, Line Border, Texture Border.** These three are all variations on (ahem) a theme. They differ only in the kind of border that appears around each photo. These themes are characterized by plenty of "white space" (margins around each photo and each page); crisp 90-degree lines (no photos cocked at an angle); and up to four photos per page with one map layout. A caption can

appear at the bottom of each page, if you like. And for the page backgrounds, you can choose from five colors or an image.

- **Snapshots.** This layout goes for that scrapbook-done-in-a-hurry look. All the photos (up to six per page) are slightly askew and often overlap. The photos all have white edges, as though they're bordered prints from the 1970s. You can pick from six textured backgrounds or use an image instead.

- **Modern Lines.** Each page can have up to four photos on it, with plenty of white margin, plus fine gray "modern lines" that separate the pictures. You can add a one-line caption to the bottom of each page, or leave the pages text-free. This theme gives you a choice of 12 background colors or an image.

- **Formal.** Think "wedding" or "graduation." When you order this book, the photos are printed to look like they've been mounted onto or inset into fancy album pages. For each page, you can choose a textured, gray or pale-blue background. Up to six photos can occupy a page, and you have one map layout option. You can also add a short caption to the bottom of each page.

- **Watercolor.** "Watercolor," in this case, refers to the page backgrounds, which contain gentle, textured, two-toned pastel colors (you get five color combo choices). You can have up to six photos "mounted" on a page either slightly askew, for an informal look, or neatly parallel to the page edges, with one map layout. Note, though, that this design doesn't let you add captions, so you'll have to let the *pictures* tell the story.

- **Contemporary.** The page backgrounds are gray or textured white, the photos are all clean and square to the page, and captions (if you add any) appear in light gray, modern type. The maximum number of photos on a page is three, ensuring that they remain large enough to make a bold statement. Apple is clearly hoping you'll choose only one maximum-impact photo per page; it offers you four different "white-space" treatments for one-photo pages.

- **Folio.** This design is among the most powerful of the bunch, primarily because of the jet-black page backgrounds. (You can also choose a softly textured white.) It looks really cool and allows up to two photos per page, with one map layout.

 This template must have been some designer's pet project, because it's the only one that offers special layout designs for a title page, an About page, and an explanatory-text page, all done up in great-looking fonts in white, gray, and black. Caption space is also provided.

- **Family Album.** This theme makes it official: Apple has gone nuts with making printed pages look like scrapbook pages. In this design, photos look as though they've been affixed to the page using every conceivable method: using "photo corners," taped into photo montages made up of 25 smaller images, licked like giant postage stamps with perforated edges, fastened by inserting their corners into little slits in the page, and even inserted into one of those school-photo binders with an oval opening so your charming face peers out. Up to six

pictures can occupy a page, with one map layout; a page caption is optional. Background choices include white (softly textured), olive green, or an image.

- **Crayon.** Here's another design where the page backgrounds are printed to look like they're textured. For each page, you can choose either a photos-mounted-askew layout or—get this—a straight layout in which each photo has a frame "drawn" around it with a crayon. And to keep with that Crayola-ish theme, you can choose from any of six background colors for each page.

 You can place up to six photos on a page, with one map layout, and can include a caption at the bottom of each page.

The buttons in the bottom-left corner of the window let you choose the book's size (as explained in the previous section, different sizes are available for different book types). Once you pick a size, the area below the buttons fills you in on the details of the options you've selected, including the maximum number of pages, dimensions, and price. The buttons near the bottom right of the window look like little sheets of paper; they let you pick the background color of your book (you can always change it later in the creation process).

Once you've settled on a theme for your book, your initial spate of decision-making is mercifully complete. Click Create.

■ Phase 3: Design the Pages

When you click Create, two things happen. First, a new item appears in your Source list under the Projects heading, representing the book layout you're about to create. You can work with it as you would other kinds of Source-list items. For example, you rename it by clicking its existing name, file it in a folder by dragging it there, delete it by selecting it and pressing the Delete key on your keyboard, and so on.

> **NOTE** Books (and all other iPhoto projects) aren't tied to the album from which they sprang (if you used an album as the basis for your project, that is). So rearranging or reassigning photos in the original album doesn't wreak havoc with the project that's associated with it.

Second, you see the miniature page-layout program shown in Figure 9-4, which displays thumbnails of the individual pages. This is called All Pages view because you can see all the pages in the project.

You've already selected photos and a theme. Now the most time-consuming phase begins: designing the individual pages.

> **NOTE** If you change themes after you've started designing pages, you'll lose most or all of your customization when iPhoto flows your photos into the new theme. A workaround is to *duplicate* your original project before changing themes; to do that, Control-click it in the Source list and choose Duplicate. That way, you can safeguard your page-design work on the other theme in case you change your mind.

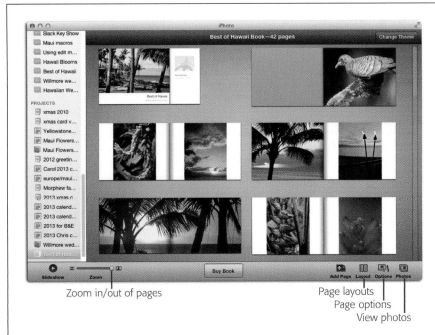

FIGURE 9-4

This is what iPhoto's miniature page-layout program looks like in All Pages view. You can always swap themes—or even book type—by clicking Change Theme in the upper right.

You can drag pages to reorder them, and use the Zoom slider to make the pages bigger or smaller. The options at the bottom right let you add pages, view different layout designs for each page, see page-specific options, or see all the photos you selected for your project.

Zoom in/out of pages

Page layouts
Page options
View photos

You may be surprised to see your pages already filled with photos. iPhoto's Autoflow feature automatically places your photos into the pages in the sequence you've set up; it also factors in Faces tags (it tries to center faces within frames) and ratings (page 86). It's a fast and easy way to lay out the pages of your book, but of course you may not agree with iPhoto's choices. For example, the program may clump that prizewinning shot of you and Benedict Cumberbatch on the same page as three less-impressive photos.

Fortunately, you can always adjust the layout afterward, rearranging where necessary, as described on the following pages.

NOTE If you want to place your pictures manually, you can clear iPhoto's automatic placement by clicking Photos in the toolbar and choosing Clear Placed Photos. Now you're free to place them however you wish, as discussed on page 241.

Open a Page

In All Pages view, the first few miniature layouts represent the cover, the inside flap (for hardcover books), and an Introduction page. When you double-click one of the page thumbnails, a larger version of that two-page spread appears in the main editing area; this is called Single Page view. (To go back to viewing all your pages, click All Pages at the top left of the photo-viewing area or press ⌘-◄.)

In either view, when you click Photos in the toolbar, a panel opens on the right side of your screen that contains the photos you've selected for inclusion in your project (Figure 9-5). A checkmark on a thumbnail indicates that either you or iPhoto has placed that photo onto one of your pages.

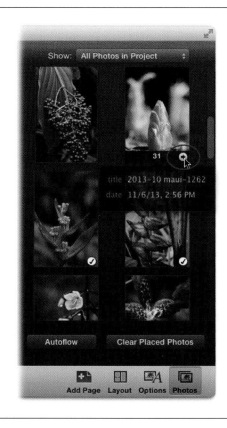

FIGURE 9-5

The Photos panel shows you the pictures in your project. You can use the Show pop-up menu at the top to switch between viewing all the photos in your project, only the ones that have been placed on a page, unplaced photos, or the photos in one of the Recent items in your Source list, like the last-viewed Event, Last Import, and so on.

A checkmark on a thumbnail indicates that the photo is already in your book. If you point to a thumbnail, iPhoto displays a little number at the bottom indicating what page(s) it lives on. To visit that page, click the arrow to its right (circled).

You can't change the arrangement of photo thumbnails in the Photos panel. If you want your photos to appear in an order other than chronological, create an album and reorder the photos there before starting your book project.

Choose a Page Layout

If you flip through the page thumbnails, you can see that iPhoto has cheerfully suggested varying the number of photos per page. Depending on the theme, you may see two on the first page, a big bold one on the next, a set of four on the next, and so on.

If you approve of these photos-per-page proposals, great. You can go to work choosing which photos to put on each page, as described in the next section.

Sooner or later, though, there will come a time when you want three related photos to appear on a page that currently holds only two. That's the purpose of the Layout panel shown in Figure 9-6, which shows you the different page layouts that can fit the number of photos you pick.

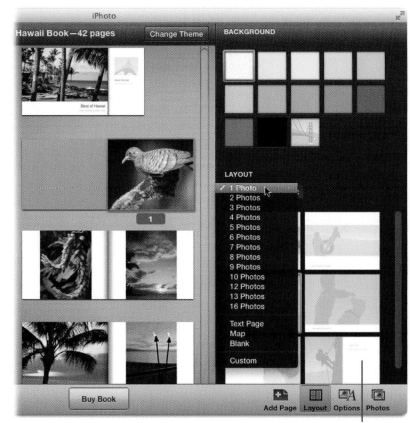

FIGURE 9-6

Top: Click a page in All Pages view, and then click Layout in the toolbar to reveal the panel shown here, which lets you specify the background color for certain pages (front and back cover, flaps, and pages that allow captions), and how many photos you want on the selected page.

The Layout section changes to show you the different page designs for the quantity of photos you pick. Both the number of photos and page designs change according to the page type you've chosen on the left. (You get fewer options for specialized page types like Cover, Flaps, Maps, and Text Pages.)

Page design thumbnails

NOTE After you double-click a page to enter Single Page view—and before you've clicked to select a photo on the page—a little pop-up menu appears above the page preview that lets you switch layouts and backgrounds *without* opening the Layout panel. If this menu disappears, you can summon it by clicking the number displayed beneath each page.

The first page in your book is the cover, which offers fewer options in the Layout panel than most other page types. For a hardcover book, the cover appears on the glossy dust jacket *and* the cover of the actual book (yep, the book's cover is actually a reprint of the dust jacket). You have a choice of six cover layouts that include one to four photos. For example, you're usually offered a choice of one huge photo (and no text), a big photo with a title beneath, four smaller photos plus a title, and so on.

For the *rest* of your pages, the Layout menu gives you design choices aplenty:

- **1 Photo, 2 Photos, 3 Photos...** These items let you specify how many photos appear on the selected page. iPhoto automatically arranges the photos according to its own sense of symmetry. (Some themes offer up to 16 photos per page.) Use these options to create a pleasing overall layout for the book and to give it variety. Follow a page that contains one big photo with a page of four smaller ones, for example.

 You can also use these options to fit the number of photos you have to the length of your book. If you have lots of pictures and don't want to go over the 20-page minimum, then choose higher picture counts for most pages. Conversely, if iPhoto warns you that you have blank pages at the end of your book, then spread your photos out by putting just one or two on some pages.

- **Text Page.** Satisfy your inner author by adding a Text Page to your book. In most themes, this special page design (which used to be named Introduction) has no photos at all. It's just a big set of text boxes that you can type (or paste) into. This is where you can let the audience know about the trip, the company, or the family; tell the story behind the book; praise the book's lucky recipient; scare off intellectual-property thieves with impressive-sounding copyright notices; and so on.

> **TIP** A Text Page doesn't have to be the first page of the book after the cover—you can turn *any* page into a Text Page. Such pages make terrific section dividers. They're especially useful in designs where no text accompanies the photos, where they can set the scene and explain the following pages of pictures.

- **Map.** Although the Travel themes go to town with map styles, you can add an *actual* map page to any theme. (A map can't be on a book's cover or dust jacket, however.) Your photos don't *need* to have location info embedded in them if you want to add a map, but if you've got geotagged photos in the mix, the map page automatically displays *that* area of the world.

 You can fine-tune your map in a variety of ways, like dragging the map image around within the page until it shows the area you want. And you can summon lots of design options by double-clicking the map to open the Options panel. At the top of the map, a slider appears that lets you adjust the size of the area on display, and you can use the Option panel's Location section to plot additional places, as shown in Figure 9-7.

> **TIP** Maps are a great way to illustrate the route you took on a cross-country trip or multi-destination vacation. To add Indiana Jones–style lines linking each location on the journey, choose Curved from the Option panel's Line pop-up menu. iPhoto links the locations in the order they appear in the panel's Places list, so to change the lines connecting each place, drag the location names to the correct spot on the list.

The various checkboxes let you show or hide titles and text, display location names, enhance the map's look with textures and shadows, and even display

a compass on the page. Control-click the map to get a shortcut menu with *even more* options, such as highlighting the region with a soft white glow and color change (visible in Figure 9-7), as well as centering the map on the Places info you enter in the panel's Location section. If you want to start over, choose Restore Default Map in the shortcut menu.

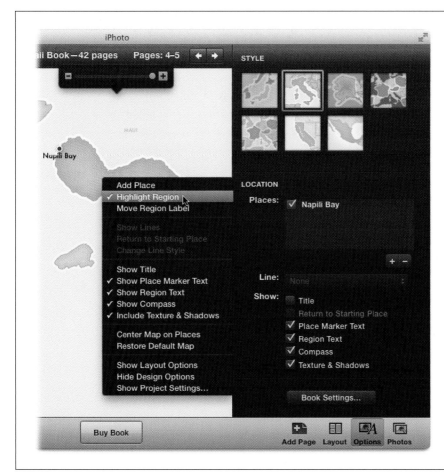

FIGURE 9-7

After adding a Map page, the customizing fun begins. In All Pages view, double-click the map page to enter Single Page view, and then double-click the map again to open the Options panel shown here. You can choose from a variety of map styles at the top of the panel and plot new points by clicking the + sign in the Places list. (To delete a location, select it and then click the – sign.)

Control-clicking the map summons the shortcut menu shown here.

- **Spread.** This absolutely gorgeous layout *spreads* your photos across two full pages in a variety of designs (one choice even makes a single photo fill both pages). It's a great way to showcase your most beautiful pictures, and to break up pages that include captions. You can add text, though that can make iPhoto shrink your photos.

- **Blank.** Here's another way to separate sections of your book: Use an empty page. Well, empty of *pictures,* anyway; most of the themes offer different "looks" for a blank page, such as a choice of color, simulated page texture, or background image (the latter could even be your logo).

TIP When choosing layouts, keep in mind that the book is published horizontally, in landscape mode. On pages with only one photo, a horizontal shot looks best, since it'll fill the page edge to edge. On pages with two photos, two vertical (portrait-mode) shots look best; they'll appear side by side, filling the page top to bottom.

Once you've chosen how *many* photos you want on a page, iPhoto displays thumbnail representations of the page designs available to you (labeled in Figure 9-6). If you choose 3 Photos, for example, the thumbnails offer you a few different arrangements of those three photos—big one on top, two down the side, or whatever. Click one to select it.

Lay Out the Book

The key to understanding iPhoto's book-layout mode is realizing that pages and photos are *draggable.* Dragging is the key to all kinds of book-design fun. In fact, between dragging photos and using a handful of menu commands, you can perform every conceivable kind of photo- and page-manipulation trick imaginable.

NOTE The view you're in determines what's draggable. For example, in All Pages view, you can drag the *pages* themselves—left, right, up, or down—to rearrange them. In Single Page view, you can drag *photos*—between pages or from the Photos panel onto a page. (To enter Single Page view, double-click a page.)

■ WAYS TO MANIPULATE PHOTOS

iPhoto's book-layout mode is crawling with tricks that let you move photos around, add them to pages, remove them, and so on. Once you double-click a page to enter Single Page view, you can move photos around in the following ways:

- **Enlarge a picture** by clicking it. A tiny Zoom slider appears above the photo, which you can use to magnify the picture within its frame (Figure 9-8, top). This trick is helpful when you want to call attention to part of the photo, or to crop a photo for book-layout purposes without actually editing the original.

TIP You may be pleasantly surprised to discover that iPhoto does a fairly smart job of placing photos within their frames when you zoom in. That's face recognition at work—it tries to avoid lopping off parts of people's heads.

FREQUENTLY ASKED QUESTION

Recycling Photos

I want to use my cover photo as one of the pages in the book, just like they do in real coffee-table books. How do I do that?

Easy. iPhoto lets you use a single photo on as many different book pages as you like.

In other words, just because a thumbnail has a checkmark on it (meaning that you've already used it) doesn't mean you can't

use it again. In fact, you absolutely *should* repeat a photo that appears on the cover of your book, or on one of the dust jacket's flaps. Simply add the photo to all the desired pages just like you'd add an unplaced image: Drag it from the Photos panel into the spot where you want to use it. No big deal.

- **Swap two photos on the same page (or two-page spread)** by dragging one directly on top of the other (the picture you're dragging sprouts a blue border). When you let go of the mouse button, the two pictures swap places (see Figure 9-8, middle and bottom).

- **Move a photo to a different page of the book** by dragging it from one page onto another.

- **Swap in a photo** by dragging it out of the Photos panel and onto a photo that's already on a page.

- **Add a photo to a page** by dragging it from the Photos panel onto a *blank* spot of the page. iPhoto automatically increases the number of photos on that page, even changing the Layout pop-up menu to match.

> **NOTE** You can't use this technique to create a layout that doesn't exist. For example, if there are three photos on a page and you add a fourth, iPhoto switches to the next *available* layout in your theme, which might be one with six photos.

- **Remove a photo from a page** by clicking it and then pressing the Delete key on your keyboard. In the Photos panel, the checkmark on the photo's thumbnail disappears (if that was the only page it existed on).

- **Remove a photo from the book altogether** by clicking its thumbnail in the Photos panel and then pressing the Delete key. It disappears from the Photos panel (and thus your project), but it's still in your library.

- **Change how photos are stacked** by Control-clicking an image and, from the shortcut menu, choosing "Move to Front" or "Send to Back." Of course, this works only on page designs that have overlapping photo frames (such as Tropical Travel and Snapshots).

- **Add a border or effect to a photo** by double-clicking the photo in Single Page view to open the Options panel shown in Figure 9-9. (You can also click Options in the toolbar.) A variety of border styles appear at the top of the panel. These vary according to your theme. For more on borders, skip ahead to page 247.

 You can add a creative color treatment to your photo by clicking one of the thumbnails in the Options panel's Effects section. Your choices include B & W (black and white), Sepia (brown tint), Antique (for a slightly faded, vintage look), and Original (removes any effects you've added previously). None of these effects alter the original photo. You can edit the same photos in different ways in every single book or project—all without touching the originals.

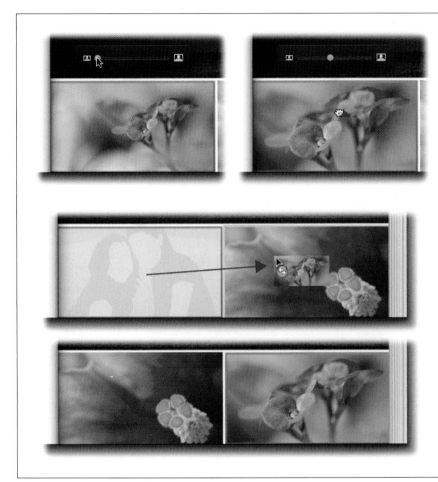

FIGURE 9-8

Top: Click a photo to make its Zoom slider appear (the blue border lets you know the photo is selected); drag the slider to enlarge the photo within its frame (left). Once you've enlarged a photo, you can drag it to adjust its position within its frame; your cursor turns into a tiny hand (right).

Middle: To swap photos, click and drag one photo atop another. The photo you're dragging disappears from its frame and appears as a miniature beneath your cursor.

Bottom: When you release your mouse button, the two photos swap places.

- **Edit a photo** by Control-clicking it and choosing Edit Photo from the shortcut menu. In a flash, iPhoto's book-layout mode disappears, and you find yourself in Edit view (Chapter 5). When you're finished editing, click the button at the top left of the editing window that's labeled with the name of your book project (for example, "Best of Hawaii"). Poof! You return to book-layout mode, with your changes intact.

> **NOTE** Unlike effects you apply from the Options panel, the changes you make in Edit view *do* affect the original photo.

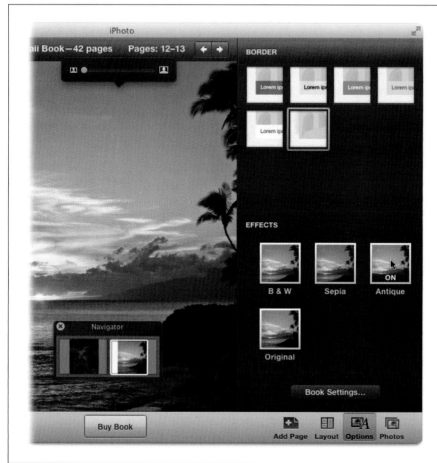

FIGURE 9-9

Double-click a photo in Single Page view to open the Options panel shown here (clicking Options in the toolbar works, too). The icons at the top of the panel let you add a border to your photo; you can add text to this border, if you like (see page 247). The buttons in the Effects section let you add treatments to the photo: Click an effect once to apply it; click it again to remove it. The Antique effect is applied in this example.

You can use the Navigator panel (shown here at bottom left) to move around within a single page while you're zoomed in.

■ **ADDING PICTURES TO THE PROJECT**

To add pictures to the Photos panel, you have to add them to your book *project.* This means temporarily *leaving* your project by choosing another item in the Source list. For example, you can click any Event, album, smart album, or slideshow to see what photos are inside—and then drag the good ones onto your book's icon in the Source list to add them to your project.

Alternatively, you can select some photos and then click Add To in iPhoto's toolbar. In the menu that appears, click Book, and then click the project you want to add the pictures to.

Once the new photos arrive in the Photos panel, you can drag them onto individual pages as described in the previous section.

■ MANIPULATING PAGES

Photos aren't the only ones having all the customization fun. In All Pages view, you can rearrange, add, and remove the *pages* themselves; just click the All Pages button near the top left of your window or press ⌘-◂. Then use these techniques:

• **Move pages around within the book** by dragging their thumbnails horizontally in the photo-viewing area (see Figure 9-10). Shift- or ⌘-click to select multiple pages. (If you click a two-page spread that has a single photo that covers both pages, iPhoto automatically selects them both.)

TIP It's often easier to decide on page order *after* you've perfected the individual pages in your book.

FIGURE 9-10

Top: All Pages view lets you rearrange the pages in your book however you want. In this example, one page is being dragged onto a two-page spread. Notice how iPhoto breaks apart the pages of the destination spread you're pointing to in order to make room for the new one.

Bottom: To select multiple pages, Shift- or ⌘-click them, and then drag the pages wherever you want. When you move two or more pages, iPhoto makes room between the spreads to accommodate the ones you're moving.

- **Remove a page from the book** by clicking its icon and then pressing the Delete key. iPhoto asks if you're sure you know what you're doing, as Figure 9-11 (top) shows. (The minimum number of pages you can have in a book is 20.)

 Note that removing a page never removes any *pictures* from the book project. You're just removing the checkmark from that photo's thumbnail in the Photos panel because it's not used on a page anymore. However, removing a page *does* vaporize any captions you've typed in (so you might want to copy and paste them into a text document first).

- **Insert a new page into the book** by clicking Add Page in the toolbar, or by Control-clicking a page and choosing Add Page from the shortcut menu. Before you go nuts adding pages, though, note that iPhoto inserts the new page *after* the currently selected page. So it's helpful to begin by first clicking the desired page thumbnail in All Pages view, as shown in Figure 9-11 (bottom).

- **Change project (book) settings** by clicking Options in the toolbar and then clicking Book Settings, or by Control-clicking a page and choosing Show Project Settings. In the resulting window, you can turn off Auto-layout pages, wherein iPhoto tries to factor in things like orientation when autoflowing pictures onto your pages. You can also turn off the Apple logo that's automatically included on the last page of your book.

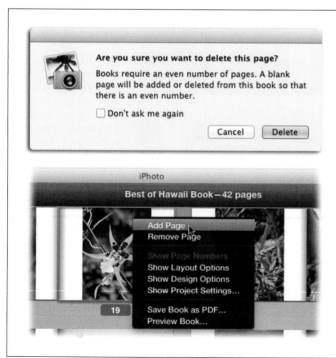

FIGURE 9-11

Top: iPhoto lets you delete as many pages as you want en masse; however, books require an even number of pages. So if you delete a page and end up with an odd number instead, iPhoto will add a blank page automatically to restore its even-numbered balance.

Bottom: You can Control-click any page and, from the shortcut menu, choose Add Page or Remove Page. This menu also reveals other goodies like the ability to access project settings (described above), save the book as a PDF (page 257), or preview what the book will look like should you choose to order it (page 255).

■ LAYOUT STRATEGIES

Sometimes chronological order is the natural sequence for your photos, especially for memento books of trips, parties, weddings, and so on. Of course, nothing is stopping you from cheating a bit—rearranging certain scenes, say—for greater impact and variety.

As you drag your pictures into order, consider these effects:

- Intersperse group shots with solo portraits, scenery with people shots, or vertical photos with horizontal ones.

- On multiple-photo pages, exploit the direction your subjects face. On a three-picture page, for example, you could arrange the people in the photos so that they're all looking roughly toward the center of the page, for a feeling of inclusion. You might put a father looking up toward a shot of his son, or siblings back-to-back facing outward, signifying competition.

- Group similar shots together on a page.

Backgrounds and Borders

Some themes let you choose the background color of the pages, and others let you tweak photo or caption borders. You can change these design details by using the Layout and Options panels.

Backgrounds can be changed in either All Pages or Single Page view. Just select the page(s) you want to change and then click Layout in the toolbar. Any background options appear at the top of the Layout panel. Depending on the theme, you may have two choices (like black or white), or you may have a half-dozen (a range of pastels, say). Most intriguingly, you can use one of your *photos* as a background, and then adjust its transparency so that it forms a faded image behind the other photos (see the box on page 250 for creative background ideas). Sunsets, sandy beaches, cobblestones, and so on can work well as backgrounds. Figure 9-12 has the details.

Borders, on the other hand, are editable only while you're in Single Page view. Once you've double-clicked a page to enter Single Page view, click to select the photo (or text field) whose border you want to change, and then click Options in the toolbar. An array of border choices appear at the top right; your choices vary widely, as Figure 9-13 shows, and depend on which theme you're using. Click one of the thumbnails to apply that border to the selected item.

Layout menu

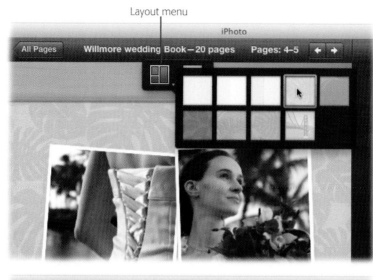

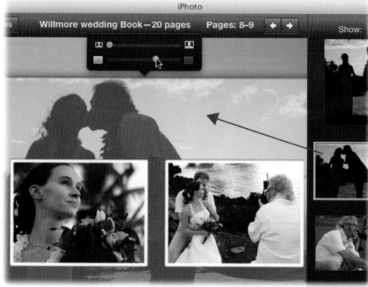

FIGURE 9-12

Top: In Single Page view, click the page number beneath any page to select the page and summon a Layout pop-up menu (labeled here). It lets you pick the number of photos per page and a design layout, and gives you quick access to available background choices (but not borders).

Bottom: To use a picture as a backdrop, choose the last background option (the one with the Golden Gate Bridge on it) and then, with the Photos panel open, drag your picture onto the page's background. The controls shown here appear automatically. Use the top slider to adjust the background photo's zoom level, and the bottom slider to change its transparency (drag left to make it more see-through). The idea is that a background photo should be fainter and subtler than the foreground shots.

If you really want to get creative, try using the same picture for both the background and the foreground. By enlarging the background shot and decreasing its transparency, you can create some neat effects.

Fitting Photos to Frames

iPhoto's design templates operate on the simple premise that all of your photos have a 4:3 aspect ratio. That is, the long and short sides of the photo are in four-to-three proportion (four inches by three inches, for example).

In most cases, that's what you already have, since those are the standard proportions of typical digital photos. If all your pictures are in 4:3 (or 3:4) proportion, they'll fit neatly and beautifully into the page-layout slots iPhoto provides for them.

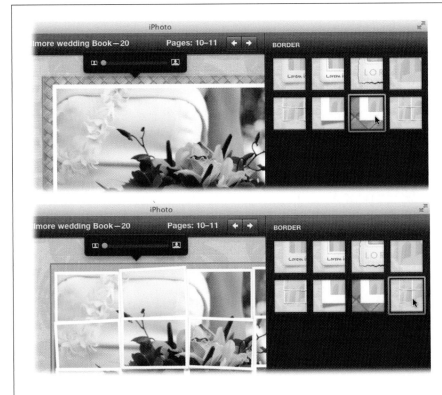

FIGURE 9-13

As you can see here, changing a photo's border makes a big difference in the overall look of the page. A woven border is shown in the top image, while a photo mosaic is shown in the bottom one. (Tropical Travel book design theme was used in this example).

Border choices with the placeholder text "lorem ipsum" include a text field that you can use for captioning. If you don't see any border choices in the Options panel, then you probably don't have anything selected. Also, some themes have way more choices than others.

But not all photos have a 4:3 ratio. You may have cropped a photo into some other shape. Or you may have a camera that can take pictures in 16:9 ratio (like a high-definition TV screen), or the more traditional 3:2 film dimension, which work better as 4 × 6-inch prints.

When these photos land in one of iPhoto's page designs, the program tries to save you the humiliation of misaligned photos. Rather than leave unsightly strips of white along certain edges (therefore producing photos that aren't aligned with one another), iPhoto automatically enlarges oddly cropped photos so they perfectly fill the 4:3 space allotted to them. Unfortunately, this solution isn't always ideal. Sometimes, iPhoto lops off an important part of the picture in the process.

In that case, you have two alternatives. First, you can use the "Fit Photo to Frame Size" command shown in Figure 9-14. Second, you can crop your non-4:3 photos using the Constrain pop-up menu (page 129) set to "4 × 3 (Book)." This way, *you*

get to decide which parts of the photo get lopped off. (Or just use the adjustment technique shown at the top of Figure 9-8.)

Page Limits

iPhoto books can have anywhere from 20 to 100 double-sided pages (in other words, 10 to 50 actual sheets of paper between the covers). Of course, if you have more than 100 pages' worth of pictures, there's nothing to stop you from creating multiple books. (*Our Trip to East Texas, Vol. XI,* anyone?)

Hiding and Formatting Page Numbers

Don't be alarmed if iPhoto puts page numbers on the corners of your book pages—that's strictly a function of the theme you've chosen (some have numbering, some don't). In any case, you never have to worry about a page number winding up superimposed on one of your pictures. A picture *always* takes priority, covering up the page number.

Even so, if your theme puts numbers on your pages and you feel that they're intruding on the mood your book creates, you can eliminate them. You can also change their *formatting*.

Creating Pro-Level Books

While iPhoto may seem like a tool for dabblers and hobbyists, opportunities abound for more pro-level uses, *especially* when creating book projects. Here are a couple of ideas for taking your book project to the next level:

Custom backgrounds. The ability to use a photo as a background gives you all manner of creative options. Try shooting your own *textures* with this use in mind. For example, if you like nature photography, you could take a close-up shot of rocks, grass, or tree bark and use that as a background. If you're creating a book of your kids' favorite sport, take a picture of the soccer ball, ballet shoes, or dirt bike and use *that* as a background on some pages.

If you're a fine artist and paint on a specific medium (canvas, velvet, water-color paper, or whatever), you could take a close-up shot of that texture for use in a book that showcases your work. The possibilities are limited only by your imagination.

Branded intro or outro page. Let's say you use iPhoto for organizing and processing personal stuff, but you also use Adobe Photoshop or Photoshop Elements for more serious projects. While you *can* make photo books in Photoshop Elements, it's not a particularly pleasant process, and Photoshop won't let you do it at all. (Adobe Photoshop Lightroom is a great alternative, but it has a $150 price tag.)

An easy solution is to save JPEGs of your masterpieces in the other program, and then import them into iPhoto and create your book there. You can even create branded *logo* pages in the other program and then import them into iPhoto for use as the first or last page of your book.

For example, if you're creating an 11 × 8.5-inch book, create a new document in Photoshop or Elements that's the same size, and then design it to include your logo and contact info. Since iPhoto doesn't support transparency (see-through areas), you'll need to think about what color *background* you want your logo to appear on and include that in the Photoshop document, too. Heck, you could even create *testimonial* pages in Photoshop, with a few words from adoring fans, and import those into iPhoto to sprinkle throughout your book.

And that's not all. You can use the process described above to design a custom *background image* that includes your logo. To keep the logo from being distracting, put it at the bottom of the page in a small size, or position the logo so it hangs off a page's edge, making a portion of it visible. Back in iPhoto, use its background opacity control (page 248) to keep the logo subtle.

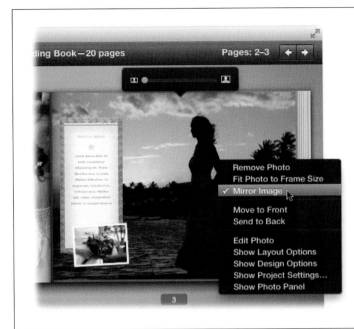

FIGURE 9-14

Control-click a photo in Single Page view and you get this handy shortcut menu. Not only can you use it to keep iPhoto from blowing up your photo so it fills the frame (by choosing "Fit Photo to Frame Size"), but you can also use it to flip a photo horizontally. iPhoto calls this trick "mirroring."

For example, in the original shot of this bride, she was on the left side of the photo, facing right. By choosing Mirror Image, iPhoto flips the photo so she's on the right side instead, and facing left toward the book's spine.

In All Pages or Single Page view, click Options in iPhoto's toolbar, and then click Book Settings. You'll see a "Show page numbers" setting that you can turn off. If you leave it on, you can change the way the page numbers look by using the first pop-up menu to change the font and the menu beneath it to adjust style (bold, italic, and so on). The numeric field lets you change the font size (use the up/down arrows or enter a new number in the field).

TIP You can also Control-click anywhere in the photo-viewing area of All Pages view and, from the shortcut menu, choose Show Page Numbers to turn them on or off.

■ Phase 4: Edit the Titles and Captions

Depending on the theme and page-layout templates you've chosen, iPhoto may offer you any of several kinds of text boxes that you can fill with titles, explanations, and captions by typing or pasting text you've copied from somewhere else (Figure 9-15):

- **The book's title.** This box appears on the book's cover. If it's a hardbound book, it appears on the dust jacket (described next), too. When you first create a book, iPhoto proposes the *album's* name as the book name, but you're welcome to change it.

A second text box, set with slightly smaller type formatting, appears below the title. Use it for a subtitle: the date, "A Trip Down Memory Lane," "Happy Birthday, Aunt Casey," or whatever.

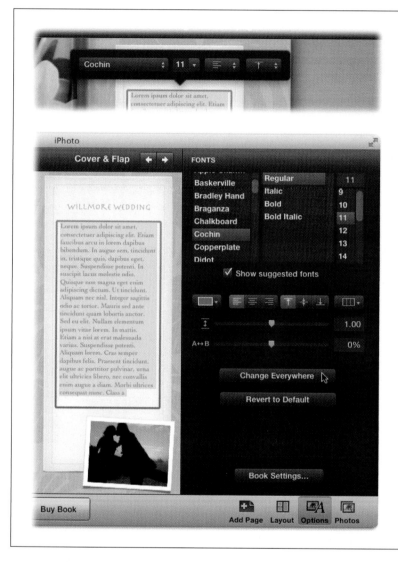

FIGURE 9-15

Top: As soon as you click some text, this pop-up menu of fonts, sizes, and alignment controls appears.

Bottom: For more formatting power, click Options in your toolbar to open the Fonts panel, where you have a full arsenal of typographic controls. You can even alter the text's alignment. To make your changes affect all the text in the book, click Change Everywhere.

If your text doesn't fit within a text box, iPhoto alerts you of impending doom by displaying a red triangle with an exclamation point inside. Either whittle down your text or reformat it so it fits.

- **The dust jacket.** If you order a hardbound book, you've got that glossy dust jacket to consider. You can type up marketing blather or other descriptive material to appear on the inside front cover flap, just like on a book at Barnes & Noble. You're also allowed a couple of lines of text on the back cover.

- **Captions.** Apple really, really doesn't want you adding a caption to *each photo.* Every theme lets you caption an *entire page,* but only the Folio theme lets you

caption each photo—and it limits you to two photos per page, max. That said, some themes have border options that let you include text (page 247).

- **Text Page, About, Contact.** Most themes let you add Text Pages, which are striking, simple, title-plus-text-block affairs that let you describe the book, chapter, or photo grouping. And the Folio theme—which is intended as a showcase for photographers to display their best work—offers two *additional* Text Page options: The About layout offers a text box as well as a big title and a subtitle. The Contact layout includes places to list your phone number, website, email address, and so on—along with the contact info for your agent.

Editing Text

In general, editing text on your book pages is mercifully straightforward. First, open a page in Single Page view, and then do the following:

- Click inside a text box to place the insertion-point cursor in it so you can begin typing. Use the Zoom slider in the toolbar to zoom in on the page so the type is large enough to see and edit. Click outside a text box—on another part of the page, for example—when you're finished.

- Highlight some text and then use the Edit menu's Cut, Copy, and Paste commands to transfer text from box to box. (You may find it easier to compose the text in a word processor where you can save it, copy it, and *then* paste it into iPhoto.)

- You can move highlighted text *within* a text box by dragging it and dropping it. The trick is to hold down the mouse button for a moment *before* dragging. Add the Option key to make a copy of the selected text instead of moving it.

- Double-click a word, or triple-click a paragraph, to select it.

- Press Control-▸ or Control-◂ to make the insertion point jump to the beginning or end of the current line.

- To make typographically proper quotation marks (curly like "this" instead of straight like "this"), press Option-[and Shift-Option-[, respectively. And to make a true long dash—like this—instead of two hyphens, press Shift-Option-hyphen.

Check Your Spelling

Taking the time to perfect your book's text is *extremely* important. A misspelling or typo you make here will haunt you—and amuse the book's recipient—forever.

You can ask iPhoto to check your spelling in several ways:

- **Show spelling and grammar.** Perhaps the safest way to ensure that your book doesn't include embarrassing spelling or grammatical mistakes is to click inside a text block or highlight some text, and then choose Edit→Spelling→"Show Spelling and Grammar" (or Control-click the text box and choose the same command from the resulting shortcut menu). OS X's standard "Spelling and

Grammar" dialog box appears, which lets you fix or ignore potential problems. This command's keyboard shortcut is ⌘-colon (:).

- **Check spelling.** This command does exactly the same thing, though without checking grammar (and without the dialog box). Click inside a text block or highlight some text, and then choose Edit→Spelling→Check Spelling (or press ⌘-semicolon). If the word is misspelled, in iPhoto's opinion, then a red dotted line appears under it. Proceed as shown in Figure 9-16.

- **Check as you type.** The trouble with the spelling commands described above is that they operate on only one text block at a time. So to check your entire photo book, you have to click inside each title or caption and invoke the spelling command again—there's no way to have iPhoto sweep through your entire book at once.

Fortunately, the Edit→Spelling→Check Spelling While Typing command is turned on straight from the factory. It makes iPhoto flag words it doesn't recognize *as you type them.*

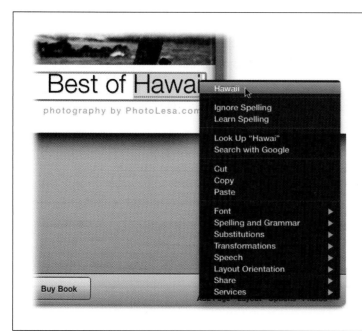

FIGURE 9-16

Control-click any word that's underlined with a red dotted line. If the resulting shortcut menu contains the correct spelling, choose it.

If the word is fine as is, click either Ignore Spelling ("Stop underlining this, iPhoto. It's a word I want spelled this way, so let's move on") or Learn Spelling ("This name or word is not only correctly spelled, but it's also one that I may use again. Add it to my OS X dictionary so you'll never flag it again.").

As you can see, this menu is chock-full of useful options!

Sure enough, whenever you type a word that's not in iPhoto's dictionary, iPhoto adds a dashed red underline. (Technically, it underlines any word not in the *OS X* dictionary, since you're actually using the standard OS X spell checker—the same one that watches over you in OS X's Mail program, for example.)

To correct a misspelling that iPhoto has found in this way, Control-click it and proceed as shown in Figure 9-16.

- **Check grammar with spelling.** This feature is an automatic version of the first item in this list. If iPhoto thinks you've made a spelling or grammatical mistake, it underlines the offending word(s) or phrase(s) in red. To turn it on, choose Edit→Spelling→Check Grammar With Spelling.

- **Correct spelling automatically.** This option lets iPhoto fix your mistakes automatically. If you harbor an *enormous* amount of trust in the program's dictionary, take a deep breath and choose Edit→Spelling→Correct Spelling Automatically.

Listen to Your Book

Unfortunately, even a spell checker won't find missing words or really awkward writing. For those situations, what you really want is for iPhoto to *read your text boxes aloud* to you.

No problem: Just highlight some text and then Control-click the highlighted area. The shortcut menu shown in Figure 9-16 appears, containing the Speech submenu. From it, you can choose Start Speaking and Stop Speaking, which makes iPhoto start and stop reading the selected text aloud. It uses whatever voice you've selected in →System Preferences→Dictation & Speech.

▇ Phase 5: Preview Your Masterpiece

Ordering a professionally bound book is, needless to say, quite a commitment. Before blowing a bunch of money on a one-shot deal, you'd be wise to proofread and inspect it from every possible angle.

Print It

As any proofreader can tell you, looking over a book on paper is a sure way to discover errors that somehow elude detection onscreen. That's why it's a smart idea to print out your own, low-tech edition of your book at home before beaming it to Apple's bindery.

While you're in Book mode, choose File→Print to launch the standard OS X Print dialog box; fire up your printer and click Print. The result may not be wire-bound and printed on acid-free paper, but it's a tantalizing preview of the real thing—and a convenient way to give the book one final look.

Slideshow It

Here's a feature that might not seem to make much sense at first: After you're finished designing a book, you can *play* it as a slideshow. Just click Slideshow in iPhoto's toolbar; your screen goes black. Depending on the complexity of your book's layout, it may take iPhoto a minute or two to compose itself and generate the slideshow.

Once the show starts in glorious full-screen mode, it uses the Classic slideshow theme (page 191). To change the music or transitions, wiggle your mouse to display the mini toolbar and then click the Music or Settings icons. When you're satisfied,

the show kicks in, displaying the cover of your book before moving on to each individual page, one at a time, though you can also flip through the pages manually using your keyboard's left and right arrow keys. (This is probably one of the easier ways to get a book turned into a movie.)

Viewing your book as a slideshow is primarily a proofreading technique. It presents each page at life size (or even larger than life) without the distractions of menus or other iPhoto window elements, so you can get one last, loving look before you place your order.

But book slideshows are also kind of cool for another reason: They present a more varied look at your photos than a regular slideshow. That is, your photos appear in page groupings, with captions, layouts, and backgrounds that there'd otherwise be no way to create in a slideshow.

You've almost certainly encountered PDF (Portable Document Format) files before. Many a software manual, Read Me file, and downloadable "white paper" come in this format. When you create a PDF document and send it to a friend, it looks *exactly* the same on the recipient's screen as it did on yours, complete with the same fonts, colors, page design, and other elements. Your friend gets to see all of this even if he doesn't *have* the fonts or the program you used to create the document. PDF files open on Mac, Windows, and even Linux machines—and you can even search the text inside them.

Goodbye, Yellow Exclamation Points

As you worked on your project designs in early versions of iPhoto (iPhoto '09 and prior), you may have encountered dreaded yellow triangle exclamation points. They appeared on photos or individual pages of your book or calendar when photos didn't have enough resolution to reproduce well in the finished book.

But these days, the only place you'll spot a yellow triangle warning is on the order screen when you're purchasing prints (shown on page 184).

Apple says that its photo-enlargement technology has gotten so good, your pictures will look fabulous regardless of their resolution. Plus, Apple figures you're shooting with a camera that's at least 3 megapixels (which includes the vintage iPhone 3GS), so you'll have enough pixels to produce a nice print. (A 3-megapixel device can produce a high-quality 8 × 10-inch print, and a decent 10 × 13-inch print.)

Bottom line: Unless you're using photos that you've snatched from the Web or received in an email—at a greatly reduced size—you don't have anything to worry about.

That said, if a photo looks blurry after you place it in your project, it'll print blurry, too (Apple's photo-enlargement technology can't work miracles). In that case, the easiest solution is to shrink the photo. And the simplest way to do *that* is to increase the number of pictures on that page. Or, if your page design has places that hold both large and small photos, drag the problem photo onto one of the smaller frames to swap it with a larger photo.

If *that* doesn't work, then your only options are to eliminate the photo from your book or to cross your fingers and order the book anyway.

Turn It into a PDF File

If other people want to have a look at your photo book before it goes to be printed—or if they'd just like to have a copy of their own—a PDF file makes a convenient package (plus you can show it off on your iPad). Here's how to create a PDF file:

1. **With your book design on the screen in front of you, choose File→Print.**

 The Print dialog box appears.

2. **Click PDF→Save as PDF.**

 The Save As sheet appears.

3. **Type a name for the file, choose where you want to save it, and then click Save.**

 Your PDF file is ready to distribute. The easiest way to get the PDF onto your iOS device is by using Apple's free iBooks program. Once you've downloaded and installed iBooks on both your iOS device and your Mac, launch the program on your Mac, and then drag and drop the PDF of your photo book onto the iBooks window. Next, fire up iTunes, connect your iOS device to your Mac, and then click its name at the upper right of the iTunes window. Click the Books tab, turn on the PDF's checkmark, and then click Sync. Finally, on your iOS device, open iBooks to view your PDF.

> **TIP** You can also create a PDF by using the book-creation shortcut menu. Just Control-click an empty spot in the woodgrain background in either All Pages or Single Page view, and then choose "Save Book as PDF." Give your PDF a name in the resulting dialog box and click Save.
>
> If you want to *see* the PDF before saving it, choose Preview Book from the shortcut menu instead to open an unsaved version in OS X's Preview program. To save the resulting PDF, choose File→Save As.

■ Phase 6: Send the Book to the Bindery

When you think your book is ready for birth, click Buy Book in iPhoto's toolbar.

> **NOTE** If iPhoto discovers any issues with your book, it displays dialog boxes letting you know. These can include things like not filling in all the default text boxes, like the title and subtitle; that your book is "incomplete" (you didn't fill in all the gray placeholder rectangles with pictures); and so on. You have to fix these things before you can print the book. Once everything looks good, click Buy Book again.

After several minutes of converting your design into an Internet-transmittable file, iPhoto displays a screen where you can enter a quantity, shipping info, and so on. At this stage, your tasks are largely administrative:

- **Inspect the charges.** If you've gone beyond the basic 20 pages, you'll see that you're about to be charged between 30 cents and $1 per additional page, depending on the book type.

- **Indicate the quantity.** You can order multiple copies of the same book. Indeed, after you've spent so much time on a gift book for someone else, you may well be tempted to order yourself a copy.

NOTE Veteran iPhoto fans will notice that Apple no longer offers a choice of cover color for hardcover books. That's because the cover is actually a reprint of the dust jacket.

- **Enter the Zip code where you want it sent.** The book doesn't have to come to you; it can go anywhere. Though in order for iPhoto to calculate the proper sales tax, it needs to know the destination Zip code.

- **Pick a shipping method.** For U.S. orders, Standard shipping takes about four days and costs $6. Express means overnight or second-day shipping (depending on when you place the order) and costs $11. An additional copy sent to the same address doesn't add anything to the shipping cost.

NOTE You can order books if you live in Europe, Asia Pacific, Japan, or North America, but Apple offers shipping only to people in your own region.

Your Apple ID

You can't actually order a book until you've signed up for an Apple account. You already have one if you've ever bought something from an online Apple store or the iTunes Store. Regardless of whether you have an Apple account, ordering your first iPhoto book requires you to complete some electronic paperwork:

1. **Adjust the fields in the Your Order window as explained above, and then click Check Out.**

2. **On the Sign In screen that appears, enter your Apple account info or click "Create Apple ID now."**

 If you're an Apple aficionado, enter your Apple ID and password in the Returning Customer fields. (An Apple ID is your email or your iCloud address, if you have one.) Then click Sign In and skip to step 3.

 If you're an Apple newbie, click "Create Apple ID now" and enjoy a whirlwind tour through Apple's account-signup screens. You'll be asked for your contact info and credit card number, a password, and whether you want to receive Apple junk mail. You'll also be offered the chance to enter addresses of people

you may want books shipped to. Click Continue; you wind up right where you started: at the Your Order screen.

3. **Click Check Out.**

 You've already stored your credit card information, so there's nothing to do now but wait for your Mac to upload the book. After a few minutes, you'll see a confirmation message.

4. **From the Ship To pop-up menu on the next screen, choose the lucky recipient of your book.**

 If it's you, choose Myself. If not, you can choose Add New Address from this pop-up menu.

5. **Click Done, and then go about your life for a few days, holding your breath until the book arrives.**

 When it does, you'll certainly be impressed. The photos are printed on Indigo digital presses (fancy, digital, four-color offset machines). The book itself is classy, handsome...and it smells really good!

Photo Calendars

Custom-made photo books? Old hat, dude. Nowadays, people are buzzing about the *other* custom stuff you can order: calendars, greeting cards, and postcards. (Mugs and bumper stickers will have to wait for future versions. In the meantime, you can order them from *www.cafepress.com*.)

WORKAROUND WORKSHOP

Secrets of the Apple Book-Publishing Empire

It's no secret that when you order prints of your photos via the Internet using iPhoto, Kodak makes the prints. But neither temptation nor torture will persuade Apple to reveal who makes the gorgeous iPhoto *books.*

It didn't take long for Mac fans on the Internet, however, to discover some astonishing similarities between iPhoto books and the books created by a firm called MyPublisher.com. The pricing, timing, and books themselves are all identical. (When asked if it's Apple's publishing partner, MyPublisher.com says, "We don't discuss our partner relationships," which means "Yes.")

iPhoto-generated books are more elegantly designed than the ones you build yourself at MyPublisher.com (or anywhere

else, for that matter). And it's certainly easier to upload books directly from iPhoto, rather than to upload photo files one at a time using your web browser.

Still, you should know that building your books directly at MyPublisher.com offers greater design freedom than iPhoto does. You have a wider choice of cover colors and materials (even leather), you can add borders around the pages, and you have much more flexibility over the placement of photos and text.

In fact, it's easy to get carried away with these options and produce something absolutely ghastly, which is probably why Apple chose to limit your options. This way, you simply can't go wrong.

The calendars are absolutely beautiful—and *huge* (10.4 × 13 inches). As shown in Figure 9-17, each one is wire-bound, with a big Picture of the Month (or Pictures of the Month) above the date grid. You can customize each calendar with text, titles, national holidays, events imported from your iCal calendar, and even little thumbnail photos on the date squares.

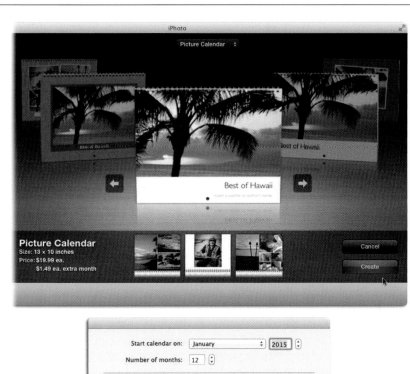

FIGURE 9-17

Top: iPhoto's various calendar themes have different date sizes, photo placements, and background patterns.

Bottom: Your calendar doesn't have to start with January—you can pick any starting month you want. And the calendar can include up to 24 months (two years).

The "Show calendars" box lets you include calendars you've set up in iCal— Work, Social, Star Trek Conventions, whatever—in your iPhoto calendar. It's worth noting that several third-party entities, such as TripIt and Star Walk, may have added their own calendars to your Mac and, as a result, they're available to add to your printed calendar, too.

For the curious, TripIt is an excellent trip-planning program, and Star Walk is for identifying celestial bodies and viewing astronomical events.

If you've designed an iPhoto book, then designing an iPhoto calendar will give you an overwhelming sense of déjà vu. iPhoto's calendar-design setup is *identical* to its book-design setup (and card-design setup, and so on). But since you're usually dealing with 12 calendar pages instead of 20 book pages, they don't take as long to assemble (and they make *fantastic* yet practical holiday gifts!).

Anyway, here's the drill:

Phase 1: Choose the Photos

Pick out pictures for the cover photo, the "picture of the month" photos, and any pictures you want to drag onto individual date squares. You can select an Event, a full album, several albums, or any group of thumbnails in the viewing area to get started (though creating an album specifically for your calendar is more efficient).

Phase 2: Choose the Calendar's Design

Click the Share button in iPhoto's toolbar, and then choose Calendar.

iPhoto's photo-viewing area changes to display miniature calendar designs in a carousel (Figure 9-17, top). These are the calendar *themes,* which are just like the book themes described earlier in this chapter. Scroll through them—either by pressing the ▸ and ◂ keys or by swiping a finger across your Magic Mouse or Magic Trackpad—to see a preview of each one. The designs differ in photo spacing, the size of the numbers marking the dates, the availability of captions, and so on. When the carousel settles on the theme you want, click Create.

The dialog box shown at the bottom of Figure 9-17 appears so you can choose options such as what period you want the calendar to cover. The "Show national holidays" pop-up menu lets you fill your calendar with the dates your country's government has deemed important. For example, the United States' holidays include Valentine's Day, Lincoln's Birthday, and Thanksgiving; the French holidays include Whit Sunday, Assumption Day, and Bastille Day (in English); and the Malaysian holidays include Merdeka, Awal Ramadan, and Yang Di-Pertua of Sarawak's Birthday (but you knew that).

If you keep your calendar in iCal (the OS X calendar program in your Applications folder), you can choose to have *those* events appear on your printed photo calendar, too (see Figure 9-17, bottom). You can also turn on "Show birthdays from Contacts." That's a reference to the OS X address-book program, which—along with names, addresses, and phone numbers—has a space to record each person's birthday. Incorporating them into your *printed* calendar means you'll never forget a loved one's (or even a *liked* one's) special day.

> **TIP** This isn't the only chance you'll have to adjust these settings. You can return to them at any time—when you're moving to Italy, for example, and want to change the holidays—by following the instructions in Figure 9-18.

When you're finished setting things up, click OK. You arrive in the calendar-design workspace, which looks like a big desktop (Figure 9-18), just like the book-design view. A new icon appears in your Source list to represent the calendar you're creating; you can file it into a folder, rename it, or trash it just as you would a slideshow or a book.

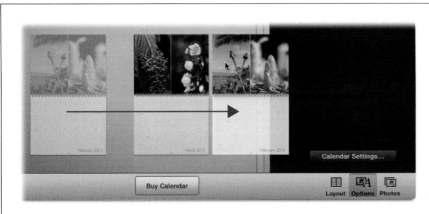

FIGURE 9-18

You can rearrange the pages of your calendar in this view; just click and drag the pages, as shown here. When you're working on a calendar project in All Pages view, you can return to the calendar's settings by clicking Options in the toolbar and then clicking Calendar Settings (it doesn't matter whether you have any calendar pages selected).

Now you're ready for the fun part: arranging photos on your calendar pages.

Phase 3: Design the Pages

Each of the calendar's page spreads shows a "photo of the month" on the upper page (above the spiral binding) and a month grid on the lower page. iPhoto automatically populates your pages with photos and places them in chronological order according to when they were taken; it also attempts to factor in Faces tags (to center faces inside photo frames), orientation (landscape vs. portrait), and ratings.

However, once you double-click a page to enter Single Page view, you can replace iPhoto's choices with your *own* by clicking Photos in the toolbar. When you do, the Photos panel opens, displaying thumbnails of the pictures you've selected for inclusion. To replace a photo, drag it from the Photos panel onto the photo frame or existing photo.

> **TIP** If you're not a fan of iPhoto's Autoflow feature—you'd rather place all the photos onto the calendar pages yourself—then open the Photos panel and click Clear Placed Photos. The photos are instantly replaced with generic gray boxes onto which you can drop photos of your choosing.

The design controls in Single Page view work exactly the same way as they do when you're designing a book (page 235). You can click a photo to reveal its zoom slider (Figure 9-19) and then reposition the photo within its frame by clicking and dragging (your cursor turns into a tiny hand).

NOTE When you open the Photos panel, you see little numbers on some (or all) of the photo thumbnails. That number indicates which calendar page the photo is used on; click the arrow to the number's right to see that page.

It's worth noting that iPhoto counts each calendar page as *2,* beginning with the first month (it excludes the front and back covers), so a one-year calendar has 24 pages.

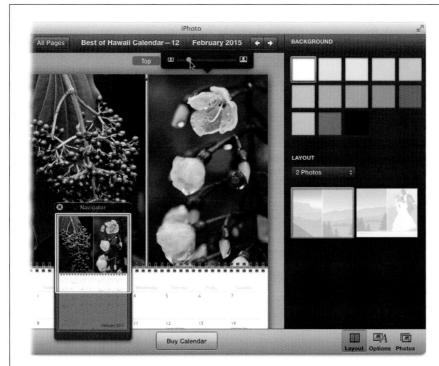

FIGURE 9-19

The Zoom slider shown here lets you zoom into/ out of a photo. The Zoom slider in iPhoto's toolbar, on the other hand, lets you zoom into/out of pages as you're designing them. Zoom into a page and the Navigator appears (see lower left); use it to re-position the current page while zoomed in (or use gesturing on your Magic Mouse or trackpad).

The white arrows near the top of this window let you view other pages. Change the number of photos per page by clicking Layout in the toolbar. Pick a number of photos from the Layout pop-up menu shown here, and then click a design thumbnail to apply it. The Background thumbnails at the top let you pick a color for any empty space on the page.

In Single Page view, you can drag pictures into the photo boxes exactly the way you do when you're designing a book. If you don't see the photo you want in the Photos panel, you can add it to your calendar project in a couple of ways. Once you've located the photo in your library, here's what to do:

- Select the photo, click Add To in the toolbar, choose Calendar, and then pick the calendar you're working on.

- Select the photo and drag it onto your calendar project's icon in the Source list.

Either way, the photo lands in your Photos panel, ready to be (briefly) immortalized on a calendar page.

Speaking of placing photos, choose one really good shot to grace the calendar's front cover; this is what the recipient (even if it's you) is going to see when he unwraps the calendar. You'll want to repeat the photo elsewhere in your calendar in order to fully enjoy it, though.

And of course you'll want to illustrate each month with an especially appropriate photo—or more than one. Click Layout in the toolbar to open the Layout panel, and then use the pop-up menu to choose 2 Photos, 3 Photos, or whatever; some themes let you place as many as seven pictures above the spiral binding.

There's one other place you can put photos that might not have occurred to you: the *individual date squares* (see Figure 9-20). You can put people's faces on their birthday squares, for example, or vacation shots on the dates when you took them.

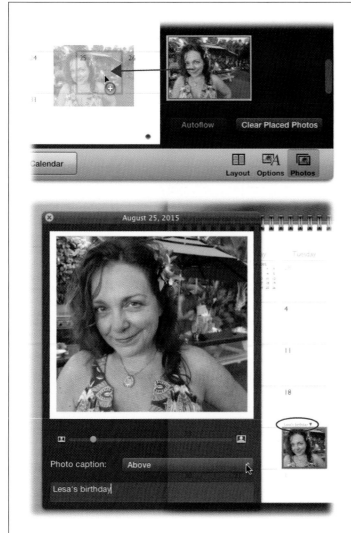

FIGURE 9-20

After you drag an image from the Photos panel onto a date square (top), double-click the photo in the calendar to display a handy panel (bottom). You can use the panel's slider to enlarge the picture within its box or drag the picture to reposition it in the frame.

To add a caption, choose a location from the "Photo caption" pop-up menu, and then enter some text. Since the photo fills the entire date square—hiding the date itself—captions have to live outside the square: above it, below it, or to its left or right.

Once you've dropped a picture onto a date square, it's hard to get rid of. Try selecting the date it lives on by clicking it (you see a blue border around the date square) and then pressing the Delete key on your keyboard. If that doesn't work, then drag the photo from the date square into the Photos panel; you see a little puff of smoke as the photo disappears.

You can edit photos right on the calendar-page layouts. Once you're in Single Page view, click Options in the toolbar and choose from three creative color effects: B & W, Sepia, and Antique. (These effects don't change the photo in your library.) For more editing power, Control-click the image and choose Edit Photo from the shortcut menu. Just be aware that the changes you make in this way *do* affect the original photo in your library.

When you're finished editing a particular month, you can move on to the next month by clicking one of the white arrows at the top of the window, to the right of the current page's name ("August 2015," for example).

Phase 4: Edit the Text

Once your calendar is photographically compelling, you can finish it off with titles, captions, and other text goodness. The cover, for example, offers both a main title and—in most themes—a subtitle.

Click the placeholder words to select and replace them with text of your own. You can also single-click any date square to open a caption box where you can type important events (like "Robin's Graduation" or "New Avengers Movie"; see Figure 9-21). If the date has a photo on it, you need to choose a location from the Caption pop-up menu, as described in the previous section.

> **TIP** Once the caption box is open, you don't have to close it and reopen it for another date. Each time you click a square on the calendar, the caption box automatically changes to show its text contents. (This trick also applies to the photo box shown in Figure 9-20.)

Just as with books, you can change the text formatting—either globally (for all pages) or for just some selected text:

- To change the text globally, click Options in the toolbar. In the resulting panel, specify the fonts and sizes you want, and then click Change Everywhere. (If you decide that Apple's original font assignments were actually better than what you've come up with, click "Revert to Default.")

- To change the formatting of a single word or sentence, highlight it and then use the formatting pop-up menu that appears. (If you'd rather use the Options panel's controls, you can do that instead.)

Phase 5: Order the Calendar

When you've said to yourself, "I'm [your name here], and I approve of this calendar," then, click the Buy Calendar button in the toolbar.

If you've left any gray photo boxes empty or if any caption placeholders are still empty, an error message appears. You won't be able to order the calendar without filling in the photo boxes, although leaving captions empty is OK. (The calendar will simply print without any text there—not even the dummy placeholder text.)

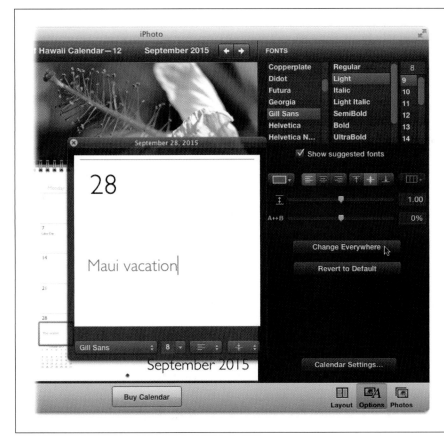

FIGURE 9-21

Click any date square to open this caption box.

iPhoto really wants to center your text vertically within the square, so you need to click a spot near the middle of the caption box to get the blinking insertion point. To change the vertical alignment— say, to make the text appear at the top or the bottom of the square—use the little pop-up menu at the bottom right of the caption box.

For even more typographical controls, click Options in the toolbar to display the panel shown here.

After a moment, your Mac connects to the Internet, and you see an order screen. It looks and works just like the order screen for prints (Chapter 7) and books, except the pricing is a little different. A 12-month calendar costs an incredibly affordable $20. Each additional month adds $1.50 to the price, though there's a 10% discount if you order 25 (!) or more at a time.

Assuming you're all signed up as a certified Apple customer (page 258), all you have to do is specify how many copies you want, where you want them shipped, and via which method (Standard or Express). Click Check Out, and mark off the very few days on your *old* calendar as you wait for the new one to arrive.

NOTE It's worth noting that when you give custom calendars to loved ones, there's no going back: They come to expect them *yearly* because they're of such high quality (and people have been known to throw fits if they don't get one). Consider yourself warned.

Greeting Cards and Postcards

Why stop at books and calendars? iPhoto also offers gorgeous greeting-card and postcard designs (Figure 9-22). These items are professionally printed and don't cost an arm and a leg.

> **NOTE** You can also use iPhoto to create *letterpress* cards, which have inked designs pressed into beautifully textured paper. They're spectacular—but cost $3 each.

Here's how to create these custom goodies:

1. **Select the photo(s) you want to use in your card, and then click Share in the toolbar and choose Card.**

 iPhoto's familiar themes carousel appears, this time showing card designs (Figure 9-22).

> **TIP** Contrary to what you might think, it's best to start with *several* photos—some card themes can hold up to seven pictures. So consider corralling card candidates into an *album* before starting the card-creation process.

2. **At the top of the theme-choosing area, pick a card type—Letterpress, Folded, or Flat—and then use the arrow keys or pop-up menu to peruse the various designs.**

 iPhoto offers 31 different design themes for letterpress cards, and nine *categories* of themes for folded and flat cards. They include holiday themes (including Easter, Valentine's Day, and Halloween), thank-you notes, baby announcements, birthday cards, invitations, and so on.

3. **If you're making a letterpress card (which has fewer customization options), click Create. If you're making a folded or flat card, use the icons labeled in Figure 9-22 to choose a layout and background color for your card, and *then* click Create.**

> **NOTE** If you choose Letterpress, you can watch a movie extolling this type of card's many virtues; just click the Play icon that appears at the bottom of the window, next to the card preview.

You arrive at the now-familiar page-design screen (technically it's Single Page view), where you can adjust the photo, background, and text (see Figure 9-23). You'll see two rectangles: the inside and outside (for a greeting card) or front and back (for a postcard).

A new icon appears in your Source list representing your card-in-progress.

4. **Adjust the photo(s).**

Click a photo to enter the picture-adjustment mode described on page 251, where you can drag the slider to enlarge the photo, or drag the picture to adjust its position inside the frame.

You can also replace the photo. If you had the foresight to choose several candidates in step 1, then simply open the Photos panel (click Photos in the toolbar), and then drag thumbnails directly into the card's photo frames to try them out.

If you didn't think ahead, all is not lost. In the Source list, click the album that contains the photos you want to try as alternatives, and then drag their thumbnails onto the card's Source list icon. Alternatively, select the photo(s), click Add To in the toolbar, choose Card, and then pick the one you're working on.

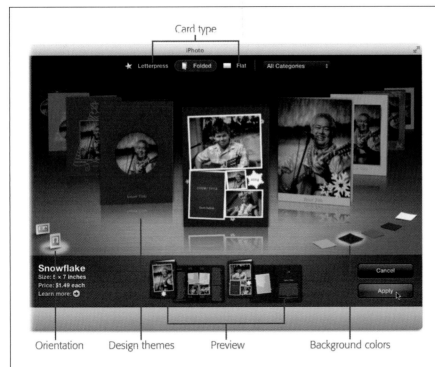

Card type

Orientation Design themes Preview Background colors

FIGURE 9-22

Choose a card type at the top of the window; the various design themes appear below in a spinning carousel.

As of this writing, there are 31 letterpress themes. If you choose Folded or Flat (think postcard), you get a whopping nine categories, including tons of themes fit for every card-sending opportunity you can imagine (the Baby & Kids category alone contains 30 designs!).

If you've read about how to create books or calendars, this section's description of the card-ordering process will feel like déjà vu all over again—only simpler, because you have fewer pages to deal with.

5. **Open the Layout panel to adjust the card's background color and design.**

Click Layout in the toolbar to see alternative design and color schemes, as shown in Figure 9-23.

The designs in the Layout panel change depending on whether you've clicked the front of the card or the inside/back. For the front, you get alternative text-and-photo layouts (like ones that let you put a caption on the front of the card,

or round the corners of the photo). If you've clicked the back of a Flat card, then you get to choose a standard mailable postcard back (with lines where you can write in a name and address, for example), or a non-mailable design that looks more like the inside of a greeting card.

TIP Some interior card designs were meant to be used as a yearly newsletter and have lots of room for text, as well as space for several small pictures.

The Layout and Background options for greeting cards vary based on which theme you choose; Holiday/Events cards have the most options. The Orientation pop-up menu lets you specify whether this card is folded at the top or the left side (Horizontal or Vertical, respectively).

Click a photo and then open the Options panel to give it a creative color effect (black and white, sepia, or antique), or click Edit Photo to pop into Edit view.

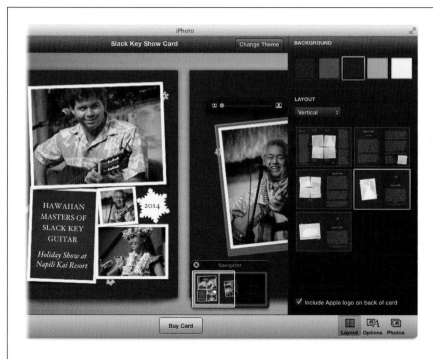

FIGURE 9-23

Depending on what side of the card is selected (outside/inside, or front/back), you'll see different designs in the Layout panel. You also get to pick a color scheme (and, in some designs, a pattern) for the background and interior of the card, and a pop-up menu for choosing vertical or horizontal orientation. The Navigator panel shows which part of the card you're viewing.

With a photo selected, click Options in the toolbar to display Effects buttons that convert your photo to black and white, sepia, or antique. You also get an Edit button that transports you to Edit view.

6. **Edit the text.**

Click any bit of placeholder text to open its text box for editing. (It's generally uncool to send out baby-announcement cards bearing the legend "Insert a name here.")

TIP Don't forget that you can zoom in on any part of your card by dragging the Zoom slider in the toolbar, which is especially helpful when you're adding text.

You can also edit the text styles and fonts as described on page 252.

7. **Order the card.**

 When the card looks good, click Buy Card. Your Mac goes online, and the order screen appears. Happily, you can buy cards individually (you don't have to buy, say, 12 at a time—thanks, Apple!).

 Letterpress and Folded cards are 5 × 7 inches, come with matching envelopes, and cost $3 and $1.50 each, respectively. Postcards are 4 × 6 inches, also come with matching envelopes, and cost 99 cents each. Unfortunately, there are no discounts, no matter how many you order.

As you can see, these cards are affordable *and* impressive. You can consider making them part of your everyday arsenal of social graces. After all, you're living in an era where very few other people can pull off such a thing—and you'll be the one who gets credited with the computer savvy, design prowess, and thoughtfulness to actually put a physical card in the mail.

iPhoto Goes to the Movies

As Chapter 6 makes clear, once you select your images and pair music with them, iPhoto orchestrates the production and presents it live on your Mac's screen as a slideshow. Which is great—as long as everyone in your social circle lives within six feet of your screen.

The day will come when you want friends and family who live a little farther away to be able to see your slideshows. That's the beauty of QuickTime, a multimedia program built into every Mac. Even if the recipient uses a Windows PC—hey, every family has its black sheep—she can still see your photos: QuickTime movies play just as well on HPs and Dells as they do on iMacs and MacBooks.

Fortunately, iPhoto makes it easier than ever to convert those photos into mini-movies. The program's Slideshow Export option lets you save your slideshows as QuickTime movie files that play flawlessly on iPads, iPods, iPhones, Apple TVs, and other video-watching gadgets. Within seconds, you'll have a file on your hard drive that you can send to other people (including Windows folks) via services like Dropbox; post on your web page; upload to YouTube, Facebook or Flickr; or burn onto a CD or DVD.

This chapter teaches you how to do all those things and more.

NOTE If you're using iPhoto on an iPad and you have an iCloud account (page 12), you can create a slideshow and then publish it on your iCloud web page. This method lets you skip the whole "exporting it as a movie" process. Flip ahead to page 399 for details.

Making Movies

Older versions of iPhoto offered *two* ways to export your photos as a slideshow. Now there's just one.

In the old days, you could export an album of photos as a basic movie; the process required some effort but resulted in an emailable file. The current method, called Slideshow Export, is foolproof yet produces a *gigantic* file that's too big to email. Why? Because the resolution of your photos is likely *quite* high. Plus, the movie retains all the fancy animations, transitions, music, and other custom goodies described back in Chapter 6. (Movie length is a big factor, too.)

For the curious, exporting your slideshow at 640 × 480 resolution results in a final file size that's nearly one megabyte per photo—more if you keep each photo onscreen for several seconds. So if your slideshow consists of more than, say, 10 pictures, emailing it isn't an option.

Happily, there are many other ways to share your movie, as you'll learn later in this chapter, so the inability to email it isn't a deal-breaker. The Slideshow Export feature converts your slideshow into a QuickTime movie that's designed to look *fantastic* on specific screens, like an iPhone, iPad, iPod Touch, or Apple TV. There's even an option to send the exported movie over to iTunes so you can sync it onto your iOS devices.

To export your first movie, all you need is a slideshow—whether it's an instant slideshow or one that you've saved. Flip back to Chapter 6 for instructions on creating both kinds.

Slideshow Storytelling 101

Before sending your slideshow movie to hapless relatives who'll have to endure downloading it over a dial-up connection, it's a good idea to make sure it's worth watching in the first place. And if you're planning on uploading the movie to YouTube, you don't want to give Internet hecklers ammunition for leaving disparaging comments (though you could turn off YouTube's Discussion tab). Here are some tips for creating the best possible movie:

As you review your slideshow, place the pictures into the proper sequence, remembering that you won't be there to explain them as it plays. Ask yourself, "If I knew nothing about this subject, would this show make sense to me?"

With that in mind, you might decide that your slideshow could use a few more descriptive images to better tell the story. In that case, go back through your photo library and look for pictures of recognizable landmarks and signs. Put one or two

at the beginning of the show to set the stage. For example, if your slideshow is about a vacation in Washington, D.C., then you might want to open with a picture of the Capitol, the White House, or the Lincoln Memorial.

Another option is to turn on captions (page 163) to aid in your storytelling. When you do that, iPhoto displays the photo's name and/or description as a text overlay atop the picture whenever it's visible onscreen. You might also want to begin your show with some opening credits. You can let iPhoto do the job with a title slide (page 164). Or, for something more elaborate, you can create the text in a program like Pages or Photoshop Elements and save the document as a JPEG (make sure it matches the pixel dimensions of your slideshow). Then drag the JPEG into your slideshow album, placing it first in the sequence. Now you've got yourself an opening title screen! You could do the same for closing credits, too.

Exporting an Instant Slideshow

Say you've got an instant slideshow up on your Mac's screen right now, full of freshly snapped pictures of the kids. And you *really* want to take a copy of it with you on your iPad when you leave for the airport in a few hours. Here's what to do:

1. **Choose File→Export (or press Shift-⌘-E).**

 The Export dialog box appears.

2. **Click the dialog box's Slideshow tab (Figure 10-1), and adjust the settings.**

 This is where you choose what *size* you want the movie to be. (The size determines things like the file's audio and video compression.) Here are your options:

 - **Standard Definition (480p).** With a resolution of 640 × 480 pixels, this size is good for an iPod Touch (third generation), iPhone 3GS, iPad 1, and Apple TV (first generation). This setting creates the smallest file, though it's perfectly watchable on a computer, and it's great for transferring to another Mac via AirDrop (page 226), sharing with loved ones using Dropbox (page 275), and so on.

 - **High Definition (720p).** At 1280 × 720 pixels, this size looks even better on your computer—but makes for a bigger file. It works with the iPod Touch (fourth generation), iPhone 4, iPad, and Apple TV (second generation). If you're planning to upload the movie to YouTube, pick this option.

 - **High Definition (1080p).** If you want a slideshow that looks awesome on the latest iOS devices and TV screens, go for this 1920 × 1080 pixel option. It's compatible with the iPod Touch (fifth generation), iPhone 5, iPad 2, and Apple TV (third generation). Just be prepared for a hefty file.

> **NOTE** You can upload a 1920 × 1080 movie to YouTube, though it'll take a while. But if you're posting a video of your photos in the hopes of winning a National Geographic competition, then the extra quality could be worth it.

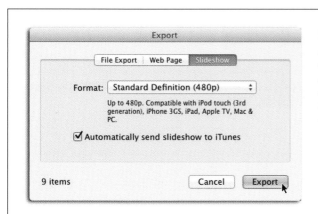

FIGURE 10-1

iPhoto's Slideshow Export feature takes the guesswork out of picking the right settings. Choose an option from the Format pop-up menu based on what device (you or your recipient) will use to watch the movie. When you pick a setting, the text beneath it changes to tell you what gadgets the video will work best with.

If you want to send the exported file right into iTunes for easy syncing to an iPhone, iPad, or iPod Touch, leave "Automatically send slideshow to iTunes" turned on. (To learn more about syncing iPhoto content with those devices, see page 321.) If you don't want the file in iTunes, turn off this setting.

> **TIP** Want to put your new movie into a Pages document? How about a Keynote presentation? Easy. Turning on "Automatically send slideshow to iTunes" makes the resulting movie available in the Mac's *Media Browser,* which is accessible from those programs.

3. **Click Export and specify a destination.**

 When you click Export, iPhoto lets you change the exported movie's destination. If you don't specify one, the file lands in Home→Pictures→iPhoto Slideshows. When you click OK, iPhoto exports the slideshow as a QuickTime-friendly *.m4v* file. The process may take several minutes. (Motion-heavy themes like Shatter take longer to export than a straightforward Classic slideshow.) If you opted to send the file to iTunes, then iPhoto kicks the exported slideshow into the *Videos* area of your iTunes library. From there, it's one quick sync to iPadville (see page 321 for more on syncing).

Exporting a Saved Slideshow

That masterpiece of a slideshow you spent all weekend slaving over—one of the *saved* slideshows described on page 164—is very easy to export. In fact, it's basically the same process as exporting an instant slideshow:

1. **In the Slideshows section of your Source list, select your magnum opus.**

2. **Click Export in the toolbar (see Figure 10-2).**

 iPhoto displays the same settings shown in Figure 10-1, though this time they appear in a pane. Perform steps 2 and 3 in the previous section to export your saved slideshow.

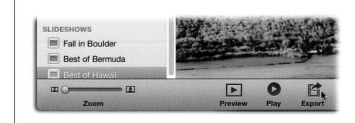

FIGURE 10-2

Exporting a saved slideshow doesn't get any easier than this. Just select the show in the Source list and then click Export on the toolbar. You don't even have to root around in menus to find an export option (although File→Export works, too).

That's it. The next section gives you a few ideas on how to share your movie with others online.

TIP Even Windows PC owners can enjoy your QuickTime movies—if they visit *www.apple.com/quicktime/download* and download the free QuickTime Player program for Windows.

Sharing Movies Online

With all the high-quality photos, music, animations, and other bells and whistles (not to mention movie *length*), exported slideshows are typically far too large to email, but there are other ways of getting them to your friends over the Internet. For one, you can use AirDrop (page 226) to transfer it between Macs in your home or office, or you can use the file-transfer feature of an instant-messaging program like Messages (page 188) to send the file from your Mac to another computer (even a PC).

NOTE You can use iCloud (page 196) to transfer documents and data from Mac programs such as Automator, Preview, TextEdit, Keynote, and Pages, but iCloud doesn't (yet) work with iPhoto. Bummer!

Here are two ways of getting your movie off your Mac and in front of other peoples' eyeballs:

- **Dropbox.** This free file-sharing service lets you upload large files to its servers and then send a download link to others. You can also use it to store files that you might need to access elsewhere (say, big work files that you need to access from home). Dropbox even lets you create *shared folders* that you can invite other people to. It's a fabulous resource to have in your file-sharing bag of tricks.

 Once you sign up for a free account at *Dropbox.com* and log in, you see a folder named Public (you can create your own folders, but Public works just fine). Double-click this folder to open it, and then drag your exported movie into it; you see a status bar letting you know how long it'll take to upload. When it's finished, Control-click the file and choose "Copy public link." A window opens that contains the web address of your movie; click "Copy to clipboard" and fire up your email program. Paste the link into the email and let her rip. When your pal opens the message and clicks the link, the file downloads from Dropbox onto his hard drive—no muss, no fuss.

TIP A free Dropbox account gives you 2 GB of storage; you can pay to get more. Either way, you'll *definitely* want to free up space by deleting files from your Public folder once they've been downloaded.

- **YouTube.** This is Google's free video-sharing site. TV networks use it to broadcast some of their content (BBC, CBS, and so on), and individuals use it to post anything and everything under the sun: from controversial TV clips, to amateur "funniest home videos" style stuff, to short original movies, to pseudo-educational content ("Hosting Your First Tupperware Party" anyone?), and then some.

NOTE To upload a movie to YouTube, it must be less than 15 minutes long and smaller than 32 gigabytes.

Visit *YouTube.com*, create a free account, and then sign in. Click Upload near the top of the page and then drag your exported movie file onto the web page (or click "Select files to upload" and then find the file on your hard drive). Set the privacy menu to Public, Unlisted (meaning YouTube won't list it in any of its categories, making it harder to find), or Private (only those you share the link with can see it).

Once the file finishes uploading, click the Share link. The "Share this video" section opens, and you see a slew of icons that you can use to share the link with Facebook, Twitter, Google+, Pinterest, and so on. You also see a web address that you can copy and send via email. Click Embed to get a block of HTML code that you can use instead, or click Email and fill out YouTube's email form.

NOTE If you've added your favorite Taylor Swift tune as background music to your slideshow, YouTube may reject posting it for copyright reasons. In that case, tuck your tail between your legs and edit the slideshow to use one of iPhoto's built-in music tracks instead. Alternatively, use GarageBand to create your *own* copyright-free soundtrack.

POWER USERS' CLINIC

Viewing Photos and Slideshows on an Apple TV

If you own an Apple TV (*www.apple.com/appletv*), you can use it to display photos and slideshows on your home theater system. Few Mac tricks are as impressive to friends and family as this one.

Depending on exactly which model Apple TV you have, the photos are either streamed to your TV straight from iTunes (if you own a second generation or later) or copied onto the Apple TV itself during an iTunes sync (if you own a first generation). If you haven't gone to the trouble of creating a slideshow from your pictures in iPhoto, the Apple TV includes a dozen or so slideshow styles that you can use on your photos, too.

For this technique to work, your Mac and Apple TV need to be on the same wireless network. If you've got an iCloud account, simply sign into it on your Apple TV, and then choose iCloud Photos or Photo Stream from the main menu; then you can see those pictures on your Apple TV. If you're rolling *sans* iCloud, sharing needs to be turned on in iTunes on your Mac *and* on the Apple TV. Here's how to set that up:

With your Apple ID in hand, fire up iTunes on your Mac and choose File→Home Sharing→Turn On Home Sharing (for iTunes 10.7 and earlier, choose Advanced→"Turn on Home Sharing"). When prompted, enter your Apple ID and password. Then choose File→Home Sharing→"Choose Photos to Share." The iTunes window changes to display a list of your albums, Events, and Faces albums. Make sure the "Share Photos from" option is turned on, and then use the controls to share all of your photos or a portion of them. Be sure to turn on "Include videos" so any slideshows you've exported as QuickTime movies are in on the fun, too. When you're done, click Apply.

On the Apple TV, choose Settings→Computers→Turn On Home Sharing. Enter your Apple ID; you'll see the iTunes libraries you shared from your Mac. Simply choose what you want to see (Photos or Videos, say). As long as the Mac containing the shared library is turned on and iTunes is running, you see your photos parade across your TV. All you have to do now is sit back and enjoy the show!

Fun with QuickTime Player

QuickTime Player—which you'll find in your Mac's Applications folder—is, well, just a media player. But it does have some features worth noting:

- **Play movies in Full Screen mode.** QuickTime Player can play full-screen videos—no menu bar, Dock, window edges, or other distracting elements. In effect, it turns your laptop screen into a portable theater. Choose View→Enter Full Screen (or press Option-⌘-F).

> **NOTE** Apple discontinued QuickTime Pro—the $30 upgrade that offered more powerful editing features—after version 7. (If you owned it before upgrading to Snow Leopard, you may still find it in your Macintosh HD→Applications→Utilities folder.) Then again, you may as well use iMovie, which you should already own.

- **Record video and audio.** You can record your own videos in QuickTime Player, using the built-in camera on your Mac, a USB webcam, and so on. And you can record audio with your Mac's built-in microphone, or an external mic or musical instrument connected via USB.

 To do either, choose File→New Movie Recording or New Audio Recording. In the resulting window, pick one of the input sources described above, choose a quality, and then click the red Record button. When you're finished, click the same button again. You'll find the new movie waiting in your Movies folder (inside your Home folder).

- **Rotate or flip a clip.** QuickTime Player's Edit menu contains Rotate Left, Rotate Right, Flip Horizontal, and Flip Vertical commands, which can be handy when a movie turns out to be flipped or rotated the wrong way—or when you want to flip or rotate it for creative purposes.

- **Split, combine, and shorten your flicks.** QuickTime Player is great for *splitting* and *combining* your movie clips—two tricks that iPhoto *can't* perform—as well as trimming off excess footage, just like iPhoto can (page 280).

 To *split* a single clip in two, choose View→Show Clips (or press ⌘-E), and then drag QuickTime Player's *playhead* (the red bar circled in Figure 10-3, top) to the spot where you want the movie to split. Choose Edit→Split Clip (or press ⌘-Y), and you see both clips highlighted in yellow. At this point, you can insert another clip (as described next) or rearrange the clips by dragging them left or right. If you split the clip into *three* chunks, you can select the middle one (a yellow outline appears around it) and zap it by pressing the Delete key on your keyboard.

 To *combine* clips, open one clip and then choose Edit→"Add Clip to End." In the Open dialog box, double-click the clip you want to tack on. You can also drag movie clips' icons from the desktop right into a movie window. QuickTime Player adds them to the end of the existing movie. (You can then repeat the process to combine several clips.)

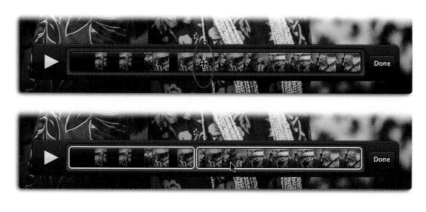

FIGURE 10-3

Top: QuickTime Player lets you split clips, which is helpful when you want to chop something out of the middle. The key is to position the program's play-head (circled) in the right spot before triggering the Split command. When you point your mouse at the playhead, your cursor turns into a double-sided arrow (circled).

Bottom: After splitting a clip, both pieces sport a yellow border that indicates they're selected. Click a single clip to select it and deselect the other.

If you want the second movie to appear somewhere in the *middle* of the first movie, split the clip as described earlier, and then click the clip that appears right before the spot where the new movie will go. Choose Edit→Insert Clip After Selection; in the resulting dialog box, double-click the movie file you want to bring in. (You can also drag a movie file from the Finder directly into the gap between two clips.)

Exporting Edited Movies

After you've finished working on a movie in QuickTime Player, you can send it out into the world in a variety of ways:

- **Choose File→Export** and pick 480p, 720p, 1080p, and so on (see page 273). Pick iTunes if you want to sync it onto your iOS devices and Apple TV.

- **Choose File→Share** and pick from Facebook, Flickr, YouTube, Messages, and more. Pick your poison; Quick Time optimizes your masterpiece for that particular program or service.

> **TIP** There's no way to upload an exported slideshow movie to Facebook or Flickr from *inside* iPhoto, but you could do so via QuickTime Player. Simply open the movie file in QuickTime Player and then choose File→Share. You could also use Facebook or Flickr's website to get it done.

When you're finished, choose File→Close. In the resulting dialog box, name your edited masterpiece and click Save. Once you've stored the new version on your hard drive, you can drag it back into iPhoto.

Movies from Your Camera

Digital-camera movies were once a novelty that few people cared about. Today, though, they've become a convenient way to record video without lugging around a camcorder. Current digicams can capture movies with standard (640 × 480) or even high-definition resolution, TV smoothness (24 frames per second), and sound. Most smartphones (including iPhones) can capture high-quality video, too.

When you import your movies into iPhoto, the program cheerfully adds those video files to your library, denoted by a little camcorder icon and a duration indicator. iPhoto doesn't let you do *much* with such videos, but you can watch them and trim footage off either end.

> **TIP** Want to make your camera's movies easy to find? Create a smart album as described in Chapter 2 (page 59), and set the New Smart Album dialog box "Photo," "is," and "Movie." After that, you'll always find your movies collected in this self-updating album.

Playing Digital Movies in iPhoto

To play a movie that's found its way into iPhoto, double-click its thumbnail. (Or, if the thumbnail is selected already, press the space bar.) The movie expands to fill the photo-viewing area and begins to play.

If you keep your mouse still while the video is playing, then after a moment, the control bar vanishes. (The bar also vanishes if you move your cursor outside the video area). This minimalist design works great when all you want to see is your movie. To bring back the control bar, simply wiggle your mouse. Figure 10-4 explains these controls, but the main thing is this: Hit the space bar to pause or resume playback.

When you've had enough, tap the space bar again; the movie collapses back into thumbnail form.

> **TIP** The control bar's ✿ button harbors a pop-up menu that lets you view the movie at its original size or blown up to fill the iPhoto window. It holds the Trim and Reset Trim commands, described next.

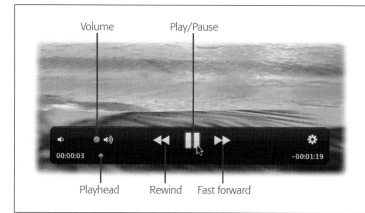

FIGURE 10-4

The volume slider controls the sound of your movie independently of the volume setting on your computer (click the ◄› icon to mute the video). The control bar also includes the typical Play/Pause, Fast-Forward, and Rewind buttons.

Editing Movies in iPhoto

To trim off the boring parts of a movie, right here in iPhoto, follow these simple steps:

1. **Double-click the movie's thumbnail.**

 You can also select the video's thumbnail and then press the space bar. Either way, the movie starts playing.

2. **In the video's control bar, click ✿ and choose Trim.**

 The control bar transforms to display stills from your video, with yellow handles at either end. Your job now is to isolate the part of the movie you want to keep.

3. **Drag the yellow handles left or right to designate the new start and end points of your movie, and then click Trim (see Figure 10-5).**

 iPhoto trims your movie. Now you can show it to people without subjecting them to the 30 seconds of fumbling at the beginning and end of the shot.

> **TIP** Google the phrase "Wadsworth Constant" and you'll be surprised to learn that the first 30 percent of *any* video may be irrelevant. In fact, if you add *@wadsworth=1* to the end of any YouTube URL, the first 30 percent of that video is automatically skipped. Who knew?

The changes aren't permanent, though. You can always restore the original version (the full-length director's cut, if you will) by clicking ✿ again and choosing Reset Trim.

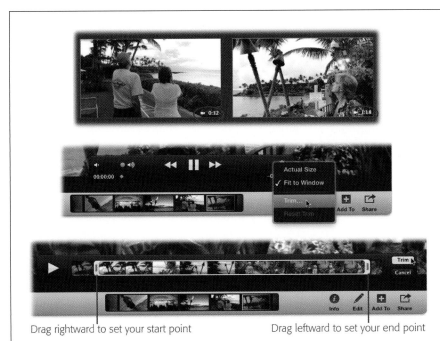

FIGURE 10-5

Top: iPhoto indicates videos by putting a tiny camcorder icon at the bottom left of their thumbnails. The number on the right side represents the movie's duration.

Middle: When playing a video, click the ✿ to reveal this menu.

Bottom: When you've positioned the yellow handles just right, click the Trim button. (You can also move around within your movie by swiping a finger across the top of your Magic Mouse or Magic Trackpad.)

Drag rightward to set your start point Drag leftward to set your end point

Editing Movies in iMovie

For more editing power, you can use iMovie, Apple's video-editing program. In the Event Library at the left side of the iMovie window (choose Window→Event Library if you don't see it), click iPhoto Videos. Then drag the clip you want to edit into iMovie's Project area.

The end.

All right, there's a *little* more to it—like learning how to *use* iMovie—but that's a different book (*iMovie: The Missing Manual,* to be exact). The point here is that you can incorporate movies from iPhoto's library in whatever iMovie project you have open, ready to edit as you would any other clips.

Burning a Slideshow Movie CD or DVD

If your slideshow has more than 10 pictures, it's probably too big to send to people by email. Luckily, you've got an alternative: Burn a CD or DVD of the slideshow. The process is described in detail on page 303.

Slideshow Movies on the Web

Chapter 8 details how to post individual *photos* on the Web. But with a few adjustments to the instructions, you can just as easily post your slideshow *movies* on the Web, too, complete with music.

If you maintain your own website, you can upload the movie as you would any graphic file. Create a link to it in the same way, and your movie will start to play in your visitors' web browsers when they click that link.

But if you have an iCloud account and an iPad, posting the movie is even easier—and you can do it from iPhoto on your iPad, *without* resorting to iMovie. The whole glorious and frustratingly iOS-only process works as described on page 399.

You can also share movies on Flickr and Facebook. Just select the movie in iPhoto, click the Share button, and choose the one you prefer. Unfortunately you can't upload a slideshow that you've exported as a QuickTime movie to either one; you'll have to visit their respective websites and upload them that way instead. (Though you can use QuickTime Player to upload straight to Flickr or Facebook, as described on page 278.)

Advanced iPhoto

Screensavers, AppleScript, and Automator

You've assembled a library of digital images, sent heart-touching moments to friends and family via email, published your recent vacation pics on the Web, edited a movie or three, and even boosted the stock prices of Canon and Epson single-handedly through your consumption of inkjet printer cartridges. What more could there be?

Plenty. This chapter covers iPhoto's final repertoire of photo stunts, like turning your photos into one of the best screensavers that's ever floated across a computer monitor, plastering one particularly delicious shot across your desktop, calling upon AppleScript to automate photo-related chores for you, and harnessing iPhoto's partnership with Automator. (This chapter's alternate title: "Miscellaneous iPhoto Stunts that Didn't Really Fit in the Outline.")

■ Building a Custom Screensaver

The Mac's screensaver feature is *so* good, it's pushed more than one Windows person to switch to a Mac. When the screensaver kicks in (after a few minutes of inactivity on your part), your Mac's screen becomes a personal movie theater. The effect is something like a slideshow, except that the pictures don't simply appear one after another and sit there on the screen. Instead, they're much more animated. They slide gently across the screen (or *multiple* screens), zooming in or out, smoothly dissolving from one to the next.

OS X comes equipped with a few photo collections that look great with this treatment: forests, space shots, and so on. But let the rabble use those canned screensavers. You, a digital master, can use your *own* photos as screensaver material.

Your entire iPhoto world—everything in your Source list, plus Faces and Places info (Chapter 4) and saved slideshows (page 164)—is accessible from within your Mac's System Preferences and, therefore, available as an instant screensaver. Just imagine the possibilities! If you've taken the time to tag your photos with Faces info, you can create a screensaver of Mom and Dad's entire life to play at their 50th wedding anniversary shindig in seconds, *without* opening iPhoto. Having a dinner party and want to show off recent photos from Italy? If they're geotagged (page 103), your screensaver is ready and waiting for you.

NOTE If you've got dual monitors—or a monitor plugged into a laptop—you see *different* photos on each monitor as the screensaver plays. Sweet!

Choose →System Preferences→Desktop & Screen Saver. Near the top of the window shown in Figure 11-1 (top), click the Screen Saver tab, and then click one of the 14 *photo-based* screensaver themes in the list on the left. When you do, a Source pop-up menu appears beneath the theme's preview on the right; choose Photo Library (it may take a moment for your Mac to populate this menu, so be patient). A new pane appears with a list of your iPhoto goodies on the left (see Figure 11-1, bottom); just scroll to your album of choice. Click it to see what photos are inside, and then click Choose. Back in the Desktop & Screen Saver window, pick a theme from the panel on the left; you see a mini version of your new screensaver playing on the right.

TIP In the Desktop & Screen Saver preferences pane, if you pick one of the seven *non*-photo-based themes (like Flurry or Arabesque), the Source menu doesn't show itself. Simply click one of the photo-based themes instead to make it appear.

NOTE Unless you're using a plasma screen as your monitor, you don't *technically* need a screensaver to protect it from burn-in. Today's flat-panel screens never burn in, and even a fairly modern CRT monitor wouldn't burn an image into the screen unless you left it on continuously for two years. No, screensavers today are solely about entertainment (and/or privacy).

There are two ways to control when your screensaver takes over your monitor: by using the "Start after" setting to specify a duration of keyboard or mouse inactivity and/or by clicking Hot Corners. The latter method presents you with a pane that lets you turn each corner of your monitor into a *hot spot.* Whenever you position your cursor into the specified corner(s), the screensaver either turns on instantly (great when you're shopping on eBay and your boss walks by) or stays off permanently (for when you're reading onscreen or watching a movie). For example, you can use two corners for controlling the screensaver and the other two for, say, summoning Dashboard and the Notification Center (OS X's widget and alert features, respectively).

Either way, pressing any key or clicking the mouse always exits the screensaver and takes you back to whatever you were doing.

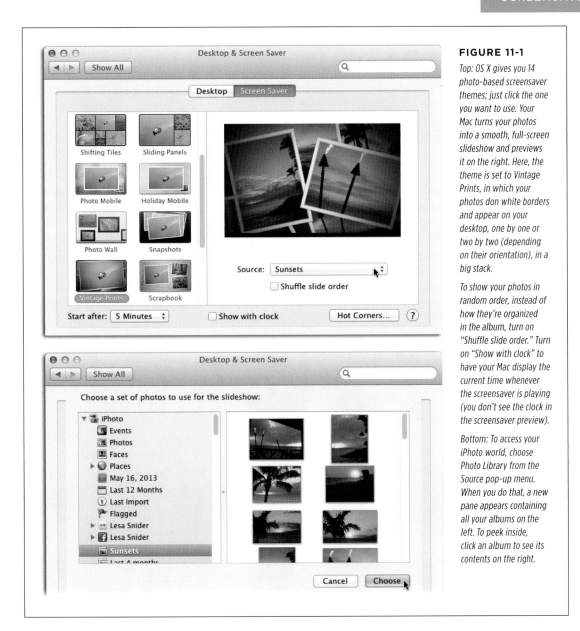

FIGURE 11-1

*Top: OS X gives you 14
photo-based screensaver
themes; just click the one
you want to use. Your
Mac turns your photos
into a smooth, full-screen
slideshow and previews
it on the right. Here, the
theme is set to Vintage
Prints, in which your
photos don white borders
and appear on your
desktop, one by one or
two by two (depending
on their orientation), in a
big stack.*

*To show your photos in
random order, instead of
how they're organized
in the album, turn on
"Shuffle slide order." Turn
on "Show with clock" to
have your Mac display the
current time whenever
the screensaver is playing
(you don't see the clock in
the screensaver preview).*

*Bottom: To access your
iPhoto world, choose
Photo Library from the
Source pop-up menu.
When you do that, a new
pane appears containing
all your albums on the
left. To peek inside,
click an album to see its
contents on the right.*

One-Click Desktop Backdrop

iPhoto's desktop-image feature is the best way to drive home the point that photos of your children (or dog, or mother, or self) are the most beautiful in the world. You pick one spectacular shot to replace the standard OS X Mavericks wave photo desktop background. It's like refrigerator art on steroids.

Creating wallpaper in iPhoto is so easy that you could change the picture every day—and you may well want to. In iPhoto, click a thumbnail, and then choose Share→Set Desktop (that's the Share *menu* at the top of your screen, not the Share *icon* in iPhoto's toolbar). Your desktop is now filled with the picture you picked, though you may need to minimize the iPhoto window to see it.

> **NOTE** If you select *several* thumbnails or an album in iPhoto (not in the Desktop & Screen Saver preferences) before choosing Share→Set Desktop, your Mac assumes that you want it to *rotate* among your selected photos, displaying a new one every few minutes.

Just three bits of advice. First, choose a picture that's as big as your screen (at least 1280 × 800 pixels, for example). Otherwise, OS X will stretch it to fit, distorting the photo in the process. If you're *really* fussy, you can even crop the photo to the exact measurements of the screen; in fact, the first command in iPhoto's Constrain pop-up menu (page 129) lists the exact dimensions of your monitor, so you can crop the designated photo (or a copy of it) to fit precisely with just one click.

Second, horizontal shots work much better than vertical ones; iPhoto enlarges vertical shots to fit the width of the screen, potentially chopping off the heads and feet of your loved ones.

Finally, if a photo doesn't precisely match the screen's proportions, the pop-up menu at the top of Figure 11-2 lets you specify how you want OS X to handle this discrepancy:

- **Fill Screen.** This option enlarges or reduces the image so that it fills every inch of your desktop, and in most cases, OS X does a good job. But if the image is small, the low-resolution stretching can look awful. Conversely, if the image is large but its proportions don't match your screen's, parts get chopped off. Either way, this option never distorts the picture, as the Stretch option (below) does.

- **Fit to Screen.** This setting centers the photo neatly on the screen, at whatever size fits. The photo doesn't fill the entire background; instead, it sits right smack in the center of the monitor. Of course, this arrangement may leave a swath of empty border all the way around the picture. As a remedy, Apple provides a color swatch next to the pop-up menu. Click it to open the Colors panel and specify a hue for the "frame" around the photo.

- **Stretch to Fill Screen.** Use this option at your peril, since it makes your picture fit the screen *exactly,* come hell or high water. Unfortunately, larger pictures may be squished vertically or horizontally, and small pictures are *drastically* enlarged and reshaped, usually with grisly results.

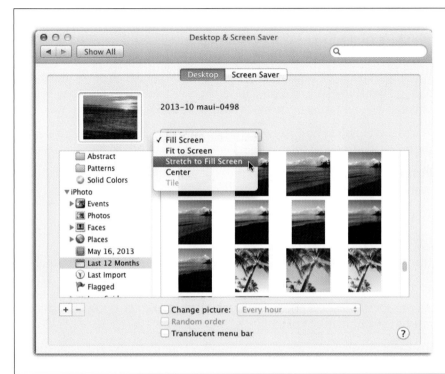

FIGURE 11-2

If your photo doesn't fit the screen perfectly, choose a different option from this pop-up menu. In most cases, though, the factory setting of Fill Screen works just fine.

While you're in the Desktop & Screen Saver window's Desktop pane, you might notice that all of your iPhoto albums are listed below the collection of images that came with your Mac. You can navigate through those albums to find a new desktop image.

- **Center.** This one is basically the same as "Fit to Screen," except that it displays your picture at full size. If the picture is larger than the screen, you see only the middle; the edges get chopped off where they extend beyond your screen. Conversely, if the picture is too small, you may never see it.

- **Tile.** This option makes your picture repeat over and over until the multiple images fill your monitor. (If your picture is larger than the screen, this option is grayed out as in Figure 11-2.)

And one last thing: If public outcry demands that you return your desktop to one of the standard system backdrops, go to →System Preferences→Desktop & Screen Saver, and click the Desktop tab; then choose Apple in the list on the left, and then take your pick.

Exporting and Converting Pictures

The whole point of iPhoto is to provide a central location for *all* your photos, but that doesn't mean they're locked in there forever. You'll be pleased to know that it's as easy to take pictures *out* of iPhoto as it is to put them in. Liberating a picture from iPhoto can be useful in situations like these:

- You're creating a web page or photo book *outside* of iPhoto and you need a photo in a certain size and format.

- You shot a bunch of 10-megapixel photos but you're running out of disk space, and you wish they were all 6-megapixel shots instead. (They'll still have plenty of detail without taking up so much hard-drive space.)

- You're submitting some prize-winning photos to a newspaper or magazine, and the publication requires them in TIFF format, not iPhoto's standard JPEG format.

- Somebody else on your network loves one of your pictures and would like to use it as a desktop background on *that* machine.

- You want to send a batch of pictures to someone on a CD or DVD.

Exporting by Dragging

It's amazingly easy to export photos from iPhoto: Just drag their thumbnails out of the photo-viewing area and onto the desktop, as shown in Figure 11-3. But that's not all: You can also drag thumbnails onto a folder's icon, into an *open* Finder window, or even into a *Mail* message (handy!). After a moment, their file icons appear in the destination.

The drag-and-drop method has enormous virtue in its simplicity and speed, but it doesn't grant you much flexibility. It produces JPEG files only, at the original camera pixel dimensions, with the camera's own cryptic naming scheme (unless you renamed them in iPhoto).

Exporting by Dialog Box

To gain control over the dimensions, names, and file formats of the exported graphics, use the Export command. After selecting a picture, a group of pictures, or an album, invoke this command by choosing File→Export (or pressing Shift-⌘-E). The highly useful Export dialog box shown in Figure 11-4 appears.

Click the File Export tab (if it's not already active), and then make the following decisions:

> **TIP** If you want to email a few photos, don't bother with the Export dialog box; use iPhoto's Mail command instead. Page 191 has the scoop.

- **Kind.** You can use this pop-up menu to specify the file format of the photo(s) you're about to export. Here are your options:

- **Original.** iPhoto exports the photo in whatever format it was in when you imported it. If the picture came from a digital camera, for example, it's probably a JPEG.

 If your camera captured the photo in raw format (page 19), the Original option is even more valuable. It lets you export the raw file so that you can, for example, work with it in a more sophisticated editor like Adobe Photoshop Lightroom or Adobe Camera Raw (the latter comes with Photoshop and Photoshop Elements). That said, the exported file doesn't contain any edits you've made in iPhoto.

FIGURE 11-3

The drag-and-drop technique produces full-size JPEG files, exactly as they appear in iPhoto. Their names, however, might not be particularly user friendly. If you haven't renamed your photos yet (page 64), then a picture named IMG_5197.jpg will wind up on your desktop.

- **Current.** This option exports the file in whatever format it's currently in. For example, if you imported a raw image and then edited it, it will be exported as a JPEG.

- **JPEG.** This abbreviation stands for Joint Photographic Experts Group (that's the group of geeks who came up with this format). JPEG format is the most popular format for photos on the Internet (and in iPhoto) thanks to its wide range of colors and relatively small file size.

NOTE If you choose JPEG, you can use the JPEG Quality pop-up menu to specify a quality level (High, Medium, and so on). Just remember that the file size gets bigger as the quality increases.

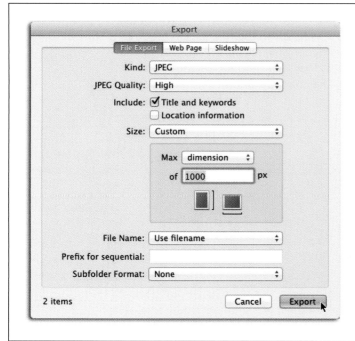

FIGURE 11-4

The Export dialog box gives you control over the file format, names, and dimensions of the pictures you're about to extract from iPhoto. You can also include the photo's map coordinates by turning on Location Information. You can even tell iPhoto to use whatever names you gave your pictures, instead of the original filenames bestowed by your camera. To do so, choose "Use title" from the File Name pop-up menu.

And don't miss the Size pop-up menu's Custom option, which lets you export scaled-down versions of your photos for use in web pages, as desktop pictures, and so on.

The number of photos you're about to export appears in the dialog box's lower left.

- **TIFF.** These files (whose abbreviation is short for Tagged Image File Format) are something like JPEG without the "lossy" compression. That is, they maintain every bit of quality available in the original photograph, but because of that they take up much more disk space (or memory-card space) than JPEGs. TIFF can be a good choice if quality is more important than portability—if, say, the photo is destined for printing by a service that *requires* this format (though these days, more online printers prefer a JPEG at the highest quality).

- **PNG.** This format (short for "Portable Network Graphics") was designed to replace the GIF format on the Web. (The company that came up with the algorithms behind the GIF format exercised its legal muscle...long story.) Whereas GIF graphics generally don't make good photos because they're limited to 256 colors, PNG is a good choice for photos (except the variation called *PNG-8,* which is just as limited as GIF). The resulting files are smaller than TIFF images but larger than JPEGs, yet don't exhibit any of the compression-related quality issues of the latter.

- **Titles and keywords.** iPhoto maintains two names for each photo: its original filename as it appears in the Finder, and the title you may have assigned while working in iPhoto (page 63).

If you turn on the Export dialog box's "Title and keywords" setting (available for JPEG or TIFF formats only), then each exported file has the name you gave it in iPhoto. The file also contains any keywords you assigned to it (page 80). That's a big deal, because it means that (a) you'll be able to find it on your Mac with a Spotlight search, and (b) if you import it into another iPhoto library (or other program that understands keywords, such as Aperture, Adobe Photoshop Lightroom, or Photoshop Elements), it remembers the keywords you gave it.

- **Location information.** Turn on this setting to include Places info in your exported file(s).

- **Size.** As you learned on page 131, although digital-camera files may not always have enough resolution for large prints (depending on your camera's quality setting when you took the shot), they generally have far too much resolution for displaying onscreen. Fortunately, you can use this setting to reduce the number of pixels in your photos, shrinking them down to something more manageable.

 Your choices here are Small (320 × 240 pixels, suitable for emailing or web pages visited by dial-up victims); Medium (640 × 480, also good for email and websites); Large (1280 × 960, nice for slideshows); Full Size (whatever size the photo is now, best for printing); and Custom.

 If you choose Custom, you get the curious controls shown in Figure 11-4, where a Max pop-up menu lets you specify the maximum pixel dimension for each photo's height, width, or both. Why didn't Apple just offer you Height and Width boxes? Because the exported photos might have different proportions, so saying, "Export these at 800 × 600" wouldn't always make sense. This way, you're specifying the *maximum* dimensions on one side or both (or rather, the longest edge).

- **File Name.** From this pop-up menu, you can specify how you want iPhoto to name the exported files:

 - **Use title.** The files are named whatever you named them in iPhoto (page 63).

 - **Use filename.** The files bear the original names given to them by your camera, like DSC_0192.jpg or IMG_4821.JPG.

 - **Sequential.** The files will be named Bad Hair Day 1, Bad Hair Day 2, and so on. (In the "Prefix for sequential" box, type *Bad Hair Day* or whatever you like.)

 - **Album name with number.** This option tells iPhoto to name your exported photos according to the name of the album they're in and their sequence *within* that album. So if an exported photo is the fourth picture in an album titled Sunsets, iPhoto will call the exported file "Sunsets–04.jpg." Because *you* determine the order within an album (by dragging, so long as it's not a smart album [page 59]), this is the only option that lets you control the numbering of the exported files.

Plug-Ins and Add-Ons

Friends and foes of Apple can all agree on one thing: iPhoto is no Photoshop. iPhoto was deliberately designed to be simple and streamlined, although it's picking up more power with each new version.

Yet Apple thoughtfully left the back door open. Other programmers are free to write add-ons and plug-ins—software that contributes additional features, lends new flexibility, and gooses up the power of iPhoto.

And yet, with great power comes great complexity—in this case, power and complexity that Apple chose to omit. But at least this plug-in arrangement means that nobody can blame *Apple* for junking up iPhoto with extra features. After all, *you're* the one who installed them.

A few of the most important plug-ins and add-on programs are described in the relevant chapters of this book:

- **Duplicate Annihilator** (*www.brattoo.com/propaganda*) determines whether you have any duplicate photos, missing photos, or corrupt JPEGs in your iPhoto library, and gives you several options for dealing with them.

- **iPhoto Library Manager** (page 310) lets you create and manage multiple iPhoto libraries more easily than Apple does.

- **Portraits & Prints** (see the box on page 182) expands iPhoto's printing features and lets you create a multiphoto layout on a *single* sheet of paper that you can print.

- **SmugMugExport** (*www.aarone.org/smugmugexport*) lets you export photos from iPhoto to SmugMug, a popular resource for storing photos and creating web galleries, as well as whipping up photo-based mementos like prints, mugs, and shirts.

As iPhoto's popularity grows, new add-ons and plug-ins will surely sprout up like roses in your macro lens. It's worthwhile to peruse sites such as MacUpdate.com and Download.com from time to time to see what's available. Search for *iPhoto,* and you'll be surprised at the number of goodies waiting for you to try.

AppleScript Tricks

AppleScript is the famous Macintosh *scripting language*—a software robot that you can program to perform certain repetitive or tedious tasks for you.

iPhoto is fully *scriptable,* meaning that AppleScript gurus can manipulate it by remote control with AppleScripts that they create. (It even works with Automator, the program in OS X that makes programming even *easier* than using AppleScript; see the following section.)

But even if you're not an AppleScript programmer, this is still good news, because you're perfectly welcome to exploit the ready-made, prewritten AppleScripts that other people come up with. You can find them by Googling *iPhoto AppleScripts.*

Automator Tricks

If you use your Mac long enough, you're bound to start repeating certain tasks over and over again. Automator is a program that lets you teach your Mac what to do, step by step, by assembling a series of instructions called *actions* (each is a single, specific task). You can make your Mac perform super-complex tasks by assembling a variety of prerecorded actions into a specific order in Automator. To trigger the task, you can click Automator's Run button or save the task as a genuine, double-clickable, standalone application. Either way, your Mac faithfully runs each action one at a time, one right after the other.

As it turns out, Automator works great with iPhoto. By following "recipes" that you find online—or the sample described here—you can add all kinds of new, timesaving features to iPhoto and your Mac.

The Lay of the Land

To open Automator, visit your Applications folder and give the program's icon a swift double-click. Click New Document, and you should see something like Figure 11-5, starring these key elements:

- **Type pane.** The Type pane (Figure 11-5, top) lists the different things you can create in Automator. (If you single-click an icon, its description appears at the bottom of the pane.) For example, to combine several actions into a single complex task, choose Workflow; to create an action that automatically runs when you drop files onto it, choose Application; or to create an action that's available within the Service menu of many OS X programs, choose Service.

- **Library list.** Automator's Library list shows you all the items on your Mac that can be controlled by Automator actions: Calendar, Contacts, Files & Folders, and so on. When you click an item in this list, the Action list to its right shows you every action (command) that the chosen item understands.

TIP To see all of Automator's ready-made actions for iPhoto, type *iPhoto* into the Search box near the program's top left.

- **Action list.** This list (which doesn't have a heading—it's to the right of the Library list) shows you the contents of whatever category you've selected in the Library list. If, for example, you select Photos in the Library list, the Action list shows you all the photo-related actions available on your Mac. To build a workflow (or customize an existing one), drag actions from the Action list into the Workflow pane, as shown in Figure 11-5 (middle). (Double-clicking an action does the same thing.)

FIGURE 11-5

Top: You can choose what you want to create—and how you'll trigger it—in this pane. (You can reopen it later by choosing File→New.) To create a task that you can trigger by dropping files or folders onto an icon, for example, choose Application.

Middle: Narrow down your options by choosing what kind of task you want Automator to perform. In this case, choose Photos in the far left column (the Library list). Then either double-click an action in the second column (the Action list) or drag the action into the Workflow pane on the right to tweak its settings.

Bottom: By choosing "Import Files into iPhoto" and adjusting the settings as shown here, you can have Automator fetch files you've scanned and plop them into iPhoto, saving you the drudgery of creating a new album, importing the files into it, and then deleting the originals from your hard drive. To trigger the task, scan all your files, stick them in a folder, and then drop that folder onto the application's icon. If you do a lot of scanning, this can be a huge timesaver.

- **Workflow pane.** Think of this pane as Automator's *kitchen.* It's where you put your actions in whatever order you want, set any action-specific preferences, and fry them all up in a pan.

 The Workflow pane is also where you see how the info from one action gets piped into another, creating a stream of information. This aspect of Automator differentiates it from the dozens of *nonvisual,* programming-based automation tools out there.

 When you drag an action from the Action list into the Workflow pane, any surrounding actions scoot aside to make room for it. When you let go of the mouse, the action you dragged materializes in the Workflow pane.

> **TIP** If you select an action in the Action list and then press Return, Automator automatically inserts that action at the bottom of the Workflow pane.

Saving Your Task

Once you're finished creating your little Automator robot, you need to save it by choosing File→Save As. Give your new task a name, and then click the File Format pop-up menu. Choose Workflow if you'll trigger the task from within Automator by clicking the program's Run button (shown in Figure 11-5), or choose Application to create an icon that triggers the task when you drop files onto it.

> **TIP** If you picked Application in the Type pane, you can choose File→Save instead. In that case, Automator already knows *what* you want to save; you just need to give it a name and tell it where to put the new application on your hard drive.

The Auto Import Folder

If you know where to look, you'll find that Apple *secretly* included an Automator folder action into your copy of iPhoto. That's right—it's just sitting on your hard drive waiting to be discovered. It's a folder called Auto Import.

The beauty of this magic folder is that you can park it on your desktop and then drag photo files onto it as you go about your day. Then, the next time you open iPhoto, they'll be imported automatically. How is this useful? In so many ways:

- As you add more photos, iPhoto takes longer and longer to open. When you know iPhoto is going to take 30 seconds to open and you just have a couple of photos to import, for example, it scarcely seems worth sitting through the startup process. But thanks to the Auto Import folder, you can add photos anytime, a couple at a time or whatever, without waiting for iPhoto to open. When you finally have some time to really work, *then* you can open iPhoto and it will grab the photos you've scheduled for importing.

- You can park different "Add to iPhoto" folders on your desktop, one for each iPhoto *library* (page 306). When iPhoto opens, it's smart enough to import only the photos in the Auto Import folder that corresponds to the library you're using.

- When you're in a hurry, you can insert your camera's memory card into your Mac, look over the photos in the Finder, and then copy only the worthwhile ones to your Mac by dropping them into the Auto Import folder. That way they're safe and ready to be imported into iPhoto, but you haven't wasted any time waiting for iPhoto to open and close.

Here's how to set up the Auto Import folder:

1. **In your Mac's Finder, locate your iPhoto library in your Home→Pictures folder.**

 As you learned back in Chapter 1, this is where your iPhoto library lives unless you moved it somewhere else. (See page 25 for details.)

2. **Control-click the iPhoto Library icon and choose Show Package Contents (Figure 11-6, top).**

 A new Finder window opens showing everything that's inside the iPhoto Library package.

3. **Locate the folder named Auto Import, and then ⌘-Option drag it onto your desktop (Figure 11-6, bottom).**

 You've hit pay dirt! This is the folder action Apple snuck into your copy of iPhoto without telling you. Holding down the ⌘ and Option keys forces your Mac to create an *alias* of the folder (a shortcut to the real one). The alias has a little curved arrow on its bottom-left corner.

From now on, whenever you want to schedule some pictures for iPhoto importing, drag them onto the Auto Import icon on your desktop. The next time iPhoto opens, you'll see it flip automatically into Importing mode and slurp those photos in. After the import is complete, you'll notice that the Auto Import folder is empty once again.

FIGURE 11-6

If iPhoto isn't running, the files are added the next time you launch the program. If iPhoto is running, the files you drop onto the Auto Import folder are added to your library immediately.

Once you've created the Auto Import alias, you can rename it anything you want. A good choice might be "Add to iPhoto."

iPhoto File Management

F or years, iPhoto fans experienced the heartache of iPhoto Overload—the syndrome in which the program gets too full of photos, winds up gasping for RAM, and acts as if you've slathered it with a thick coat of molasses. And for years, true iPhoto fans adopted an array of countermeasures to keep the speed up, including splitting their iPhoto libraries into several smaller chunks.

These days iPhoto is faster (see the box on page 22) and can manage a whopping *one million* pictures per library, so such drastic measures aren't generally necessary. And with the plummeting cost of external hard drives, backing up your iPhoto library isn't the painful process that it used to be.

Nonetheless, learning how iPhoto manages its library files is still a worthy pursuit. It's the key to burning your photos—or an exported slideshow (page 274)—to CD or DVD, and transferring them to other machines, as well as swapping photo libraries and merging them together.

iPhoto Backups

Unfortunately, bad things can happen to digital photos. They can be accidentally deleted with a slip of your pinkie. They can become mysteriously corrupted and subsequently unopenable. They can get mangled by a crashed hard drive and lost forever. Losing one-of-a-kind family photos can be extremely painful—and in some documented cases, even marriage-threatening. So if you value your digital photos (and your relationships), you should back them up regularly, perhaps after each major batch of new photos joins your collection, and certainly before *upgrading* iPhoto when a new version comes out.

If you're using your Mac's Time Machine feature, then you're already covered. Your entire machine is constantly backed up, as the box on page 307 explains.

If you have an iCloud account and you've turned on photo sharing (page 13), then the last *1,000* pictures you've taken or imported into iPhoto are secure...but that's it. (Of course, the free iCloud account offers only 5 GB of storage space, although you can buy more.)

Happily, there are other ways to back up your precious photos, as the following sections spell out.

> **NOTE** Veteran iPhoto jockeys may remember a feature called iPhoto Discs, which let you burn your entire iPhoto library—originals, thumbnails, titles, keywords, comments, ratings, and so on—onto one or more discs to create an archive. But the burning process was slow, newer laptops don't even *have* disc drives, and most libraries are too big to burn onto disc anyway; that feature is gone now. These days, it's faster and more efficient to preserve your iPhoto Library file by copying it onto an external hard drive, as the following section explains.

Backing Up to a Hard Drive

One of iPhoto's main jobs is to keep all your photos together in one place—one icon that's easy to copy to a backup disk of any kind.

That all-important icon is the *iPhoto library,* which resides inside the Pictures folder of the Home folder that bears your name. If your user name (the short name you use to log into OS X) is *Casey,* for example, then the full path to your iPhoto library file from your main hard drive window drive is Macintosh HD→Users→Casey→Pictures→iPhoto Library. Alternatively, pop open a Finder window and choose Go→Home, and then double-click the Pictures folder.

As described in Chapter 2, the iPhoto library contains not just your photos, but also a huge assortment of essential elements:

- All the thumbnails you see in the photo-viewing area.

- The originals of photos you've edited in iPhoto or an external editor.

- Various data files that keep track of your iPhoto keywords, flags, ratings, albums, and so on.

To prepare for a disaster, you should back up *all* these components.

To perform a complete backup, quit iPhoto and then Option-drag the iPhoto library icon to another location on your hard drive. However, copying it to another spot on the *same* disk means you'll lose both the original iPhoto library and its backup if, say, your hard drive crashes or an asteroid hits your computer. Copying it to a *different* hard drive—to another external hard drive or another Mac via the network—is the *best* route—drag the icon to an external drive to begin the copying (no modifier key required).

You'd be surprised at how cheap hard drives are these days. As of this writing, you can buy a 1-terabyte hard drive (that's 1,000 gigabytes) for *way* under $100, for goodness' sake—and hard drive prices-per-gigabyte only go down.

Burning Files to CD or DVD

Burning a CD or DVD is handy for backing up your photos, transferring them to another computer (even a Windows PC), mailing them to somebody, or offloading (archiving) older files to free up hard drive space. You can buy blank CDs and DVDs incredibly cheaply in bulk via the Web.

TIP When you're shopping for CDs or DVDs, Verbatim DataLifePlus is a good brand to look for (especially their archival-quality DVDs, which allegedly last for 100 years).

CDs can store about 700 megabytes of data. *Single-layer* DVDs store roughly six times as much data as a CD, for a total of 4.3 gigabytes. *Dual-layer* DVDs—like the ones you get when you rent or buy a Hollywood movie—are more expensive but hold twice the data of their single-layer brethren (8.5 gigabytes). So, if your iPhoto library file is smaller than, say, 4 gigabytes, you could burn it onto a single-layer DVD; if it's smaller than 8 gigabytes, you can squeeze it onto a dual-layer DVD. With this method, your entire iPhoto realm remains intact.

TIP Not sure what kinds of discs your Mac can burn? Choose →About This Mac, and then click More Info. In the resulting dialog box, click the Storage tab. Scroll down (if necessary) and there it is, plain as day: a list of the formats your machine can write (that is, burn). For example, depending on your Mac's model, you might see "CD-Write: -R, -RW, DVD-Write: -R, -RW, +R, +RW, -R DL."

However, if your iPhoto Library file is *larger* than 8 gigabytes, you'll need to export your photos and videos first, and then burn the *individual* files to disc instead. The downside to this approach is that, depending on the export options you pick, any edits you've made to the photos become permanent and you lose the organizational structure you've worked so hard to create in iPhoto (like folders and albums). If you've added flags or star ratings, they get stripped out too, though keywords and location tags can remain intact if you turn *on* those two options in the Export dialog box as described in step 1 below).

TIP Another option is to spring for an external *Blu-ray burner,* which can store a whopping 25 GB on a single layer BD-R!

Whether you're burning your entire iPhoto library onto disc, or individually exported photos, video, or a slideshow, the process is the same. Here's how it works:

1. **Prepare your files.**

 Exactly how you do this depends on what you're planning to burn:

 - If you're burning your iPhoto library file, locate it by opening a Finder window that points to your Macintosh HD→Users→[your user name]→Pictures folder, or by choosing Go→Home→Pictures.

 - If you're exporting *individual* files, in iPhoto, select the album, photos, or videos that you want to burn, and then choose File→Export. In the dialog box that appears, click the File Export tab. To export full-size photos with your edits intact (though undoable should you import these photos back into iPhoto), set the Kind menu to JPEG, the JPEG Quality menu to Maximum, and, if you've added keywords or Places tags, turn on "Title and keywords" and "Location information." Set the Size menu to Full Size and, if you've given your pictures custom filenames, choose "Use title" from the File Name menu (if you haven't, leave it set to "Use filename").

 To export your original photos *without* any edits you've made, pick Original from the Kind menu instead.

 > **NOTE** For detailed instructions on exporting *slideshows,* see page 274.

 Click Export and then, in the next dialog box, pick a destination for the exported files. Click OK to get the export process under way.

2. **Put a blank CD or DVD into your burner and tell your Mac what to do with the disc.**

 A few seconds after you insert the disc, you see the dialog box shown in Figure 12-1, top. Choose "Open Finder," and then click OK.

 Now the disc's icon appears on your desktop as Untitled CD or Untitled DVD, as well as in the sidebar of any Finder window, complete with the burn symbol (☢).

3. **Drag the file(s) onto the disc's icon.**

 At this point you can drag your files and folders onto the disc's icon on your desktop, or double-click the icon to open a window like the one in Figure 12-1 (bottom), and then drag the files into the window. These files may include your iPhoto library (if it's not too big), photos and videos you've exported from iPhoto, an exported slideshow movie, or any combination thereof.

 You can add, remove, reorganize, and rename the files on the not-yet-burned disc just as you would in any Finder window. All you're really doing is dragging aliases (shortcuts) around; the real files are left untouched on your hard drive.

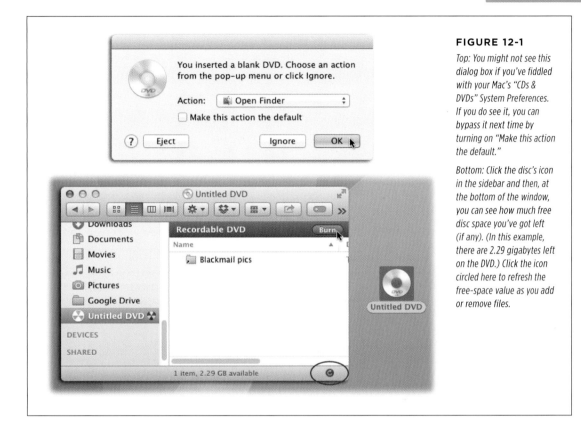

FIGURE 12-1

Top: You might not see this dialog box if you've fiddled with your Mac's "CDs & DVDs" System Preferences. If you do see it, you can bypass it next time by turning on "Make this action the default."

Bottom: Click the disc's icon in the sidebar and then, at the bottom of the window, you can see how much free disc space you've got left (if any). (In this example, there are 2.29 gigabytes left on the DVD.) Click the icon circled here to refresh the free-space value as you add or remove files.

4. **Tell your Mac to get ready to burn the files.**

 When the disc's icon contains the files and folders you want to immortalize, do one of the following:

 - On your desktop, click the disc's icon and then choose File→Burn [disc name].

 - Click the ☢ next to the disc's name in the sidebar of a Finder window.

 - In the upper-right corner of the disc's window (Figure 12-1, bottom), click Burn.

 - On your desktop, drag the disc's icon toward the Trash icon in the Dock. As soon as you begin to drag, the Trash icon turns into a yellow ☢; drop the disc's icon onto it.

 - On your desktop, Control-click the disc's icon and choose Burn [disc name].

 In any case, a confirmation dialog box appears.

5. **Edit the disc's name, if you want, and then click Burn.**

 You can rename the CD or DVD just as you would a file or a folder.

 Once you click Burn, your Mac saves the files onto the CD or DVD. When the recording process is over (it'll take several minutes), eject the disc by pressing the ⏏ key or by Control-clicking the disc's icon on your desktop and choosing "Eject [disc name]."

There's another approach: In the Finder, choose File→New Burn Folder. A new folder cleverly named—you guessed it—*Burn Folder* appears on your desktop. Name it anything you want, and then drag your files inside. Now open the folder and click the Burn button in the upper-right corner. The Mac asks for a blank CD or DVD and then walks you through the process of burning it. (This method is especially handy when you don't have any blank discs lying around. Simply gather up the files you want to back up, and then perform the burn whenever you get around to buying some discs.)

Either way, once you've tested that the disc(s) you've burned work, you can delete the exported files on your hard drive to reclaim some space.

NOTE The discs that your Mac burns work equally well on Macs and on Windows (or Linux) PCs. If you plan to insert a disc into a PC, however, remember that Windows doesn't permit certain symbols in filenames. So you'll run into trouble if any of your filenames contain these symbols: \ / : * ? " < > |. In fact, you won't be able to open any folders on your disc that contain illegally named files.

◼ Managing Photo Libraries

These days iPhoto can comfortably manage around a million photos in a single library, give or take a few thousand, depending on what model your Mac is and how much memory it has.

But some people feel uneasy about keeping that many eggs in a single basket. They wish they could break up their libraries into several smaller, easier-to-manage, easier-to-back-up chunks.

If that's your situation, then you can archive some of your photos to CD or DVD as described in the previous section, and then *delete* the archived photos from your library to shrink it down in size. For example, you might choose to archive older photos, or albums you rarely use.

NOTE Remember, burning photos to disc doesn't *remove* them from iPhoto; you have to do that part yourself (page 68). If you don't, your library won't get any smaller. Just make sure that the CD or DVD you've burned works properly before deleting your original photos from iPhoto.

Turn On Your Time Machine

There are two kinds of people in the world: those who have a regular backup system—and those who *will.* You'll get that grisly joke immediately if you've ever known the pain that comes with having your hard drive die. All those photos, all that music you've ripped and organized into playlists, all your email—*gone.*

If you don't have much to back up, you might be able to get by with a free online backup system like Dropbox, CrashPlan, or iDrive. But those methods leave most of your Mac—all your programs and settings—unprotected (well, save for CrashPlan). What you *really* want is a backup that's rock solid, complete, and *automatic.* That's the idea behind Time Machine, a marquee feature of OS X. It's a silent, set-it-and-forget-it path to peace of mind.

Setting up Time Machine is easy, though it requires a second hard drive like an external USB, FireWire, or Thunderbolt hard drive; an AirPort Time Capsule (an AirPort wireless base station/network backup hard drive in one, available in gigantic capacities); another internal hard drive; or something similar.

Whatever you use, the backup disk has to be bigger than the drive you're backing up (preferably *much* bigger).

The moment you connect an external hard drive (or the first time you turn on your Mac after installing an internal one), you see a message inviting you to use it as Time Machine's backup drive. If you click "Use as Backup Disk," you're taken to the Time Machine pane of System Preferences (you can also open this pane directly). You see a huge off/on switch on the left side of the pane, showing that Time Machine is now on, your backup disk has been selected, and the copying process has begun. Your Mac starts copying *everything* on your hard drive, including OS X itself, all your programs, and everyone's Home folders. You know that because you see both a progress message and the ↻ symbol that appears next to the backup drive's name in the Finder's sidebar.

And that, ladies and gentlemen, is the easiest setup for a backup program in history.

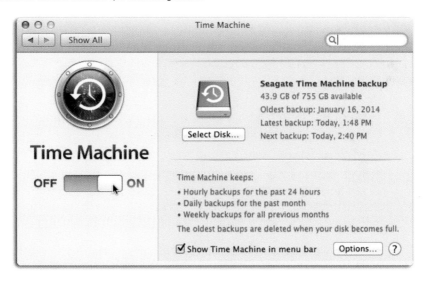

The following section explains a couple of other options: using disk images and splitting one library into several.

iPhoto Disk Images

The one disadvantage of the abovementioned offload-to-disc technique is that it takes a big hunk of your photo collection *offline,* so that you can no longer get to it easily. If you suddenly need a set of photos that you've archived, for example, you have to hunt down the right disc. That could be a problem if you happen to be in New York and need the photos you left on a DVD in San Francisco.

Here's a brilliant solution to that disc-management problem: Turn your discs into *disk image files* on your hard drive. These files are basically virtual CDs that you can keep on your hard drive at all times.

To create one, open Disk Utility (which sits in your Applications→Utilities folder); then insert the CD or DVD you've burned (page 303). In the left pane of the Disk Utility window, click the disc's icon (see Figure 12-2).

FIGURE 12-2

Be sure to click the CD or DVD icon bearing a plain-English name, like "iPhoto Library" or "Wedding photos" as shown here (it's usually the last one listed). Don't click the icon bearing your CD burner's name, like "MATSHITA DVD-R."

Then choose File→New→"Disk Image from [disc name]," or click New Image at the top of the window (circled in Figure 12-2). In the resulting Save As dialog box, you can type a name for the disk image you're about to create. You can even password-protect it by choosing "128-bit AES" from the Encryption pop-up menu. Next, choose a location for the disk image, such as your desktop, and then click Save.

You've just created a disk image file whose name ends with .dmg. When you want to view its contents in iPhoto, double-click the .dmg file's icon. You'll see its contents appear in the form of a CD icon in iPhoto's Source list, just as though you'd inserted the original disc.

You can spin off numerous chunks of your iPhoto collection this way, and "mount" as many of them simultaneously as you like—a spectacular way to manage tens of thousands of photos, chunk by chunk, without having to deal with a clumsy collection of discs.

Multiple iPhoto Libraries

Now that iPhoto can hold tons of photos in a single library, there's not as much need to split it into separate libraries as there once was. Still, there are two good reasons why you might want to consider it:

- Splitting your collection into several libraries may make iPhoto run faster, especially during scrolling, because there are fewer photos in it. (Fortunately, iPhoto is noticeably faster than previous versions, as explained in the box on page 22.)

- You can keep different types of collections or projects separate. You might want to maintain a Home library for personal use, for example, and a Work library for images that pertain to your business. Or you can start a new library every other year.

> **NOTE** The iCloud photo streams you learned about on page 12 work with *one* library at a time. So if you create a new library and then switch to it, iPhoto offers to push your photo streams to the *new* library instead (they won't show up in the old one).

■ CREATING NEW LIBRARIES

iPhoto includes a tool for creating fresh libraries and switching among several of them. Here's how to use it:

1. **Quit iPhoto.**

 You're going to do the next step in the Finder.

2. **While pressing the Option key, open iPhoto again.**

 When iPhoto starts up, it senses that you're up to something and offers you the chance to create a new library or choose an existing one (Figure 12-3).

3. **Click Create New, fill in the Save As dialog box that opens, and then click Save.**

 You're offered not only the chance to create a new library, but also to choose a location for it if it's not your regularly scheduled Pictures folder. Type a name for the new library (*Wedding Photo Library* or whatever), and then click Save. When iPhoto finishes opening, all remnants of your old iPhoto library are gone. You're left with a blank window, ready to import photos.

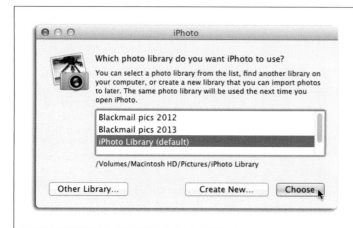

FIGURE 12-3

If you open iPhoto while holding down the Option key, the program invites you to pick which library you want to open or to create a new one. If your goal is to start a fresh library for the new year, click Create New and give it a name.

To pick an existing library, either double-click it in the list or click it once to select it and then click Choose.

Using this technique, you can spawn as many new photo libraries as you need. You can archive the old libraries on CD or DVD, move them to another Mac, or just keep them somewhere on your hard drive so that you can swap any one of them back in whenever you need it.

As for *how* you swap them back in, you have two options: Apple's way and an easier way.

■ SWAPPING LIBRARIES (APPLE'S METHOD)

Once you've built yourself at least two iPhoto libraries, you can use the same Option-key trick (see step 2 above) to switch between them. When the dialog box in Figure 12-3 appears, select the library you want to open in the list, and then click Choose. (If you don't see the library you want, then click Other Library and hunt it down on your hard drive.)

When iPhoto finishes reopening, you'll find the new set of photos in place.

■ SWAPPING LIBRARIES (AUTOMATIC METHOD)

If you think that Option-key business sounds a little disorienting, you're not alone. Brian Webster, a self-proclaimed computer nerd, thought the same thing—but *he* decided to do something about it. He wrote iPhoto Library Manager, a $30 program that streamlines the process of creating and swapping iPhoto libraries (see Figure 12-4). If you've got the extra cash, waste no time in downloading it from Brian's site, *www.fatcatsoftware.com/iplm*. (The free version lets you swap libraries, but not much else.)

The beauty of this program is that it offers a tidy list of all your libraries, and you can switch among them with two quick clicks.

FIGURE 12-4

iPhoto Library Manager lets you quickly switch among as many iPhoto libraries as you want.

Select a library from the list on the left and the other columns show its albums and thumbnails. (The active [open] library has a checkmark next to its name.) You can download the program for free, though the $30 version includes more features.

Here are a few pointers for using iPhoto Library Manager:

- The program doesn't just activate *existing* iPhoto libraries; it can also create new libraries for you. Just click Create Library in the toolbar, choose a location and name for the library, and then click OK.

- You still have to quit and relaunch iPhoto for a change in libraries to take effect. Conveniently, iPhoto Library Manager includes Quit iPhoto and Launch iPhoto buttons in its toolbar (just widen the program's window if you don't see them).

- iPhoto Library Manager is fully AppleScript-able. If you're handy with writing AppleScript (discussed in Chapter 11), then you can write one that swaps your various libraries automatically with a mere double-click.

Merging Photo Libraries

You've just arrived home from your safari of deepest Kenya. You're jet-lagged and dusty, but your MacBook Pro is bursting at the seams with fresh photos. You can't wait to transfer the new pictures into your main iPhoto library—you know, the one on your Mac Pro 6-Core Dual GPU with 64 gigs of RAM and a Sharp 4K display.

Or, less dramatically, suppose you've just upgraded to iPhoto. You're thrilled that you can fit a million pictures into a single library—but you still have six old iPhoto 5 library folders containing about 10,000 pictures each.

In both cases, you have the same problem: How are you supposed to merge the libraries into a single, unified one?

How Not to Do It

You certainly can combine the *photos* of two Macs' photo libraries—just export them from one (File→Export) and then import them into the other (File→"Import to Library"). As a result, however, you lose all of your album organization, your ability to undo edits, your ratings and comments, and so on.

Your next instinct might be: "Hey, I know! I'll just drag the iPhoto library icon from computer number 1 into the iPhoto window of computer number 2!"

Big mistake. You'll wind up with duplicates or triplicates of every photo in the viewing area, in one enormous, unmanageable, uncategorized, sloshing library. You could also use CDs or DVDs as intermediaries, but that's time-consuming and uses up blank discs.

The Good Way

The only *sane* way to merge libraries is to use iPhoto Library Manager, described on page 310. For $30, you can unlock some features that aren't available in the free version—including a miraculously simple Merge Libraries command. All you do is click Merge Libraries in the toolbar at the top of its window, and then proceed as shown in Figure 12-5.

> **NOTE** iPhoto Library Manager's merging process preserves all your keywords, ratings, titles, albums, and edits. However, it *doesn't* maintain books, calendars, saved slideshows, or smart albums.

◼ Beyond iPhoto

Depending on how massive your digital photo collection grows and how you use it, you may find yourself wanting more editing or file-management power than iPhoto offers. Maybe you want to adjust the exposure of multiple files at once, build your own treatments that you can apply to photos as presets, create partial-color effects (see Figure 12-6), build fine-art-gallery-level templates for printing, or you'd like a system that lets a whole workgroup share a library of photos simultaneously.

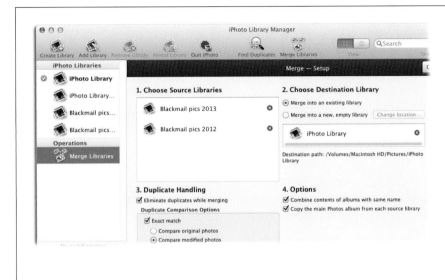

FIGURE 12-5

Drag the icons of the libraries you want to combine from the list on the left into the box in section 1. To combine them into a new library, leave "Merge into a new, empty library" selected in section 2 on the right. To add them to an existing library, drag the existing library from the list on the left into the box in section 2, set your Duplicate Handling options in section 3, click Preview, inspect the proposed mega-library, click Merge—and then walk away (the process can take a while).

FIGURE 12-6

Lightroom and Aperture are two fantastic and fairly user-friendly database and image-editing programs that do what iPhoto does—and a lot more besides. As you can see here, you can use Lightroom to create a partial-color effect. (Aperture, Lightroom's archrival, works similarly.)

One nice thing about Aperture is that it now uses the same library as iPhoto, so you don't have to do any importing or exporting. It also works well with iMovie. For example, it seamlessly imports iMovie libraries, complete with albums, keywords, ratings, and so on.

To enjoy such features, you'll have to move beyond iPhoto into the world of professional image-management and editing software, which means spending money. Programs like Adobe Photoshop Lightroom ($150, *www.adobe.com/lightroom*), Apple's own Aperture ($80, *www.apple.com/aperture*), or, for *larger* operations, Extensis Portfolio Server Studio ($2,000, *www.extensis.com*) are all terrific programs for someone who wants to take the next step up. If you're mainly interested in powerful, pixel-level editing for tricks like swapping heads, removing complex objects, combining images into composites, adding text, and so on, the consumer-level Adobe Photoshop Elements or the pro-level Photoshop CC might make better sense. (Adobe offers free trial versions of most of its software at *www.adobe.com*.) That said, the highly affordable Pixelmator has an impressive following ($30, *www. pixelmator.com*).

Some of these features are obviously mentioned with professionals in mind, like graphic designers and studio photographers. But these kinds of programs are worth considering if and when your photo collection—and your passion for digital photography—one day outgrows iPhoto.

> **TIP** To learn more about Adobe Photoshop, Photoshop Elements, and Photoshop Lightroom, check out your co-author's training videos and ebooks at *www.PhotoLesa.com*.

GEM IN THE ROUGH

iPhoto and Aperture: The Uni-Library

You were alive to see the day: iPhoto (9.3 and later) and Aperture (3.3 and later) can now open *each other's* libraries! You can keep all your photos in a single library, and blithely jump back and forth between those two programs to edit them. (You can't use the same library in both programs simultaneously, however.)

All your Faces, Places, albums, and web-published photos work in both programs. Slideshows show up identically in both. You can edit pictures in either program; the edits show up in the other. (Which is a big deal, because Aperture lets you make selective edits with brushes—a feature iPhoto lacks.) And you can remove those edits in either program, too.

You can also perform some very powerful library manipulation with Aperture. For example, you can combine multiple iPhoto libraries into one master library—using Aperture. If you're clever, you can even use Aperture to create a compact special library of *all* your photos—hundreds of thousands—at a smaller, laptop-friendly size; the huge, full-resolution originals can remain at home on some backup drive.

To open an Aperture library in iPhoto, choose File→"Switch to Library," and then find and open the Aperture library. To open an iPhoto library in Aperture, choose File→"Switch to Library"→Other/New.

Only a couple of caveats stand in your way. First, there's some different terminology; what you know as Events are called Projects in Aperture.

Second, although smart albums show up and work identically in both programs, you have to *edit* a smart album in the program that created it. There are similar conditions regarding slideshows and printed products like books; see *http://support. apple.com/kb/ht5260* for details.

Note, too, that photos you've hidden in iPhoto (page 47) aren't visible at all in Aperture. (If you want to see them in Aperture, unhide them in iPhoto first.)

Otherwise, though, this new file compatibility can be a huge convenience for the true Mac photophile.

iPhoto for iOS

iPhoto on the iPad

I Photo isn't just for Macs anymore. These days you can use it on your iPhone, iPod Touch, or iPad. As long as the device is running iOS 7 or later—the software that powers Apple's mobile gadgets—you can hold iPhoto's organizational and image-editing prowess in the palm of your hands.

This development is exciting because it releases you from the shackles of your desk. The iPad in particular sports a screen that's perfectly suited for displaying and editing your photos while you're away from your main machine. Imagine flying home from Fiji and having your pictures perfected before you hit baggage claim, or parking at your favorite coffee shop and whipping up a web journal (an online digital scrapbook—see page 383).

iPhoto for iOS lets you do all those things and more. You can use it to upload photos to Facebook, Flickr, or Twitter; design and order hardcover books, prints, panoramas, or posters; create slideshows; and beam pictures onto other iOS devices or pass them off to iPhoto-friendly iOS apps like iMovie.

You've already learned most of what you need to know to use iPhoto on your iPad, though this version of the program has significantly different controls. This chapter gives you an overview of what you can do with iPhoto for iOS; explains how to get photos onto your iPad; and teaches you how to view, compare, flag, tag, and create slideshows from your shots.

An Overview of iPhoto for iOS

iPhoto for iOS requires an iPhone 4 or later, iPod Touch fourth generation or later, iPad Air, iPad 2 or later, or an iPad mini. If you purchased your iOS gadget after October 1, 2013, you can download iPhoto from the Mac App Store for free; otherwise you have to pay $5.

Once you install iPhoto, you've got everything you need to view, edit, and share pictures right there on your mobile device. The program looks the same no matter which device you're using it on, though this book focuses on using it on the iPad because it has the biggest screen. (The minor differences in the iPhone/iPod Touch and iPad versions are noted.) Here's what you can do with iPhoto on your iPad:

- **See all your pictures.** iPhoto's opening screen lets you see your photo thumbnails in three familiar categories: Photos, Albums, and Projects (see Figure 13-1). As you'll learn in the next section, it's incredibly easy to get photos into iPhoto whether they're in your Camera Roll (pictures you've taken with your iPad; page 374), synced via iTunes (page 321), shared using iCloud (page 196), saved from an email or instant message (page 325), or downloaded directly onto your iPad from your camera or memory card (see the box on page 322).

> **NOTE** iPhoto for the iOS creates albums *automatically* when you do certain things such as edit, flag, tag, or view a picture.

FIGURE 13-1

Tap Photos, Albums, or Projects at the bottom of iPhoto's main screen to pick a grouping of pictures to view. By choosing Albums, you can see your iPad's Camera Roll as well as your iCloud photo streams. Any albums you've set to sync in iTunes show up here, too.

Tap the ⑦ at the bottom left of the screen to display the helpful yellow tips shown here. Tap the ⑦ again to hide them.

- **Compare, flag, and tag photos.** You can select multiple photos and see them side by side (page 337), and add a flag or favorite tag to mark the ones you like best (page 334). If you double-tap a thumbnail, iPhoto shows you all the similar photos in that particular album. You can also create and add keywords (page 334), add captions (page 336), and search for specific shots (page 336).

- **Edit your photos.** iPhoto on your iPad lets you perform all the same editing tricks as iPhoto can on your Mac, plus a whole lot more. Not only can you edit *whole* photos by cropping, straightening, rotating, correcting exposure, resetting the white balance, sharpening, and copying/pasting edits from one photo to another, but you can also alter only certain areas of your pictures. For example, you can intensify just the blues or greens, or use iPhoto to repair, lighten, darken, saturate, desaturate, sharpen, and soften certain spots using your fingertips (a maneuver called *on-image gesturing*). Also available only in iPhoto for iOS: the ability to apply nine categories of creative effects including painterly edges, color treatments (warming, cooling, black and white, and so on), trendy filters, and artistic blurring. Chapter 14 has the scoop.

- **Share your photos.** In addition to posting pictures on Facebook, Flickr, and Twitter, you can also create (or contribute to) shared iCloud photo streams (see page 373). You can also email photos, send them via instant message, beam them onto another iOS device, transfer them via AirDrop, and more. See Chapter 15 for details.

- **Create web journals and slideshows.** *Web journals,* a feature exclusive to iPhoto for iOS, are like digital scrapbooks (page 383). Once you pick the pictures to include, you can customize the layout in myriad ways: move and resize photos, tweak the design, add fun stuff like maps, and so on. You can beam or AirDrop journals to other iOS devices, sync a journal's HTML files back to your Mac using iTunes, or—if you have an iCloud account—post them onto the Web. You can also create slideshows that you can view on your iPad, share with other iOS gadgets, and post online.

- **Design and order books and prints.** You can create and order hardcover books right from your iPad (page 401). You can also order prints in a variety of sizes. And if you've got a wireless printer connected to your home or office network, you can even print directly from your iPad.

At this point, you're probably wondering what you *can't* do with iPhoto on your iPad. In a nutshell, you can't create albums or folders, add Faces or Places tags, create cards and calendars, or trim movies.

Now that you have an idea of what the app can do, you're ready to start importing photos into iPhoto for iOS.

▆ Importing Pictures

Every Apple mobile device comes with a built-in app called *Photos* (not to be confused with iPhoto). This app is the central repository for all the photos and videos on your gadget. It also lets you create, share, and edit slideshows, but it can't compete with iPhoto's skill set.

Happily, all the pictures and videos that live in the Photos app show up in iPhoto for iOS *automatically;* you don't have to do a thing. And how do you get pictures into Photos (and therefore into iPhoto), you ask? By doing any of the following:

- Take a picture with your iPad or take a screenshot on your iPad (by simultaneously pressing the home button and the sleep/wake button).

- Beam a photo from one iOS device to another (page 371).

- Create an iCloud account and turn on My Photo Stream (page 12). If you subscribe to someone else's photo stream (page 373), those photos show up in the Photos app, too.

- Use iTunes to sync pictures between your iPad and your Mac (page 321).

- Use iTunes to copy pictures from your Mac to your iPad (page 323).

- AirDrop pictures from one iOS device to another (page 326).

- Save a photo from *another* iOS app (page 374).

- Save a photo you've received by email or text message (page 325).

- Save photos or videos from Facebook or Flickr (page 326).

- Import pictures directly onto your iPad from your digital camera or memory card as explained in the box on page 322.

Using iCloud Photo Streams

If you've got an iCloud account and you turn on My Photo Stream (page 12), pictures appear in the Photos app on your iPad, and thus as an album in iPhoto, *automatically.* Each time a new photo enters your life—when you take a picture with your iPad or iPhone, for example, or import one onto your Mac—it gets added to your photo stream and appears on all your iCloud-connected machines (provided you've flicked the photo stream switch on those devices, too). Here's where to find your pictures:

- **iPhone, iPad, iPod Touch.** In your Photos app, you see an album called My Photo Stream. It includes the most recent photos you've taken with any of your iOS gadgets, or that you've imported to your Mac; you see this same album in iPhoto for iOS (it's visible in Figure 13-1). To save space on your iOS device, your photo stream consists of just the last 1,000 photos, and the iCloud servers store your photos for only 30 days. But as long as your gadgets go online at least once a month, they update themselves automatically in order to remain current with the photo stream. To have *permanent* access to a picture in your photo stream on your device, you need to save it to your Camera Roll, as Figure 13-2 explains.

- **On a Mac.** In iPhoto on your Mac, your photo stream appears in the Shared section of your Source list as an item labeled iCloud. If you turned on Automatic Import in iPhoto's iCloud preferences on your Mac (page 14), you don't have to worry about that 30-day, 1,000-photo limit; once pictures appear on your *Mac,* they stay until you delete them. This is one of the best features of iCloud, because it means you don't have to sync your iPad (or iPhone) over a USB cable to get your photos onto your Mac or vice versa. It all happens automatically and wirelessly via WiFi.

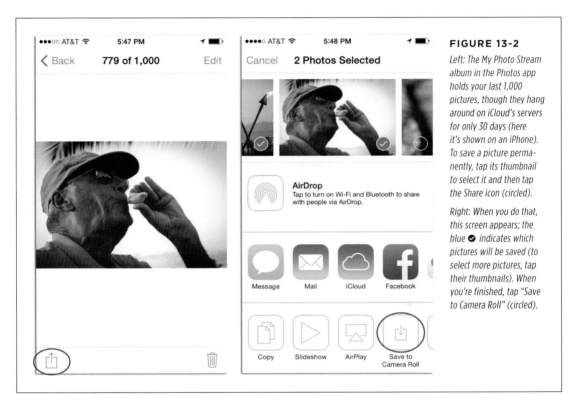

FIGURE 13-2

Left: The My Photo Stream album in the Photos app holds your last 1,000 pictures, though they hang around on iCloud's servers for only 30 days (here it's shown on an iPhone). To save a picture permanently, tap its thumbnail to select it and then tap the Share icon (circled).

Right: When you do that, this screen appears; the blue ✓ indicates which pictures will be saved (to select more pictures, tap their thumbnails). When you're finished, tap "Save to Camera Roll" (circled).

> **TIP** If you've got an Apple TV and you're using it to view your photos (see the box on page 276), sign into your iCloud account on your Apple TV and a new album called Photo Stream appears there, too. Few Mac magic tricks are as impressive as displaying your photos on a big plasma-screen TV!

Syncing with iTunes

iTunes, as you probably know, is Apple's free multimedia jukebox program that comes preinstalled on every Mac. It's been loading music onto iPods since the turn of the 21st century, and you use it to control which digital movies and photos get synced onto your iOS devices.

The syncing process is simple:

1. **Connect your iPad (or iPhone, or iPod Touch) to your Mac; when iTunes opens, click your iPad's name, and then click the Photos tab.**

 If you set iTunes to open automatically when you connect your iPad (using the Summary tab), it'll pop right open. If not, go ahead and launch iTunes, and you see the screen shown in Figure 13-3.

2. **Turn on "Sync photos from," and then choose iPhoto.**

3. **Choose which photos to sync.**

 If you picked iPhoto in the previous step and you want *all* your pictures synced, choose "All photos, albums, Events, and Faces." If you just want *some* of them, click "Selected albums, events, and faces, and automatically include..." instead, and then turn on the checkboxes of the albums, events, and faces you want synced. (The "faces" option is available only if you're syncing from iPhoto on the Mac, and only if you've used Faces tags.) Either way, your selections are organized into the same structure in iPhoto for iOS when you import them (in albums, Events, and so on).

> **TIP** If you want to sync videos to your iPad, including any slideshows you've exported as QuickTime movies (page 274), be sure to turn on "Include videos." However, videos consume a *lot* of space; if you run out of room on your device, deleting videos is a fast fix.

FREQUENTLY ASKED QUESTION

From Camera to iPad

Dude, I don't even have a Mac; all I've got is this iPad. How the heck am I supposed to get my pictures onto it?

No Mac? No problem. There's another way to get pictures onto your iPad: You can import them directly from your digital camera or memory card. This maneuver requires purchasing a Lightning to USB Camera Adapter or Lightning to SD Card Camera Reader ($30 each at the Apple Store; less on Amazon.com). These connectors work on newer full-sized iPads (fourth generation and later), as well as iPad minis.

If you've got an older, full-sized iPad (first, second, or third generation), you can save a little money by getting the iPad Camera Connection Kit instead, which also costs $30 at the Apple Store (*http://tinyurl.com/968aj4h*); it's also less on Amazon.com. This kit consists of two white connectors that plug into your iPad. One connector lets you plug in the USB cable that came with your camera, and the other has a slot for an SD card.

Either way, once your iPad detects a camera or memory card, it launches the Photos app. Tap to pick which photos or videos to import, and then tap Import (or Import All to transfer *all* your shots). If you shoot in raw format (page 19), you'll end up working with JPEG versions of them in iPhoto for iOS, though they'll carry a RAW label that you can see in the Info pane (page 332).

As you choose albums, events, or faces to sync, a faint number appears to each item's right showing you how many photos are inside. (For example, in Figure 13-3, you can see that the Sunsets album contains 38 photos.) And at the bottom of the iTunes window, a colorful graph shows you the amounts and types of files that are headed for your iPad: Audio, Video, Photos, Apps, Books, Documents & Data, and Other (for your personal data). More importantly, this graph shows how much room your iPad has left, so you won't get overzealous in syncing your stuff.

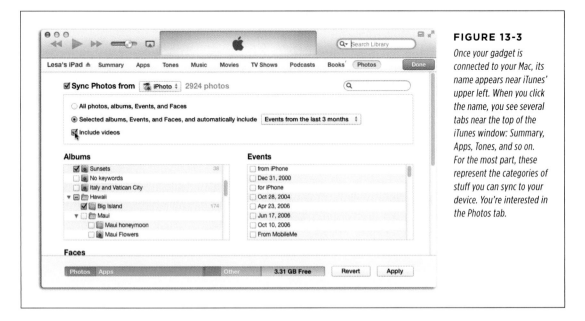

FIGURE 13-3

Once your gadget is connected to your Mac, its name appears near iTunes' upper left. When you click the name, you see several tabs near the top of the iTunes window: Summary, Apps, Tones, and so on. For the most part, these represent the categories of stuff you can sync to your device. You're interested in the Photos tab.

4. **Click Apply.**

 iTunes does its thing, creating downsized copies of your photos that will look great on your iPad, and then sends them over.

NOTE If you want *full-size* copies of your photos synced to your iPad—say, for ordering prints or designing a hardcover book—you need to use iTunes' file-sharing feature instead. The next section has the details.

After the sync is complete, click the ⏏ next to your device's name to disconnect it. Now you'll be able to wave your iPad around, and people will *beg* to see your photos.

Using iTunes File Sharing

Apple realizes that your iPad doesn't have nearly as much memory as your Mac. That's why it *downsizes* your photos during a sync. And if you're only using your iOS device to *display* photos, either on the device itself or on the Web, then you can get away with far fewer pixels.

But if you're planning on ordering large prints or creating a hardcover book from your iPad (see Chapter 15), you want the maximum number of pixels, so Apple's printing companies have more info to work with. The more pixels contained in your photo, the smaller those pixels can be when printed. The goal is to have pixels so small that you can't see them individually in the printed piece.

To transfer a *full-size* photo file from your Mac to your iOS device, you have to use iTunes' file-sharing feature.

First, export the full-size files you want to transfer to your iPad (see page 290 for instructions) and put them in a folder. Next, fire up iTunes, connect your iPad to your Mac, click your iPad's name, and then click the Apps tab. Scroll down until you see the File Sharing section (Figure 13-4, top), and then click iPhoto in the Apps list. At the bottom of the iPhoto Documents section, click Add, and then navigate to the folder where you stored the pictures, select the ones you want, and then click Add. Finally, click iTunes' Apply button. Your photos will be copied to your iPad, in full-resolution glory, the next time you sync.

Honestly, it's less harrowing to create your print projects on your Mac rather than on an iPad, because then you don't have to think about downsized versions vs. full-sized versions at all. Of course, if you're *capturing* on your iOS device, then you're always working with the full-sized versions of those particular photos, so there's nothing to worry about. (That said, if you order small- to medium-sized prints from an iPad 2, it's unlikely you'd spot a quality difference between the downsized and full-sized versions anyway.)

Syncing Wirelessly

The familiar USB cable you use to connect your iPad to your Mac is all well and good—but the iPad is a *wireless* device, for Thor's sake. Why not sync it to your Mac wirelessly?

To perform this stunt, iTunes has to be running on your Mac, and your Mac and iPad have to be on the same WiFi network. To set up wireless syncing, connect the iPad using the USB cable, one last time (ironic, but true). In iTunes, click the iPad's name at the upper right. On the Summary tab, scroll down and turn on "Sync with this iPad over Wi-Fi," and then click Apply. You can now eject and detach the iPad.

From now on, whenever the iPad is on the WiFi network, it's *automatically* connected to your Mac as long as the Mac is turned on and iTunes is running.

But connecting isn't the same as syncing, which is a more data-intensive, battery-draining process. Syncing happens in either of two ways:

- **Automatically.** If the iPad is plugged into a power source (like a speaker dock or a wall outlet), and it's on the same WiFi network as the Mac, it syncs with the Mac all by itself (again, iTunes must be open).

- **Manually.** You can also trigger a sync manually—and the iPad doesn't even have to be plugged into power. To start the sync, grab your iPad, go to Settings→General→iTunes Wi-Fi Sync and tap Sync Now. Alternatively, you can open iTunes on your Mac and click Sync (you see this button only if something has changed since your last sync; otherwise it reads "Apply.")

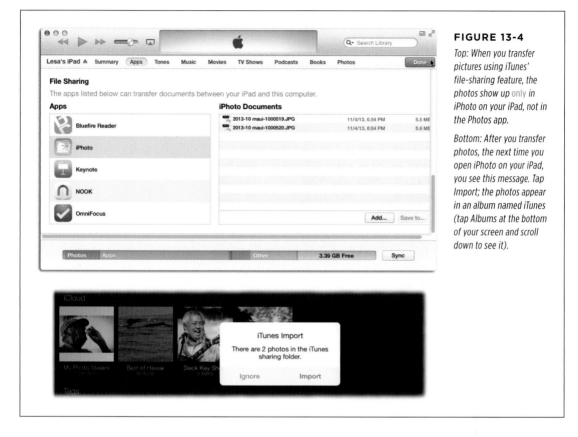

FIGURE 13-4

Top: When you transfer pictures using iTunes' file-sharing feature, the photos show up only in iPhoto on your iPad, not in the Photos app.

Bottom: After you transfer photos, the next time you open iPhoto on your iPad, you see this message. Tap Import; the photos appear in an album named iTunes (tap Albums at the bottom of your screen and scroll down to see it).

Saving Photos from Messages, Email, or the Web

If you've received a photo via email or instant message, saving it to your Camera Roll so you can access it in iPhoto is super easy.

If the photo arrived via Mail, click the Reply button at the top right of your screen (it looks like a curved arrow) and, in the resulting sheet, click Save Image or Save Video. (If you use a different app for email, then the process may be slightly different.)

If it was delivered via Messages (Apple's instant-messaging app), tap the ⬆ at the top right of your screen (see Figure 13-5, top). In the sheet that appears, swipe leftward across the program icons until you see "Open in iPhoto." Tap it to have your iPad close Messages and open the photo in iPhoto. Alternatively, you can tap Save Image (or Save Video) to stick it in your Camera Roll, which appears as an album in iPhoto.

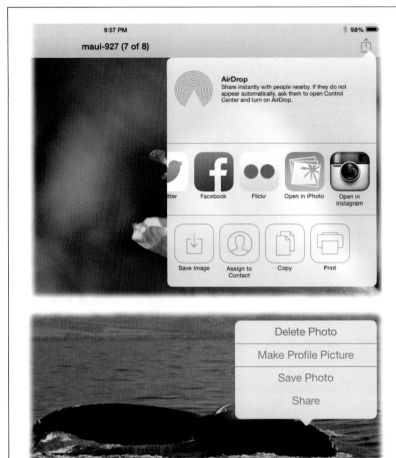

FIGURE 13-5

Top: If you received a photo in a text message, tap the ⬆ at the top right of your screen to see your options for saving the photo.

Bottom: If you're viewing a photo on the Web—say, on Facebook, Flickr, or Twitter—tap and hold the photo to get these options instead.

Saving a picture from the Web is nearly the same process. If you're viewing a photo on Facebook, Flickr, or Twitter, all you have to do is touch and hold the photo (or video clip) for about a second and a sheet appears (Figure 13-5, bottom). Tap Save Image (or Save Video); your iPad deposits a copy in your Camera Roll.

Using AirDrop

With AirDrop, you can shoot a photo (or several) from one iOS device to another—wirelessly, securely, and instantly. It's much faster than emailing or text messaging, since you don't have to know (or type) the other guy's address. The photo ends up in your Camera Roll, and in the Camera Roll album in iPhoto. The whole process is described in Chapter 15 (page 371).

▨ Browsing Photos

The first step in viewing and browsing your pictures is to choose which *group* of photos you want to see. As you saw back in Figure 13-1, iPhoto for iOS gives you three choices—just tap the appropriate link at the bottom of the main screen:

- **Photos.** This view displays thumbnails of every photo you've ever snapped with, saved to, imported to (synced), or beamed to your iPad, as Figure 13-6 shows. Thumbnails appear in date order, grouped by month. What you *don't* see in this view are photos contained in your iCloud photo streams.

- **Albums.** Choose this view to see all the pictures you've synced with your Mac, organized into their respective albums, Events, and so on (this view is shown back in Figure 13-1). You also see any iCloud photo streams you've created or subscribed to, along with a bunch of albums that iPhoto creates *automatically.* You'll use this view a lot; it's described in the next section.

- **Projects.** This view shows you all the photo books, web journals, and slideshows that you've created on your iPad; projects you've created in iPhoto on your Mac aren't included. Chapter 15 has the scoop on creating and managing projects.

FIGURE 13-6

In Photos view, your pictures are grouped chronologically by month. As you scroll through your collection, you see a gray scrollbar and year markers appear along it (both are visible here).

If you place your finger at the right edge of your screen and drag, you invoke a "power scroll" that lets you cruise through your thumbnails even faster.

Viewing Albums

As you recall, albums are a collection of photos and videos shown as a small stack of thumbnails. Tap an album to open it, and you see all the photo and video thumbnails it contains.

The biggest difference between iPhoto albums on your iPad and on your Mac is that you *don't* create them manually on your iPad. Instead, iPhoto for iOS creates new albums *automatically* when you do certain things such as edit, flag, tag or even view a photo.

> **TIP** While you can't manually create albums in iPhoto for iOS, you *can* create them in the Photos app. Just open the Photos app and find the photos that you'll want to be in the new album. Tap Select, and then tap each thumbnail that you want to include in your new album. When you're finished, tap Add To at the bottom of your screen. Finally, scroll down to the bottom of the next screen and tap New Album.

Albums view is arguably the most useful way to see and work with your photos in iPhoto for iOS, because they're categorized by the kind of album they're in. Tap Albums at the bottom of iPhoto's main screen to see them in these glorious groupings:

- **Library.** This category includes albums that iPhoto creates automatically. Here's what you get:

 - **Edited.** When you edit a photo in iPhoto, it appears in this album—even if all you did was add a caption to it (page 336).

Viewing Photos on an External Monitor or TV

If you'd like to see your photos on a big screen, you can project them wirelessly, thanks to a feature called AirPlay. It lets you transmit photos, music, and hi-def video (with audio) from your iPad (or other iOS device) to an Apple TV or another AirPlay-equipped receiver across the room for an audience to enjoy. Whatever is on your iPad's screen gets sent to the other device. This is especially useful when you're viewing your photos as a slideshow, as described later in this chapter (page 338).

AirPlay-equipped devices include the Apple TV (version 2 or later), and a slew of speakers, stereos, and audio receivers (which are for playing *music* instead).

To make AirPlay work, make sure your iPad and the other device are on the same WiFi network. Then grab your iPad and use your finger to swipe up from the bottom of the screen to open the Control Center (it doesn't matter whether iPhoto is open). Tap the 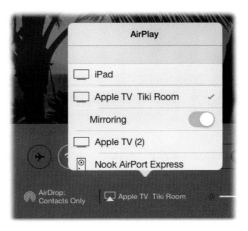 to see a list of available AirPlay receivers, and then tap the one you want to connect to. If you pick an Apple TV, turn on the Mirroring switch beneath it (otherwise it'll play audio from only your device).

That's it! Everything on your iPad's screen now appears on the TV. At the top of the iPad's screen, the appears, so you don't forget that your every move is visible to *everyone in the living room.* (This icon isn't visible in iPhoto when you're viewing individual photos, but you can see it in Photos, Albums, or Projects view.) To turn AirPlay off, reopen the Control Center, tap the AirPlay icon, and then tap your device's name.

- **Flagged.** As you learned back on page 73, flags are a great way to mark photos that you want to do something specific with later, such as delete, email, or edit. If you flag a picture in iPhoto for iOS, they show up here with a tiny orange pennant on each thumbnail. Confusingly, this album *doesn't* contain photos you've flagged in iPhoto on your *Mac.*

- **Favorites.** iPhoto for iOS also lets you mark photos as *favorites* (page 334). When you do, a cute little red heart appears on each thumbnail. Favorites are another great way to mark (and thus automatically group) photos that you want to do something special with later, such as create a Facebook album (page 367), add to a photo book (page 401), or order prints (page 376).

- **Beamed.** To the delight of *Star Trek* fans everywhere, iPhoto lets you *beam* photos from one iOS device to another (page 371). If you've transported photos in that way, they appear here.

- **AirDrop.** If you've transferred any photos from another iOS device onto your iPad using AirDrop (page 371), they show up here.

- **Recent.** This album contains the most recent pictures you've viewed in iPhoto.

- **Camera Roll.** This ever-so-useful album contains all the photos you've taken with your iPad and that you've saved to your Camera Roll using iPhoto (page 374), or from a text message, email, or the Web (page 325).

- **iCloud.** If you've got an iCloud account and you've turned on your photo stream (page 12), those pictures show up in this category.

- **My Photo Stream.** This album contains the last 1,000 pictures you've taken with any of your iOS gadgets, or that you've imported into iPhoto on your Mac. (As you learned earlier in this chapter, iCloud's servers store your photos for 30 days.)

- **Shared photo streams.** If you've created any shared photo streams on your Mac or iPad, you see them listed here.

- **Tags.** If you add custom tags (page 334) to pictures in iPhoto on your iPad, they show up in this album. Tags are just like keywords (page 80), though the keywords you assign in iPhoto on your Mac don't show up here.

- **Albums.** This section includes all the albums you've created on your Mac and synced onto your iPad using iTunes (page 321). And if you've created any albums in the Photos app on your iPad, they show up in this group, too.

- **Events.** As you might suspect, this is where you find any Events that you've synced from your Mac onto your iPad using iTunes. (To learn more about Events, see Chapter 2.)

- **Apps.** Some programs can send pictures *directly* to iPhoto for iOS. For example, if you use iTunes' file-sharing feature (page 323) to send full-size photos from your Mac to your iPad, those photos land in an album in this group named iTunes. You'll see an album here for each program that has fired over a photo.

- **Faces.** This section shows albums that you've synced using iTunes, named with the Faces tags you've added. (For more on Faces tags, see Chapter 4.)

- **Photo Box.** You can think of this album as a catch-all for photos that iPhoto isn't sure what to do with. If a photo lives in an album that iPhoto created automatically—such as Edited, Favorites, Journals, or Tags—and you *delete* the photo from your iPad (via the Photos app, say), it doesn't get deleted from that album in iPhoto. Why? Because it still has the edits or tags that you added, or it still lives in a slideshow or web journal that you've made on your iPad. Only if you remove the thing that made iPhoto put the photo in the automatic album in the first place—you undo the photo's edits, remove its tags, or delete it from a web journal, for example—does iPhoto remove it from the automatic album and shove it into this Photo Box.

Viewing Individual Photos

No matter which group of photos you're viewing, tapping a photo's thumbnail opens it at a larger size, as shown in Figure 13-7. This view includes controls at the top and bottom of your screen that let you do things like edit the picture (Chapter 14), enhance it or rotate it (page 334), add flags and tags (page 334), share it (Chapter 15), see its info (page 332), turn it into the key photo for an album (page 332), and so on.

> **TIP** You can also compare *multiple* photos—handy for deciding which photos to keep or use in projects. Flip ahead to page 337 for the full story.

Once you're viewing an individual photo, you see thumbnails of the *other* photos contained in that particular album on the left or bottom of your screen (see Figure 13-7), depending on how you're holding your iPad.

> **TIP** You can also view the previous or next photo in the album by swiping left or right.

Is this as far as you can zoom into your photo, you ask? Heck no. To see deeper into your picture, you can do one of the following:

- **Zoom in or out using gestures.** To zoom into your photo, use the *spreading* gesture: Place two fingers (usually thumb and forefinger) on the screen and then spread them apart. The image magically grows as though it's printed on a sheet of rubber. Once you've zoomed in like this, you can zoom out again by putting two fingers on the screen and *pinching* them together.

- **Double-tap the photo.** This maneuver also zooms in, magnifying the photo. Double-tapping the photo *again* restores it to its original size.

- **See it in full-screen view.** Tap the photo once to make it hog your entire screen; tap it again to return to the screen shown in Figure 13-7.

Drag to change thumbnail grid width

View all photos, albums, & projects

Enhance Rotate Previous Next

FIGURE 13-7

You can change the size of the thumbnail grid by dragging the icon labeled here (left). Drag the photo count (circled) to the right of your screen to reposition the grid on the right side instead of the left. If you're holding your iPad vertically, then the thumbnails appear at the bottom of the screen.

Clicking the < at the top of the screen returns you to the main screen, where you can see all of your photos, albums, or projects. To see the previous or next photo in the album, click the < and > at the bottom right of your screen (labeled here).

- **Use the loupe.** You can summon iPhoto's *magnification loupe* by placing *two* fingers approximately three inches apart atop the photo (or use one finger from each hand); it doesn't matter where you place your fingers, or whether or not you're already zoomed in. When you do, you see the black ring shown in Figure 13-8 (and your hear a slick little sound if your iPad's sound is turned on). This loupe lets you zoom into a specific spot in your photo at up to 3x magnification. To dismiss the loupe, tap anywhere in the photo outside the black ring.

TIP If you're not already a pro at using gestures on your iPad, you can get up to speed by watching a few of Apple's instructional videos on your Mac. They're tucked away in the Trackpad preferences pane: Choose →
System Preferences→Trackpad. The resulting pane includes a list of gestures. Point your cursor at a gesture to watch a demonstration video. Click the other tabs at the top of the pane to see even more gestures and demos.

FIGURE 13-8

The loupe is like your own personal magnifying glass. You can tap inside it and drag it to another location. To change magnification level, place a finger on either side of the black ring and then rotate your fingers clockwise to zoom in, or counter-clockwise to zoom out.

It takes some practice to master the loupe; but once you do, it's a super slick trick!

■ VIEWING PHOTO INFO

iPhoto can display all manner of insider information about how and when a photo was captured. For example, you can see the date and time the photo was snapped, what camera it was taken with, what its pixel dimensions are, and so on. To see this info in iPhoto on your iPad, tap the ❶ at the top right of your screen (Figure 13-9).

NOTE Unlike the Info button in iPhoto on your Mac, the Info button in iPhoto for iOS doesn't show you keywords, Faces or Places tags, or whether the photo has been shared.

■ CHANGING AN ALBUM'S KEY PHOTO

Once you're viewing a photo within an album, you can make it that album's *key photo*—the picture that represents the album in iPhoto's main screen.

Simply tap the ellipsis (...) at the bottom right of your screen (see Figure 13-10) and, in the resulting pane, tap "Set as Key Photo."

FIGURE 13-9

The Info button shows you all kinds of useful tidbits about your photo, including its exposure settings (helpful for learning how to improve your photography).

To hide the extra data, tap the Info button again or tap anywhere on the photo.

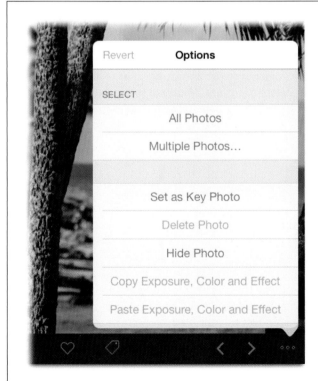

FIGURE 13-10

Feel free to change an album's representative picture using the Options icon (it looks like an ellipsis).

If the "Set as Key Photo" option is dimmed, then iPhoto won't let you change the key photo for that particular album. The program lets you change key photos only for albums you create on your Mac and sync to the iPad, as well as Favorites, Tags, Events, Apps, and Faces. So albums like Camera Roll and photo streams are off limits.

■ AUTO-ENHANCING AND ROTATING

When viewing an individual photo, you have access to tools for auto-enhancing and rotating the picture (they're labeled back in Figure 13-7). You'll learn about more advanced editing in Chapter 14, but these handy tools are as easy as editing could possibly get. Here's what each one does:

- **Auto-Enhance.** When you tap this magical, do-it-all icon, iPhoto analyzes the relative brightness and color saturation of all the pixels in your photo and attempts to "balance" it by adjusting the brightness and contrast, and intensifying dull or grayish-looking areas. It also tries to eradicate any red-eye that it finds. Usually, the pictures look richer and more vivid as a result. You may find that Auto-Enhance has little effect on some photos, only minimally improves others, and *totally* rescues a few. In any case, if you don't care for the result, tap the Undo icon. (For more on using the Auto-Enhance adjustment, see page 124.)

- **Rotate.** To rotate your photo 90 degrees, tap this icon. Keep tapping it to rotate the picture in 90-degree increments.

> **TIP** You can rotate photo in *smaller* increments in Crop mode (page 346). This trick is helpful when you need to straighten a crooked horizon, for example.

■ FLAGGING, "FAVORITING," AND TAGGING PHOTOS

When you mark photos by adding flags to them, designating them as favorites, or adding tags to them, iPhoto groups them into albums so you can easily find them in Albums view (page 328).

You can use these markers to mean *anything* you want. For example, you might flag photos that you want to delete (flags are discussed in depth on page 73), and you might "favorite" photos that you want to add to a web journal (page 383) or a Facebook album (page 367). (Favorites are an iPhoto for iOS–only feature; you can't designate favorites in iPhoto for Mac.) Either way, Figure 13-11 shows you how to get the job done.

> **TIP** If you tap and *hold* the flag icon, you see a menu with these options: Flag All, Unflag All, Last 24 Hours, Last 7 Days, or Multiple. The first two flag or unflag all the photos in the current album. Choose Last 24 Hours or Last 7 Days to flag only those photos you've taken or imported within those time periods within that album. Or tap Multiple and then use the thumbnail grid on the left to pick all the photos you want to flag. When you tap Done, iPhoto flags all the thumbnails you selected.

Tagging, on the other hand, is a way to add *keywords* to your pictures in iPhoto for iOS (for more on keywords, see page 80). Oddly, any keywords you've applied in iPhoto on your Mac *don't* transfer over to your iPad.

To add a custom tag to a photo, tap the tag icon beneath it and then tap Enter New Tag (see Figure 13-12). When the keyboard appears, type away; tap Done when you're finished to see the white tag appear on the photo's thumbnail. You can add as many tags as you want to your photos; each tag gets its own album in the Tags category of Albums view.

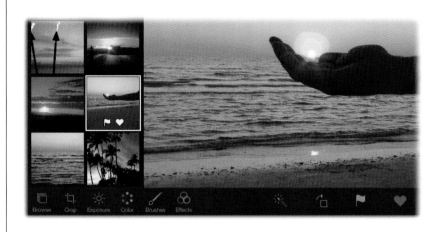

FIGURE 13-11

To flag or "favorite" a photo (or both), tap the flag or heart icon beneath it. When you add a flag, the icon turns orange; when you designate a favorite, the heart icon turns red. You'll also see a white flag and/or white heart appear on the photo in the thumbnail grid.

To unflag or unfavorite a photo, just tap the appropriate icon again.

To remove a tag from a photo, tap the tag icon, and then tap the tag's name.

> **TIP** You can create a *default tag,* which iPhoto applies as soon as you tap the tag icon, saving you from having to tap *again* to select a tag in the list. To set a default tag, tap the tag icon, enter the tag's name, and then tap Done; next, tap the right side of the Tags pane, next to the tag's name. When you do, a little tag outline appears, indicating that it's now the default (this icon is circled in Figure 13-12, left). iPhoto lets you assign only one default tag, but you can change it anytime you want.

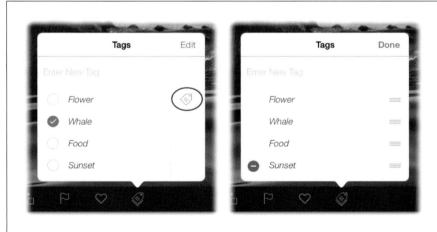

FIGURE 13-12

Left: Once you've entered some tags, iPhoto lists them in the Tags pane. To apply a previously entered tag, tap it and a blue checkmark appears next to it.

Right: Tapping Edit summons this pane where you can tap a tag to select it; tap the red circle that appears to delete it (you can delete only tags that aren't applied to any photos). Drag the horizontal lines to the tag's right up or down to reposition the tag in the list.

■ ADDING CAPTIONS

You may have noticed the Add Caption text lurking at the top of your screen when you're viewing a photo. This lets you add text that appears on the photo whenever you use it in projects like a photo book (page 401), a web journal (page 383), or a slideshow (page 397).

To add a caption, tap the thumbnail you want to add a caption to, and then tap Add Caption. Type some text, and then tap Done. To edit or delete a caption, tap it, and then use your iPad's keyboard to change or get rid of it.

> **NOTE** To add a caption in iPhoto on an iPhone or iPod Touch, tap the ❶ to open the photo's Info pane, and then tap Add Caption.

■ DELETING AND HIDING PHOTOS

iPhoto for iOS is pretty persnickety about which photos you can delete. For example, you can't delete photos in any albums that you synced using iTunes, nor photos in an iCloud photo stream.

Basically, you can delete only what's in your *Camera Roll* album. To do that, tap the photo's thumbnail; then tap the Options icon at the bottom right of your screen (it looks like three dots). Choose Delete Photo.

However, you can delete pictures and videos from the *Photos* app on your iPad (even ones that are in iCloud photo streams). When you do that, the pictures are deleted from iPhoto, too—*if* you haven't edited the photo, captioned it, tagged it as a favorite, or used it in a web journal (page 383) or a slideshow (page 397). If you've used or altered the photos in any of those ways, they disappear from the Photos app but not from iPhoto.

There's another option, too: If you don't want to *see* a photo but you don't want to—or can't—delete it, you can always *hide* it. In iPhoto, tap the photo's thumbnail, tap the Options icon, and then tap Hide Photo; a tiny white X appears on the photo's thumbnail. The photo is now hidden in iPhoto but remains visible in your Photos app. To unhide the photo, tap the Options icon again in iPhoto, and then tap Unhide Photo.

Filtering Photos

As you flag photos, the label at the top of iPhoto's thumbnail grid changes to show you how many photos you've flagged (see Figure 13-13, left). For example, if you're viewing an album of 138 pictures and you've flagged 3, the label reads "138 Photos (3 [flag])." (Oddly, this label doesn't keep track of photos you've favorited or hidden.)

But that's not all. If you tap this label, you reveal a Filter pane that lets you see only the photos that you've messed with, as Figure 13-13 explains. The same pane also lets you change the sort order of your pictures. From the factory, thumbnails are shown in chronological order, oldest first. Tap Newest First, and you reverse that order.

When you first open the Filter pane, it's set to Simple, which lets you tap criteria that iPhoto uses to determine which pictures to display. By clicking Advanced, you

get even more options: Tap a green circle to include photos with that particular feature, and tap inside a red circle to exclude them. Tap Any to have iPhoto show you pictures that match *any* of the criteria you set; tap All to have iPhoto show you only those photos that match *all* of the criteria you've picked.

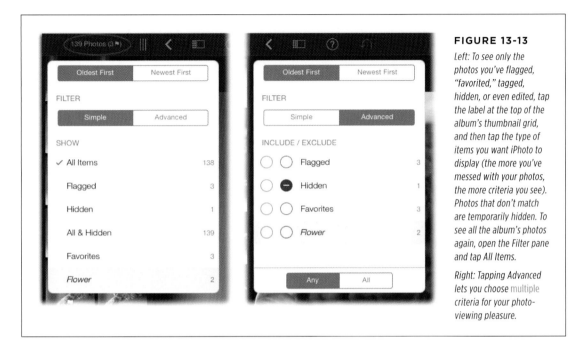

FIGURE 13-13

Left: To see only the photos you've flagged, "favorited," tagged, hidden, or even edited, tap the label at the top of the album's thumbnail grid, and then tap the type of items you want iPhoto to display (the more you've messed with your photos, the more criteria you see). Photos that don't match are temporarily hidden. To see all the album's photos again, open the Filter pane and tap All Items.

Right: Tapping Advanced lets you choose multiple criteria for your photo-viewing pleasure.

Viewing and Selecting Multiple Photos

iPhoto gives you some pretty slick ways to compare shots. In addition to seeing a before-and-after versions once you've edited a photo, you can view multiple photos, and even have iPhoto fetch similar photos from the album you're viewing and display them automatically. This section explains how.

Viewing and Selecting Similar Photos

To have iPhoto sift through the album you're viewing and find all the similar shots, just double-tap a thumbnail in the grid. If iPhoto finds similar shots—and they have to be nearly identical for this to work—iPhoto selects them in the thumbnail grid and shows them to you side by side in the viewing area (see Figure 13-14).

Viewing and Selecting a Range of Photos

To view multiple photos that are next to each other in the thumbnail grid, you'll need two fingers. Simultaneously tap the first and last thumbnails in the range you want to see; iPhoto displays the selected pictures (as well as all the ones in between) in the viewing area.

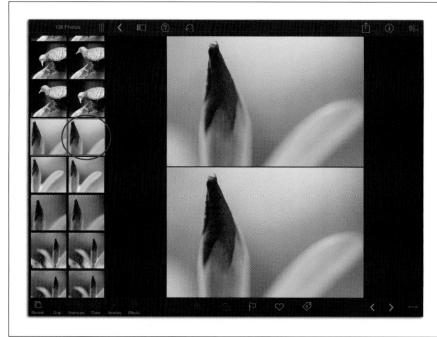

FIGURE 13-14

If iPhoto can locate similar shots, they appear in the viewing area. Your photos have to be incredibly similar for this to work. For example, if you double-tap the thumbnail circled here, iPhoto displays just one similar photo (even though there are several shots of this flower in this album).

If iPhoto finds a match, and you've got your iPad's sound turned on, you hear a chirping xylophone sound. If it can't find any similar pictures, you hear a single chirp instead, and iPhoto displays only the photo you double-tapped.

To view multiple photos that *aren't* next to each other in the thumbnail grid, tap one photo and then tap and hold each additional photo. You can also drag a photo from the thumbnail grid into the viewing area.

To deselect a photo, swipe down across it in the viewing area, or tap and hold its thumbnail in the grid.

> **TIP** You can also use the Options menu to choose which photos to view. Tap the three dots at the lower-right corner of your screen, choose Multiple Photos, and then tap the thumbnails of each picture you want to see.

Viewing Photos as a Slideshow

iPhoto can display your pictures as an auto-advancing slideshow. While creating a slideshow is technically creating a *project,* which is covered in Chapter 15 (page 397), this section covers the down-and-dirty version because it's so simple and useful.

Start by opening an album or an Event. Tap the ⬆ at the top right of your screen. In the resulting pane's "Create a Project" category, tap Slideshow (Figure 13-15, left). The pane changes to let you pick the photos you want to see. If you've already selected some photos using the technique described in the previous section, tap Selected.

To see a slideshow of the photos you've flagged (page 334), tap Flagged. To have iPhoto include *all* the album's photos in the slideshow, tap All. To pick certain photos, tap Choose Photos, and then tap the thumbnails of the ones you want to see (you can include up to 200); when you're finished, tap Next.

Another pane appears containing themes (Figure 13-15, right); just tap one to choose it. If you want to hear music with the show, turn on the Play Music switch, and then tap the Music entry that appears beneath it to pick your tune. Adjust the Slideshow Speed slider to specify how long each photo stays onscreen; drag it left to make photos linger longer or right to make them speed by.

Tap Create Slideshow; iPhoto assembles the show (you see a status bar). When it's finished, tap Show and then tap the ▶ at the top of your screen. (Tapping Done instead saves the slideshow to your Projects view so you can see it later).

NOTE If your phone or tablet goes to sleep while transmitting your slideshow to a TV using AirPlay (see the box on page 328), the TV stops playing the show. The solution is to plug your iOS device into a power source for the duration of the slideshow.

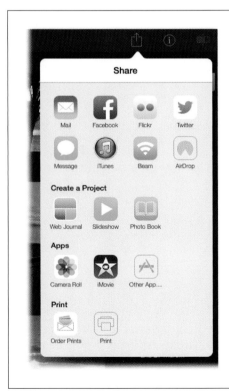

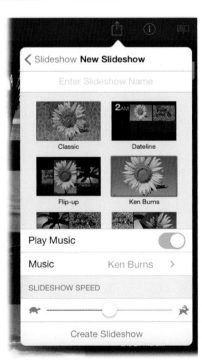

FIGURE 13-15

Left: Once you've selected some photos, tap ⬆ and then tap Slideshow.

Right: You've got nearly all the same slideshow themes in iPhoto on your iPad that you do in iPhoto on your Mac (page 153). You'll learn more about creating and playing slideshows in Chapter 15, so consider this a teaser.

Editing Photos on the iPad

A s you learned in Chapter 5, iPhoto lets you edit your photos in myriad ways. You also know that you can undo your edits anytime to get back to your original shot. Happily, editing on your iPad works the exact same way. Interestingly, you can actually do *more* editing in iPhoto for iOS than you can with iPhoto for Mac.

For example, the edits you make using iPhoto on your Mac affect the entire photo. There's no way to tell the program, "Hey, I want you to make this edit only in this one area." It's a different story in iPhoto on your iPad, where its *brushes* let you paint edits onto your photo in the areas where you want them. This feature is incredibly useful when you need to lighten, darken, or even sharpen certain spots of a photo. You'll learn all about iPhoto's brushes on page 352.

You also have access to far more effects in iPhoto on your iPad than you do on your Mac. As of this writing, there are nine different effect categories, each containing at least seven fun photo treatments. Coverage of these goodies starts on page 357.

Once you start editing images on your iPad, it's important to understand how iPhoto for iOS handles *syncing* those edited photos. You'd think it'd be an easy, two-way syncing process, but it's not. As you'll learn in the box on page 346, getting the edited versions onto your computer takes some doing (and in the process, your edits become permanent).

You've already learned how to do a *little* editing on your iPad by using the Auto-Enhance and Rotate tools (page 334). This chapter teaches you how to do everything else.

Editing Basics

To edit a photo, tap its thumbnail to open it. (To get to your thumbnails, you have to be in Photos or Albums view [page 327]).

Once you open a photo, a row of editing tools appears at the bottom of your screen (Figure 14-1). Tap a tool to see its settings appear to its right.

> **NOTE** The screen on your iPhone or iPod Touch is too small to display all of these editing tools. Instead, you see a white toolbox icon; tap it to make the editing tools appear. When you're finished editing, tap the Browse icon at the lower left.

Photo has been edited Undo/Redo Show Original

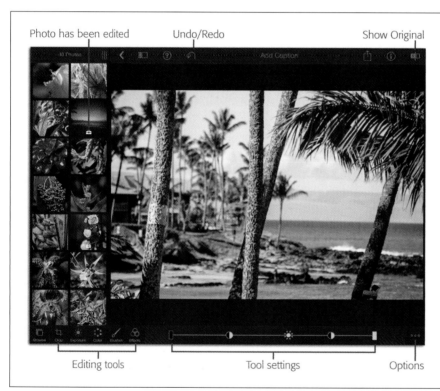

Editing tools Tool settings Options

FIGURE 14-1

To edit a picture, open it to display the editing tools labeled here. Tap any editing tool to make its settings appear to its right. This screenshot shows the Exposure tool's settings (a brightness bar), but the settings vary from tool to tool. To put the tool away and bring back the Auto-Enhance, Rotate, Flag, Favorite, and Tag icons you learned about in the last chapter, tap the tool's icon again.

When you edit a picture, a white toolbox icon appears on its thumbnail (two are visible here).

As Figure 14-1 explains, once you edit a photo, a tiny white toolbox appears on its thumbnail to indicate that it's been messed with. In addition, the Show Original icon at the top right of your screen lights up. Tap it once to see your original photo in all its pre-edited glory, and tap it again to see the edited version (you can do this dance as many times as you want). This is a fantastic way to see if the edits you're making are having enough of an effect on the photo.

Before you dive in and start tweaking images, it's helpful to know a few techniques that can save your bacon if you make a mistake. The following sections teach you

how to undo your edits and revert to the original version of a photo. You'll also discover how to copy and paste edits from one picture to another, how to sync edited photos, and how iPhoto handles raw files.

TIP On an iOS device, any editing tool you use automatically deactivates itself when you tap another thumbnail. To keep the same tool active when you open another photo, head to iPhoto's main screen (the one with Photos, Albums, and Projects listed at the bottom) and tap the Options icon (the three dots). In the resulting menu, turn on Keep Edit Tool Enabled.

Undoing Edits

iPhoto on your iPad saves your edits automatically, but you can always back out of them. Here are your choices:

- **Undo/Redo.** iPhoto keeps track of all the edits you make while a photo is open; you can think of this as the photo's *temporary* editing history. Once you make an edit, you can tap the Undo/Redo icon labeled in Figure 14-1 to undo what you've just done. Keep tapping the button to undo as many edits as you want; there's no limit. If you change your mind after undoing an edit, you can *redo* it by tapping the same icon again and then choosing "Redo [tool name]."

 However, once you *close* the photo (by tapping another thumbnail or returning to iPhoto's main screen), iPhoto resets the photo's history. You lose the ability to back out of your edits one by one.

NOTE On an iPhone or iPod Touch, you don't get an Undo/Redo button (there's only so much room on those tiny screens). To undo the last thing you did, *shake* your device and then tap Undo (or Cancel).

- **Reset/Erase.** Depending on the editing tool you used, the Options menu gives you the chance to either reset or erase individual edits whenever you want (even after you close the photo). For example, if you've used the Exposure tool, you can tap that tool to reactivate it (if it isn't still active), tap the Options icon at the bottom right of your screen, and then tap Reset Exposure. Likewise, if you've used the Brushes tool, you can get rid of some of your brushstrokes (say, by tapping "Erase [Sharpen] Strokes"), or you can zap them all by tapping Erase All Strokes. If you've applied an Effect, you can tap Remove Effect. (The choices don't appear in the menu until an editing tool is selected.)

NOTE On an iPhone or iPod Touch, the Options icon lives at the *top right* of your screen. Depending on the editing tool you use, you get the choice to reset, remove, or erase all.

- **Revert to original.** You can also undo *all* the edits you've made to a photo, anytime you want, by reverting to the original version. With a photo open and *without* any editing tools active (just tap Browse to deselect any tool), tap the Options icon, and then tap Revert at the top of the resulting menu. To make this

life-saving command easier to spot, Apple made it red. (The Revert command is visible at the bottom of Figure 14-2, though it's grayed out because no edits had been made to that photo.) Once you revert to the original version of a photo, iPhoto removes the image from the Edited album (page 328).

As the box on page 346 explains, edits made in iPhoto on your iPad become permanent in the version of the photo that you transfer to your computer by either plugging the device into your Mac and importing the photos into iPhoto or by using iTunes file sharing. That said, you can always get back to the original photo in iPhoto on your iPad.

Editing Raw and Full-Sized Photos

While iPhoto is happy to let you start with a raw file (page 19), that's not what you end up with once you edit it. You get a downsized JPEG instead.

When you import a raw file onto your iPad (page 320) and then edit the file in iPhoto, you're actually viewing and editing a JPEG version of the file that's *embedded* in the raw file, just like you do in iPhoto for Mac (page 148). The same thing happens if you shoot raw + JPEG, wherein your camera captures one file of each format when you snap a shot—iPhoto uses the JPEG. Why? Because a raw file is like a film negative that iPhoto has to convert to JPEG format for displaying, editing, and exporting.

> **TIP** You can transfer *unedited* raw files from your iPad to your computer using iTunes' file-sharing feature. Flip ahead to page 323 for the details.

UP TO SPEED

Copying and Pasting Edits

iPhoto lets you copy some or all of the edits you make to one photo to *other* photos. If you have several photos from the same shoot that were shot under similar lighting conditions, this trick can be quite the timesaver.

One helpful hint: Before you get started, flag (page 334) all the photos that you want to be edited in a similar way. Next, open the Flagged album (page 329), edit one of the photos, and then copy your edits using the techniques described here. Finally, use the Options menu to select the rest of the photos in the Flagged album and then paste the edits en masse.

Here are your edit-pasting options:

- **Copy/paste individual edits.** To copy a change you've made using the Exposure, Color, or Effects tools, make sure that particular tool is active (if it isn't, tap it), and then tap the Options icon. In the resulting menu, tap

"Copy [tool name]" (see Figure 14-2, top). Then use the techniques you learned on page 337 to select thumbnails of the other photos you want to apply the change to, tap the Options icon again, and then tap "Paste [tool name]."

- **Copy/paste multiple edits.** If you've used the Exposure, Color, and/or Effect tool on a photo, you can copy all of those edits at once. Start by selecting the photo with the settings you want to copy, make sure no editing tool is active, and then tap the Options icon and choose "Copy Exposure, Color and Effect." Next, select the photos you want to apply the edits to (page 337), and then tap the Options icon again and choose "Paste Exposure, Color and Effect" (Figure 14-2, bottom). iPhoto makes the changes and automatically adds the previously unedited photo(s) to the Edited album.

FIGURE 14-2

Top: You can use the Options menu to copy individual edits made with a particular tool while that tool is active (the Exposure tool is active here).

Bottom: To copy or paste multiple edits, select a photo and then tap Browse at the bottom left to deactivate all the editing tools. Then tap Options, and the menu that appears lets you copy or paste changes made with the Exposure, Color, or Effects tools. (iPhoto doesn't let you copy or paste changes made with the Crop or Brushes tools.)

When you edit a full-size JPEG derived from a raw file, your iPad automatically saves a downsized version of the picture back to your iPad's Camera Roll. (Apple knows you've got less space on your iOS device than you do on your computer, so it tries to optimize photos for your device's screen size.)

To save a *full-sized* version of the edited JPEG derived from a raw file, you have to save it to your device's Camera Roll manually. Just tap the ⬆ near the top right of your screen and, in the resulting menu, tap Camera Roll. After you do that, the next time you plug your device into your Mac, a full-sized version of the file will get transferred to your computer. Be aware that photos in the Camera Roll are sorted chronologically by the date they were taken, which means you'll have to do some scrolling to locate the edited version.

Incidentally, this maneuver is just the ticket for saving different *versions* of pictures you edit in iPhoto. For example, if you're trying to decide between creative effects—say, black-and-white, sepia, or duotone—saving each version to your Camera Roll produces multiple copies so you can keep them all.

NOTE Saving to your Camera Roll also lets you share edited photos *outside* of iPhoto, to programs such as the incredibly popular Instagram.

▉ Cropping and Straightening

Cropping means shaving off unnecessary portions of a photo. Usually, you crop an image to improve its composition—adjusting where the subject appears within the frame of the picture. Often, a photo has more impact if it's cropped tightly around the subject, especially in portraits. Or maybe you want to crop out wasted space, like big expanses of sky. You can even chop a former romantic interest out of an otherwise perfect family portrait. Cropping is also very useful if your photo needs to have a certain *aspect ratio* (length-to-width proportion), like 8 × 10 or 5 × 7 inches.

To crop a photo, open it and then tap Crop; a white border surrounds your photo (Figure 14-3, top). You can then either crop the photo using a size preset or manually using gestures:

- **Crop with presets.** If you tap the Options icon, you get a choice of 12 canned proportions: 3 × 2, 4 × 3, 1 × 1, 16 × 9, 8 × 10, and so on (Figure 14-3, top). These options limit the cropping frame to preset proportions, which is important if you plan to order prints of photos that you've taken with an iOS device.

Copying Edited Photos to Your Computer

Alas, editing photos in iPhoto on your iPad isn't all happiness and light; there's a bit of darkness lurking in the shadows (cue scary music). Why? Because photos you edit on your iPad *aren't* automatically synced into iPhoto on your Mac. In other words, there's no two-way syncing for edited shots; the two versions of iPhoto are completely independent in this regard.

Should you care? It depends. If you edit photos on your iPad *and* use your iPad to share and print them, then probably not (though it's certainly helpful to understand how the program works). But if you want to transfer the edited versions onto your computer so you can keep a master copy and/or include them in other print projects, then *yes.* In that case, keep reading.

There are three fixes to this conundrum:

- **Save the edited files to your Camera Roll (page 374).** The full-size files are available for importing into iPhoto (or Aperture) the next time you plug your iPad into your Mac, plus they automatically appear in your iCloud photo stream (available on your Mac). That said, in iPhoto for Mac, you can't tweak the edits you make in iPhoto on

your iPad (though you can always fire up iPhoto on your iPad and make or undo changes there). Not surprisingly, if you edit a file in iPhoto's Camera Roll album, the app saves your changes to the Camera Roll automatically. Just remember that photos in the Camera Roll album are sorted chronologically by the date they were taken, so you'll have to do some scrolling to find the edited version.

- **Use iTunes file sharing (page 323).** This method transfers a full-size version of your picture into iTunes on your Mac the next time you do an iTunes sync. After that, you can save the pictures anywhere on your hard drive. As with the previous method, any edits you've made in iPhoto on your iPad aren't changeable on your Mac.

- **Set up a shared photo stream (page 373).** If you've got an iCloud account (page 12), you can create a shared photo stream for transferring edited photos to your computer. However, this method transfers a *downsized* version of the photo and, again, your edits become permanent. If you're not planning to print the photo from your computer, then this is no big deal.

For example, prints come only in standard sizes like 4 × 6, 5 × 7, 8 × 10, and so on. But unless you crop them, the iPad's photos are all 4 × 3 (iPhone photos are 3 × 2), which doesn't divide evenly into most standard print sizes. Limiting your cropping to one of these standard sizes guarantees that your cropped photos will fit perfectly into Kodak prints. (If you don't constrain your cropping this way, then Kodak—not you—will decide how to crop them to fit.)

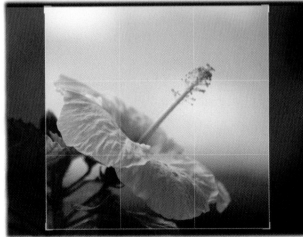

FIGURE 14-3

Top: To crop your photo using a preset, tap the Options icon, and then tap the size you want (swipe leftward to see more sizes). Tapping the padlock icon circled here constrains a photo's aspect ratio when you drag the crop box's corners.

Bottom: Once you've drawn a crop box, either manually or by picking a preset, you can use the pinch and spread gestures (page 330) to zoom in or out of the photo.

- **Crop manually.** Using your finger, drag inward on any edge or corner; a tic-tac-toe grid appears on your photo (Figure 14-3, bottom), just in case you want to crop according to the Rule of Thirds (see *http://tinyurl.com/yw3dvm*). You can drag the cropping rectangle into any size and proportions. When you remove your finger from the screen, the part of the photo *outside* the crop box disappears. You can recenter the photo within the crop box by dragging any part of the photo, inside or outside the box (at which point you see the photo's original edges, though they're dimmed).

Straightening, on the other hand, lets you fix crooked objects (or a horizon) if your camera was tilted when you took the shot. See the big dial that appears at the bottom of your screen when the Crop tool is active? You can drag this dial to straighten your photos manually. You can also straighten or fine-tune the rotation of a picture by placing two fingers on the screen and *twisting* them.

TIP Another way to straighten a photo is by using your iOS device's built-in gyroscope. Tap the dial at the bottom of your screen with your finger; a grid appears on your photo. Tilt your iPad, iPhone, or iPod Touch to make the photo rotate. When you get it just right, tap the dial again (or anywhere on your screen).

iPhoto can also straighten a photo automatically, as Figure 14-4 explains.

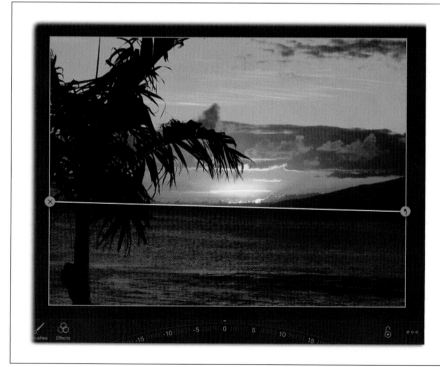

FIGURE 14-4

If iPhoto finds a horizon in your photo, it displays a line on top of it, as shown here. To have iPhoto straighten the photo automatically, tap the curved arrow at the right end of the line. To delete the line, tap the X on the left end instead.

Of course, you can always use the Rotate tool to flip a photo 90 degrees: Just tap the Browse icon at the bottom left of your screen; the tool's icon appears beneath the photo.

To uncrop or unstraighten a photo, tap the Options icon; in the resulting menu, tap Reset Crop & Straighten. If you used the Rotate tool, keep tapping the tool's icon until your photo is back the way you want it, or tap Revert to restore your original.

Adjusting Exposure and Contrast

As you learned back in Chapter 5, iPhoto on the Mac lets you change your photo's exposure and contrast, as well as darken or lighten its shadows and highlights. You can do the same things in iPhoto on your iPad, but the controls are a lot more fun.

NOTE To lighten or darken only certain parts of your photo (rather than the whole thing), use iPhoto's Brushes. Page 352 has the details.

To tweak exposure and contrast, open a photo and tap Exposure. A blue slider with five icons appears beneath your photo. You can adjust the exposure and contrast in two ways:

- **Using the slider.** The five icons perched atop the blue slider (they're labeled in Figure 14-5) are *draggable.* Here's how to use them:

 - Drag the Brightness icon left to darken your photo or right to lighten it.

 - Dragging the Shadows icon leftward darkens just the shadows; dragging it rightward lightens them. If you drag the icon leftward into the striped area, that area in the slider temporarily turns red to indicate that you're forcing some shadow pixels to pure black (so they lose detail).

 - Likewise, dragging the Highlights icon left darkens just the highlights and dragging right lightens them. If you drag this icon rightward into the striped area, it turns red, warning you that some highlight pixels are being forced to pure white (and getting stripped of detail).

 - Drag one of the Contrast icons leftward to decrease overall photo contrast, or drag it rightward to increase it (it doesn't matter which one you drag; moving one moves them both).

- **Using on-image gesturing.** Instead of using the slider, you can drag up, down, left or right atop your photo, as Figure 14-5 explains.

To undo exposure and contrast changes, tap the Options icon and choose Reset Exposure.

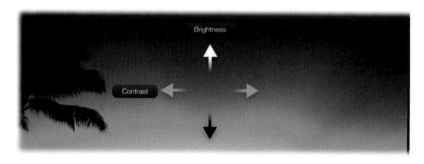

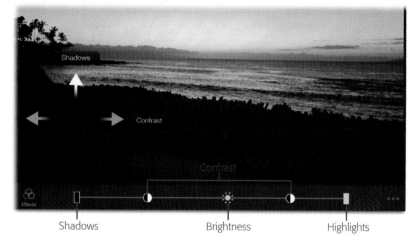

FIGURE 14-5

Top: Tap and hold a spot in your photo to reveal iPhoto's on-image controls. If you tap an area that contains mostly midtones (pixels whose brightness is midway between shadows and highlights), you see the brightness and contrast controls. Drag up to brighten the overall image or down to darken it; drag left to decrease contrast or right to increase it.

Bottom: Tap an area in the shadows, and you get the shadows and contrast controls instead: Drag up to brighten the shadows or down to darken them. To adjust the shadows' contrast, drag left to decrease it or right to increase it.

Tap a bright area of your photo and the up/down controls are labeled Highlights instead.

Adjusting Color

You can use iPhoto's Color tool to tweak a photo's overall saturation (page 140), the intensity of just the blues or just the greens in the photo, as well as the photo's overall color temperature (page 143) from cool to warm. This same tool also lets you change the photo's white balance (page 143) and, as Figure 14-6 describes, that's the best edit to start with.

As with the Exposure tool, you can also change the colors in your photo by tapping and holding your photo, and then using on-image gesturing (see Figure 14-6, bottom).

> **TIP** If you've got people in your picture, you can have iPhoto preserve their skin tones when you're using the Color tool. To do that, tap the Options icon and tap the Preserve Skin Tones slider (the slider turns green to let you know the feature is turned on).

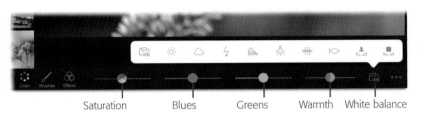

FIGURE 14-6

Top: A white balance adjustment can perfect your photo's colors, so tap the camera icon and try these various settings. If the photo still needs some color help, use the sliders labeled here to adjust the saturation, intensity of blues or greens, or overall temperature. Drag the Warmth slider left to cool the photo or right to warm it.

Bottom: Alternatively, tap and hold the image to reveal these controls. Drag up to increase saturation or down to decrease it; drag left to cool the photo or right to warm it.

Changing White Balance

As mentioned above, you can change a photo's white balance using the presets shown in Figure 14-6 (top); just tap one to apply it. Here's what the icons mean from left to right: original (what your camera was set to), sun, cloudy, flash, shade, incandescent (think old-fashioned light bulbs), fluorescent, and underwater.

The last two icons aren't actually presets at all. Instead, they let you change the white balance *manually* by dragging a magnification loupe atop your photo. Tap the second-to-last icon (which represents "custom white balance based on skin tone") and then drag the loupe atop a person's face or other area of skin. Alternatively, tap the last icon ("custom white balance") and then drag the loupe to an area of your photo that should be white or neutral gray, as shown in Figure 14-7.

> **TIP** Once you change the white balance of your photo, you can fine-tune it using the Warmth slider.

To undo all the changes you've made with the Color tool, tap the Options icon and choose Reset Color.

FIGURE 14-7

When setting the white balance manually, drag the magnification loupe to an area of your photo that's midway between black and white, for a nice neutral gray. In this photo, that's somewhere on the bird's (now comically big) beak.

Using Brushes

Congratulations—you've finally made it to the section on digital finger-painting!

Most of the editing you've accomplished in your iPhoto career affects a *whole* photo. But with iPhoto for iPad's *Brushes* tool, you can use on-image gesturing to affect a photo in just the areas that need it.

All eight of iPhoto's brushes work the same way: Open a photo, tap Brushes, and then choose the brush you want to use (Figure 14-8). Then use your finger to paint the change onto the area that needs it. To switch to a *different* brush, tap the name of the current brush at the bottom of your screen, and then tap a new one.

TIP The size of the area affected by your brushstrokes is directly proportional to your photo's zoom level. For example, to adjust fine details (like eyes), zoom way into the photo using the spread gesture (page 330). (Once you've zoomed in, use *two fingers* to reposition the photo; using one finger applies brushstrokes.) To adjust larger areas (like a background), zoom out using the pinch gesture (page 330).

Here's what each brush does:

- **Repair.** This brush is great for removing blemishes, spots caused by specks of dust on your camera's sensor, or small objects. Painting with this brush copies nearby pixels onto the area you're fixing and blends them together to make the change look realistic. Alas, you can't use this brush to remove a whole person from your picture; that's a job for Photoshop or Photoshop Elements.

- **Red-Eye.** As you might suspect, painting with this brush removes the creepy, possessed look sometimes introduced by your camera's flash (page 126). When you swipe with this brush, a message says, "Tap each red-eye." If you do that, iPhoto turns the red in each eye black. (If iPhoto can't find any red eye to fix, the brush shakes, and you hear a menacing sound.)

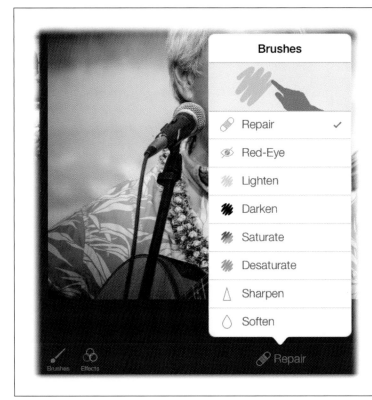

FIGURE 14-8

The Brushes tool is unique to iPhoto for iOS. It lets you paint changes onto your photo using the tip of your finger.

This, dear friends, is where iPhoto on the iPad gets fun.

> **TIP** The Auto-Enhance tool (page 334) also tries to get rid of red eye.

- **Lighten.** Use this brush to lighten an area that's in shadow (if your camera's flash didn't fire, say). You can also use it to lighten teeth (Figure 14-9) or each iris of your subject's eyes.

- **Darken.** This brush darkens areas that are too light. It's great for recovering details in overexposed skies.

- **Saturate.** Painting with this brush intensifies colors. You might use this tool to accentuate a colorful flower.

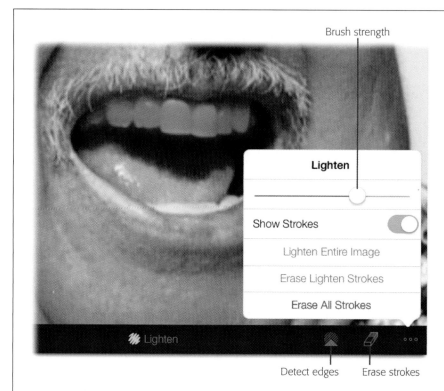

Brush strength

FIGURE 14-9

You can use the Lighten brush to whiten your subject's teeth. Tap the Options icon and then turn on Show Strokes to see a red overlay where you've painted (visible here). Turn on Detect Edges and iPhoto tries to confine your strokes to areas of similar color and brightness (more on this setting on page 355).

When you're finished painting, turn off Show Strokes so you can see your handiwork, and then use the strength slider labeled here to fine-tune the opacity of your edits (drag left to reduce their strength, or drag right to increase it).

Detect edges Erase strokes

- **Desaturate.** You can use this brush to reduce the intensity of color in an area or, if you keep painting over the same area, remove color entirely. With a little patience, you can use the brush to create the partial-color effect shown in Figure 14-10.

- **Sharpen.** If there are details in your photo that you want to exaggerate—such as eyes, lips, and hair in a portrait, a flower's petals, or an animal's fur—use this brush. If you want to sharpen the entire photo, don't waste your time painting the whole image. Instead, activate this brush and then tap the Options icon. In the resulting menu, tap Sharpen Entire Image and call it done (see Figure 14-11).

- **Soften.** This brush lets you soften an area by blurring it. It's handy when you've got a distracting background. However, it's *really* easy to go too far with this brush, so use it sparingly or you'll turn your pictures into pixel pudding.

Thankfully, iPhoto understands how difficult it can be to finger-paint changes onto a photo. Once you've activated the Brushes tool, you'll spot two *more* tools at the bottom of your screen (they're labeled back in Figure 14-9):

- **Detect Edges.** Give this icon a tap to make iPhoto try its best to apply your brushstrokes to areas that are similar to the ones you drag across in terms of color and brightness values. Turn on this setting when you've got decent contrast between the object you're painting and its background. It's particularly helpful when you're lightening teeth or eyes, desaturating the background of a photo to create a partial-color effect, and so on.

FIGURE 14-10

To create a partial-color effect, grab the Desaturate brush, open the Options menu, and then tap Desaturate Entire Image. Next, tap the Eraser (it's blue here) and brush across the area that you want to remain in color. If necessary, use the Undo button at the top of your screen to undo strokes and fix mistakes (undoing strokes using the Options menu forces you to start over).

This technique takes practice, but the results are worth it.

- **Erase Brush Strokes.** This tool lets you erase brushstrokes by dragging across them. It's helpful when you've painted outside the lines, so to speak. (And how do you know that you've painted outside the lines? By opening the Options menu and turning on Show Strokes.)

> **TIP** While it's true that you can have hours of fun brushing with your fingers, if you want to edit your pictures precisely, you'll get better results using a stylus (a pen-sized, artistic brush with a special tip designed to work on touchscreens). A couple of good ones include the Sensu (*www.sensubrush.com;* $39) and the Bamboo Stylus (*www.wacom.com;* $30).

Brush Options

Whenever the Brushes tool is active, you get some incredibly useful commands in the Options menu, which are ripe for the tapping. Here are your choices:

- **Strength.** Depending on which brush you're using, you either get a strength slider (for the Lighten, Darken, Saturate, and Desaturate brushes), as shown in Figure 14-9, or Low, Medium, and High buttons (for the Sharpen and Soften brushes), as shown in Figure 14-11.

NOTE The Repair and Red-Eye brushes give you the fewest options of all. Basically, you can either delete the most recent strokes you made by tapping "Clear [brush] Strokes" or Erase All Strokes. Period.

- **Show Strokes.** Turn on this setting to see your brushstrokes as a red overlay. It's incredibly helpful to toggle this switch on and off while you're using a brush, *especially* if you're doing detail work and trying to be precise.

- **[Brush] Entire Image.** Technically, this command defeats the purpose of using iPhoto's brushes, as it applies the change to the whole image. However, it's perfect for use with the *Sharpen* brush because it keeps you from spending an hour trying to paint across your entire photo in order to sharpen the whole darn thing.

- **Erase [brush] Strokes.** Tap this option to turn your brush into an effect-*removal* brush. Now when you "paint" with your finger, you *erase* the previous effect of your brushing.

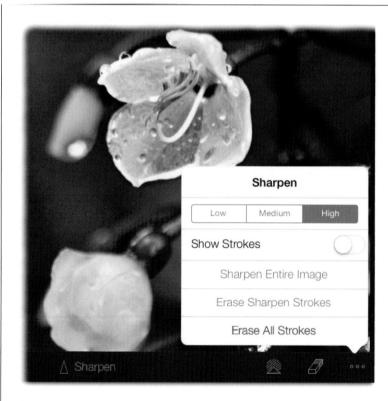

FIGURE 14-11

Different brushes give you different options. With the Sharpen brush active, the Options menu gives you the ability to specify Low, Medium, or High amounts of sharpening.

To sharpen the whole image, tap Sharpen Entire Image. Paint across an area for a little selective sharpening instead.

- **Erase All Strokes.** As you might suspect, this option deletes *all* the strokes you've made with that particular brush.

All in all, iPhoto's brushes work incredibly well, and you can use as many brushes on a photo as you want. However, it's worth noting that your brushstrokes might

be temporarily *hidden* while you're editing with other tools. If you're using the Crop tool, for example, iPhoto hides your brush handiwork until you're finished cropping.

Fun with Effects

As you learned back in Chapter 5, iPhoto's effects let you do things like adjust the lighting and colors in your pictures, and even tweak their borders. There are *far* more effects for you to experiment with in iPhoto for iOS than there are in iPhoto on your Mac. Consider it a bonus for plunking down the money for an iOS gadget.

Once you've opened a photo, tap Effects. You see the screen shown in Figure 14-12. Tap an effect thumbnail to apply it to your photo and then, *if* the effect can be customized, tap and drag on the photo to adjust the effect's settings. (The following list explains which effects are customizable.)

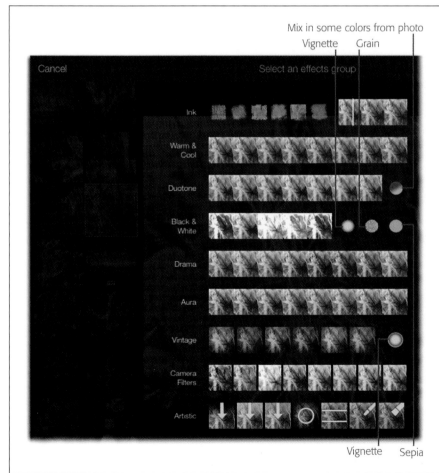

Mix in some colors from photo
Vignette Grain

Vignette Sepia

FIGURE 14-12

Tap the Effects tool to see this screen. Many of iPhoto's effects were inspired by Instagram, the incredibly popular photo-sharing app.

Some effects categories let you add a vignette (a soft, dark edge), grain (speckles that mimic film), or a sepia tone (a brown overlay).

TIP iPhoto lets you apply only one effect to a photo, but there's a workaround. Apply the first effect, tap ⬆, and then tap Camera Roll. Go to Albums view (page 327), tap the Camera Roll album, and then scroll to find the photo you just applied the effect to (thumbnails appear in chronological order according to their *shot* dates, not *edit* dates). Then you can tap Effects and add your *second* effect. This technique is handy when you want to, say, create a watercolor and then give it a painterly edge.

iPhoto's effects are divided into nine categories, with each one containing at least seven creative treatments that you can apply to your photos. Here's a sampling of what effects let you do:

- **Ink.** This category lets you add painterly edges to a photo, including crosshatch, diagonal, palette knife, splatter, chalk, and waterdrop edges. It also lets you adjust the saturation of the colors in your photo from any point between black and white and full color. After applying one of the effects in this category, touch and drag atop your photo to adjust texture and saturation, as Figure 14-13 explains.

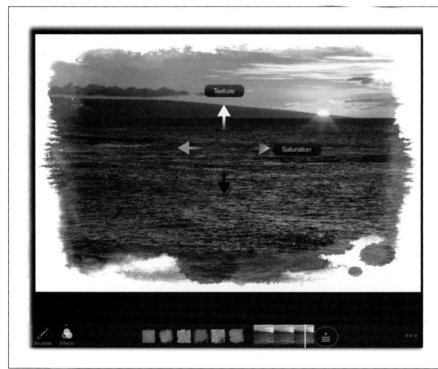

FIGURE 14-13

Tap and hold your finger atop your photo to display these controls, and then drag up to increase the texture, or down to decrease it. Drag left to desaturate the photo (remove color) or right to saturate it. Alternatively, you can drag the vertical white line on the thumbnails beneath your photo left to desaturate or right to saturate.

Once you've applied an effect, you can return to the effects screen shown in Figure 14-12 by tapping the icon that's circled here.

- **Warming & Cooling.** The effects in this category apply orange (warming) or blue (cooling) tones to your photo. The effects in this group are one-trick ponies and can't really be customized. However, once you tap a thumbnail to apply one of these effects, a white vertical line appears atop the thumbnails beneath the photo; drag it left for more warming or right for more cooling.

- **Duotone.** With these effects, iPhoto turns your image black and white and then tints the shadows with one color (a.k.a. tone) and your highlights with another (hence the name "duotone," for the two colors involved). Once you apply an effect in this category, tap the image and drag upward to increase the effect, or downward to decrease it. Figure 14-14 has more.

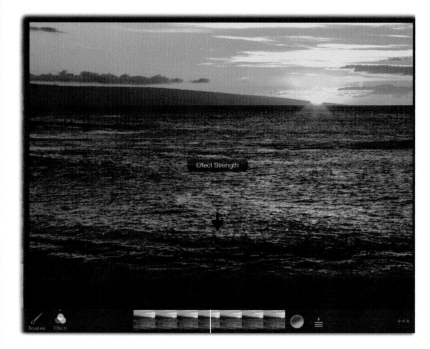

FIGURE 14-14

After applying a duotone effect, you can tap and hold your finger on the photo, and then drag up to increase the duotone's strength, or drag down to decrease it.

Below your photo, drag the white vertical line atop the thumbnails to introduce different color overlays. Or tap the colored circle below the image to mix in a little color from the original photo; this setting is turned on here, and the original color is visible near the sun.

- **Black & White.** You guessed it: The effects in this category convert a color photo to black and white. You can also add a soft, dark edge to your photos using the Vignette effect (which is also available in the Vintage and Artistic categories). Effects in this group are customizable by touching your photo and dragging left or right to adjust film tone, as shown in Figure 14-15. You can also drag up or down to adjust the picture's brightness. Below the photo, dragging the white vertical bar atop the thumbnails changes contrast.

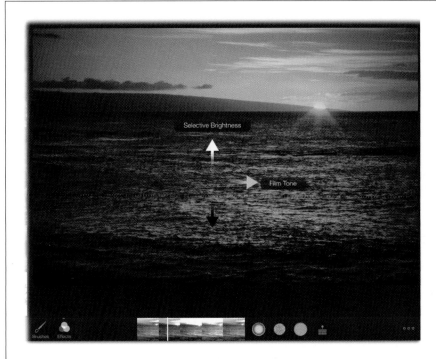

FIGURE 14-15

*Effects in the Black &
White category also let
you add a dark edge
vignette, introduce film
grain, or give the photo a
sepia (brown) tone.*

*The sepia and vignette
options are both turned
on here.*

- **Drama.** Exaggerate the contrast in your photo using the effects in this category. Once you apply one, you can change brightness and film tone by dragging atop your photo (see Figure 14-16).

- **Aura.** The effects in this category accentuate the brightest colors in your image and make the other colors appear either black and white or black and white with a hint of a color overlay (similar to the effects in the duotone category). Drag the white vertical bar atop the thumbnails beneath your photo to fine-tune these effects.

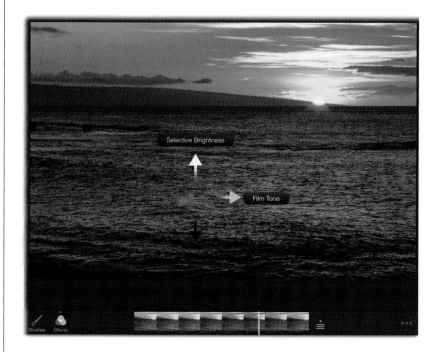

FIGURE 14-16

The Drama category adds, well, drama to your photo by increasing brightness in certain areas and adding a film tone (color overlay that mimics the look of actual film).

Touch and hold your finger atop the photo, and then drag up to brighten it or down to darken it. Drag left to soften the film tone or right to make it more dramatic (dragging the white vertical bar atop the thumbnails beneath your photo does the same thing).

- **Vintage.** Make your photo look old by adding an effect from this category. This grouping includes effects that simulate older film qualities such as early chrome, Sixties, saturated film, neutral film, and muted. It also gives you the option of adding an edge vignette (see Figure 14-17).

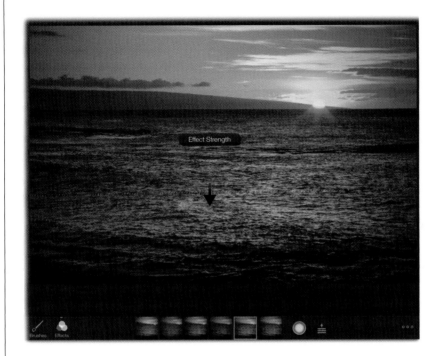

FIGURE 14-17

Once you apply one of iPhoto's Vintage effects, you can drag atop the photo to adjust the effect's strength.

Tap the circle below the photo to add an edge vignette.

- **Camera Filters.** The trendiest effects of all, this group lets you apply a mono, tonal, noir, fade, chrome, cross process, transfer, or instant (camera) look to your picture, as Figure 14-18 shows.

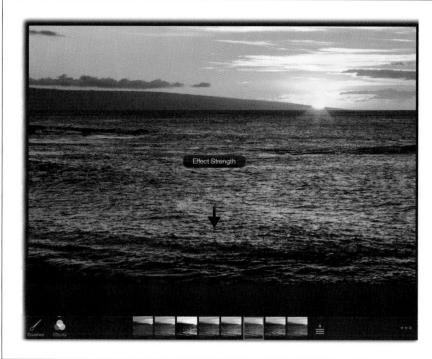

FIGURE 14-18

The effects in the Camera Filters category let you do things like give your image an overprocessed or bleached look.

You can apply the effects in the this category via your iOS device's Camera app, too. Once you snap a shot in the Camera app, tap the shot's thumbnail to open it, tap Edit, and then tap Filters (the three intersecting circles) at the bottom of your screen to see the same set of filters.

- **Artistic.** Perhaps the most creative of iPhoto's effects, the ones in this group let you add a dark gradient, warm gradient, cool gradient, vignette, tilt-shift blur, oil paint, or watercolor effect to your photo. The gradients are helpful for fixing overexposed skies. And you can make a photo look like a miniature by adding a Tilt-Shift blur (named for the tilting camera lens that makes this look possible); see Figure 14-19.

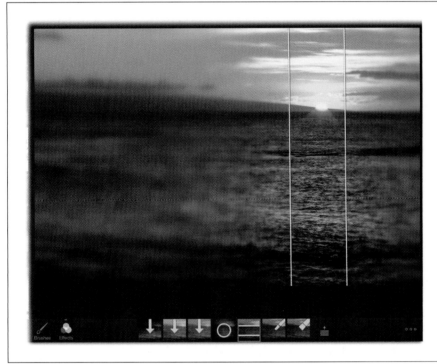

FIGURE 14-19

If you apply a gradient, vignette, or tilt-shift effect, you can adjust it by using one or two fingers.

Here, a tilt-shift blur was applied, which you adjust by twisting two fingers atop your photo to rotate the focus band (the area between the white lines). You can also pinch or spread two fingers to change the band's width.

If you decide you don't like the effect(s) you've applied, no problem. You can return to a picture anytime you want and remove the effect, thereby restoring it to its original pristine condition. You can also copy an effect from one photo and apply it to other photos. Here's how:

- **Remove an effect.** To remove an effect from a photo, select the image (or use the techniques described on page 377 to select multiple photos), and then tap the Options icon at the bottom right of your screen; choose Remove Effect.

- **Copy/paste and effect.** Select the image whose effect you like, and then tap the Options icon and choose Copy Effect. Next, select the thumbnail(s) of the photo(s) that you want to apply the effect to, and then tap the Options icon again and choose Paste Effect.

Sharing Photos on the iPad

I f you want to do something more with a photo than just stare at it, you can *share* it. iPhoto on your iPad (or other iOS device) lets you print a photo; text it; beam it; email it; AirDrop it; post it on Twitter, Facebook, or Flickr; or pass it over to another app.

iPhoto also lets you create some incredibly cool projects. You can whip up a *web journal* (a digital scrapbook you can share online) from your photos and video that includes nifty widgets like weather, a map, or a note (the web journal feature is unique to iPhoto for iOS). You can also create a slick slideshow and share it on the Web or beam it to a buddy, as well as handcraft (and order) a hardcover book or individual prints from the Apple Mother Ship.

Think about it for half a second and you realize that not only do iOS gadgets have some of the best cameras on any mobile device, they're also typically online. So once you've taken a few pictures, or synced some using your computer (page 321), and you've used iPhoto to perfect them—which is what this book is all about—you can do something with them right away. That's instant gratification at its technological best.

This chapter teaches you how to do all of those things and more.

■ Sharing Photos and Videos

In iPhoto for iOS, it's easy to send pictures via email, web, text message, AirDrop, iCloud photo stream, and so on.

The app's Share icon (⬆) is your headquarters for sending stuff elsewhere, and for creating projects (which are covered later in this chapter, beginning on page 382).

Once you've opened a photo or selected a few using the thumbnail grid, tap the icon to see the pane in Figure 15-1.

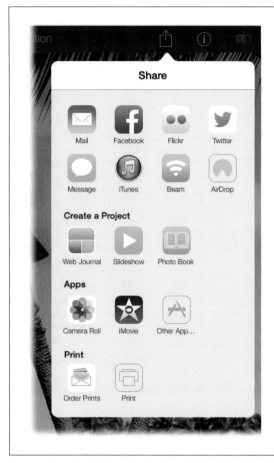

Before diving headfirst into Shareland, here are two things to keep in mind:

- **Selecting photos.** You don't have to select any photos before tapping the Share icon, though you do need to have at least one photo *open.* As Figure 15-2 (left) shows, when you tap an icon in the Share pane, iPhoto gives you the opportunity to pick exactly what you want to share. You can share selected photos, all the flagged photos (page 334) in the album or Event you're viewing, or *all* photos in that album or Event. Tap Choose Photos, and then use the techniques described on page 337 to select photos in the thumbnail grid. When you're finished picking pictures, tap the Next button at the top right of your screen. (Sharing *projects* works a little differently, as the section beginning on page 382 describes.)

- **Location info.** If your photos include location data such as Places tags, you need to decide whether you want to include that info when you share your photos

with the world. To tell iPhoto your preference, head to the main screen—the one with Photos, Albums, and Projects at the bottom—tap the Options icon (the three dots), and then tap Location to see the pane shown in Figure 15-2 (right) and adjust the settings.

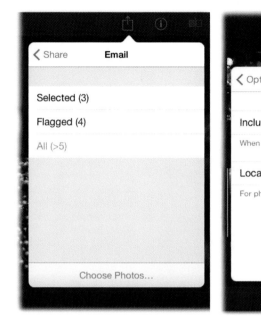

FIGURE 15-2

Left: Tap any icon in the Share pane to get these handy options for selecting photos (Email was chosen here). The number to the right of All indicates how many photos you can share using that particular method. For example, you can email only five photos at once.

Right: iPhoto's Location options let you turn location data on or off when sharing your shots. Turn on Location Lookup if you want iPhoto to add location info to the image for you, which is helpful when you start adding widgets to web journals (page 390).

The next section starts you off nice and easy, in the familiar territory of sharing your pictures and videos via email.

Mail

When you open the Share pane and tap Mail, iPhoto automatically compresses, rotates, and attaches the selected photo or video clip to a new outgoing message. All you have to do is address it, type a subject, and tap Send. You don't even have to decide how much to scale down the photo from its original size—iPhoto handles the downsizing all by itself.

Unlike iPhoto for Mac, iPhoto for iOS doesn't keep track of when or to whom you've emailed your photos. You have to use the database in your skull to remember.

Facebook, Flickr, Twitter

If you've told your iPad (or other iOS device) your Facebook, Flickr, or Twitter user name and password (by going to the iPad's settings and choosing the appropriate app), then posting a photo from your iPad to your Facebook Timeline, Flickr page, or Twitter feed is ridiculously simple.

NOTE Facebook and Flickr let you post up to 10 photos at a time. Twitter, on the other hand, lets you post just *one*.

Open the photo you want to post, tap 📤, and then tap Facebook, Flickr, or Twitter. iPhoto offers you the chance to type a message that will accompany your photo, as shown in Figure 15-3. You can also tap Location if you want Twitterites or Facebookers to know where the photo was taken (Flickr no longer uses iPhoto's location data).

TIP The Location option is available only if you've permitted Twitter or Facebook to use your location information, which you set up in your iPad's Settings→Privacy→Location Services settings.

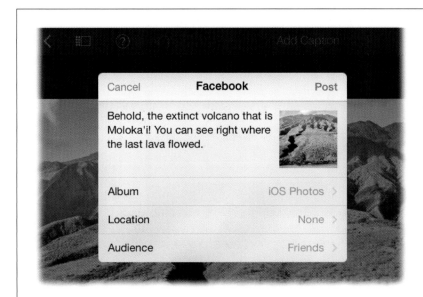

FIGURE 15-3

If you're posting to Facebook or Flickr, you can indicate which album or set you want to post to. You can also specify whom you're sharing this item with—just your friends, everyone, and so on—by tapping Audience.

If you're posting to Twitter, your message can use only 140 characters. (Fewer, actually, because some of your characters are eaten up by the link to the photo.) iPhoto helps out by keeping a count of how many characters you've typed.

When you tap Send or Post, your photo and your accompanying tweet or post zoom off to Facebook, Flickr, or Twitter for all to enjoy.

NOTE Unfortunately, iPhoto doesn't have a quick way to share photos with Instagram (the world's *second* largest photo-sharing community behind Facebook), but that doesn't mean you can't get it done; flip ahead to page 375 for a workaround.

Message

You can also share photos as an instant message or text message so they wind up on the recipient's cellphone screen. It's a delicious feature, almost handier than sending a photo by email. After all, your friends and relatives don't sit in front of their computers all day and all night (unless they're serious geeks).

> **NOTE** If you're sending a photo to another Apple gadget, like an iPhone, iPad, iPod Touch, or Mac, it will be sent as a free iMessage (assuming the recipient has turned on the iMessages option); your cellphone carrier won't even be involved. But if you're sending to a non-Apple cellphone, it will be a regular MMS message. All of this is described on page 188.

To share this way, open the Share pane and tap Message. You can then pick up to five photos using the techniques described earlier in this chapter (page 337). Specify the recipient's phone number or choose someone from your Contacts list. (If you're sending the picture by iMessage, then the person's email address also works.) Then type a little note, tap Send, and off the photo goes.

> **TIP** Free photo-sharing sites like Flickr and Snapfish let you upload photos from your phone, too. For example, Flickr gives you a private email address for this purpose (visit *www.flickr.com/account/uploadbyemail* to find out what it is). And the big ones, including Flickr, also offer special iPhone apps that make uploading easier; they're available from the App Store.

Sharing Photos to iTunes

As you learned on page 323, iTunes' file-sharing feature lets you transfer full-sized photos from your computer to your iPad instead of the downsized versions produced by a regular iTunes sync. This section teaches you how to perform iTunes file sharing *in the opposite direction,* to send files you've edited in iPhoto on your iPad to your Mac in their full-sized glory. (As the box on page 346 explains, edited photos aren't automatically transferred to your Mac.)

To get started, tap iPhoto's ⬆, tap iTunes, and then select the picture(s) you want to send to your computer. You see the message in Figure 15-4 (top); tap Export, and the next time you sync your iPad with your computer using iTunes, the photo(s) you selected get synced, too—*at full size.*

> **NOTE** Remember, editing a raw file on your iPad makes iPhoto save a *downsized* JPEG version of it to your iOS device's Camera Roll. To save a full-size copy of the edited photo instead, you have to manually save it to your Camera Roll by tapping ⬆ and choosing Camera Roll. That way, the picture is transferred to your Mac the next time you plug in the device and import the contents of your Camera Roll using iPhoto. And if you turn on My Photo Stream (page 13), a downsized version shows up there, too.

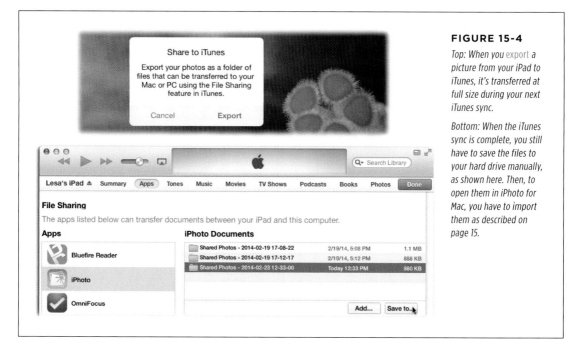

FIGURE 15-4

Top: When you export *a picture from your iPad to iTunes, it's transferred at full size during your next iTunes sync.*

Bottom: When the iTunes sync is complete, you still have to save the files to your hard drive manually, as shown here. Then, to open them in iPhoto for Mac, you have to import them as described on page 15.

But where does the picture *go?* It's sitting in iTunes on your computer, patiently waiting for you to come and save it. Here's how:

1. **On your Mac, open iTunes , and then click Apps (see Figure 15-4, bottom).**

2. **In the Apps list, select iPhoto, and then select the folder of photos that you want to save.**

 Scroll down to the bottom of the Apps screen to see the File Sharing section shown in Figure 15-4. From the Apps list on the left, choose iPhoto. When you do, a list of synced folders appears in the iPhoto Document section on the right; click the folder you want to save. Happily, the folder's sync date appears to its right, making it easy for you to figure out which one to pick.

3. **Save the folder somewhere on your hard drive.**

 At the bottom of the iPhoto Documents section, click "Save to." In the resulting dialog box, pick a location and then click Save To.

Now that the edited photos (finally) live on your computer, you can do anything you want with them. You might want to import them into iPhoto on your Mac by dragging and dropping the file(s) onto the iPhoto window, or by choosing File→"Import to Library." (When you're finished, you can delete the shared folder from iTunes by selecting it and pressing the Delete key.)

NOTE As the box on page 346 explains, the edits you make in iPhoto on your iPad are *not* undoable in iPhoto on your Mac. Bummer!

Beaming Photos

iPhoto lets you share photos with other iOS devices that *also* have iPhoto installed by *beaming* them. (If you're a *Star Trek* fan, this is the section you've been waiting for; if not, this maneuver is still darn cool.) You can wirelessly beam photos, albums, Events, web journals (page 383), and even slideshows (page 397).

TIP To wirelessly send something from one iOS device to another device that *doesn't* yet have iPhoto installed, use AirDrop instead; it's explained in the next section.

On an iPad, you can beam up to 1,000 photos at a time (on an iPhone or iPod Touch, the limit is 100). When you do, the photos arrive on the recipient's device at their full size. The more photos you send, the longer they take to transfer. And if the receiving device goes into sleep mode, the beaming is canceled (a message to that effect appears on the sending device).

The first step in sharing photos this way is to make sure iPhoto's beaming feature is turned on in *both* the sending and receiving device. Go to iPhoto's main screen—the one with Photos, Albums, and Projects at the bottom—tap the Options icon, and then make sure Wireless Beaming is turned on. Next, make sure both iOS devices are on, *awake,* and have iPhoto open. Figure 15-5 has the rest.

Once you *receive* a beamed photo, a new album named Beamed automatically appears in the Albums section of iPhoto's main screen. (Too bad Apple didn't license the sound of a starship's transporter from CBS/Viacom!)

NOTE In addition to individual photos, you can also beam web journals and slideshows. (You'll learn how to create these little gems later in this chapter.) In Projects view (page 327), tap to open the web journal or slideshow you want to send. Then tap the ⬆ at the upper right of your screen and choose Beam. On the recipient's iOS device, the item lands in iPhoto's Projects view.

Sharing via AirDrop

If you've got a newer iOS device—an iPhone 5, a fourth-generation iPad, an iPad mini, or a fifth-generation iPod Touch, or later—it has a nifty feature called AirDrop. It lets you send photos, videos, and other goodies to other iPhones, iPads, and iPod Touches wirelessly, even if they don't have iPhoto installed.

Behind the scenes, AirDrop uses Bluetooth (to find nearby gadgets within about 30 feet) and a private, temporary WiFi mini-network (to transfer the file). Both sender and receiver must have Bluetooth (Settings→Bluetooth) and WiFi (Settings→Wi-Fi) turned on, and they need iOS 7. And, not surprisingly, they must also have AirDrop turned on; to turn it on, swipe up from the bottom of your screen, tap AirDrop, and then tap Everyone. Finally, both parties must have iCloud accounts (page 12).

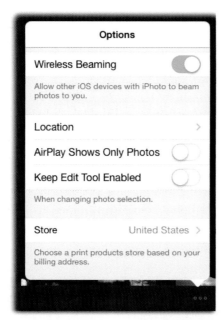

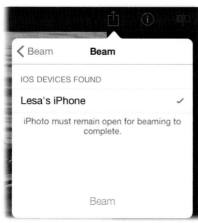

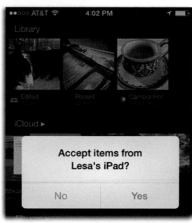

FIGURE 15-5

*Top: If the switch next to
Wireless Beaming is green,
you're good to go.*

*Bottom: If the sending
device detects another iOS
device with iPhoto run-
ning, it appears in this list
(left). Tap Beam; an "Ac-
cept?" message appears
on the receiving device
(right). Tap Yes to begin
beaming. (If the recipient
refuses the beam, you
see a "Beaming Denied"
message instead.) When
the process is finished,
a "Beaming Completed"
message appears on the
sending device; tap Done
to dismiss it.*

NOTE The Mac also has a feature called AirDrop; it, too, is for sending files wirelessly. But it's only for sending to other Macs. You can't AirDrop files between Macs and phones/tablets. Hello, Apple?!

The process goes like this: In iPhoto for iOS, select the item you want to share. Then tap the ⬆ and choose AirDrop. Within a few seconds, you see something that would have awed the masses in 1975: the icons of everyone nearby—or at least everyone with an Apple device running iOS 7 who's open to receiving AirDrop transmissions.

Tap the icon of the person you want to share with. A message appears on the recipient's screen, showing a picture of the thing you're trying to send.

At this point, it's up to your recipient. If she has iPhoto installed and taps Accept, then the transfer begins; the picture, album, event, web journal, or slideshow appears automatically in her copy of iPhoto, and the word "Sent" appears on your screen. If she taps Decline, then you must have misunderstood her willingness to accept your photo (or she tapped the wrong button). In that case, you see the word "Declined" on your screen. If she accepts the transfer but doesn't have iPhoto installed, she can tap Get App; the App Store opens to iPhoto's page so she can download it. If she doesn't want to install iPhoto, then she has to tap Cancel. At this point, you can save the photo to your Camera Roll (if it doesn't already exist there), fire up the Photos app on your iPad, and AirDrop it from there so it lands in your recipient's Camera Roll.

If you're on the receiving end of an AirDrop transmission, photos appear in a new album on iPhoto's main screen aptly named AirDrop.

iCloud Photo Streams

This special iCloud feature has two faces. There's My Photo Stream, which magically stores the last 1,000 pictures you take on every iCloud-connected Apple gadget you own (page 12). And then there are the shared photo streams (page 196) that let you publish sets of pictures that other people can subscribe to and view on their phones, tablets, or Macs. (And if you grant them permission, those people can contribute their own photos to your streams.) You can even post a photo stream as a public web gallery.

Oddly, iPhoto for iOS doesn't let you create, contribute to, or see a photo's "likes" or comments in a shared photo stream; however, you can do all of that in the *Photos* app. (Sharing a web journal or a slideshow to iCloud from your iOS device is easy, and both techniques are covered later in this chapter.)

The first step in creating a shared photo stream on an iOS device is to turn on the Photo Stream feature; the switch is in Settings→iCloud→Photos. Then, to share some of your masterpieces with your adoring fans, proceed like so:

1. **Create the stream in the Photos app.**

 Open the Photos app. On the Shared tab, scroll to the bottom of the list (if necessary) and tap New Shared Stream.

2. **Name the new stream.**

 In the Shared Stream box, name the Photo Stream ("Bday Fun" or whatever). Then tap Next.

3. **Specify your audience members.**

You're now asked for the email addresses of your lucky viewers; enter their addresses in the "To:" box just as you would in an outgoing email. (Conveniently, a list of recent sharees appears below the "To:" box.) When you're done, tap Create. You return to the list of Shared Streams, where your new stream appears at the top. But it's still empty.

4. **Pour some photos or movies into the stream.**

Tap your new stream's name. Then, on the No Items screen, tap the + to burrow through your photos and videos—you can use any of the three tabs (Photos, Shared, Albums)—to select the material you want to share. Tap their thumbnails so that they sprout checkmarks, and then tap Done. A little box appears so you can add a description.

5. **Type a little description of the new batch.**

In theory, you and other people can add to this stream later. That's why you're offered the chance to caption each new batch. Once you're done writing the caption, tap Post. The thumbnails of the shared photos and videos appear, along with the + button, in case you want to add more pictures later.

> **TIP** You can easily *remove* photos from the stream, too. On this screen of thumbnails, tap Select; tap the thumbnails you want to nuke; tap the trash icon; and then confirm your decision by tapping Delete Photo.

At any time, you can tap the Shared tab in the Photos app. There, for your amusement, is a visual record of everything that's gone on in Shared Photo Stream Land: photos you've posted, photos other people have posted, comments back and forth, "likes," and so on. It's your personal photographic Facebook. (For more on using the Photos app, pick up a copy of *iPhone: The Missing Manual.*)

Apps

iPhoto is also happy to pass your photos over to other applications, such as Camera Roll (technically part of the Photos app) or iMovie. The app doesn't even have to be made by Apple—as long as it can handle photos, you can use iPhoto to send one over to it.

■ SAVING PHOTOS TO YOUR CAMERA ROLL

iPhoto lets you save up to 100 photos to your Camera Roll; just tap ⬆, select your pictures using the techniques described earlier in this chapter (page 366), and then tap Camera Roll. The photos show up in the Camera Roll of your Photos app, as well as in the Camera Roll *album* in iPhoto, and a downsized version appears in your iCloud photo stream (if you've turned it on—see page 12).

How is this helpful? Let us count the ways:

- **Import edited photos into iPhoto or Aperture.** To get files you've edited on your iOS device back into iPhoto or Aperture on your Mac, save them to your Camera Roll (as described in the box on page 346, photos you edit in iPhoto on your iPad *aren't* automatically imported into iPhoto on your Mac). Next, plug your iPad (or other iOS device) into your Mac, fire up either program, and then import the photos at full size. (If you edit photos that are already in your Camera Roll, your changes are automatically saved in your Camera Roll.)

- **Save full-size copies of edited raw files.** As described on page 344, iPhoto for iOS displays, edits, and exports a JPEG version of any raw files you open. To save space on your iOS device, iPhoto also saves a *downsized* version of the edited JPEG to your Camera Roll. To save a *full-size* JPEG of your edited image instead, you have to save it to your Camera Roll (and, yes, you'll end up with two versions of the same edited file in your Camera Roll, one larger in size than the other).

- **Apply multiple effects.** iPhoto lets you apply only one effect to each photo, but saving the photo to your Camera Roll creates another *copy* of it. This lets you reopen the photo and apply *another* effect to it, and lets you save different versions of the same image (say, with different effects applied to it). But what if you want to apply three effects to the same shot? Simple: Apply one effect, save the photo to your Camera Roll, open the saved photo in iPhoto for iOS and apply another effect to it, save that photo to your Camera Roll, open the photo you just saved and apply another effect to it, and so on.

> **NOTE** Photos in your Camera Roll are listed in chronological order according to the date they were taken, so you may have to scroll a bit to find the one you edited.

■ SENDING PHOTOS TO OTHER APPS

iPhoto makes it super easy to send photos and slideshows over to the iMovie app so you can include them in a video project. Simply tap iPhoto's ⬆ and choose iMovie. The end.

However, don't fret if you want to use an app that's not listed in iPhoto's Share pane; there's simply not enough room to list all the possibilities. For example, while Instagram isn't included in the Share pane, you can still send photos to it, as well as any other photo-related app like Google's Snapseed (similar to Instagram) and Day One (a popular daily journal app).

To share photos with other apps, tap ⬆ and choose Other App. Next, select the photos you want to share. The resulting screen lists apps that iPhoto can share with; just tap the icon of the one you want to use. If you've got a plethora of photo-happy apps, you might need to swipe leftward on your device's screen to scroll through all the icons to find the one you're looking for.

TIP If you prefer, you can select the photos you want to share (page 366), and *then* tap Other App. The choice is yours.

Alternatively, you can save the edited photo to your Camera Roll, as described in the previous section, and then launch the other photo-happy app (such as Instagram) and access your Camera Roll via that app.

Printing Photos

iPhoto for iOS gives you two options for printing photos: Do it yourself or pay Apple to do it for you. It's good to have those options, since wrestling with your own printer can be problematic, and high-quality photo paper and ink cartridges aren't cheap. This section explains how to do both.

Printing from Your iPad

The very phrase "printing from your iOS device" might seem a little peculiar. How do you print from a gadget that doesn't have any jacks for connecting a printer?

Wirelessly.

You can send printouts from your iPad, iPhone, or iPod Touch to any printer that's connected to your Mac (as long as your Mac is on the same WiFi network as your iOS device) by springing for a program like Printopia ($20).

Or you can use your iPad's built-in AirPrint feature, which can send files directly to a WiFi printer *without* requiring a Mac. Not just any WiFi printer, though—only those that recognize AirPrint. A lot of recent Canon, Epson, HP, and Lexmark printers work with AirPrint; you can see a list of them on Apple's website: *http://support.apple. com/kb/HT4356*.

To use AirPrint, start by tapping iPhoto's �6 and choosing Print. In the resulting pane, tap Select Printer to introduce your iPad to your printer, whose name should appear automatically (if iPhoto can't find a printer, you see the message "No AirPrint Printers Found"). Figure 15-6 has the rest.

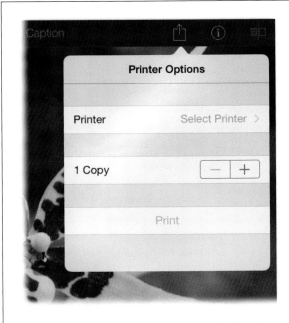

FIGURE 15-6

Once iPhoto finds your printer, you can adjust the number of copies using the − and + buttons shown here.

When you tap Print, your printout shoots wirelessly to the printer, exactly as though your iPad and printer were wired together.

Ordering Prints

The prints you can order from Apple are, it must be said, *gorgeous.* You don't even have to worry about Apple unexpectedly cropping your images; you can see and adjust the crop right there on the order screen. You can have prints sent to multiple shipping addresses, and your pictures are printed on super high-quality Fuji Crystal Archive paper so they won't fade.

You can order prints in a wide range of standard and non-standard sizes. For example, you get the traditional size options of 4 × 6, 5 × 7, and 8 × 10 inches, though you can also order square ones that are 4 × 4, 5 × 5, or 8 × 8 inches for prices ranging from 12 cents to $2 each. You can have your pictures blown up into posters, too, at 16 × 20 or a whopping 20 × 30 inches ($13 and $18, respectively).

Apple also offers an interesting, decidedly non-standard option called Auto-Sized that you can use to print your pictures at their actual proportions (think panoramas and oddly sized snapshots). For example, if you haven't cropped your pictures because you don't want them cropped into a standard print size, you can specify the shortest dimension of your photo (either width or height) and Apple will print the image at its original aspect ratio, *without* any unexpected cropping. For instance, if you have a picture that's 8 × 11, you can specify 8 inches as the shortest dimension; you'll get a print that's actually 8 × 11. Pricing for Auto-Sized prints range from 12 cents for a 4 × 4 to $6 for an 8 × 36.

NOTE The Auto-Sized route does have *some* limitations. For example, the smallest photo you can order is a 1:1 aspect ratio, and the largest is a 1:4.5 aspect ratio. In other words, if your shortest dimension is 5 inches, the smallest print you can get is a 5 × 5 and the biggest is a 5 × 22.5 (just use 4.5 as a multiplier to find the longest dimension).

The print-ordering process is remarkably customizable. Follow these steps to get some prints on the way:

1. **Open a photo in iPhoto, tap 📤, and then tap Order Prints.**

 You have to have at least one photo open to start the ordering process.

2. **Select the photos you want to print.**

 You can select photos either before tapping the Share icon or after. If you opt for the latter, use the techniques described at the beginning of this chapter (page 366).

3. **Pick a format and size.**

 As described earlier, your print-format options are Auto-Sized, Traditional, Square, and Poster. Once you pick a format, a list of available sizes appears; simply tap the one you want.

4. **Adjust the print sizes, quantity, and cropping.**

 Tap the photo you want to adjust; the menu shown in Figure 15-7 appears. To add a photo to your order or change the print size of that particular shot, tap Add New Size or Change Size (respectively), and then pick a format and size from the resulting menu. To change the quantity of prints you're about to buy of a particular photo, tap "Prints: 1" and in the resulting menu, tap the – or + sign to lower or raise the print quantity; the number after the colon updates as you make changes.

 To adjust how a photo will be cropped to fit the print size you picked, tap a photo. A light-gray border appears around it; drag the photo to reposition it. An arrow appears atop the picture showing you the directions in which you can drag it; it's visible in Figure 15-7. Whatever portion of your picture fits inside the gray border is the part that prints.

 If you change your mind about printing a certain picture, tap it and, in the resulting menu, tap Remove. When iPhoto asks if you're sure, tap Remove.

TIP To change the print size of *all* the photos in your order, tap Change Size near the top right of your screen, and then tap a new size in the resulting menu.

5. **If you'd like, add more pictures to your order.**

To add more pictures, tap the + sign near the top right of your screen and, in the menu shown in Figure 15-8, tap the photos you want to add. Next, at the bottom of the menu, tap Size, and then pick a format and size for the additions (remember, you can fine-tune sizes of individual photos once you add them to your order). When you're finished, tap Add Photos.

Add more photos

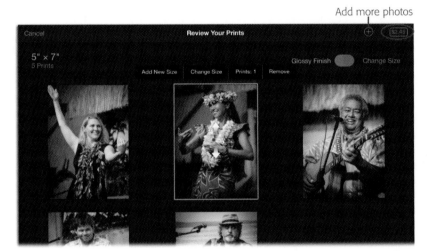

FIGURE 15-7

When you tap Order Prints, iPhoto lists the size and number of prints at the top left of your screen and calculates the cost of your order (circled). Tap a photo to get the menu shown here, which lets you adjust that photo. You can add an additional print size, change the current print size, change the quantity, or remove it from your order.

To adjust how a photo is cropped, use your fingers to reposition the photo inside the gray border; arrows appear atop the picture indicating which directions you can drag.

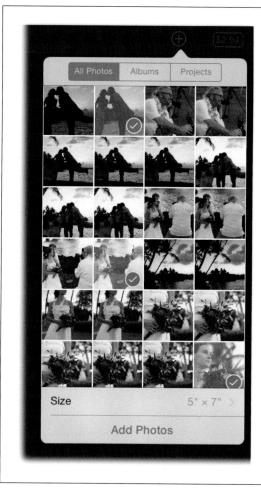

FIGURE 15-8

Tapping the Add Photos icon summons this menu. Tap All Photos, Albums, or Projects to pick a group of photos, and then swipe upward to find individual photos to add to your order. As you tap to select pictures, a blue ✓ appears on each photo's thumbnail, as shown here; tap a selected photo again to deselect it.

6. **Pick a photo finish and border.**

 See the Glossy Finish slider near the top right of your screen? Straight from the factory, Apple assumes you want a glossy finish (so the slider's background is blue). If you want a lustre finish instead—lustre is somewhat shiny, though less reflective than glossy—tap the slider (its background turns black).

 As Figure 15-9 explains, if you're ordering any poster-sized prints, you can add a white border around them.

 TIP If a photo doesn't have enough pixels to print at a particular size, a yellow warning icon appears on the photo's thumbnail (you can see one in Figure 15-9). Your choices are to change the print size to something smaller, remove the photo from your order, or let it ride and hope for the best!

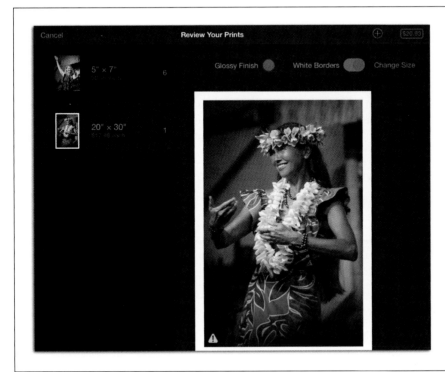

FIGURE 15-9

Once you add more print sizes to your order (say, some 5 × 7s and a poster, as shown here), the sizes stack up in a list on the left; just tap a size to view (and adjust) the photos you've prepared at that size.

When you order a poster, you also get the choice of adding a white border around it. Just tap the White Borders slider to turn it on (it turns blue).

7. **Tap the dollar amount at the top right of your screen and pick a shipping address.**

 iPhoto calculates the cost of your order as you're creating it (handy!). When you've gotten the order just right, tap the amount and pick a shipping address from the resulting list. iPhoto tunnels into your Contacts to populate the list; swipe up to find the address you want, or type a name into the Search field. If the address you want isn't in the list, tap New and then enter it. Once you tap an address, iPhoto confirms it with the U.S. Postal Service via the Internet. If a more accurate address is found—say, you entered "Avenue" and iPhoto asks to change it to "Ave" instead—it appears; just tap the modified address to accept it or tap Ignore Suggestions if you had it right to begin with.

8. **Adjust the number of sets you're ordering, and enter any additional shipping addresses.**

 The final screen lets you adjust how many *sets* of prints you want, and the addresses where you want them sent. For example, if you've prepared an order of six different 5 × 7-inch photos of cousin Casey's wedding and you also want to make another set of those prints for Aunt Edna, then instead of changing

the print quantity of the *individual* photos (as described in step 4), tap the +
beneath the word "Sets" to double the whole order.

> **NOTE** To return to the previous screen for viewing and adjusting your prints, tap Review Your Prints at the top of your screen.

If, however, you want the second set mailed directly to Aunt Edna, leave the
set quantity at 1 for your own address, and then tap Add Shipping Address at
the top right of your screen. Pick Aunt Edna's address from the resulting list;
that way, you'll *each* receive a set of those prints. To remove a shipping address
from the list, just tap the checkmark to its left (tap the same spot again to turn
the address back on).

9. **When everything looks good, tap Place Order.**

 Enter your Apple ID and tap Sign In. iPhoto then prompts you to enter your
 credit card's security code. Tap OK, and the prints are on their way!

> **TIP** If you decide to bail on ordering prints, tap Cancel at the top of your screen (at the bottom of the Checkout screen). In the message box that appears, tap Cancel Order.

▨ Creating Projects

The projects you can create in iPhoto for iOS include web journals, slideshows, and
photo books. This section teaches you how to build and manage each of them. Once
you start creating projects, they show up in neat little categories in Projects view (see
Figure 15-10). If you create a bunch, you can swipe leftward to scroll through the list.

If you fall in love with a project you've created, you can tag it as a favorite (page
334). Doing so makes that project appear in a separate row at the *top* of Projects
view, making it easier to find. To add a favorite tag in Projects view, tap and hold
the project's icon, and in the menu that appears, tap Favorite. If you change your
mind, you can unfavorite a project by tapping and holding its thumbnail and then
choosing Unfavorite.

Other useful items in this menu let you do the following:

- **Rename.** iPhoto prompts you to name each project when you create it, though
 you can always edit it by tapping this menu item.

- **Duplicate.** This maneuver lets you create a different version of a project to, say,
 experiment with the design or to personalize it for a special recipient.

- **Delete.** Tap the tiny trash icon to get rid of the project.

The next section shows you how to create perhaps the most enjoyable project of
all: a web journal.

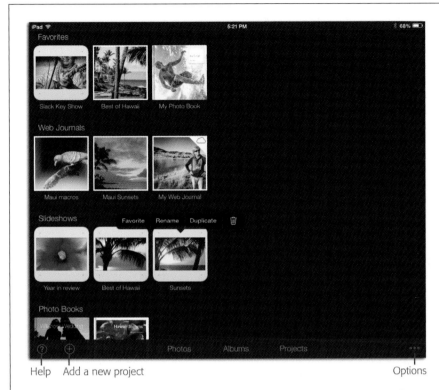

FIGURE 15-10

Projects view is mission control for web journals, slideshows, and photo books that you create in iPhoto for iOS. As you can see, projects are listed by type.

Tap and hold a project's icon to summon the handy menu shown here, which lets you tag the project as a favorite, rename it, duplicate it, or delete it.

Web Journals

If you're into scrapbooking, you'll love web journals, a feature that's available only in iPhoto for iOS. You can think of a web journal as a digital scrapbook that you can play as a slideshow or, if you have an iCloud account, share on the Web.

Web journals let you arrange up to 200 pictures into a visually pleasing and highly customizable grid-style layout. You can change the grid's size (and thus the photo thumbnails' size) or design, resize and rearrange photos using gestures (unimaginable fun), and include stuff like photo captions (page 336), a map that shows where the pictures were taken, a widget that shows what the weather was like when you took the shots, and even quaint little sticky notes that you can personalize. Figure 15-11 shows you what a web journal can look like.

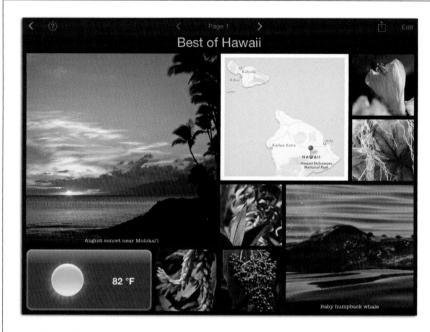

FIGURE 15-11

Web journals are an incredibly creative way to display your pictures. Because they rely heavily on the use of gestures *to customize the size and placement of your pictures, you can create them only in iPhoto for iOS, not on your Mac.*

If you've been looking for an excuse to buy an iPad, this could be it!

The first step in creating a web journal is to open a photo, album, or Event. Next, tap ⬆ and choose Web Journal. The resulting pane lets you select up to 200 photos. As described earlier in this chapter (page 366), you can select photos *before* tapping ⬆ to create a project or after.

Once you're finished picking pictures, the pane shown in Figure 15-12 appears. Tap Enter Web Journal Name and type to give your journal a meaningful moniker. You can also pick a *theme* (design style) for your journal by tapping one of six thumbnails to assign a background color, texture, and photo border style.

> **TIP** You can also create a web journal from Projects view by tapping the + at the bottom left of your screen and then tapping Web Journal.

Tap Create Web Journal; a status bar appears onscreen indicating iPhoto's progress. When it's finished, a friendly message lets you know that the journal was created. Tap Show to see the journal or Done to return to the photos from whence you came. Either way, the new journal appears as its very own thumbnail in the Journals section of Projects view (this section only appears once you've *created* a journal).

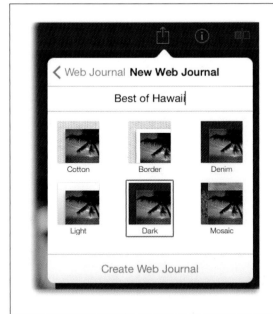

FIGURE 15-12

Your web journal theme choices are Cotton, Border, Denim, Light, Dark, and Mosaic. (For maximum contrast, go with one of the darker options.) Don't fret too much about this choice, as you can easily change themes later, as described below.

Now that you've got a journal to play with, the customization party starts. The next few sections explain all your options.

■ CUSTOMIZING THE LAYOUT

Once you see your web journal, you might change your mind about the theme you picked when you created it. Or you might decide to change the grid size, sort the photos in a different way, or alter the grid's design. Happily, changing all those things is super simple.

The first step is to *open* the journal, if it isn't open already, by tapping its thumbnail in Projects view. Tap Edit at the top right of your screen to enter edit mode (the word "Edit" turns blue, as shown in Figure 15-13, top); tap Edit again to exit edit mode (the word turns gray).

In edit mode, you can double-tap the journal's name and type something else, or single-tap the name to summon a few text formatting options (Figure 15-13, top).

To change the journal's theme, grid size, photo sort order, or layout, tap the Options icon labeled in Figure 15-13 (bottom). Here are your choices:

- **Themes.** To swap themes, simply tap another theme's thumbnail. iPhoto instantly updates your web journal.

- **Grid Size.** Straight from the factory, iPhoto uses a medium-sized thumbnail for the majority of your pictures, and thoughtfully places a few of them at a larger

size for contrast and visual interest. However, you can reduce the size of the smaller thumbnails by tapping Small (so more pictures fit on a journal page) or increase their size by tapping Large (for fewer pictures per page). There's not much difference between Small and Medium, but Large makes the thumbnails noticeably bigger.

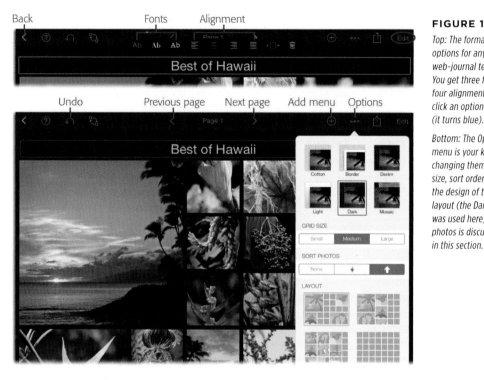

FIGURE 15-13

Top: The formatting options for any kind of web-journal text are few. You get three font and four alignment choices; click an option to apply it (it turns blue).

Bottom: The Options menu is your key to changing themes, grid size, sort order, and the design of the grid layout (the Dark theme was used here). Adding photos is discussed later in this section.

- **Sort Photos.** iPhoto assumes you want to drag photos on the journal page to rearrange them, but you can have them appear in chronological order. Tap the down arrow to put them in *descending* order (so the newest photos appear at the top of the journal page) or the up arrow to put them in *ascending* order (so the oldest ones appear at the top instead).

- **Layout.** You can choose among four different grid designs by tapping the thumbnails in this section. The first layout, which is what iPhoto automatically uses, places larger photos at each of the page's corners and fills the middle with small thumbnails. The other designs include different combinations of larger and smaller photos, except the last design, which consists of small thumbnails only.

■ **CHANGING THE JOURNAL'S KEY PHOTO**

The key photo is the one that appears atop an album, Event, or project thumbnail.

To change the key photo of a web journal, tap the journal to open it, and then tap Edit at the top right of your screen. Next, tap the thumbnail of the photo that you want to use as the new key photo. In the menu that appears above the thumbnail, tap Edit; iPhoto deposits you into the familiar editing screen you mastered back in Chapter 14. Tap the Options icon at the bottom right, and in the resulting menu, tap "Set as Key Photo." To return to your web journal, tap the < near the top left of your screen.

■ **ADDING PHOTOS AND VIDEOS**

If you forgot to include a prize-winning photo of you and Zooey Deschanel in your journal, don't panic—iPhoto is gloriously forgiving and lets you add photos and videos to a journal even *after* you create it. You've got two options:

- **Open the photo you want to add.** In Photos or Albums view, open one of the photos that you want to add and then tap ⬇. Choose Web Journal, and then pick the pictures you want to add using the techniques described on page 366. When you're finished, a pane appears showing all the journals you've created. Tap the one you want to add the shots to, and then tap New Page to add the photo(s) to a brand-new page, tap "Place by Date" to add the picture(s) in chronological order, or tap the individual page that you want to add it to. When you're finished, tap Add Photos. In the confirmation message box, tap Show to view the journal or Done to return to the photos you were looking at.

> **NOTE** If the journal you're adding photos to consists of just one page, then Page 1 is selected automatically; however, adding more photos may force iPhoto to add more pages to accommodate them. The moral of this story is this: If you add some photos to a web journal but you don't see them when you open the journal, swipe leftward to view the *next* journal page, or use the next icon labeled in Figure 15-13 (bottom).

- **Use the Add menu.** Tap the ⊕ labeled in Figure 15-13, bottom, and choose Photo. A pane appears with Photos, Albums, and Projects buttons at the top that let you pick a group of photos in order to find the ones you want to add. If you tap Albums or Projects, the pane displays your albums or projects; tap one to open it. Swipe downward to scroll through the resulting thumbnails and tap the ones you want to add to your journal. As you select photos, a blue ✓ appears on their thumbnails. When you're finished, tap Add at the pane's top left.

■ **REARRANGING, RESIZING, OR REMOVING PHOTOS**

Have a few words to say about some of the photos in your web journal? No problem. iPhoto lets you add *captions* to any photo, as well as rearrange and resize them on each page. You can delete photos from your journal, too. This section teaches you how to do all of that.

It's helpful to think of each grid slot in your journal as the photo's *frame.* By using gestures, you can change the frame's size, which also changes the photo's size.

iPhoto even lets you change the position of the photo *inside* the frame, as well as the photo's *zoom* level. You'll learn the details of all these maneuvers in the following list.

Of course, to make any changes to your web journal, you have to open the journal and then tap Edit at the top right of your screen. Once you do that, tap the thumbnail of the photo you want to alter and then perform one of these tasks:

> **NOTE** If you tap a photo's thumbnail when you're *not* in edit mode, iPhoto merely displays the picture at a larger size so you can get a better look. To do some actual editing instead, tap the Back button at the top left of your screen to return to the journal and then tap Edit.

- **Move a photo.** To move a photo to another position on the same journal page, touch and hold its thumbnail—leave your finger still for a second, and the thumbnail magically *lifts* beneath it—and then drag it to a new position. The other photos automatically scoot out of the way and rearrange themselves on the page.

- **Add a caption.** When you tap a thumbnail, the text "Add Caption" appears at the bottom of the photo; just tap it and then type something more creative. Tap Done when you're finished. Once you've added a caption, tapping the photo displays a menu above it that includes three font options and a photo-enlargement button (tap one to apply it). To remove a caption, tap the photo, tap the existing caption, and then use the Delete key on your iPad's digital keyboard to get rid of it.

- **Resize a photo.** Tap a photo (or any of the custom objects described in the next section) and then use your finger to drag any of the round, blue selection handles that appear around it (see Figure 15-14, left).

> **TIP** To make a photo as wide as your journal page, tap the photo and then, in the menu that appears above it, tap the max width icon labeled in Figure 15-14 (left). To undo the size change, tap the photo and then tap the same icon again.

- **Reposition a photo within a frame.** Double-tap a photo and use your finger to drag the photo up or down (arrows appear atop the photo letting you know which directions you can drag). This technique is helpful when you want to fine-tune the position of the photo's subject, for example. You can also *pinch* the photo with two fingers to zoom out or *spread* your fingers atop the photo to zoom in.

- **Edit a photo.** If you want to embellish the photo with some of the editing techniques you learned in Chapter 14, tap an image and then tap Edit in the menu that appears above the photo's thumbnail. When you're finished, tap the < to return to your journal.

- **Swap one photo with another.** If you want to substitute one photo for another, at the *same* size as the other photo and without causing the other thumbnails

to rearrange themselves on the page, tap the Swap icon circled in Figure 15-14 (right). Once the icon turns blue, you can drag one picture onto another to make them swap places. Turn off this behavior by tapping the Swap icon again.

Max width

FIGURE 15-14

Left: You can drag the round, blue selection handles in any direction to resize your pictures. Happily, iPhoto preserves the photo's original aspect ratio, so the photo never gets squished or stretched.

Tap a captioned photo to get the font and alignment options shown here.

Right: After you tap the Swap icon (circled), you can drag one photo atop another to make them switch places. To go back to moving photos instead of swapping them, tap this icon again to turn it off.

- **Move a photo to a different page.** If your journal has multiple pages, you can scoot photos from one page to the next. Tap and hold the photo and then drag it to the far left or right edge of your screen. When the page you want to add the photo to appears onscreen, drag the photo into the desired spot and then lift your finger. (This is handy if you add a photo to a journal and iPhoto plops it on page 2, when you really wanted it to land on page 1.)

 If your journal includes only one page, you obviously need to *add* pages before you can move images between them. Tap the ⊕ to open the Add menu, and then choose Page.

- **Delete a photo.** Tap a thumbnail, and then tap the trash can icon that appears to remove the photo from your journal. You don't get a confirmation message; the photo just disappears.

TIP If you delete a photo that you wish you had back, tap the Undo icon labeled in Figure 15-13 (bottom).

■ ADDING CUSTOM OBJECTS

To spice up your journal pages, you can add resizable and customizable objects including a map showing where the photos were taken, a box that shows the weather on the day they were shot, and notes that look like a torn piece of paper or a yellow sticky pad.

To add a custom goodie, open a web journal, tap Edit, and then tap the ✛ to open the Add menu shown in Figure 15-15.

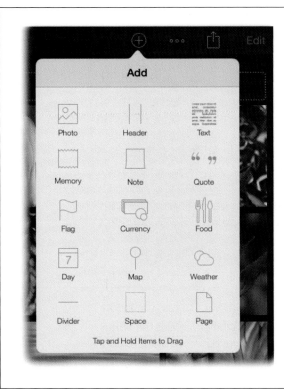

FIGURE 15-15

Tap the ✛ to reveal this menu of custom goodies that you can add to your journal pages.

Tap and hold the object you want to add, and then drag it into place on the page.

If you know where you want the custom item to land on your journal page, you can touch and hold an area between photos to reveal the Add menu. But it's challenging to get your finger in just the right spot to make the menu appear.

No matter what object you pick in the Add menu, you can drag it anywhere you want on your journal page. You can also customize the object by double-tapping it to reveal another menu (your options depend on the object). Here's a list of the stuff you can add, along with their customization options:

- **Photo.** Tap this icon to add a photo to your journal. In the resulting pane, tap Photos, Albums, or Projects to see those thumbnails, and then navigate to the picture(s) you want to add. Tap to select as many thumbnails as you want, and then tap Add.

- **Header.** See the title at the top of your first journal page? That's a header. Tapping Header in the Add menu lets you add *another* one that you can enter text into and then drag into position on your journal page. When you're finished

typing, tap anywhere else on your screen to dismiss your iPad's digital keyboard. To format the header, tap it to reveal a few formatting controls (they're the same ones you saw back in Figure 15-13, top). To edit the text, double-tap the header.

- **Text, Memory, Note, Quote.** These options give you room to add your own text. Tap Text to create a text box with no background; tap Memory to add text atop a piece of paper; tap Note for a realistic sticky-note background; or tap Quote to surround whatever you type with semi-lame curly quotes (they're tiny and you can't resize them). No matter which option you pick, you can resize the object just like you would a photo (page 387). To format it, tap the object and then use the controls that appear above it; you get the same controls as you do with Header, though Memory also gives you a choice of four kinds of paper (torn, rounded corners, notebook, or graph) and Note gives you a choice of four colors (yellow green, blue, or gray). Double-tap the object to edit its text.

- **Flag, Currency.** If your journal chronicles your adventures in another *country,* then these two options make for a slick addition to your journal. They add a picture of a flag or a picture of a pile of money, respectively. When you tap Flag, iPhoto automatically adds a flag for the country in which the photos closest to where you dropped flag object were taken. To select a different country, double-tap the flag, turn off Auto, and then tap Country.

 The Currency object works the same way: Double-tap it, turn off Auto, and then tap Currency to reveal a menu that includes Egyptian pounds, Swiss francs, and so on.

> **TIP** Even if your pictures include location info, you need to have iPhoto's Location Services feature turned on for the Flag, Currency, Map, and Weather objects to set themselves automatically. To turn it on, tap the < at the top of the screen, tap the Options icon at the bottom right of your screen, and then tap Location. In the resulting pane, make sure Include Location and Location Lookup are both turned on (page 367).

- **Food.** Perhaps the cheesiest of all, this option adds a text block with a teeny-tiny icon of boring gray cutlery above it, which you might use to describe a food picture in your journal. Unfortunately, you can't change the size of the cutlery no matter how much you resize the text box. You get the same text formatting options as you do with Header.

- **Day.** This option adds a calendar icon to your page that includes the month, day, and year you took the photos closest to where you drop the Calendar object (the date changes if you drag it next to a photo shot on another day). To enter a custom date, double-tap the calendar and, in the resulting menu, turn off Auto and then tap Date. Swipe up or down to find the date you want, and then tap to select it.

> **NOTE** Unlike the other custom objects, you can't resize the Calendar. (But honestly, it's big enough already, don't you think?) Other un-resizable objects include Flag, Weather, and Currency.

- **Map.** This option adds a resizable map to your page, which makes for a nifty addition to your journal. If you've added location tags to your photos (page 334) or if you took them with an iOS device or other geotag-happy camera, iPhoto places a pin on the map to indicate where the photo *closest* to the Map object was taken; otherwise, the map shows Cupertino, California (the location of Apple's headquarters). Don't worry; you can specify a new location easily enough.

 When you first add a map object, four white arrows appear in its center to indicate that you can drag in any direction to reposition the map. You can also use the two-fingered pinch or spread gesture to change the map's zoom level. Double-tap the map anytime to bring these controls back.

 That said, it's far easier to use the Map's search feature to find a new location. Single-tap the map, and then tap Place Pin in the menu that appears above it. Tap the search field in the next pane and then type the location you're look-ing for. (Any recent locations you've searched for appear in a list beneath the search field.) Tap Search to have iPhoto hunt for matching locations online and in your Contacts app. When the location you want appears in the list, tap it; iPhoto drops a pin onto the map in that spot. Tap the ➐ at the upper right of the pane to have iPhoto drop a pin on your current location (helpful if you took the photos at home and you're currently *at* home). Once you've placed a pin, you can remove it by tapping the map and choosing Remove Pins.

- **Weather.** Tap this icon to add the weather condition and temperature to your journal page, as shown in Figure 15-16)—a nice addition if the weather was a key factor in your trip (think beach, desert, or ski destinations). iPhoto performs this nifty trick using the location tag and date info embedded in the photo. If iPhoto doesn't know what the weather was like when you took the shot, double-tap the weather object and, if necessary, tap the Auto switch to turn it off. Then tap Weather and pick a condition from the resulting list (sunny, cloudy, rainy, and so on). Tapping Temperature reveals a list of Fahrenheit options.

- **Divider.** Adds a thin, gray, horizontal line the width of your journal page. iPhoto adds a little space before and after the line, making this option a *great* way to add some visual breathing room to your page. It's also handy for dividing a journal page into sections.

- **Space.** To keep your page from being too busy, you can use this option to add an *empty* photo frame. Think of it as an invisible spacer that you can reposition and resize any way you want (horizontally or vertically) in order to add a blank spot to your page.

- **Page.** Adds another page to your web journal. Swipe left or use the Previous and Next icons labeled in Figure 15-13 to view other pages.

After you add objects, you might decide to delete one of them. No problem—just tap the object to select it, and then tap the tiny trash icon that appears above it (the journal has to be in edit mode for this to work).

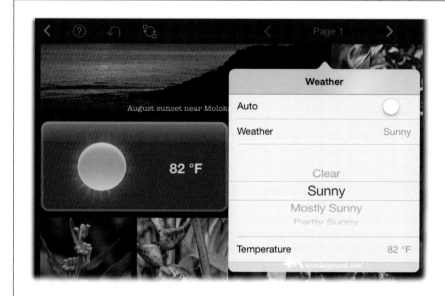

FIGURE 15-16

You can customize the Weather, Map, Flag, and Currency objects by double-tapping them to reveal a menu like this one. If you turn off the Auto Slider, iPhoto lets you tap each item in the list and handpick the info you want displayed. For a Weather object, you can specify the condition and temperature.

▩ MANAGING JOURNAL PAGES

Photos aren't the only ones having all the customization fun—you can combine, remove, and reorder individual *journal pages,* too. (You just learned how to add pages via the Add menu.) If you post the journal on the Web as described in the next section, visitors can click to move from page to page. This kind of thing is handled by the Page menu (Figure 15-17), which you open by tapping the word "Page" at the top of your screen.

> **TIP** In the Pages menu, you'll notice that iPhoto doesn't exactly give your pages inspiring names. If names like Page 1, Page 2, or Page 3 don't light your fire, just double-tap the name and type a new one (say, Sandy's Bachelor Party, Sandy's Incarceration, and so on).

Here are your page-wrangling options:

- **Combine pages.** In the Page menu, tap the empty circle to the left of the pages you want to consolidate, and then tap Combine. (You have to select more than one page to use this command.)

- **Remove pages.** Select the page you want to get rid of and then tap Remove. You don't get a confirmation message with this option, though if you delete a page that you want back, tap the Undo icon.

- **Reorder pages.** To rearrange journal pages, tap the icon labeled in Figure 15-17 and drag it up or down in the list.

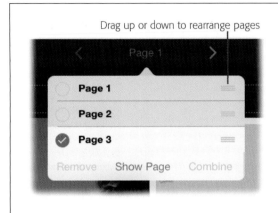
Drag up or down to rearrange pages

FIGURE 15-17

The page menu lets you combine, remove, and reorder the pages in your web journal. When you tap a page in this menu to select it, a blue ✓ appears to its left. You can skip to a certain page by selecting it and then tapping Show Page.

■ SHARING WEB JOURNALS

Once you've perfected a web journal, you can send it out into the world by sharing it in a variety of ways, using the menu shown in Figure 15-18 (left). After all, how can anyone else appreciate all your hard design work?

You can post your journal on the Web using iCloud (Apple's free syncing and storage service; page 12), copy it to your computer using iTunes file sharing (page 323), and transfer it onto another iOS device by beaming it or by using AirDrop (page 371).

NOTE If you don't want to publish your journal using iCloud, you can export it as HTML files that you can upload to your *own* website. To do that, in the Share menu, tap iTunes and then choose Export Journal HTML. The next time you sync your iPad with your computer using iTunes, the files are transferred using iTunes file sharing. (Page 225 has the scoop on how to *find* the files once they've been copied to your computer.) If you want to export the individual pictures in your journal instead, tap iTunes and then choose Export Photos Only.

Publishing a web journal using iCloud is a simple affair. Here's how to do it:

1. **Open a journal, tap ⬆, and then tap iCloud.**

 The Share menu handles getting your journal off of your iPad and in front of other people's eyeballs.

2. **Turn on "Publish to iCloud."**

 When you do, iPhoto prepares the journal and publishes it to the Web. You see a status bar indicating its progress. When iPhoto finishes, the menu repopulates itself with the options shown in Figure 15-18 (right).

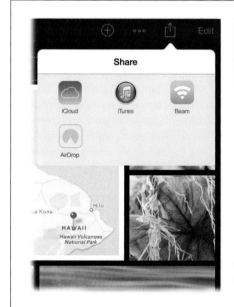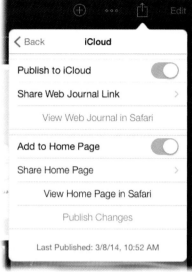

FIGURE 15-18

Left: The Share menu lets you show off your web journal.

Right: By choosing iCloud, you get a link you can share using iPhoto's messaging, emailing, tweeting, and Facebooking abilities. Publish as many journals as you want—iPhoto gives you a different link for each one. You can also gang them onto a single home page so visitors can see them all.

3. **Preview your journal by tapping "View Web Journal in Safari."**

 This step is optional, but it's a good idea to see what the journal looks like on the Web before you start telling everyone about it. When you tap this option, Safari opens and displays your journal. To return to iPhoto, double-tap your iPad's Home button and then tap iPhoto.

 Once you're back in iPhoto, you can make any necessary changes to your journal (make sure it's in edit mode!). When you're finished, tap ⬆, choose iCloud, and then tap Publish Changes (published journals don't update automatically). At the bottom of the Share menu, iPhoto dutifully reports the last time the journal was published. *Now* it's safe to tell the masses about your journal. To share it privately, proceed to step 5; otherwise, keep reading.

 NOTE While you can view published journals on any iOS device where you've turned on iCloud sharing (page 373), you can make changes to the journal only on the iOS device you used to *create* it. And remember that web journals are an iPhoto for iOS–only feature, so you can't edit them on your Mac (but you can view them there).

4. **To add this journal to your iCloud Home page, turn on "Add to Home Page."**

 Turning on this option means that *everyone* you share your Home page link with can see this journal (and any other journals that you publish in this way). It's a nice way to put all your journals on a single web page so your friends can

pick and choose what they want to see. However, if you don't want everyone to see, say, the costume you wore to the San Diego Comicon, then leave this setting turned off.

5. **Tap Share Web Journal Link or Share Home Page.**

 If you posted your journal to your iCloud home page (see step 4), then tap the latter; otherwise, tap the former. Both options give you the choices shown in Figure 15-19 (left). Tap Message to send the link via instant (text) message (in the resulting menu, add a lucky recipient and tap Send). To tweet the link, tap Twitter, compose your tweet, and then tap Post. To post the link on Facebook, tap Facebook, and then tap Post. To email the link, tap Mail, add a recipient (or several), and then tap Send. To copy the link to your iPad's memory, tap Copy, and then paste it wherever you want. To save the link to your Safari reading list so you can view it later, tap "Add to Reading List."

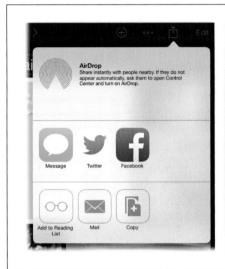
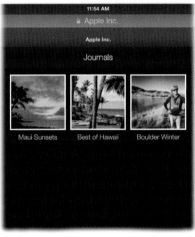

FIGURE 15-19

Left: Once you publish a journal to your iCloud account, you can let people know about it in a variety of ways.

Right: Journals you include on your iCloud Home page appear as thumbnails, like the ones shown here in Safari. Just click a journal to view it.

If you ever want to *unpublish* a journal, you have to pay a fee to Apple (kidding!). You can unpublish anytime you want—just open the journal, tap ⬆, choose iCloud, and then turn off the "Publish to iCloud" switch. That's all there is to it.

In Projects view, any journals you've published to your iCloud account have a tiny cloud icon at their upper right. Figure 15-20 has more.

As with any project you create in iPhoto for iOS, there's no way to sync a copy of it into iPhoto on your Mac. The only way to get the journal onto your computer is to use iTunes file sharing to export the journal as HTML files, as the Tip on page 394 explains.

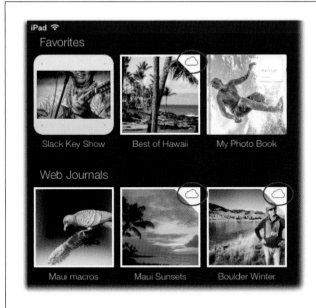

FIGURE 15-20

Journals you publish to iCloud get the special cloud symbols circled here. A cloud with a black outline means you created the journal on that particular device and therefore you can edit it. A cloud with a red outline means you created the journal on a different device, so you can't edit it on this one.

Slideshows

As you know from Chapter 6, a slideshow is a great way to display your photos and videos. With all the built-in themes, transitions, and customization options, you can put together a truly impressive show. However, iPhoto for iOS lets you go a step further and *share* the slideshow on the Web via iCloud (page 373).

You learned how to create and play a slideshow on your iPad in Chapter 13. This section teaches you how to edit an existing slideshow, as well as how to share a slideshow on the Web.

> **TIP** You can create a slideshow from Projects view by tapping ➕ at the bottom of your screen and choosing Slideshow. Then pick some pictures, and you're on your way!

▨ EDITING A SLIDESHOW

Once you've created a slideshow by following the directions on page 338, here are a few handy things you can do to it:

- **Add photos.** There are two ways to add photos to a slideshow. One method is to open the slideshow and then tap the ➕ at the top of your screen. Tap to select some photos; iPhoto adds them to your show (you can see this pane in action back on page 380).

The other method is to open an album or Event and then select photos using the methods described on page 337. After that, tap and choose Slideshow. In the next pane, you can tweak your photo selection, if need be, and then tap Selected, Flagged, or All. When you do, you see the pane shown in Figure 15-21; just tap the slideshow you want to add the photos to. When iPhoto finishes adding photos, a confirmation message appears; tap Show to open the slideshow, or tap Done to go back to whatever pictures you were perusing.

FIGURE 15-21

Left: Once you pick the photos you want to add, the Slideshow pane lists all the slideshows you've made; just tap one to select it. As you can see, this method also lets you create a new slideshow.

Right: Once iPhoto has added the images, you see this friendly, informative message.

- **Rearrange photos.** Tap a slideshow's thumbnail in Projects view to open it, tap and hold the photo you want to move (it appears to lift off the screen), and then drag it into place. iPhoto scoots the other thumbnails out of the way to make room for the one you're dragging.

- **Play, pause, and exit.** Go into Projects view and tap the thumbnail of the slideshow you want to see, and then tap the ▶ at the top of your screen to start the show. iPhoto happily auto-advances each slide, though you can run the show manually, too; just tap the screen and then use the controls described in Figure 15-22. To pause a slideshow, tap the **II**. To exit the slideshow, tap the < at the top of the screen.

> **TIP** You can also tag a slideshow as a *favorite,* making it easier to find in Projects view. Page 334 has details.

- **Edit a photo or change a slideshow's key photo.** Open a slideshow and then tap the photo you want to edit or use as the key photo (page 332). In the menu that appears, tap Edit. If the photo needs adjustment, you can do that here (see Chapter 14). To assign it as the slideshow's key photo, tap the Options icon at the bottom right of the screen and choose "Set as Key Photo." To return to the slideshow, tap the < at the top of the screen.

Back | Drag to scrub through slideshow manually | Slideshow length

0:54 ——————————————●——————————————— -1:37

Adjust volume | Previous | Pause | Next

FIGURE 15-22

Tap your screen while a slideshow plays to reveal these controls. They let you view the previous or next image, pause/play the show, change the music's volume (if there is any), or scrub through the show by dragging the slider labeled here. You can also swipe left or right to view the previous or next image (respectively).

- **Remove a photo.** Open the slideshow and then tap the thumbnail of the picture you want to remove. Tap the tiny trash icon that appears above the thumbnail, and it disappears from the show (though it's still on your iPad). You don't get a confirmation message, so if you change your mind, you can get it back by tapping the Undo icon at the top of your screen.

- **Change theme, music, and slideshow speed.** Open the slideshow and then tap the Options icon to reveal the controls described on page 339.

- **Rename, duplicate, or delete a slideshow.** In Projects view, tap and hold the slideshow you want to duplicate or delete. In the menu that appears, tap the action you want to take. To delete a slideshow, tap the trash icon and, in the confirmation message that appears, tap Delete.

▓ SHARING A SLIDESHOW

Once you've perfected your slideshow, you can share it with others using the Share menu shown in Figure 15-23. Here are your options:

- **iCloud.** If you have an iCloud account (page 12), you can post your slideshow on the Web and invite people to view it. When visitors watch your show in their

web browsers, they get controls they can use to pause the show, display the images one by one, and adjust the volume of any music you've included. The slideshow-publishing process is *exactly* the same as for web journals (ditto for making changes to it once it's been published). Page 394 has the mercifully easy details. To publish changes to a slideshow you've shared via iCloud, tap ⬆, choose iCloud, and then tap Publish Changes.

> **TIP** If you make changes to a slideshow you've published using iCloud, a tiny red circle with an exclamation point inside it appears atop the ⬆ at the top right of your screen to remind you that you haven't updated the online version to reflect your edits.

- **iTunes.** Tapping this option lets you export your slideshow as HTML files (great for posting the slideshow on your *own* website) or as individual photos that you can do anything you want with (see Figure 15-23). Once the export process is finished, your iPad lets you know; when you tap OK, the next sync copies the files to your computer. Page 225 tells you how to find the files once they're on your computer.

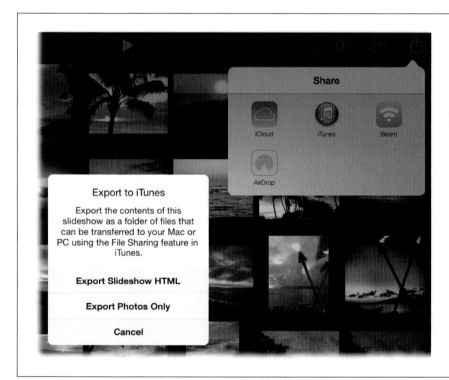

FIGURE 15-23

By sharing your slideshow using iTunes, you can generate HTML files that you can post on your personal website (if you have one).

- **Beam, AirDrop.** As with any other project—or picture, for that matter—iPhoto lets you beam slideshows to other iOS devices (see page 371). You can also use AirDrop to transfer it via wireless network to another iOS device that's within 30 feet of you (page 371). Either way, the slideshow appears in the Slideshow section of Projects view in the recipient's copy of iPhoto.

Unfortunately, even though iPhoto for Mac can create slideshows (Chapter 7) too, there's no way to sync a slideshow you've created in iPhoto on your iPad into iPhoto on your Mac. (As the box on page 346 explains, the two programs are completely independent when it comes to editing photos and creating projects.) The only way to get a slideshow from your iPad onto your computer is to use the iTunes option explained above to export HTML files. It's a huge drag.

Photo Books

You can create and order hardcover photo books from iPhoto on your iPad that are identical to the ones you can create on your Mac, as described in Chapter 9.

Here's a quick refresher: Each book begins life with at least 20 pages, though you can add up to 100. An 8 × 8-inch book costs $25 (add 80 cents for each additional page) and a 10 × 10 book will set you back $40 (additional pages cost $1 each). Once you've created a book, you can rearrange individual pages or two-page spreads; swap, resize, and reposition pictures; add captions; change the theme; and so on. The main difference between creating books in iPhoto for Mac and iPhoto for iOS device is the use of *gestures.*

There are exactly two ways to create a photo book on your iPad, and your choice depends on how you want to go about placing pictures onto the pages. Do you want iPhoto to automatically place them, or do you want to place them manually into a blank book? Here's how to do both:

- **To have iPhoto place the photos,** open a photo, album, or Event, and then tap ⬆ and choose Photo Book. As described on page 366, you can select photos *before* you tap Share, or you can use the next pane you see to select the photos you want to include (and then tap either Selected or Next). In the resulting pane, tap New Photo Book. You see the pane shown in Figure 15-24 (top), which lets you name the book and choose a size and a theme.

 Tap Create Photo Book; iPhoto assembles the book and places the pictures on each page in chronological order. (If you didn't select enough photos to fill the photo boxes of each page, the pages toward the end of the book are blank.) When iPhoto finishes, a confirmation message appears; tap Show to view the book or Done to see it later. Either way, the book's thumbnail appears in Projects view (visible in Figure 15-24, bottom).

- **To add pictures manually,** go to Projects view, tap the ➕ (Figure 15-24, bottom), and choose Photo Book. In the resulting pane, you can name the book by tapping My Photo Book and typing, as well as pick a book size and theme.

When you tap Create Photo Book, iPhoto creates a *blank* book. In the confirmation message that appears, tap Show to open the book. Tapping Done returns you to Projects view.

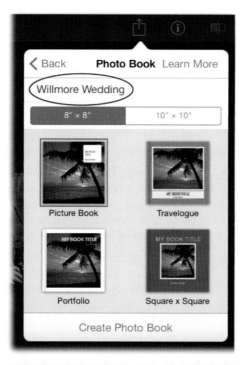

FIGURE 15-24

Top: This pane lets you name your book; just tap Photo Book Name and then type anything you want (circled). When you're finished, tap Done on your iPad's digital keyboard. Pick a size by tapping 8" × 8" or 10" × 10", and then tap one of four themes.

Bottom: By using the Add menu in Projects view, you can create a blank *book that you fill with pictures manually.*

When you open your book—either by tapping Show when you created it or by tapping its thumbnail in Projects view—you see thumbnails of all the pages it contains (Figure 15-25).

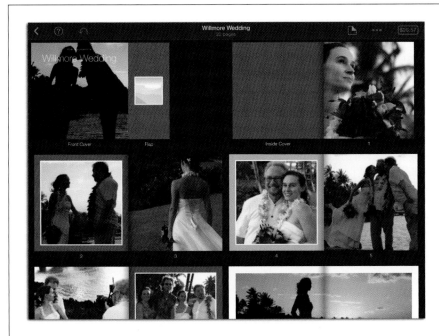

FIGURE 15-25

If you had iPhoto place photos for you, then when you first open the book, you see all of its pages filled with the pictures you picked. If you created an empty book, the pages contain gray picture place-holders instead (an empty photo box is visible on the Inside Cover page here). iPhoto shows the cost of your book in blue at the top right of your screen.

To open a two-page spread, double-tap anywhere on the page. Once you've opened a page, you can swipe left or right to see the next or previous page (respectively). To return to viewing all the pages in your book, use two fingers to pinch the page.

■ ADDING, REPLACING, AND REMOVING PHOTOS

iPhoto gives you a couple of ways to add photos to your book. You can add them one at a time to the *photo boxes* on each page, or you can add several photos to your book *project* and then place them onto pages individually. Here's how to use both methods:

- **To add or replace a photo in a photo box,** open the book you want to add the pictures to and then double-tap a page to open it. If you tap an *empty* photo box, the pane shown in Figure 15-26 appears. Navigate to the photo you want to add, and then tap it; iPhoto plops it into the photo box.

 If you tap a photo box that already contains a photo, a menu appears above it. Tap Replace to see the pane shown in Figure 15-26, which you can use to find the picture you want to use instead. Tap a photo in the list; it replaces the image in the photo box. (Where does the old photo go, you ask? iPhoto puts it in a special storage bin called Extra Photos [Figure 15-27], where the photo patiently waits for you to use it on a page later.)

- **To add several pictures to your project,** go to Photos or Albums view and tap an album or Event to open it. Use the techniques described on page 337 to select some shots, tap ⬆, and then tap Photo Book. The next pane lists all the books you've made; tap the one you want to add the pictures to, and then tap Add Photos. When iPhoto finishes adding them, a message appears; tap Show to open the book or Done to return to the album or Event you were viewing.

Pictures you add this way *aren't* automatically placed; instead, they land in the Extra Photos section at the bottom of your screen (see Figure 15-27). Swipe left or right to see all the photos it contains.

To place a photo that's in Extra Photos, tap and hold the thumbnail, and then drag it into a photo box. If the photo box you're dragging it into already contains a photo, the two photos swap places—the one that was in the photo box gets tucked into Extra Photos, and the one you dragged is removed from Extra Photos and plopped into the photo box.

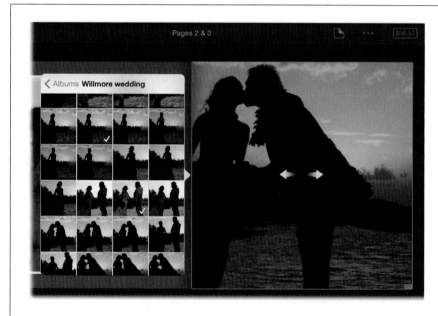

FIGURE 15-26

Double-tap a page to open it, and iPhoto displays its page numbers at the top of your screen. Tap an empty photo box to see this pane. Photos that are already included in your book have white checkmarks on them (two are visible here).

Use gesturing to position a photo within a photo box (arrows indicate the directions you can drag). To zoom into the picture, use the two-finger spread gesture.

- **To remove a photo from a photo box,** tap the photo and then, in the menu that appears above it, tap the trash icon. iPhoto removes the photo and tucks it into Extra Photos; a gray placeholder appears inside the photo box. (You can accomplish the same thing by tapping and holding a photo in a photo box and then dragging it into Extra Photos.)

> **TIP** The Extra Photos section appears whenever you open a book page, though if you don't have any unused photos, it reads, "Drag photos here to use them on other pages." Either way, you can gain back a little screen real estate by collapsing it when you're not using it. To do that, tap the words "Extra Photos"; tap again to expand it.

◼ RESIZING, REPOSITIONING, AND EDITING PHOTOS

Half the fun of creating a photo book on your iPad is manipulating the photos inside the boxes. By using gestures, you can do all kinds of things with them: resize or reposition a photo, zoom in or out of it, and swap photos between two boxes on a page. If a photo needs a little extra editing—say, it looks too dark or too light next to another one on a page—you can summon the editing tools you learned about in Chapter 14. The changes you make are reflected on your book page.

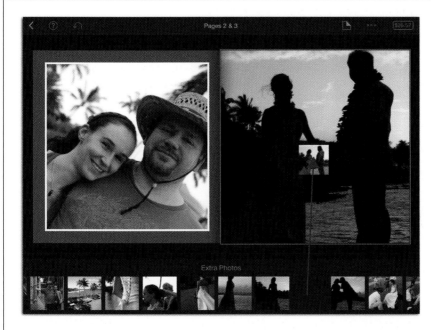

FIGURE 15-27

You can think of Extra Photos as a waiting area for photos that haven't yet been used on a book page. If you remove a photo from a photo box or add multiple photos to your project, they land here. To place one of these pictures, drag it onto a photo box.

Once you open the book project you want to play with, find the page you want to edit and double-tap it to open it. Next, tap the *photo* you want to tweak, and then proceed as follows:

- **Edit.** In the menu that appears above the photo, tap Edit (Figure 15-28, top). Then use the techniques you learned in Chapter 14 to improve the picture. When you're finished, tap the < at the left of your screen; iPhoto whisks you back to the page from whence you came.

- **Reposition.** When you tap a photo, white arrows appear on it that indicate the directions you can drag to reposition it (see Figure 15-28, top). If you enlarge the photo using the two-finger spread gesture, you get arrows in all four directions. To reposition a photo inside a box, drag in any of the indicated directions.

- **Resize.** Use the two-finger spread gesture to zoom into a photo, making it bigger (Figure 15-28, bottom). Once you've zoomed in, you can use the pinch gesture to zoom out, making it smaller.

• **Swap photos between boxes.** To swap two photos on a page, tap and hold one photo until it shrinks and lifts off the screen, and then drag it onto the other photo box. When you lift your finger, iPhoto swaps the two.

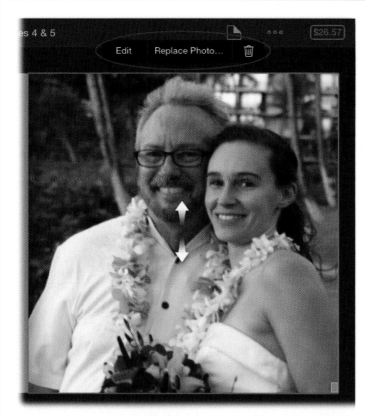

Resolution warning Photo orientation

FIGURE 15-28

Top: If you haven't yet zoomed into a photo, you see two arrows: drag up/down for portrait orientation or left/right for landscape. (A tiny rectangle at the bottom right of the photo indicates its orientation.)

Bottom: If you zoom in too far, a warning symbol appears to let you know you've increased the photo's size beyond what can be printed at high quality. Use the pinch gesture to make the image smaller to make the warning disappear.

If you use the spread or pinch gesture without first tapping a photo box, you zoom in or out of the page itself.

EDITING TEXT ON A BOOK PAGE

Depending on the theme you picked when you created the book, you'll have more or less text to edit throughout the book. Some themes include areas for captions as well as detailed descriptions. That said, *every* theme includes a title on the front cover, at the very least, so you want to be sure and customize it.

To edit text, double-tap the page to open it, and then tap the text. When you do, the formatting controls explained in Figure 15-29 appear. However, to edit the actual text, you need to double-tap the text box to summon your iPad's digital keyboard and then type whatever you want. When you're finished editing the text, tap somewhere else on the page or tap the dismiss button at the lower right of your iPad's digital keyboard.

> **NOTE** It's helpful to keep in mind that there are *multiple* text boxes involved—if there's small text on one line and larger text on another, say, iPhoto puts them in separate text boxes.

Black White Horizontal alignment Vertical alignment Smaller Larger

FIGURE 15-29

iPhoto gives you a choice of text colors (black or white), as well as horizontal and vertical alignment options. You also get two buttons that let you make the font size smaller or larger; taps on these two buttons are cumulative— keep tapping to get the size you want.

Happily, there's no need to highlight text before changing its formatting.

CHANGING A BOOK'S THEME, SIZE, AND NUMBER OF PAGES

Ever flexible, iPhoto doesn't squawk if you decide to change the theme or even the *size* of your book. All you have to do is tap the Options icon to display the pane shown in Figure 15-30 (left). To change the size of your book, tap 8″ × 8″ or 10″ × 10″. To change themes, tap the icon of the one you want to use; iPhoto reflows your pictures onto the new pages.

You can also change the number of pages in your book and how many photos each page holds. From the factory, iPhoto uses the number of photos you select when

you create the book to determine the number of pages in it. That said, photo books consist of at least 20 pages; if you don't select enough photos to fill them, you end up with blank pages at the end of the book. However, if you have *more* than 20 pages, you can tap the Options icon, tap "Number of Pages," and then use the slider at the top of the resulting pane (Figure 15-30, right) to adjust the total page count. If you've got more than 20 pages and you drag the slider leftward, iPhoto deletes pages and stuffs the photos that were on them into Extra Photos (page 403).

FIGURE 15-30

Left: The Photo Book Options pane lets you include a tasteful, light-gray Apple logo on the last page of your book...or not.

Right: Tapping "Number of Pages" reveals this pane, which lets you control how many pages are in your book as well as how many photos appear on each page. When you tap an option in the Page Density section, iPhoto reflows your photos to reflect your pick.

■ CHANGING PAGE DESIGN

To change the layout of an individual page, double-tap the page to open it, and then tap the page icon at the top left of your screen to reveal the pane shown in Figure 15-31 (left). There are a slew of delightful options for you to experiment with, so do give yourself permission for this fun activity (a frosty beverage may be helpful). Swipe up to scroll through a variety of page-layout options—you get different ones depending on the theme you picked (page 402). When you find a layout you like, tap its icon to apply it; any photos you previously added to the page change to fit the new design, meaning you may end up with *empty* photo boxes if you pick a layout that includes more photos per page than the previous layout.

iPhoto also lets you adjust each page's background color. Tap Background to see the choices shown in Figure 15-31 (right); tap one to apply it to the selected page. You can also use this pane to add a page to your book or a full-page *spread*—a layout option in which a single photo spans both pages. The next section has more info.

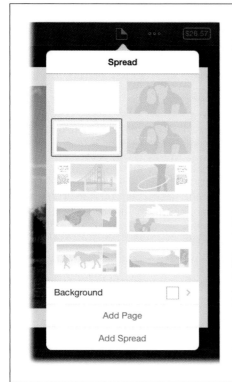 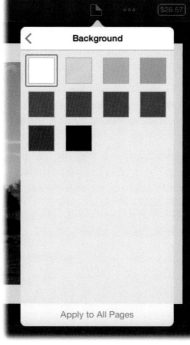

FIGURE 15-31

Left: The book options pane lets you change page-layout options, as well as add a single page or a two-page spread to your book project. Tap Background to reveal the pane shown at right.

Right: To apply a new background color to all the pages in your book, tap a color swatch, and then tap "Apply to All Pages."

ADDING, REMOVING, AND REARRANGING PAGES

iPhoto is also happy to let you add, remove, and rearrange the individual pages in your photo book; the latter is especially fun because you get to use gestures. To whip your pages into picture-perfect order, open a book project and then do the following:

- **Add a page** by tapping the page icon at the top of your screen and choosing Add Page. iPhoto adds a new page to the end of your book.

- **Add a two-page spread** to the end of your book by tapping the page icon and choosing Add Spread.

- **Move a page or two-page spread** by tapping and holding the page until it miniaturizes and "lifts" off the screen, and then dragging it to a new location. iPhoto scoots nearby pages out of its way to make room.

NOTE Unfortunately, you can't select more than one page in order to move several at once; only two-page spreads can be moved as a single entity.

■ ORDERING A PHOTO BOOK

When you've depleted your attention span and your spouse's tolerance, it's time to pull the trigger and order your book.

Take a deep breath and start the ordering process by tapping the blue price at the top right of your screen. The resulting screen lists recent shipping addresses; tap to the left of any address to select it (a checkmark appears to its left). If the lucky recipient's address isn't listed, tap Add Shipping Address and enter the details.

NOTE If your book contains any placeholder (temporary) text or empty photo boxes, a message appears to alert you. Tap OK and then add photos to, delete, or add text to the pages in question.

Once you've selected a shipping address (or three), iPhoto illuminates the word "Sets" to its right. Tap it to order more than one book and have it sent to that address; tap the + sign to add a book or the − sign to subtract one from your order.

When everything is just right, tap Place Order. Now tap your toes until the mailman delivers your masterpiece.

Appendixes

Troubleshooting

All programs have their vulnerabilities, and iPhoto is no exception. Many of its shortcomings stem from the fact that iPhoto works under the supervision of a lot of cooks, since it has to interact with printers, talk to web servers, cope with an array of file formats, and so on.

If trouble strikes, keep hands and feet inside the tram at all times—and consult the following collection of problems, solutions, questions, and answers.

The Most Important Advice in This Chapter

Apple's traditional practice is to release a new version of iPhoto (and iMovie, and Pages, and Keynote...) that's got some bugs and glitches—and then, just when public outcry reaches fever pitch a couple of weeks later, send out a .0.1 update that cleans up most of the problems.

Spare yourself the headache: Update your copy to the latest version! To do that right now, choose →Software Update to open the Mac App Store window. If there's an iPhoto update in the list, click Install.

Importing, Upgrading, and Opening

Getting photos into iPhoto is supposed to be one of the most effortless parts of the process. Remember, Steve Jobs promised that iPhoto would forever banish the "chain of pain" from digital photography. And yet...

"Unable to upgrade this photo library."

There may be locked files somewhere inside your iPhoto library. If something is locked, iPhoto can't very well convert it to the latest format.

Trouble is, there can be hundreds of thousands of files in an iPhoto library. How are you supposed to find the one file that's somehow gotten locked?

The quickest way is to type out a Unix command. Don't worry, it won't bite.

Open your Applications→Utilities folder, and then double-click Terminal. The strange, graphics-free, all-text command console may look alien and weird, but you'll witness its power in just a moment.

Type this, exactly as it appears here:

```
sudo chflags -R nouchg
```

—and add a space at the end (after "nouchg"). Don't press Return yet.

Now switch to the Finder. Open your Pictures folder and drag your iPhoto Library icon right *into* the Terminal window. Now the command looks something like this:

```
sudo chflags -R nouchg /Users/Casey/Pictures/iPhoto\ Library/
```

Press Return to issue the command. OS X asks for your account password, to prove that you know what you're doing. Type it, press Return, and your problem should be solved.

> **WARNING** Using a "sudo" command in Terminal is basically telling your Mac, "Hey! I know exactly what I'm doing and I want you to do exactly what I say." So type this command exactly as listed, and be sure to drag the correct file into the window.

iPhoto doesn't recognize my camera.

iPhoto generally "sees" any recent camera model, as well as iPhones, iPads, and photos saved on an iPod Touch. If you don't see the Import screen (Chapter 1) even though the camera most assuredly is connected, then try these steps in order:

- Make sure the camera is turned on. Check the USB cable at both ends.

- Try plugging the camera into a different USB port.

- Try unplugging *other* USB devices. Some devices hog all available USB power, leaving none for your camera.

- Some models don't see the computer until you switch them into a special "PC" mode, using the Mode dial. Check to see if your camera is in that category.

- Try turning on the camera *after* connecting its USB cable to the Mac.

- Turn the camera off, then on again, while it's plugged in.

- If iPhoto absolutely won't notice its digital companion, then use a memory-card reader, as described on page 11, or the SD card slot built into your Mac.

iPhoto crashes when I try to import.

This problem is most likely to crop up when you're bringing pictures in from your hard drive or another disk. Here are the possibilities:

- The culprit is usually a single corrupted file. Try a test: Import only half the photos in the batch. If nothing bad happens, then split the remaining photos in half again and import *them.* Keep going until you've isolated the offending file.

- Consider the graphics program you're using to save the files. It's conceivable that its version of JPEG or TIFF doesn't jibe perfectly with iPhoto's. (This scenario is most likely to occur right after you've upgraded either your graphics program or iPhoto itself.)

 To test this possibility, open a handful of images in a different editing program, save them, and then try the import again. If they work, then you might have a temporary compatibility problem. Check the editing program's website for updates and troubleshooting info.

- Some JPEGs that were originally saved in OS 9 won't import into the newer versions of iPhoto. Try opening and resaving these images in a native OS X editor like Pixelmator (*www.pixelmator.com*) or Adobe Photoshop Elements (*www.adobe.com*). Speaking of Elements, it has an excellent batch-processing tool that can automatically process *mountains* of images while you go grab some lunch (it's called the *Image Processor*).

Finally, a reminder, just in case you think iPhoto is acting up: iPhoto imports raw files—but not from all camera models—and it displays (and thus edits) a *JPEG* version of it. For details, see page 148.

iPhoto crashes when I try to empty the Trash.

Open iPhoto while pressing both the ⌘ and Option keys; you see the dialog box shown in Figure A-1. Choose Rebuild Thumbnails and then click Rebuild.

▧ Printing

Printing has its share of frustrations and wasted paper, but checking a few settings can solve some common problems:

I can't print more than one photo per page. It seems like a waste to use a whole sheet of paper for one 4 × 6 print.

Check the following:

- Make sure you've selected a paper size that's larger than the prints you want on it.

- Confirm that you selected more than one photo before starting the printing process.

My picture doesn't fit right on 4 × 6-, 5 × 7-, or 8 × 10-inch paper.

Most digital cameras produce photos in a 4:3 width-to-height ratio. Unfortunately, those dimensions don't fit neatly into any of the standard print sizes.

The solution: Crop the photos first, using the appropriate print size in the Constrain pop-up menu (see page 128).

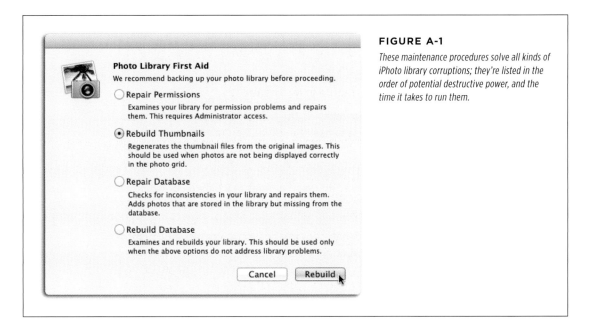

FIGURE A-1

These maintenance procedures solve all kinds of iPhoto library corruptions; they're listed in the order of potential destructive power, and the time it takes to run them.

Editing and Sharing

There's not much that can go wrong here, but when it does, it *really* goes wrong.

iPhoto crashes when I double-click a thumbnail to edit it.

You probably changed a photo file's name in the Finder—in the iPhoto Library package, behind the program's back. iPhoto hates this! Only grief can follow.

Sometimes, too, a corrupted picture file makes iPhoto crash when you try to edit it. To locate the scrambled file in the Finder, Control-click its thumbnail and, in the shortcut menu, choose Show Original File. Open the file in another graphics program, use that program's File→Save As command to replace the corrupted file, and then try again in iPhoto.

iPhoto won't let me use an external graphics program when I double-click a thumbnail.

Choose iPhoto→Preferences→Advanced. Check the Edit Photos pop-up menu to make sure that the external program's name is selected. (If not, choose "In application," and then pick the program you want to use.) If you want to make Photoshop Elements your external editor, be sure to direct iPhoto to the program's actual application icon and not the icon's *alias,* which has a tiny curved arrow atop its icon.

Also make sure that your external editing program still *exists.* You might have upgraded to a newer version of that program, one whose filename is slightly different from the version you originally specified in iPhoto.

Faces really stinks at identifying the people in my pictures!

To make Faces more skilled at matching up names to the folks in your photos, you need to help it along by *training* it. If Faces hasn't identified someone you *know* is in your library, then open the photo(s) with the poor nameless soul, click Info in the toolbar, and then click the Faces heading to expand that section. Click "Add a face," and then proceed as shown on page 94. Manually naming the face, however, doesn't do much for iPhoto's face-recognition algorithm—it's your *confirming* results in the automatic face-recognition roundup that helps Faces learn.

So click Faces in the Source list, open that person's snapshot on the corkboard, and then click Confirm Name in the toolbar. Scroll down to the "may also be in the photos below" list, and start confirming or rejecting the suggestions (page 95) so Faces gets more practice at *correctly* identifying your buddies.

Published pictures I re-edit in iPhoto aren't updating on my Flickr page.

Sometimes there are breakdowns in communication: between heads of state, management and labor, and even iPhoto and Flickr. Fortunately, that last one is the easiest to solve. In iPhoto, delete the misbehaving photo(s) from your Flickr album. Next, make your edits or changes to the pictures (if you haven't already), and then publish the photos to Flickr again, as described on page 215. If you have only one picture in the Flickr album, delete the whole album from the iPhoto Source list, fix the picture in iPhoto, and then republish the photo to Flickr as a brand-new album.

> **NOTE** Flickr used to take advantage a photo's Places tags (page 103), but it doesn't anymore. Le sigh.

I've messed up a photo while editing it, and now it's ruined!

Select the file's thumbnail and then choose Photos→"Revert to Original." iPhoto restores your photo to its original state, drawing on a backup it has secretly kept.

I can't find a picture I saved to my Camera Roll in iPhoto for iOS.

Oddly, iPhoto for iOS's Camera Roll album displays photos in chronological order according to the date they were *captured,* not the date they were *edited.* So to find the edited version of a picture, you may have to do a fair bit of scrolling.

My iCloud photo stream isn't syncing.

Photo streams sync only when you're on a WiFi connection; they can't sync over a cellular network. You can also encounter syncing problems if the Camera app is open on your iOS device (you have to close it before pictures will upload), or you may merely have a low battery. If your iOS device has less than 50 percent juice left and it *isn't* plugged into a power outlet, your photo streams stop syncing.

■ General Questions

Finally, here's a handful of general—although perfectly terrifying—troubles.

iPhoto is wigging out!

If the program "unexpectedly quits," well, that's life. It happens. This is OS X, though, so you can generally open the program right back up again and pick up where you left off.

If the flakiness is becoming really severe, try logging out (choose →Log Out) and logging back in again. And if the problem persists, see the data-purging steps on page 419.

I can't share my photos over a network.

That's because you can't do that anymore. While Apple prefers that you share photos between Macs using iCloud (page 12), Chapter 8 has additional workarounds.

I can't delete a photo!

You may be trying to delete a photo right out of a smart album. That's a no-no.

There's only one workaround: Find the photo in your iPhoto Library by heading to the Source list and clicking an icon in the Library or Recent section—Events, Photos, Last Import, or Last 12 Months—and then delete it from there.

I deleted a photo, but it's back again!

You probably deleted it from an album (or book, calendar, card, or slideshow). These are all only *aliases,* or *pointers,* to the actual photo in your library. Just removing a thumbnail from an album doesn't touch the original.

All my pictures are gone!

Somebody probably moved, renamed, or fooled with your iPhoto Library icon. That's a bad, bad idea.

If it's just been moved or renamed, then find it again using your Mac's search feature (Spotlight, for example). Drag it back into your Pictures folder, if you like. In any case, the important step is to open iPhoto while pressing the Option key. When the dialog box shown on page 416 appears, show iPhoto where your library folder is now. (If that solution doesn't work, read on.)

All my pictures are *still* gone! (or)

My thumbnails are all gray rectangles! (or)

I'm having some other crisis!

The still-missing-pictures syndrome and the gray-rectangle thumbnails are only two of several oddities that may strike with all the infrequency—and pain—of lightning. Maybe iPhoto is trying to import phantom photos. Maybe it's stuck at the "Loading photos…" screen forever. Maybe the photos just don't look right. There's a long list of rare but mystifying glitches that can arise.

What your copy of iPhoto needs is a big thwack upside the head, also known as a major data purge.

You may not need to perform all of the following steps. But if you follow them all, at least you'll know you did everything possible to make things right. Perform these steps in order; after each one, check to see if the problem is gone.

- **If you haven't already done so, upgrade to the very latest version of iPhoto.** For example, the 9.5.1 update was hot on the heels of iPhoto 9.5. Page 5 explains how to update.

- **Rebuild the iPhoto library and fix its permissions.** To do that, quit iPhoto. Then reopen it, pressing the Option and ⌘ keys as you do so.

 The dialog box shown in Figure A-1 appears; it offers four different repair techniques. They are listed in order of severity and runtime, so start at the top and work your way down if the problem persists.

 Once you click Rebuild, iPhoto works its way through each album and each photo, inspecting it for damage, repairing it if possible, and finally presenting you with your new, cleaned-up library. This can take a *very* long time, but it usually works.

- **Throw away the iPhoto preference file.** Here we are in the age of OS X, and we're still throwing away preference files?

 Absolutely. A corrupted preference file can still bewilder the program that depends on it.

 First, quit iPhoto if it's running. In the Finder, open the Go menu and, while pressing the Option key, choose Library. In the resulting Finder window, open the Preferences folder and trash the file called *com.apple.iPhoto.plist*.

 The next time you run iPhoto, it will build itself a brand-new preference file that, if you're lucky, lacks whatever corruption was causing your problems.

- **Import the library into itself.** If, after all these steps, some or all of your photos are still missing, try this radical step. Create a new, empty iPhoto library (page 309). Then drag the older, troubled library folder right from the Finder into the empty iPhoto window. The program imports all the graphics it finds (except the thumbnails, which you don't want anyway).

You lose all your keywords, Event names, comments, albums, folders, books, saved slideshows, and so on. And you might wind up with duplicates (the edited and unedited versions of the pictures). But if any photos were in the old library but somehow unaccounted for, they'll magically reappear.

- **Find the pix yourself.** If none of these steps restored your missing photos, all is not lost. Unless you somehow opened your Home→Pictures folder and, while sleepwalking, manually *threw away* your iPhoto Library folder, then your pictures are still there, somewhere, on your hard drive.

Use Spotlight or the Find command to search for them, as shown in Figure A-2.

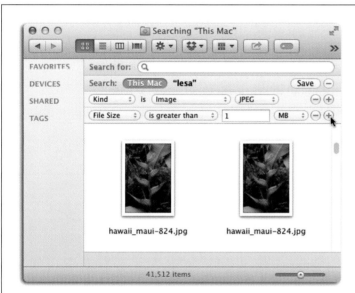

FIGURE A-2

Search for file extensions JPG or JPEG (or images, to be more general) with file sizes greater than, say, 1 MB (to avoid rounding up all the little thumbnail representations; it's the actual photos you want). The results may include thousands of photos. But in this desperate state, you may be grateful that you can either (a) click one to see where it's hiding, or (b) select all of them, drag them into a new, empty iPhoto library, and begin the process of sorting out the mess.

- **Recover from a Time Machine backup.** If you've got Time Machine turned on for backups (see the box on page 307), you can use it to restore lost files. The first step is to pinpoint the missing files using Spotlight or the Find command, as described above—*if* you can (in the case of deleted files, the search will probably come up empty, which is fine). Next, click the Time Machine icon on the Dock, or double-click it in your Applications folder. When you do, your desktop *slides* down the screen like a curtain that's been dropped from above. Front and center is your Finder window—or, rather, dozens of them, stretching back into an outer-space background. Each is a snapshot of that window at the time of a Time Machine backup. You have four ways to peruse your backup universe:

 - **Click individual windows to see what's in them.**

 - **Drag your cursor through the timeline on the right side of the screen.** It's like a master dial that flies through the windows into the past.

- **Click one of the two big, flat perspective arrows.** The one pointing into the past means "Jump directly to the most recent window version that's different from the way it is right now." In other words, it's often a waste of time to go flipping through the windows one at a time, because your missing file might have been missing for the last several backups. What you want to know is the last time the contents of a particular window changed. And that's what the big flat arrows do. They jump from one changed version of this window to another. (Or, if you began with a search, the arrow takes you to the most recent backup with a matching result.)

- **Use the search box in the corner of the window.** You can search for whatever you're missing in the current backup.

Once you find the file you want to restore (say, your iPhoto Library file), select it and then click Restore in the lower right. The OS X desktop rises again from the bottom of the screen, there's a moment of copying, and then presto!—the lost file is back in the window where it belonged. (If you recover a different version of a file that's still around, OS X asks if you want to replace it with the recovered version or keep both versions.)

Where to Go from Here

Your Mac, your trusty digital camera, and this book are all you need to *begin* enjoying the art and science of modern photography. But as your skills increase and your interests broaden, you may want to explore new techniques, add equipment, and learn from people who've become just as obsessed as you. Here's a tasty menu of resources to help you along the way.

iPhoto and the Web

- **Apple's iPhoto for Mac support page** (*www.apple.com/support/mac-apps/ iphoto*) features the latest product information, QuickTime tutorials, FAQ (frequently asked questions) lists, camera and printer compatibility charts, and links to discussion forums where other iPhoto lovers share knowledge and lend helping hands. There's even a feedback form that goes directly to Apple. In fact, each piece of feedback is read personally by top-level Apple executives. (Just a little joke there.)

- **Apple's iPhoto for iOS support page** (*www.apple.com/support/ios/iphoto*) features the latest info on using iPhoto on your iOS device.

- **Apple's iCloud support page** (*www.apple.com/support/icloud*) contains, you guessed it, helpful info on using iCloud.

- *Macworld* **magazine** (*www.macworld.com*) regularly posts reviews on new versions and helpful how-to articles on using iPhoto.

Digital Photo Equipment Online

- **Imaging-Resource** (*www.imaging-resource.com*) offers equipment reviews, price comparisons, and forums, all dedicated to putting the right digital camera in your hands.

- **Digital Photography Review** (*www.dpreview.com*) is similar: It offers news, reviews, buying guides, photo galleries, and forums. It's a must-visit site for the digicam nut.

- **Digital Camera Resource** (*www.dcresource.com*) is just what it says: a comprehensive resource page comparing the latest in digital cameras.

- **Photo.net** (*www.photo.net*) offers industry news, galleries, shopping, critiques, and community sharing.

- **Photo District News** (*www.pdnonline.com*) covers trends on the photography industry, news, and camera reviews, plus RSS feeds to keep you updated on the go.

- **LensProToGo** (*www.lensprotogo.com*) offers an incredible variety of camera gear for rent. Use it to try out a camera body, lens, and even lighting equipment, before buying it. Pricing is affordable, and the whole staff is comprised of professional photographers.

When it comes time to buy, you can't beat your local camera store for service (some stores offer training, too). Camera gear is almost always cheaper online, though. At *www.shopping.com*, for example, you can find a price roundup of all the online shops selling a particular camera.

Show Your Pictures

Nothing beats Flickr, Facebook, Twitter, and iCloud for easily posting your pictures online, straight from iPhoto. But there are alternatives:

- **Photobucket** (*www.photobucket.com*) offers its members web space for 10,000 photos—free. The photo-sharing site groups submitted pictures into categories like "Funny Signs" and "Black & White" for easy browsing on its home page, and features one-click posting to sites like Facebook, Twitter, Pinterest, and so on.

- **SmugMug** (*www.smugmug.com*) is another popular site for creating beautiful and secure photo galleries (special programming blocks visitors from Control-clicking to save images to their desktops). If you spring for the pro version, you can generate some extra income by selling your photos as files, prints, and photo products (you get to set the pricing). If you want to start an online photography business, this site is worth checking out. Pricing ranges from $40 to $300 a year.

- **Fotki.com** (*www.fotki.com*) is similar—it, too, is a thriving online community of photo fans who share their work on the Web—but the free account is unlimited. Chime in with your shots, or just check out what everyone else is shooting.

Online Instruction

- **creativeLIVE** (*www.creativeLIVE.com*) is relatively new to the online training realm, though it features some of the best instructors in the world. It offers a multitude of streaming videos on all aspects of photography, along with related software (Photoshop, Photoshop Elements, Lightroom, and so on). Courses are free while they're live (you watch them through your web browser), or you can purchase course videos for a small fee. Visit your coauthor's instructor page at *www.lesa.in/clvideos*.

- **Lynda.com** (*www.lynda.com*) is another video-training company that's been around for years. Here you'll find all manner of instruction on the basics of digital photography, using iPhoto, and a lot more. Subscriptions range from $25 a month to $375 a year.

Online Printing

- **Mpix** (*www.mpix.com*) is a wonderfully friendly online service that provides high-quality prints, books, greeting cards, and anything else that a photo can be attractively printed on. This lab is regarded very highly by photo pros all over the world.

- **Shutterfly** (*www.shutterfly.com*) is another alternative to iPhoto's built-in photo-ordering system. It's OS X–friendly and highly reviewed (at least by *Macworld*).

- **American Greetings PhotoWorks** (*www.photoworks.com*) is another OS X–friendly photo printing site that's also received high marks for quality.

■ Books

David Pogue's Digital Photography: The Missing Manual (O'Reilly) offers expert advice from the moment you start shopping for a digital camera to producing your own stunning shots—with plenty of nuts-and-bolts instruction on lighting, composition, and choosing the best camera settings along the way.

Understanding Exposure by Bryan Peterson (Amphoto Books) is another fantastic guide. To get the most out of your camera, you have to understand exposure, a confusing concept, but this book makes it crystal clear through text and beautiful imagery. If you're passionate about photography or just want to get a little more serious, this book is an essential and enjoyable read (as are *all* of Bryan's books on photography).

The Skinny Books (*www.theskinnybooks.com*) offers several slim, to-the-point ebooks on topics such as digital photography (*Take Better Pictures with Any Camera*, for example), image editing (*The Skinny on Photoshop Elements, The Skinny on Lightroom*), graphic design, and more, all hand-crafted by your coauthor, Lesa Snider.

Photoshop CC: The Missing Manual by Lesa Snider (O'Reilly) teaches you everything you need to know about using this complicated program in a comprehensive yet

conversational manner. It includes a slew of exercise files, too, so you can follow along. This book is considered the Photoshop Bible.

The Moment It Clicks by Joe McNally (New Riders Press) is an attractive book that gives you unique insight into the realm of one of the world's best shooters.

The Digital Photography Book by Scott Kelby (Peachpit Press) contains all kinds of wonderful advice on taking better pictures and choosing essential gear, along with tips and tricks for setting up simple lighting yourself.

The Digital Photography Companion by Derrick Story (O'Reilly) is a handy, on-the-go digital-photo reference that fits nicely in your camera bag.

Take Your Best Shot by Tim Grey (O'Reilly) dives into the digital darkroom, covering the fundamentals of camera hardware as well as more advanced topics like color management and optimizing images.

Index

iPhoto

THE MISSING CD

There's no CD with this book; you just saved $5.00.

Instead, every single Web address, practice file, and piece of downloadable software mentioned in this book is available at *missingmanuals.com* (click the Missing CD icon). There you'll find a tidy list of links, organized by chapter.

Don't miss a thing!
Sign up for the free Missing Manual email announcement list at missingmanuals.com. We'll let you know when we release new titles, make free sample chapters available, and update the features and articles on the Missing Manual website.